THE ART OF

OVERWATCH®

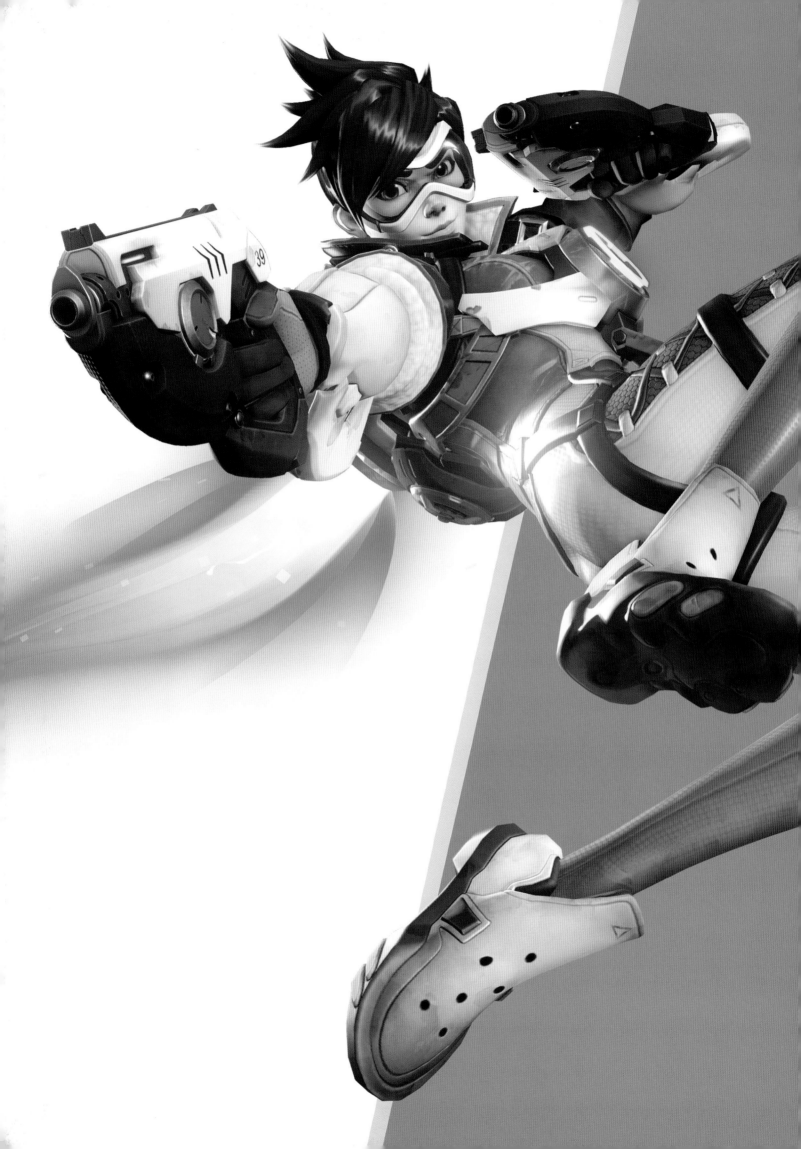

THE ART OF

OVERWATCH

LICENSED BLIZZARD ENTERTAINMENT PRODUCT

DARK HORSE BOOKS

DARK HORSE CREDITS

Publisher
MIKE RICHARDSON

Editor
DAVE MARSHALL

Assistant Editor
RACHEL ROBERTS

Designer
DAVID NESTELLE

Digital Art Technicians
**CHRISTINA McKENZIE, MELISSA MARTIN, CHRIS HORN, ADAM PRUETT,
ALLYSON HALLER,** and **CONLEY PRESLER**

BLIZZARD CREDITS

Writer
MATT BURNS

Editors
ROBERT SIMPSON, CATE GARY, ALLISON MONAHAN

Creative Consultation
ARNOLD TSANG, MICHAEL CHU, BILL PETRAS

Lore Consultation
SEAN COPELAND, CHRISTI KUGLER, JUSTIN PARKER

Production
TIMOTHY LOUGHRAN, ADAM GERSHOWITZ

Project Manager
BRIANNE M LOFTIS

Senior Manager, Global Licensing
BYRON PARNELL

Director, Creative Development
RALPH SANCHEZ

Special Thanks
**LAUREL AUSTIN, STEPHANE BELIN, JEFF CHAMBERLAIN, AARON CHAN,
SKYE CHANDLER, MICHAEL CHU, BEN DAI, ANH DANG, RYAN DENNISTON,
NICHOLAS EBERLE, QIU FANG, RENAUD GALAND, ADAM GERSHOWITZ,
GEOFF GOODMAN, DOUG A. GREGORY, JERAMIAH JOHNSON,
STEPHANIE JOHNSON, DYLAN JONES, DAVID KANG, JEFFREY KAPLAN,
ROMAN KENNEY, PHILIP KLEVESTAV, BILL PETRAS, DION ROGERS,
ARNOLD TSANG, MATHIAS VERHASSELT, BEN ZHANG, VASILI ZORIN**

Published by
Dark Horse Books
A division of Dark Horse Comics, Inc.
10956 SE Main Street
Milwaukie, OR 97222

DarkHorse.com
International Licensing (503) 905-2377
Comic Shop Locator Service (888) 266-4226

First Edition: October 2017
Standard edition ISBN: 978-1-50670-367-1
Limited edition ISBN: 978-1-50670-553-8

3 5 7 9 10 8 6 4 2
Printed in China

Blizzard.com

CONTENTS

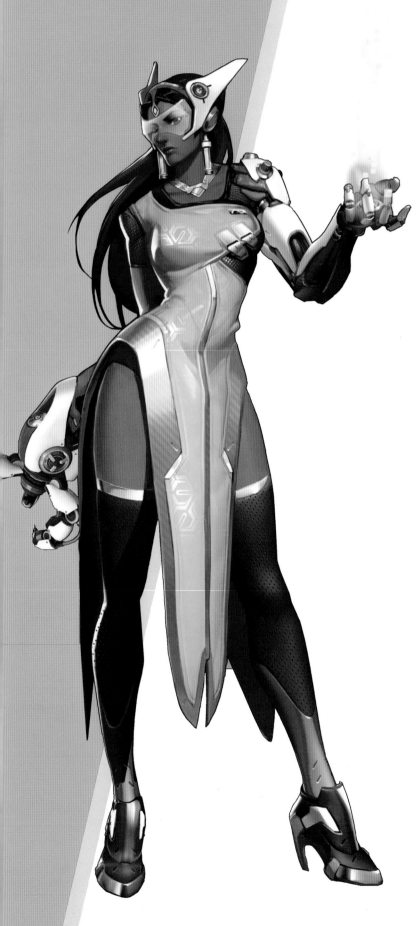

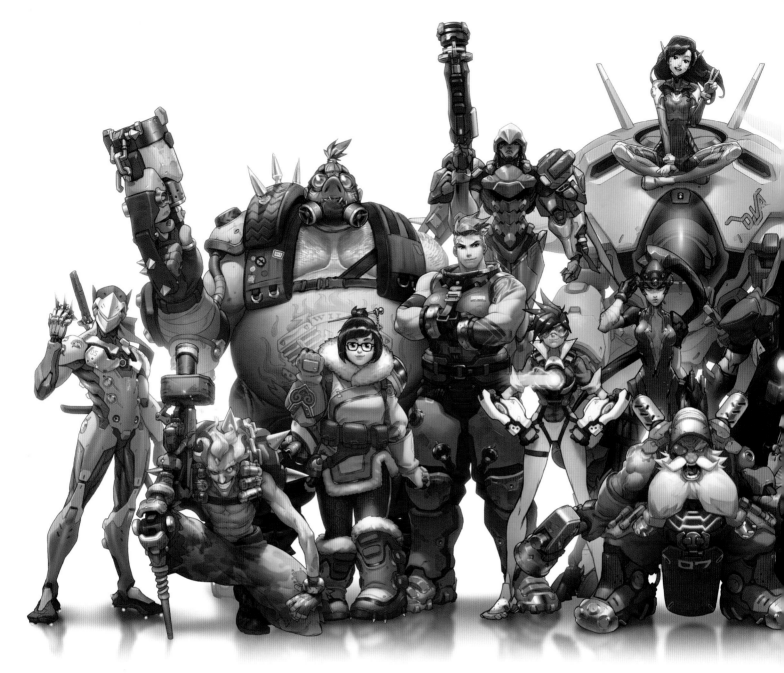

FOREWORD

THIS BOOK IS MORE THAN JUST A COLLECTION OF ART: IT'S THE HEART AND SOUL OF OVERWATCH.

Concept art has driven the game's creation since the very beginning. Early in the development of *Overwatch*, I remember sitting across from the concept art team led by Arnold Tsang, our assistant art director. He was working on an image to give the team a spark of inspiration and set the game's visual style. It was a group shot of the characters that would form the core of our game; it demonstrated what *Overwatch* heroes could be. We all watched as the early sketches of these heroes took shape. From rough sketches to the final composition, members of the art team were eager to share their ideas and collaborate with the artists who would hover around their desks. Everyone's feedback was embraced, and the team's excitement and creativity flowed into the art. A cyborg, a mutant, a crossbow-wielding

assassin, and an early version of Reinhardt were coming to life before our eyes.

When the image was done, it quickly spread throughout our offices and onto our desktop wallpapers. (It even jammed up the printer in the hallway!) The team's excitement grew with every new iteration. We had a sense of belonging. This image became a beacon to guide us through the unknown territory of early game development. And most importantly, it made us care about the heroes.

They weren't just ideas anymore. They were a part of us. Our team. Our family.

Now we had to find a home for these heroes. We needed to build a new world.

ARNOLD TSANG

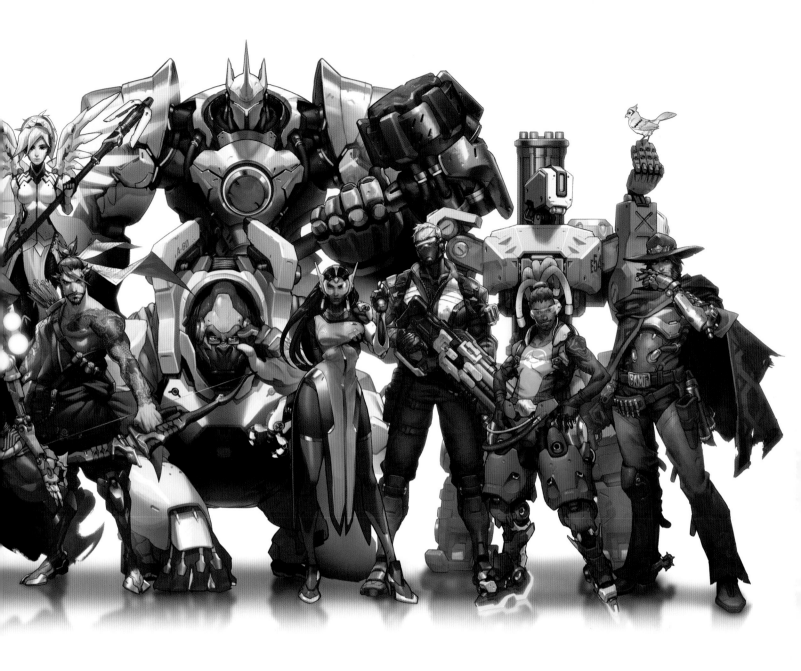

Our next key image depicted what the world of *Overwatch* would look like from the player's perspective. This painting, by Ben Zhang, showed early versions of characters like Genji and Winston, as well as a strange, spiderlike mutant, fighting in an ancient temple in the desert, with a futuristic megacity looming over the horizon.

When completed, these two pieces of concept art were instrumental in setting the style and tone of *Overwatch*. If not for them, we wouldn't be where we are today. They inspired us with a creative vision to develop not only the heroes but the entire world around them. They served as the cornerstone to everything that was yet to come, from maps and abilities to new heroes and skins.

This book is a celebration of those early paintings and the wealth of concept art that came after. These images are

more than the work of individual artists. They represent the creativity of the entire *Overwatch* team—the passion, optimism, and diversity of ideas that people from different disciplines and walks of life have poured into the game.

And now we are sharing this art with you. We hope you find it just as inspiring as we do, and we're excited to have you join us as we continue this artistic journey . . .

. . . and dare to see the world of *Overwatch* for what it could be.

BILL PETRAS
Senior Art Director of *Overwatch*

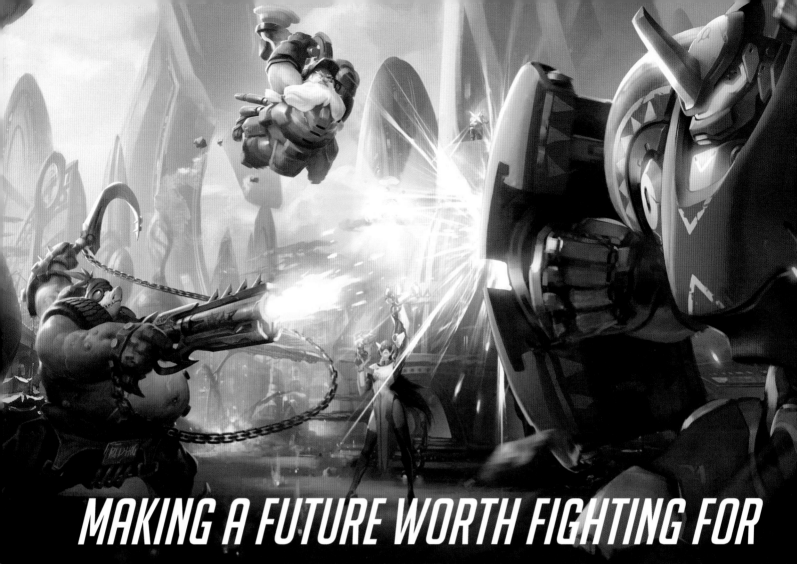

MAKING A FUTURE WORTH FIGHTING FOR

OVERWATCH VISUAL TARGET CONCEPT

On November 7, 2014, Blizzard Entertainment turned a new page in its history.

Over twenty thousand people from around the world had gathered at the Anaheim Convention Center in California for the eighth BlizzCon. Many of the attendees arrived early and flooded into the main hall to claim a seat for the opening ceremony. They expected to hear news about Blizzard's current lineup of games, but they were in for a surprise.

Before the packed main hall, Chris Metzen, Blizzard's senior vice president of Story and Franchise Development and one of the company's veteran creative forces, took the stage. For two decades, he'd shaped the universes and characters of Warcraft, StarCraft, and Diablo. More recently, he and a team of developers had been busy with something else. Now it was time for BlizzCon's attendees—and the world—to discover what that was.

Metzen unveiled a never-before-seen trailer. It wasn't set in the world of Warcraft, StarCraft, or Diablo. It was new. It was different.

It was *Overwatch*.

For the first time in seventeen years, Blizzard had created a brand-new universe: a science fiction vision of future Earth, filled with diverse and larger-than-life heroes and villains.

Over the next year and a half, the game went through various stages of beta testing and refinement. Then on May 24, 2016, *Overwatch* was released. It quickly became an international bestseller, garnering critical acclaim and winning numerous Game of the Year awards.

But the road to success was long, and it began in the wake of failure.

Years before *Overwatch*'s announcement, Blizzard had been developing a different title—a massively multiplayer online role-playing game (MMORPG) code-named Titan. Many talented artists, game designers, producers, and engineers worked on the project. They were eager to create something that would match the success of Blizzard's existing MMORPG juggernaut, *World of Warcraft*.

BEN ZHANG

Despite the team's passion and experience, Titan never quite found its footing. Blizzard ultimately canceled the project.

The developers were humbled, but they weren't ready to give up. Not yet. They were hungry to prove themselves, to craft a new idea that would succeed where Titan had failed.

After Titan's cancellation, members of the game team met to discuss the future. From their talks, an idea was born— a first-person shooter in a near-future Earth. The genre and setting were departures from Blizzard's current games, but the developers saw that as an advantage. It would give them the opportunity to explore new art styles and stories.

A guiding principle that emerged was that the game would focus on *heroes*. They would be more than just classes like those seen in many traditional first-person shooters. The characters would have their own identities and backstories. They would be the heart and soul of the game that would become known as *Overwatch*.

VOLSKAYA EARLY IDEATION

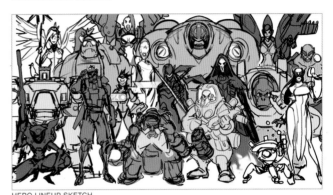
HERO LINEUP SKETCH

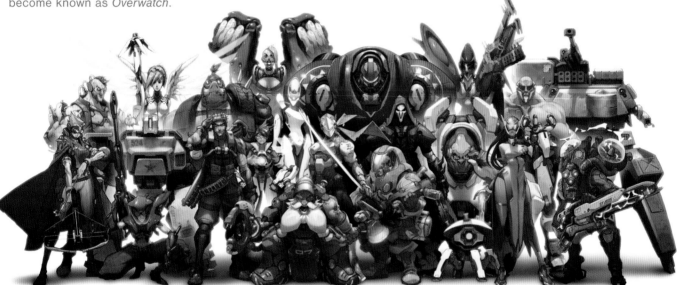
EARLY HERO LINEUP

Concept artists immediately began fleshing out this nascent idea. The first illustrations of *Overwatch*'s hero lineup helped establish a tone and personality for the game. They gave the rest of the developers a clear vision of what they were working toward. They gave them something tangible to rally around.

Artists also explored in-game concept illustrations. The first ones featured early versions of characters like Torbjörn, Roadhog, Reinhardt, Winston, Tracer, and Genji. The characters were bright and intriguing. The world they inhabited was vibrant and alluring.

These concepts were the sparks of inspiration that fueled the team going forward.

As the art style of the game took shape, the developers faced another challenge. *Overwatch* was visually unique, and it was very different from Blizzard's other universes. How could the developers keep *Overwatch* fresh and new while also making it feel like a part of the Blizzard family? How could they embrace the company's art legacy while also pushing it forward?

All of Blizzard's existing game universes had distinct themes and visual styles. StarCraft was a stark and gritty sci-fi that centered around conflict between three powerful factions: terrans, protoss, and zerg. Warcraft was a high fantasy world of elves, dwarves, demons, and other creatures. Diablo was a dark gothic fantasy where humanity was trapped amid an unending struggle between angels and demons.

TOP: **PETER C. LEE**, MIDDLE AND BOTTOM: **ARNOLD TSANG**

MOCK-UP OF ART OF BLIZZARD COVER WITH TORBJÖRN

Overwatch's developers closely examined these worlds to learn not what made them different but what made them alike. Warcraft, StarCraft, and Diablo shared Blizzard's core design pillars, such as exaggerated proportions for characters and immersive worlds filled with deep stories.

From their studies of other Blizzard games, the developers made four guiding art principles for *Overwatch.* The first was **diversity**, in terms of not only character backstories and cultures but also designs for locations, architecture, and technology. The second was creating a **hopeful future**, one that players would want to live in and fight for. The third was making locations, character proportions, animations, and poses **dynamic**. The fourth was giving the game a **handcrafted** feel, ensuring that every texture and piece of art felt stylized and lovingly crafted.

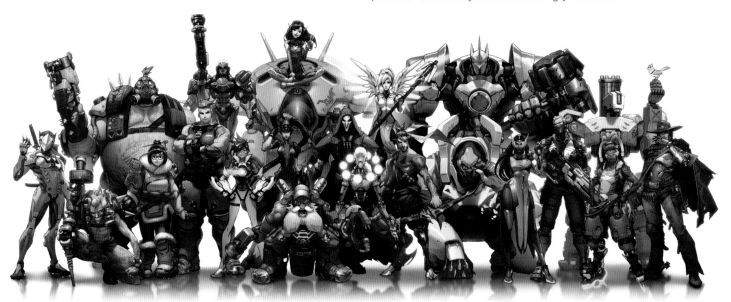

FINAL HERO LINEUP

The next hero lineup fulfilled these principles as well as the team's goal of embracing Blizzard's art legacy. The characters were highly stylized, featuring the exaggerated proportions and attention to detail also seen in Warcraft, StarCraft, and Diablo.

These new heroes fit into two categories. Some were classic archetypes that would be familiar to players of other Blizzard games, such as the armor-clad knight Reinhardt and the dwarflike engineer Torbjörn.

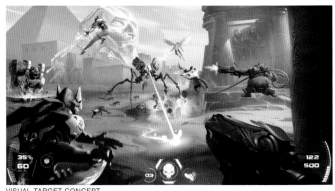

VISUAL TARGET CONCEPT

02 03 04 05 06 07

OVERWATCH OVERWATCH OVERWATCH OVERWATCH OVERWATCH OVERWATCH OVERWATCH

LOGO EXPLORATION

TOP: **WEI WANG** AND **ARNOLD TSANG**, MIDDLE TOP: **ARNOLD TSANG**, MIDDLE BOTTOM: **BEN ZHANG**, BOTTOM: **JEREMY CRAIG**

"RECALL" ANIMATED SHORT

Others were completely unique to *Overwatch*, like the exuberant time-bending hero Tracer and the highly intelligent gorilla Winston. These characters represented some of the game's core themes: the spirit of heroism and humanity's bright future.

The team applied the same art principles to *Overwatch*'s setting as they did to the game's characters. Earth was unexplored territory. It had never fully appeared in any of the company's other titles. The developers relished the opportunity to re-imagine the world through the lens of Blizzard.

The designers set out to make their maps as diverse and stylized as their heroes. They also wanted them to feel both exotic and familiar. Places like Hanamura blended traditional Japanese architecture with futuristic vehicles and cityscapes. Eichenwalde featured a village damaged by war between humans and robots, while drawing inspiration from classic fantasies of enchanted European forests and medieval castles.

To keep the focus on *Overwatch*'s heroes, the designers tied these locations to characters. The maps became more than just places where players would do battle. Some of them represented the countries that the heroes were from. Others featured heavily in the characters' backstories.

Over many months, work progressed. Concept artists, modelers, animators, lighters, game designers, and other developers continued fleshing out heroes and maps, using the core pillars of diversity, a hopeful future, dynamic characters and locations, and a handcrafted feel.

When *Overwatch* was released in 2016, it featured twenty-one heroes and twelve maps. The designers had molded its visual style into something unique and true to Blizzard's legacy, and they now had a firm foundation from which to expand.

And expand they would.

The future was bright, and the story of *Overwatch* had just begun.

MATHIAS VERHASSELT

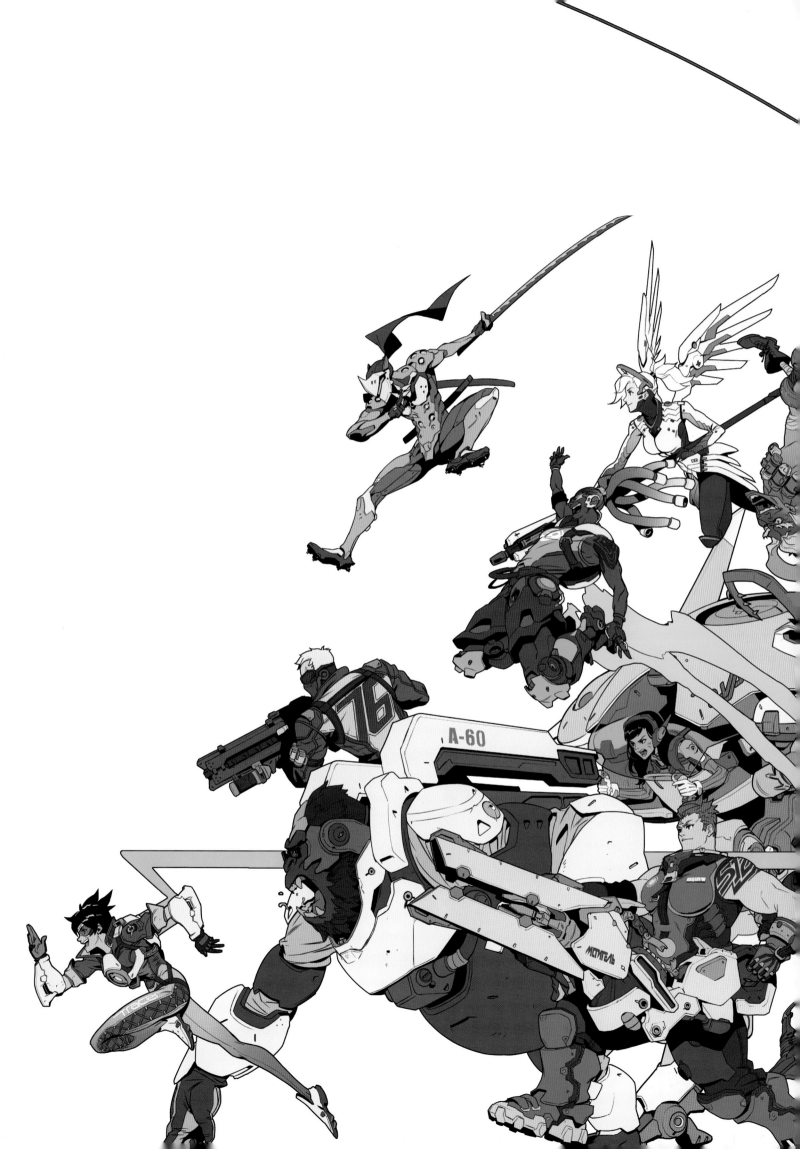

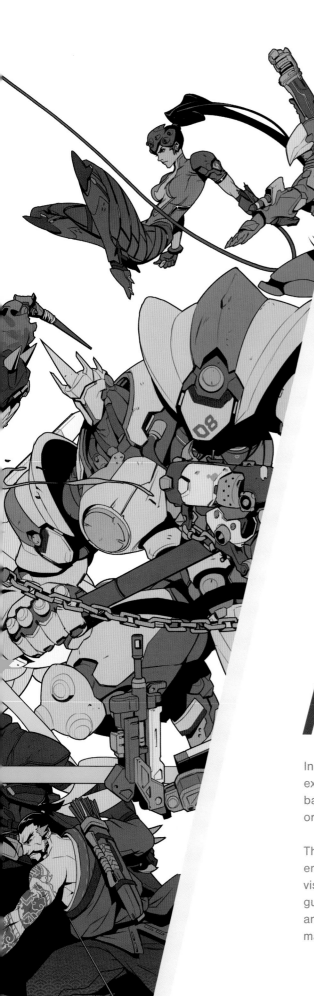

HEROES

In *Overwatch*, heroes are everything. They are the game's identity, the expressions of its core themes and values. Every character has a unique backstory, visual style, and personality. The fact that no two of them look or act the same is the very essence of *Overwatch*'s design philosophy.

The game team used *Overwatch*'s four main art principles as a road map to ensure that every hero was diverse, symbolized a bright, hopeful future, was visually dynamic in proportions and movements, and felt handcrafted. These guidelines established cohesion among the soldiers, scientists, adventurers, and oddities who live in the *Overwatch* world. They also laid a foundation for many more heroes to come.

ARNOLD TSANG

ANA

Concept art and a detailed backstory existed for Ana before the game team made her into a playable hero. She first appeared in Soldier: 76's origin short as a gifted sniper and an original member of Overwatch. However, the team found it difficult to add her to the game; Widowmaker already filled the sniper role.

A solution came when the developers combined Ana with the abilities of the Alchemist, a prototype character who used potions to harm enemies and heal allies. The result was a thoroughly unique hero: a *support* sniper who also played a key role in defining the world of *Overwatch* and its overarching story.

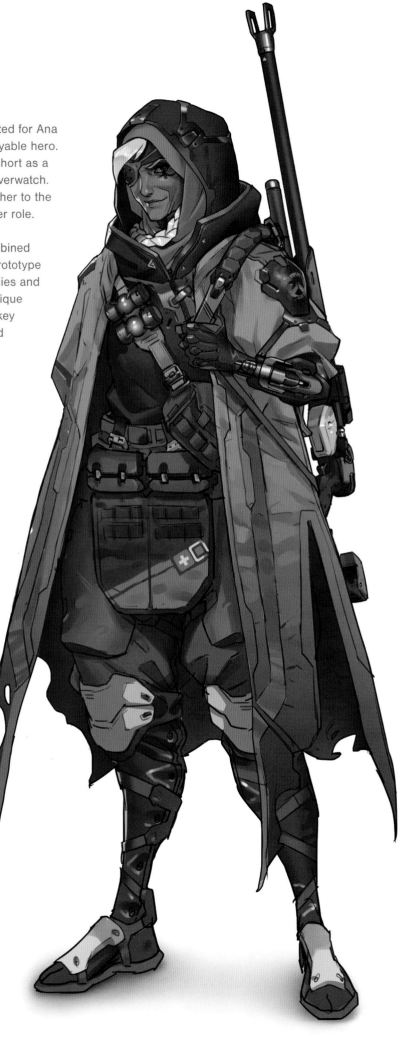

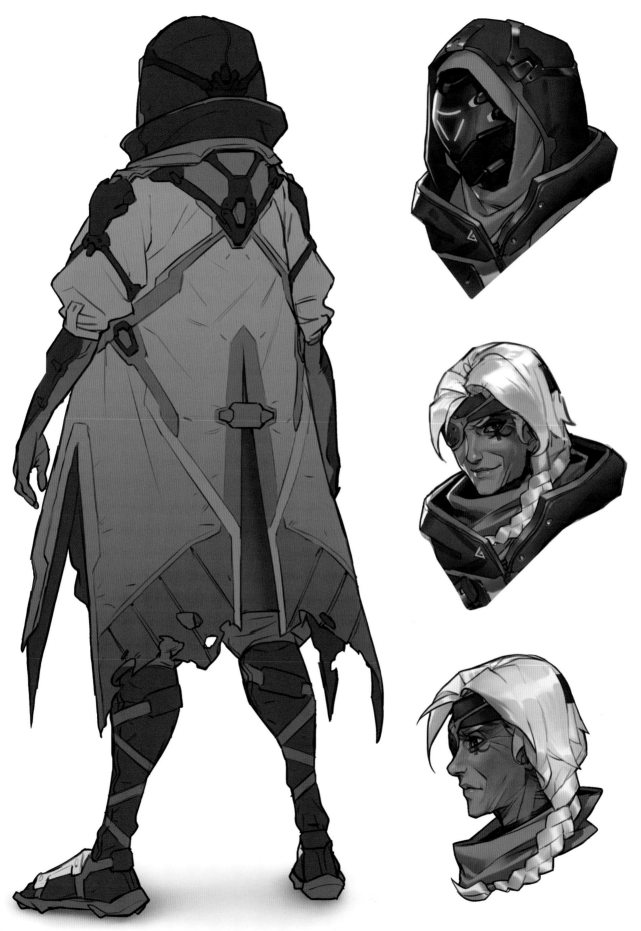

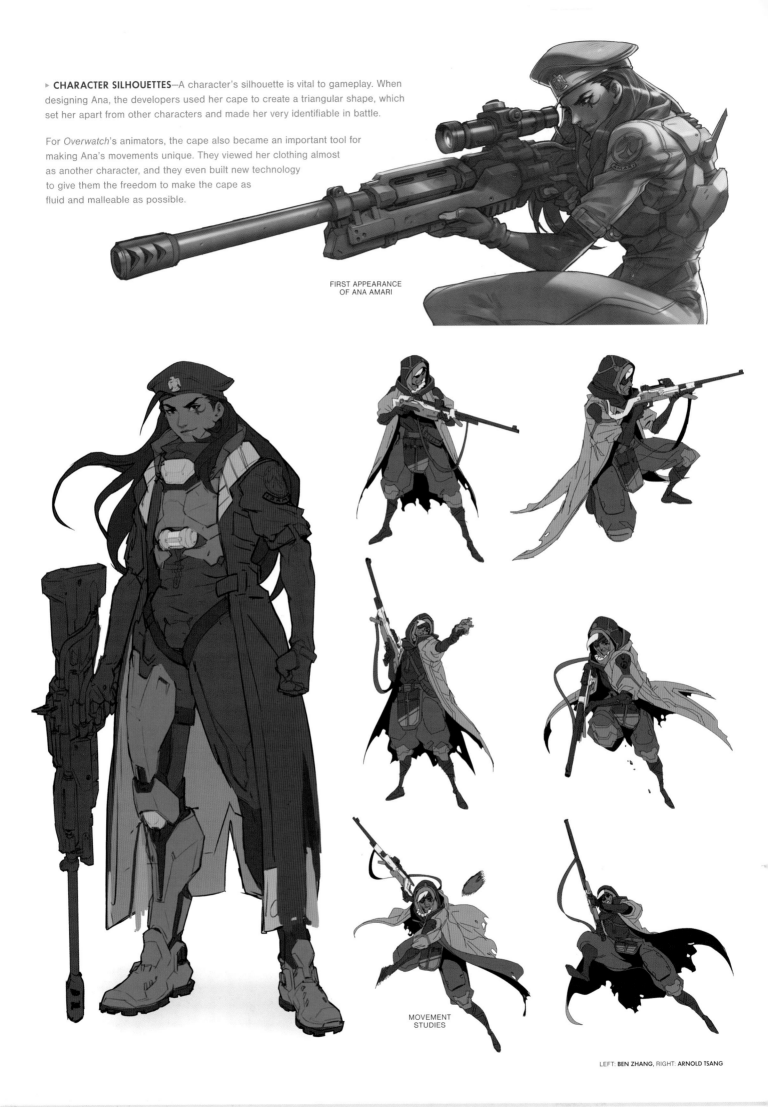

► **CHARACTER SILHOUETTES**—A character's silhouette is vital to gameplay. When designing Ana, the developers used her cape to create a triangular shape, which set her apart from other characters and made her very identifiable in battle.

For *Overwatch*'s animators, the cape also became an important tool for making Ana's movements unique. They viewed her clothing almost as another character, and they even built new technology to give them the freedom to make the cape as fluid and malleable as possible.

FIRST APPEARANCE
OF ANA AMARI

MOVEMENT
STUDIES

LEFT: **BEN ZHANG**, RIGHT: **ARNOLD TSANG**

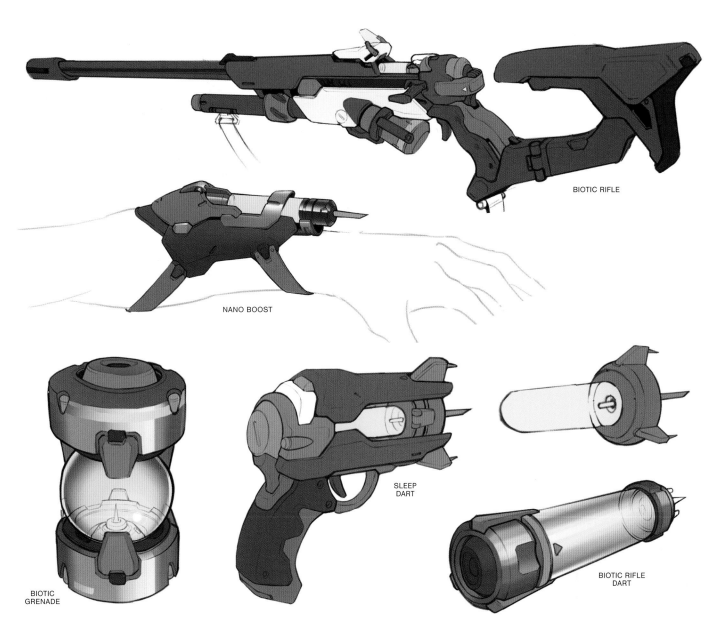

BIOTIC RIFLE

NANO BOOST

BIOTIC
GRENADE

SLEEP
DART

BIOTIC RIFLE
DART

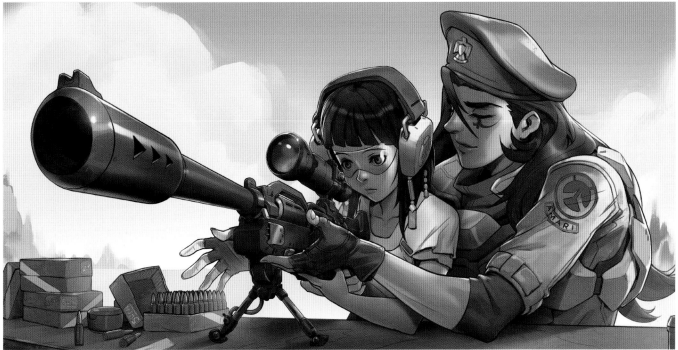

ANA WITH YOUNG FAREEHA

TOP: **DAVID KANG**, BOTTOM: **JOHN POLIDORA** AND **ARNOLD TSANG**

BASTION

Bastion was originally built for war, but the omnic is much more than a weapon. After its combat programming was damaged, Bastion developed an insatiable curiosity for nature and the untouched places of the world. The *Overwatch* team went through many different concepts before they captured this duality between death-dealing omnic and nature-loving explorer.

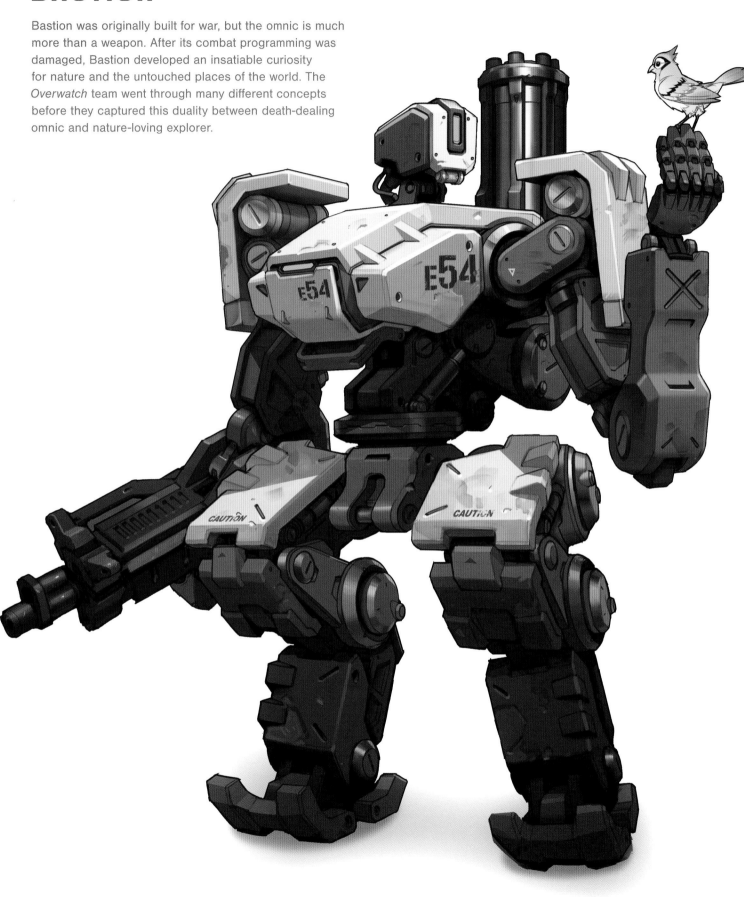

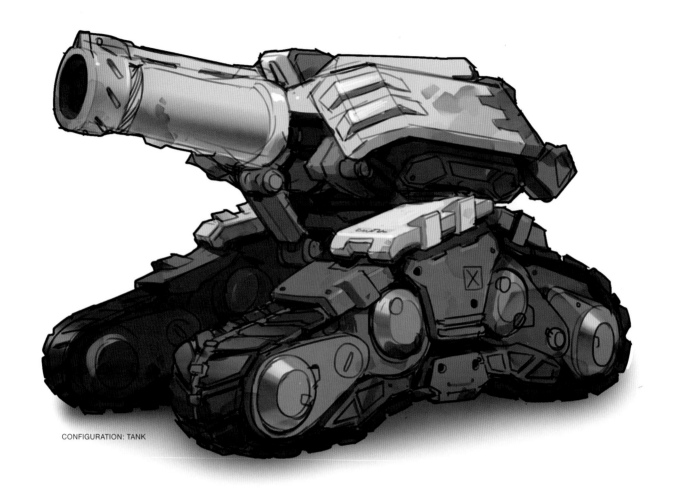

CONFIGURATION: TANK

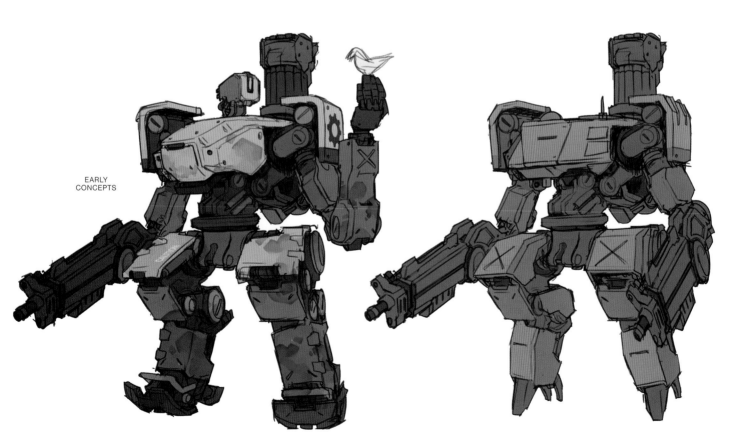

EARLY
CONCEPTS

ALL IMAGES: **ARNOLD TSANG**

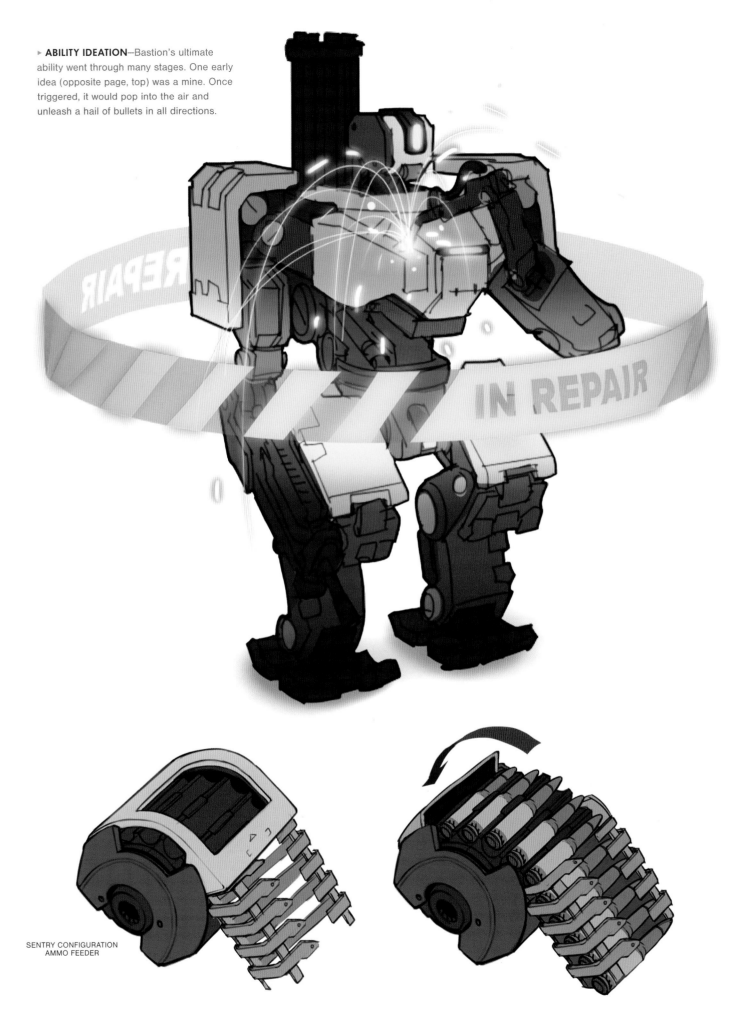

▶ **ABILITY IDEATION**—Bastion's ultimate ability went through many stages. One early idea (opposite page, top) was a mine. Once triggered, it would pop into the air and unleash a hail of bullets in all directions.

SENTRY CONFIGURATION
AMMO FEEDER

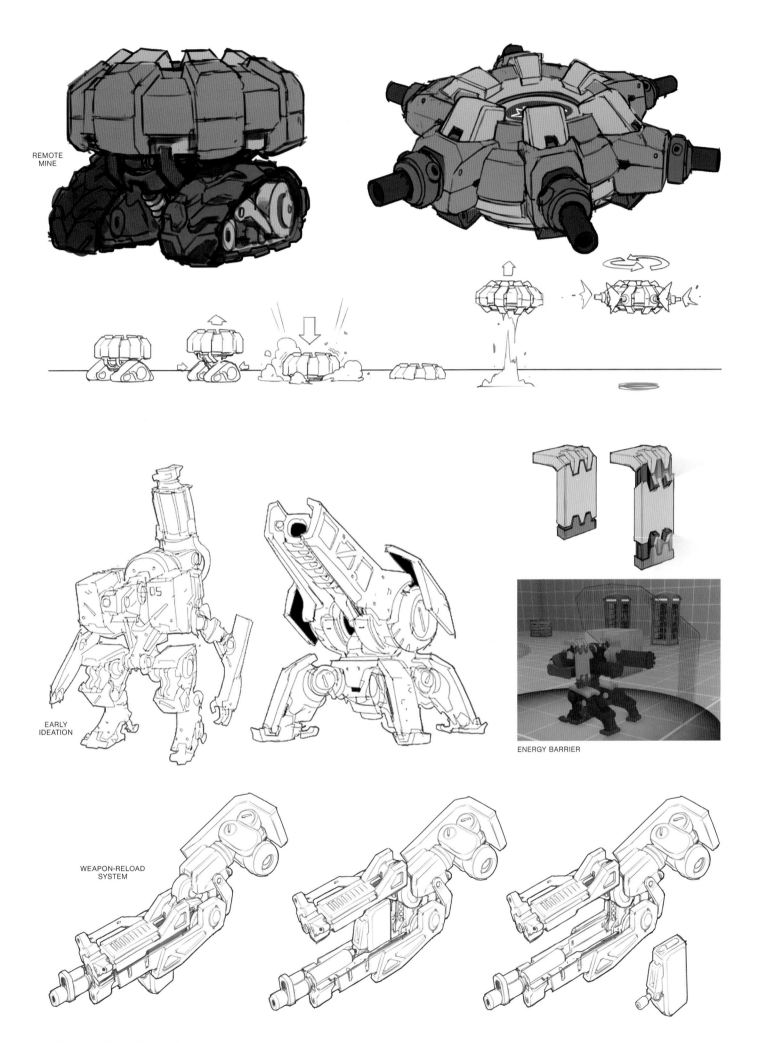

REMOTE
MINE

EARLY
IDEATION

ENERGY BARRIER

WEAPON-RELOAD
SYSTEM

TOP: **ARNOLD TSANG**, BOTTOM: **BEN ZHANG**

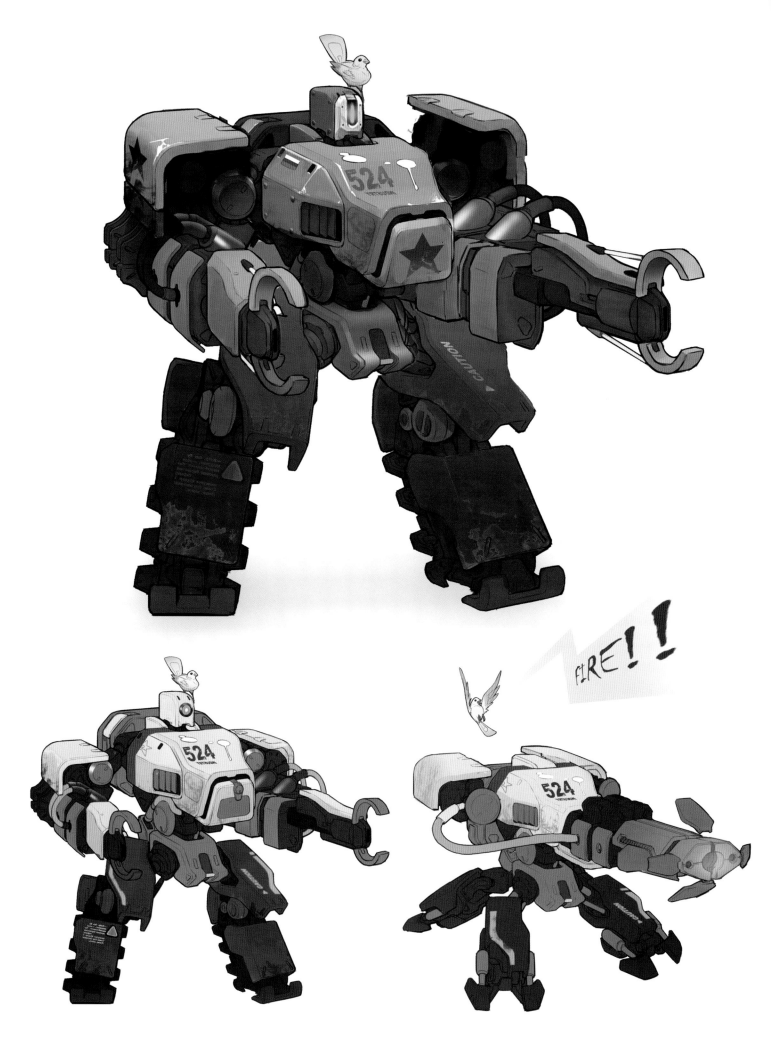

FIRE!!

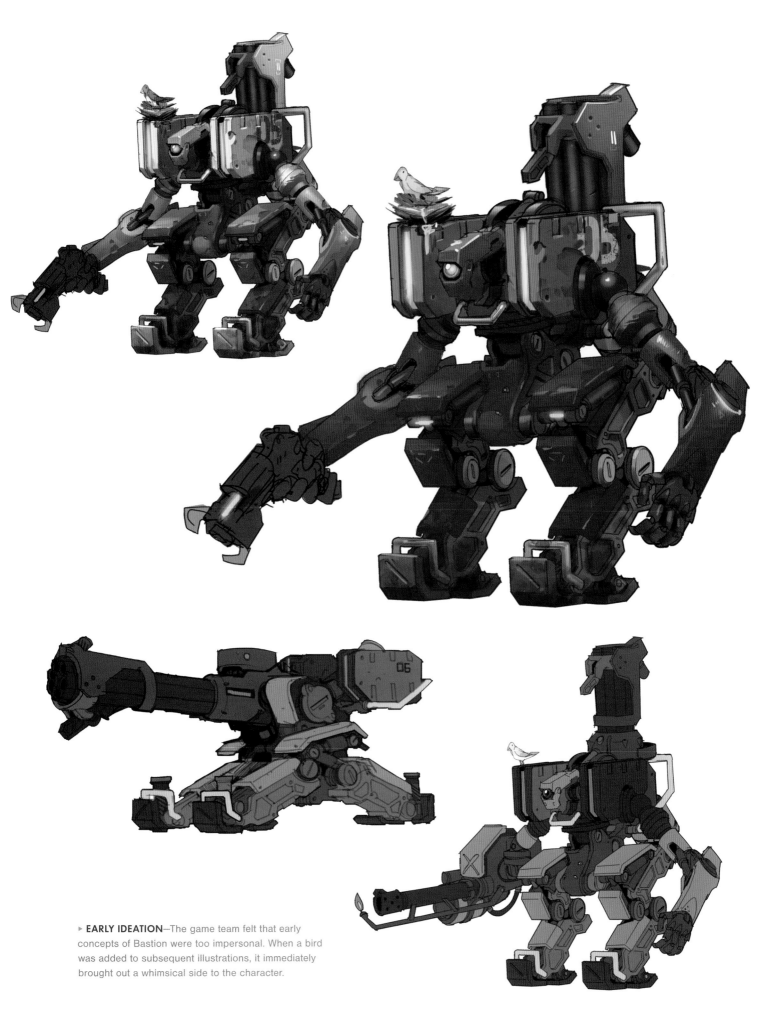

▶ **EARLY IDEATION**—The game team felt that early concepts of Bastion were too impersonal. When a bird was added to subsequent illustrations, it immediately brought out a whimsical side to the character.

ALL IMAGES: **ARNOLD TSANG**

D.VA

D.Va is a highly competitive former professional gamer who became a mech pilot to protect her homeland, South Korea, from outside threats.

In designing this character, the *Overwatch* team wanted the mech *and* the pilot to feel as if they belonged together. The machine wouldn't just be a weapon D.Va used from time to time; it would be a reflection of her fierce determination and youthful exuberance.

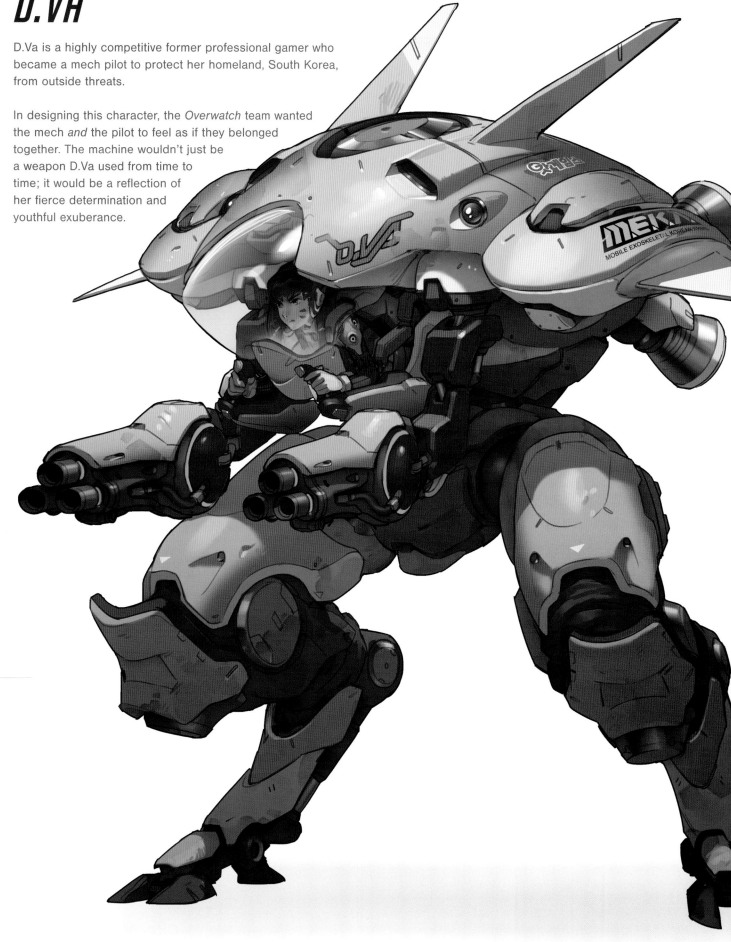

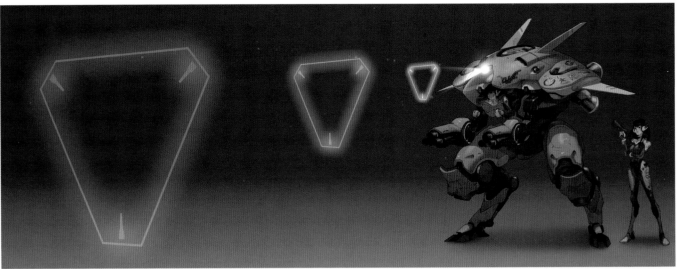

DEFENSE MATRIX VISUAL EFFECTS CONCEPT

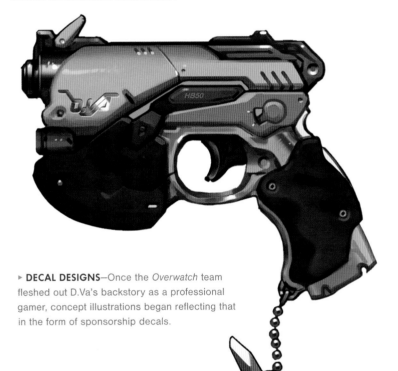

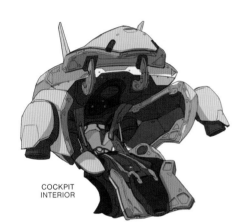

COCKPIT
INTERIOR

▶ **DECAL DESIGNS**—Once the *Overwatch* team
fleshed out D.Va's backstory as a professional
gamer, concept illustrations began reflecting that
in the form of sponsorship decals.

FUSION
CANNON

TOP: **BEN ZHANG**, MIDDLE TOP: **ARNOLD TSANG**, MIDDLE BOTTOM: **BEN ZHANG**, BOTTOM: **ARNOLD TSANG** AND **DAVID KANG**

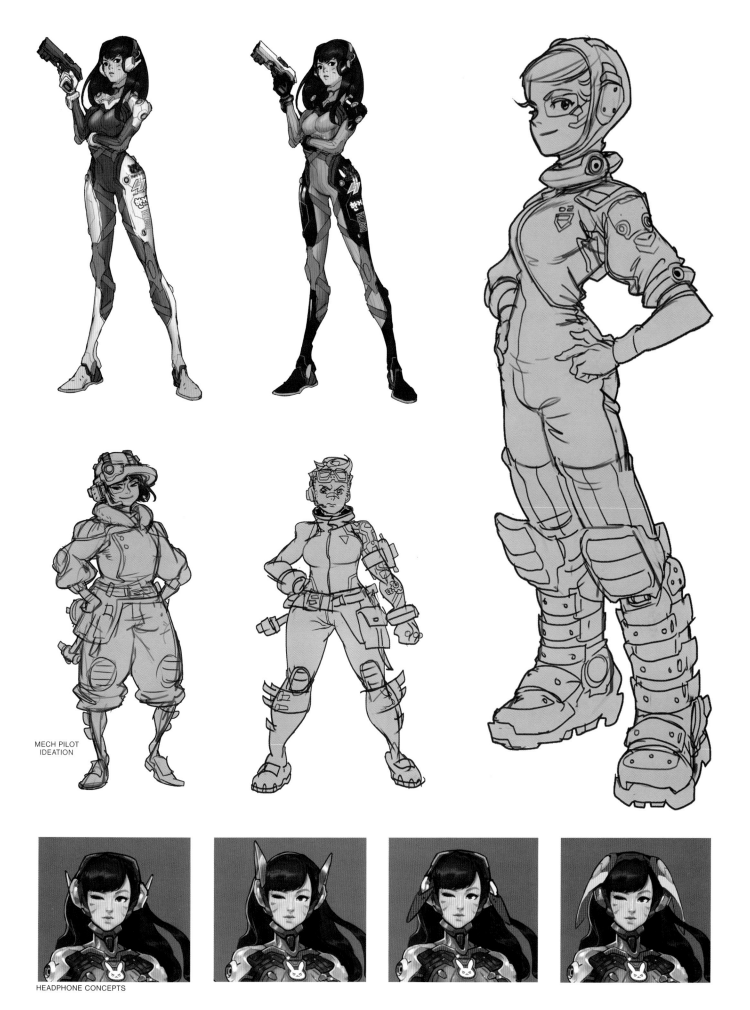

MECH PILOT
IDEATION

HEADPHONE CONCEPTS

ALL IMAGES: **ARNOLD TSANG**

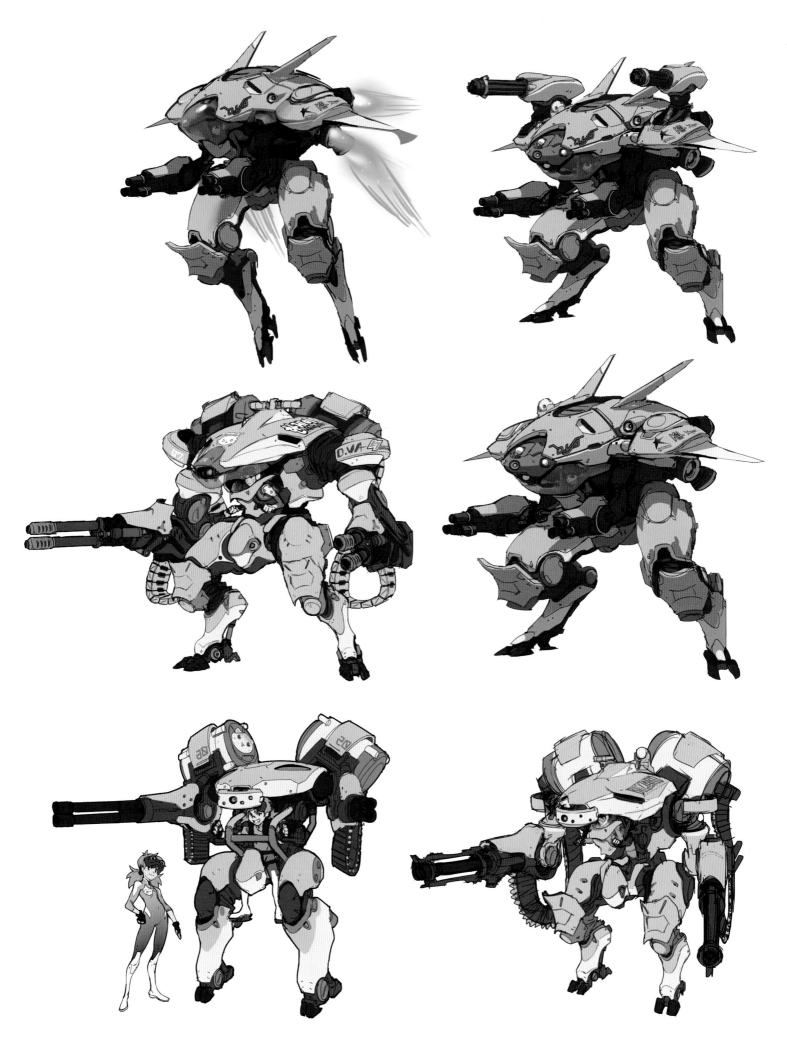

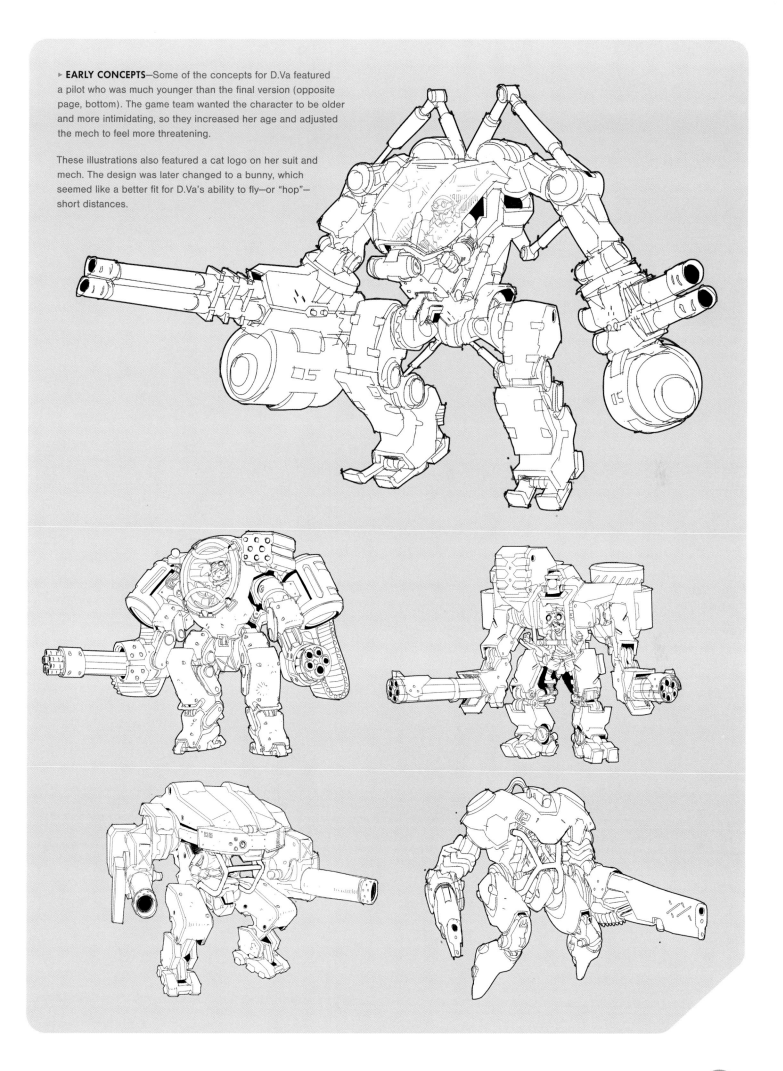

▶ **EARLY CONCEPTS**—Some of the concepts for D.Va featured a pilot who was much younger than the final version (opposite page, bottom). The game team wanted the character to be older and more intimidating, so they increased her age and adjusted the mech to feel more threatening.

These illustrations also featured a cat logo on her suit and mech. The design was later changed to a bunny, which seemed like a better fit for D.Va's ability to fly—or "hop"—short distances.

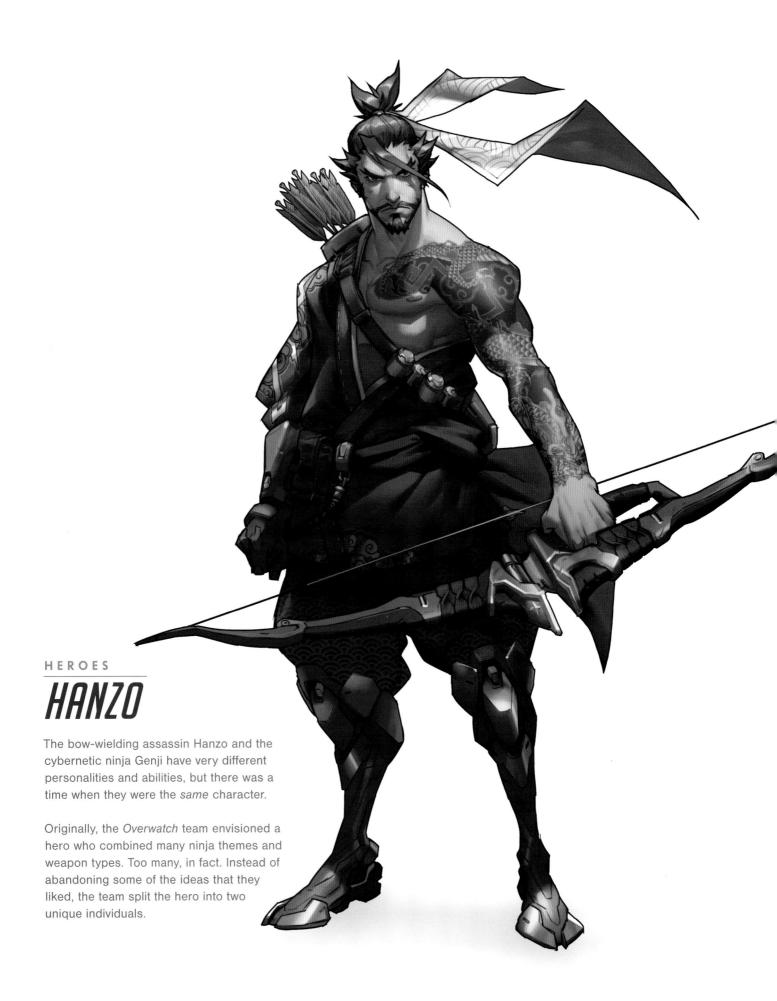

HANZO

The bow-wielding assassin Hanzo and the cybernetic ninja Genji have very different personalities and abilities, but there was a time when they were the *same* character.

Originally, the *Overwatch* team envisioned a hero who combined many ninja themes and weapon types. Too many, in fact. Instead of abandoning some of the ideas that they liked, the team split the hero into two unique individuals.

GENJI

After dividing Hanzo and Genji into two characters, the *Overwatch* team faced a new challenge: how to make each feel unique.

Genji's cybernetic body was a strong and exciting visual, and the game team wanted something similarly compelling for Hanzo. They settled on a mix of technology (his high-tech weaponry and futuristic boots and glove) and traditional Japanese cultural elements (his tattoos and the ornate patterns on his clothes).

ALL IMAGES: **ARNOLD TSANG**

 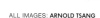

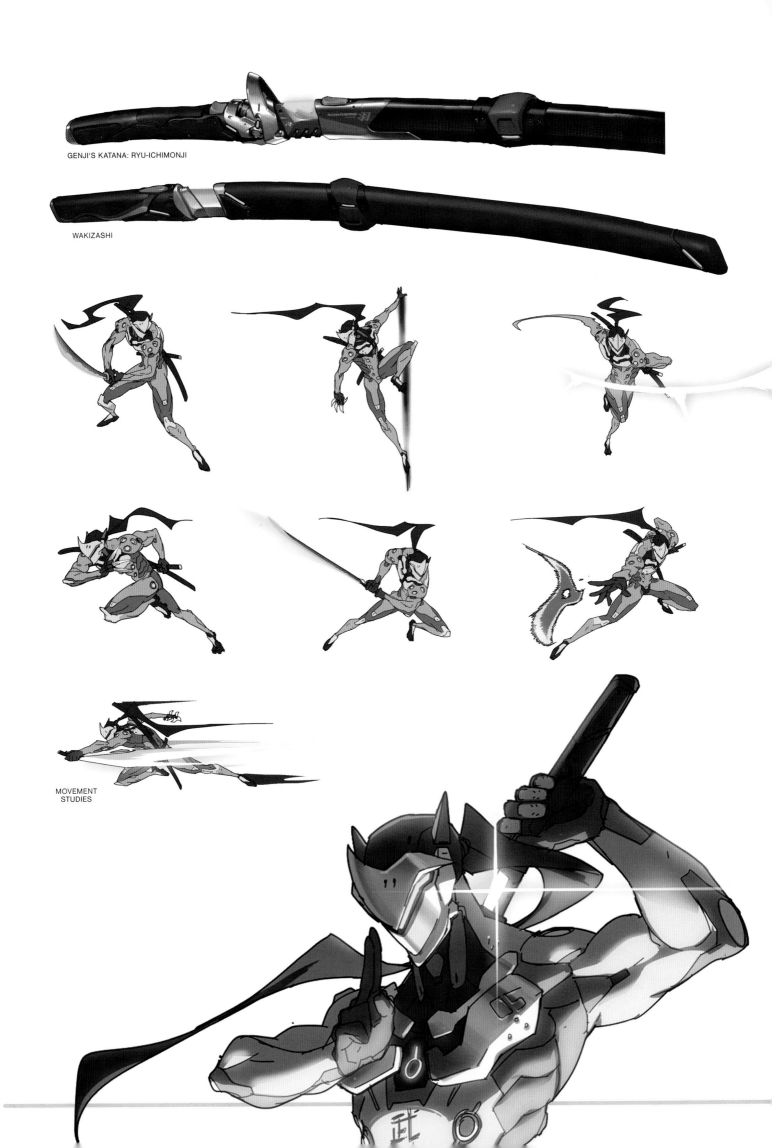

GENJI'S KATANA: RYU-ICHIMONJI

WAKIZASHI

MOVEMENT
STUDIES

▶ **FAMILY CREST CONCEPTS**—Separating Hanzo and Genji into different characters opened the door for new storytelling possibilities. The heroes became brothers, the scions of a powerful Japanese ninja clan. The *Overwatch* team experimented with various symbols to represent Hanzo and Genji's family crest (below), inspired by real Japanese clan emblems. The double dragon imagery felt like the best thematic fit, given the brothers' heritage and the fact that they both had dragon-related abilities.

ALL IMAGES: **ARNOLD TSANG**

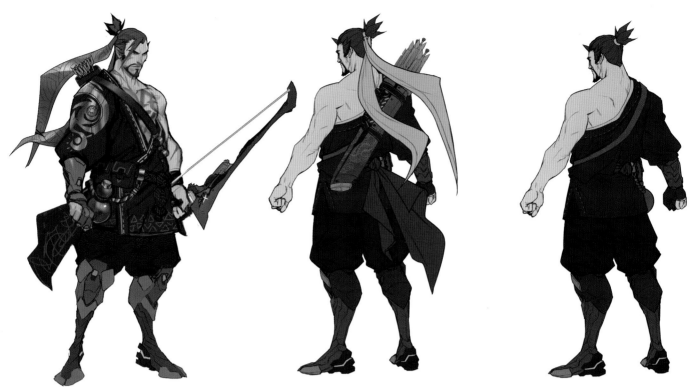

EARLY CONCEPTS

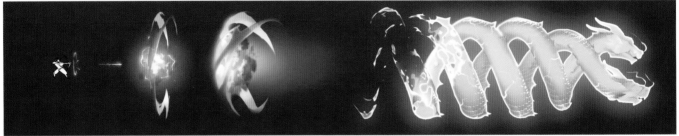

DRAGONSTRIKE

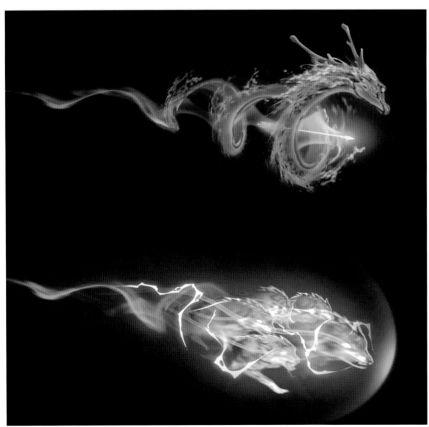

DRAGONSTRIKE IDEATION

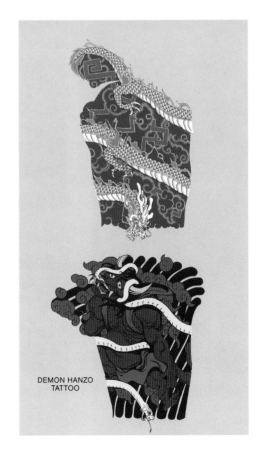

DEMON HANZO
TATTOO

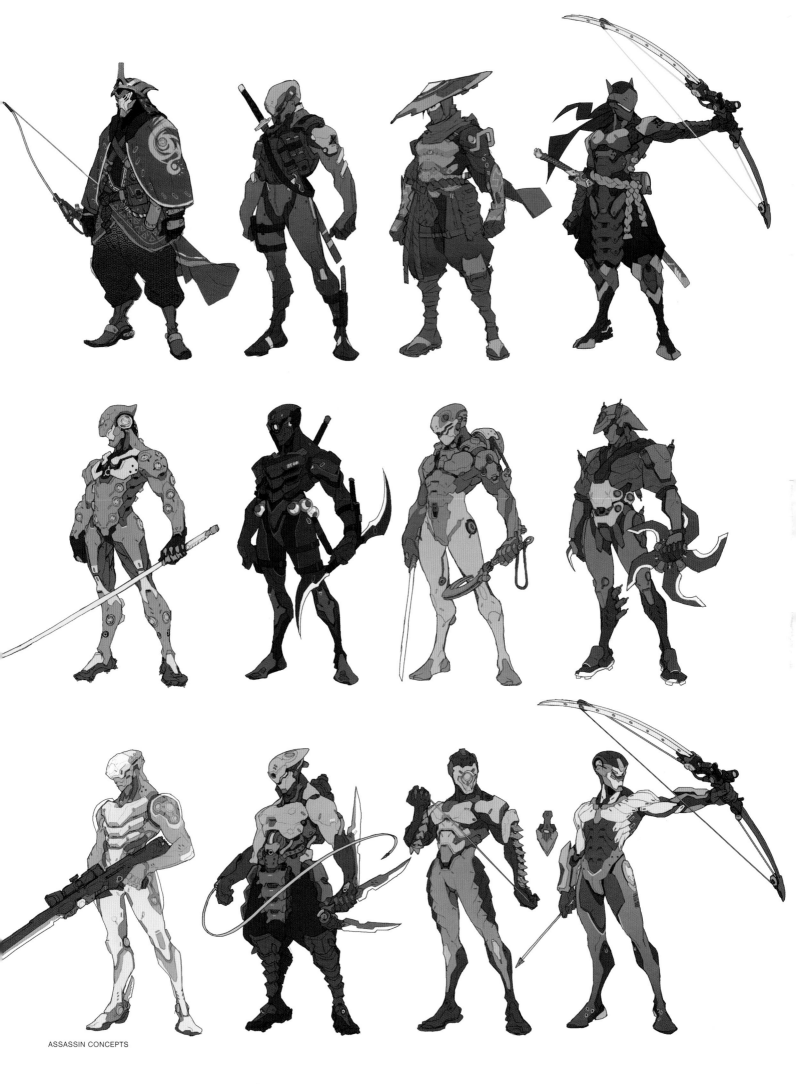

ASSASSIN CONCEPTS

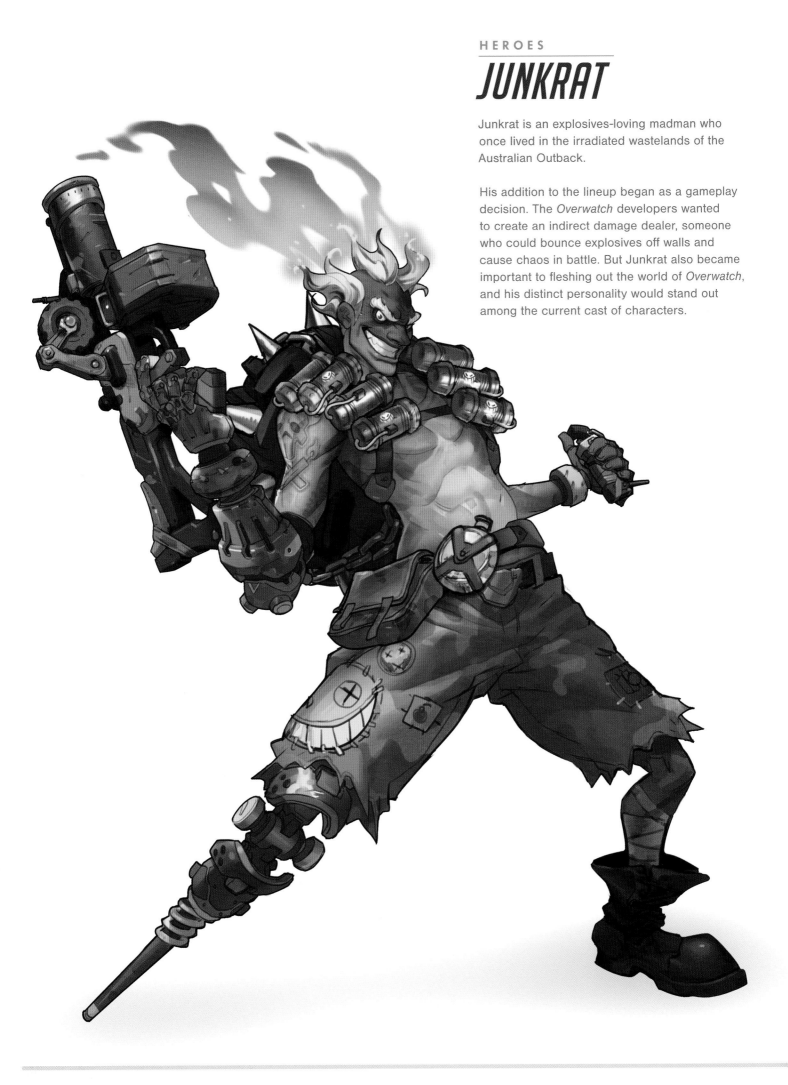

JUNKRAT

Junkrat is an explosives-loving madman who once lived in the irradiated wastelands of the Australian Outback.

His addition to the lineup began as a gameplay decision. The *Overwatch* developers wanted to create an indirect damage dealer, someone who could bounce explosives off walls and cause chaos in battle. But Junkrat also became important to fleshing out the world of *Overwatch*, and his distinct personality would stand out among the current cast of characters.

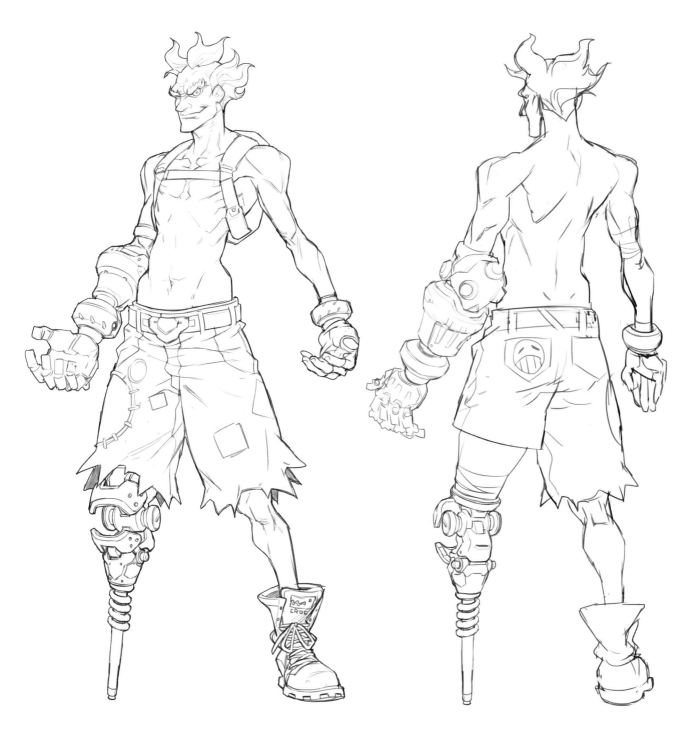

▶ **ULTIMATE ABILITY CONCEPTS**—Junkrat's ultimate ability started out as a giant missile, as seen in the early concepts on the next page. The developers felt that this ability was visually confusing during gameplay, and they opted for the explosives-laden RIP-Tire instead.

BACKPACK

ALL IMAGES: **ARNOLD TSANG**

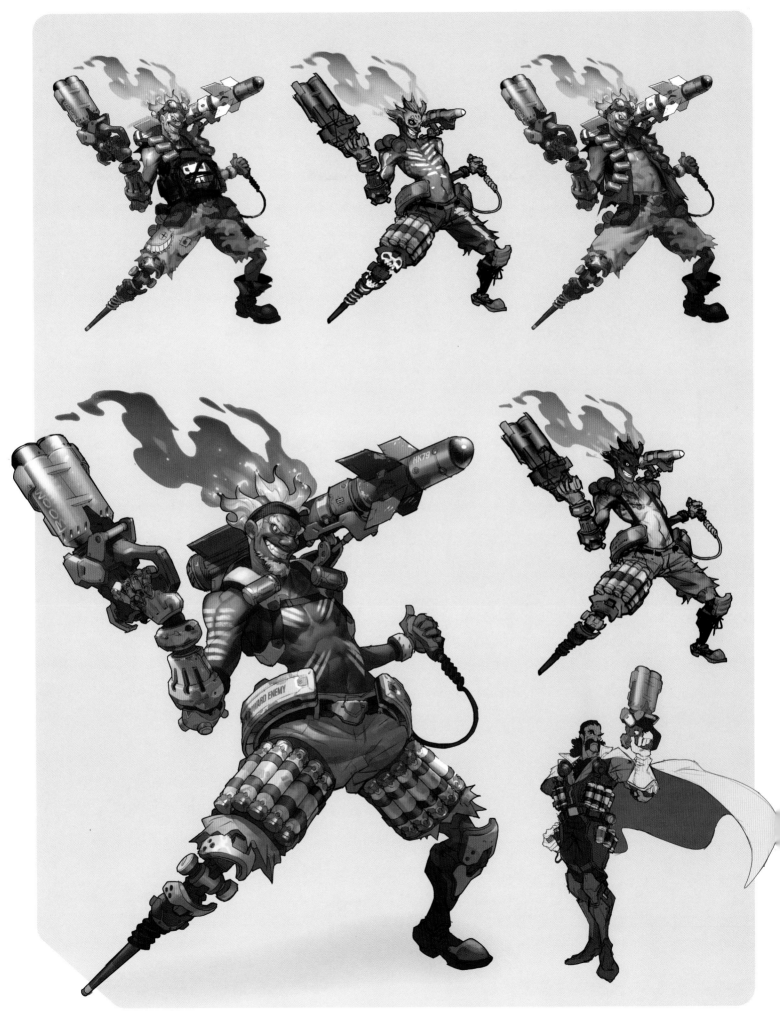

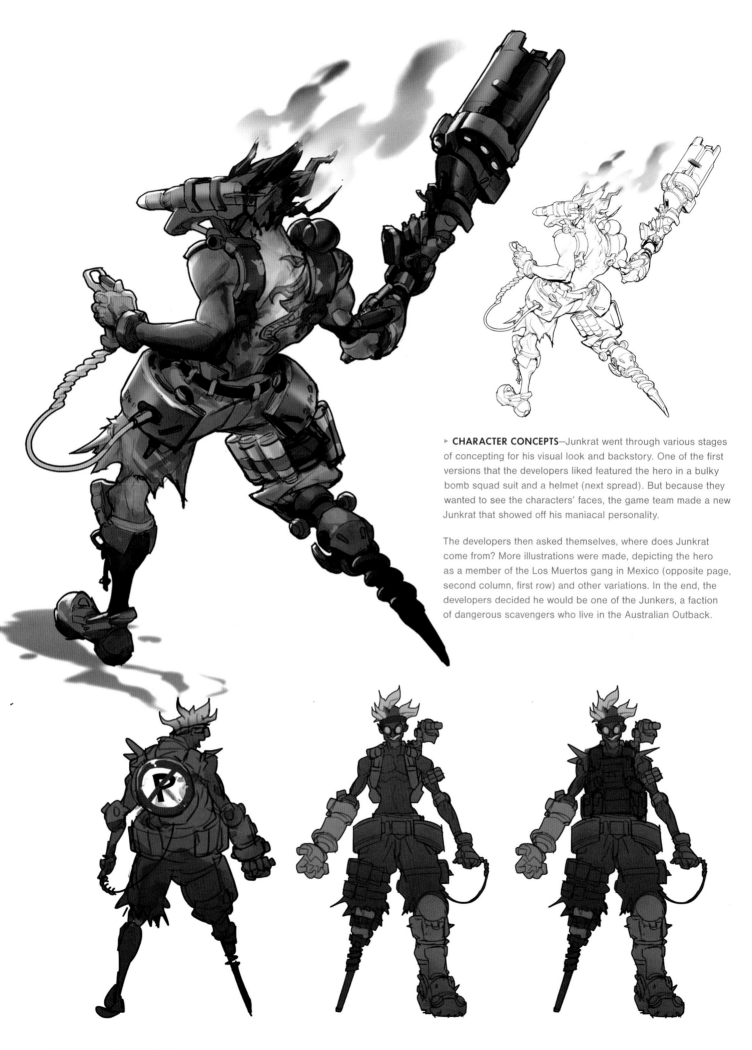

▶ **CHARACTER CONCEPTS**—Junkrat went through various stages of concepting for his visual look and backstory. One of the first versions that the developers liked featured the hero in a bulky bomb squad suit and a helmet (next spread). But because they wanted to see the characters' faces, the game team made a new Junkrat that showed off his maniacal personality.

The developers then asked themselves, where does Junkrat come from? More illustrations were made, depicting the hero as a member of the Los Muertos gang in Mexico (opposite page, second column, first row) and other variations. In the end, the developers decided he would be one of the Junkers, a faction of dangerous scavengers who live in the Australian Outback.

TOP: **BEN ZHANG**, BOTTOM: **ARNOLD TSANG**

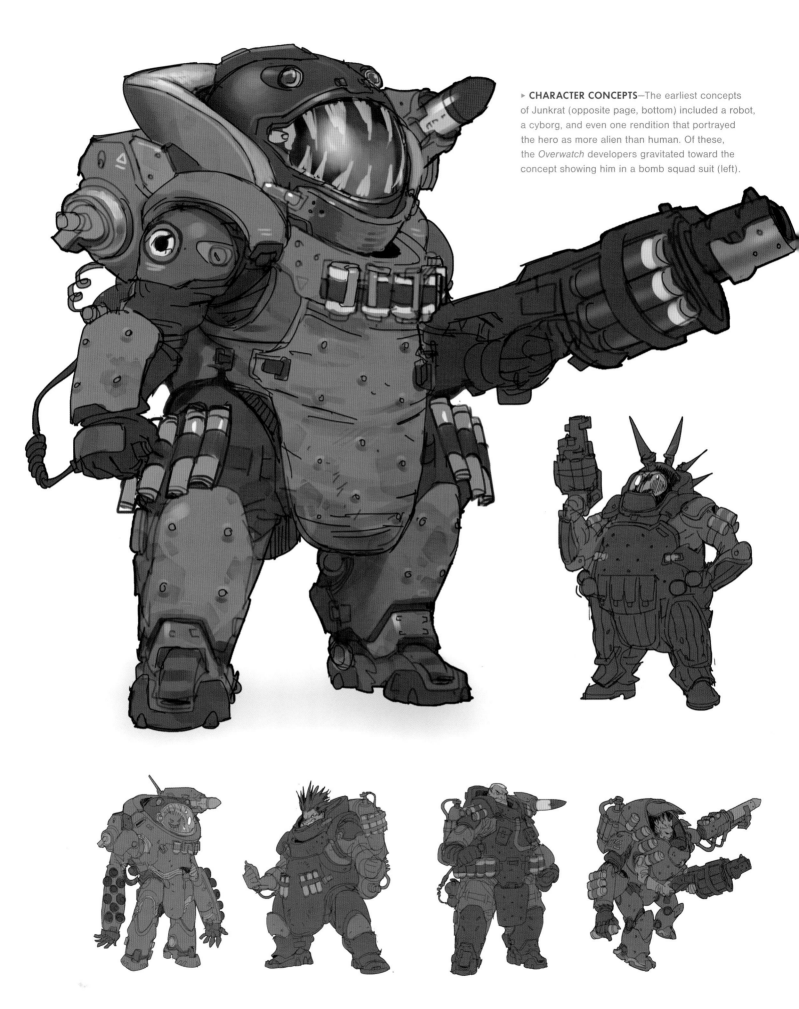

▶ **CHARACTER CONCEPTS**—The earliest concepts of Junkrat (opposite page, bottom) included a robot, a cyborg, and even one rendition that portrayed the hero as more alien than human. Of these, the *Overwatch* developers gravitated toward the concept showing him in a bomb squad suit (left).

ALL IMAGES: **ARNOLD TSANG**

TATTOO

DETONATOR

FUSE BOMB

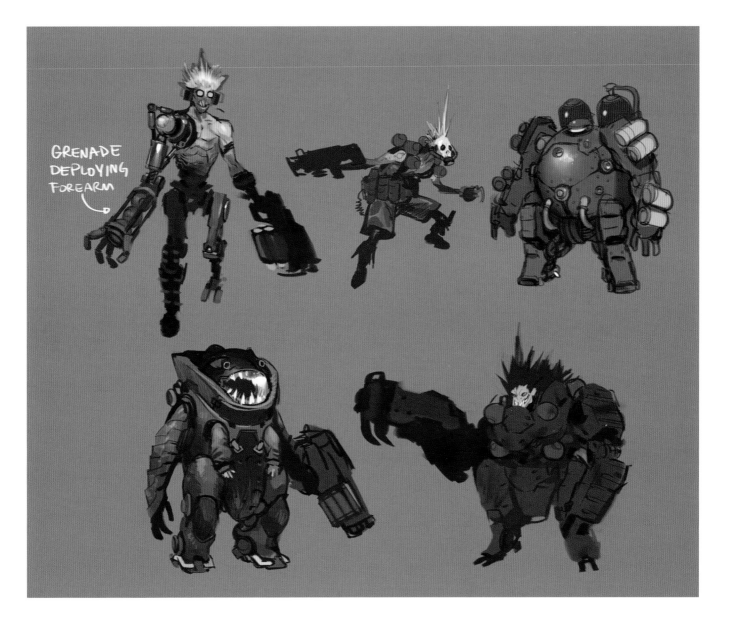

GRENADE
DEPLOYING
FOREARM

TOP LEFT: **ARNOLD TSANG**, TOP MIDDLE AND TOP RIGHT: **DAVID KANG**, BOTTOM: **ARNOLD TSANG**

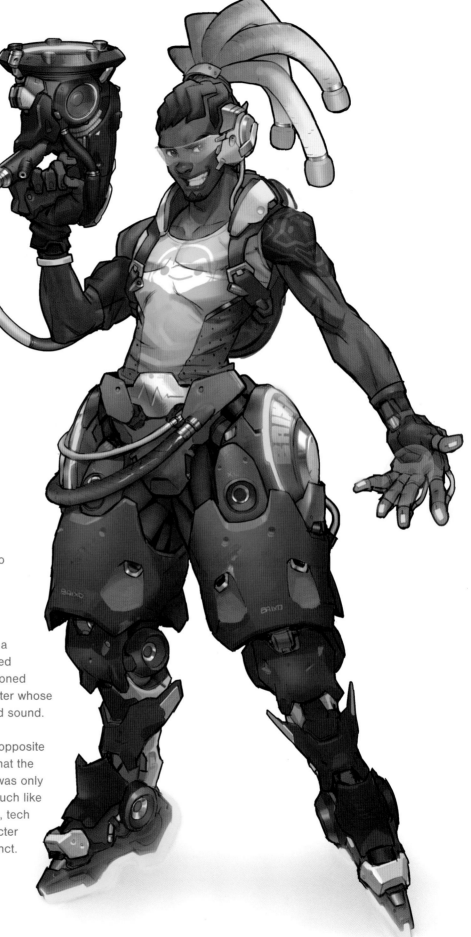

LÚCIO

Lúcio is a celebrated artist from the favelas of Rio de Janeiro, Brazil, who uses his music to inspire hope in others and fight social injustice.

Creating a music-themed hero—something akin to a sci-fi version of a fantasy bard—was an idea that excited many of the developers. They envisioned an upbeat and highly mobile character whose abilities would be based on light and sound.

One of the later concepts of Lúcio (opposite page, far right) captured much of what the developers were looking for. There was only one issue: the hero felt a little too much like a regular civilian. In the final version, tech and armor were added to the character so that he felt more heroic and distinct.

ARNOLD TSANG

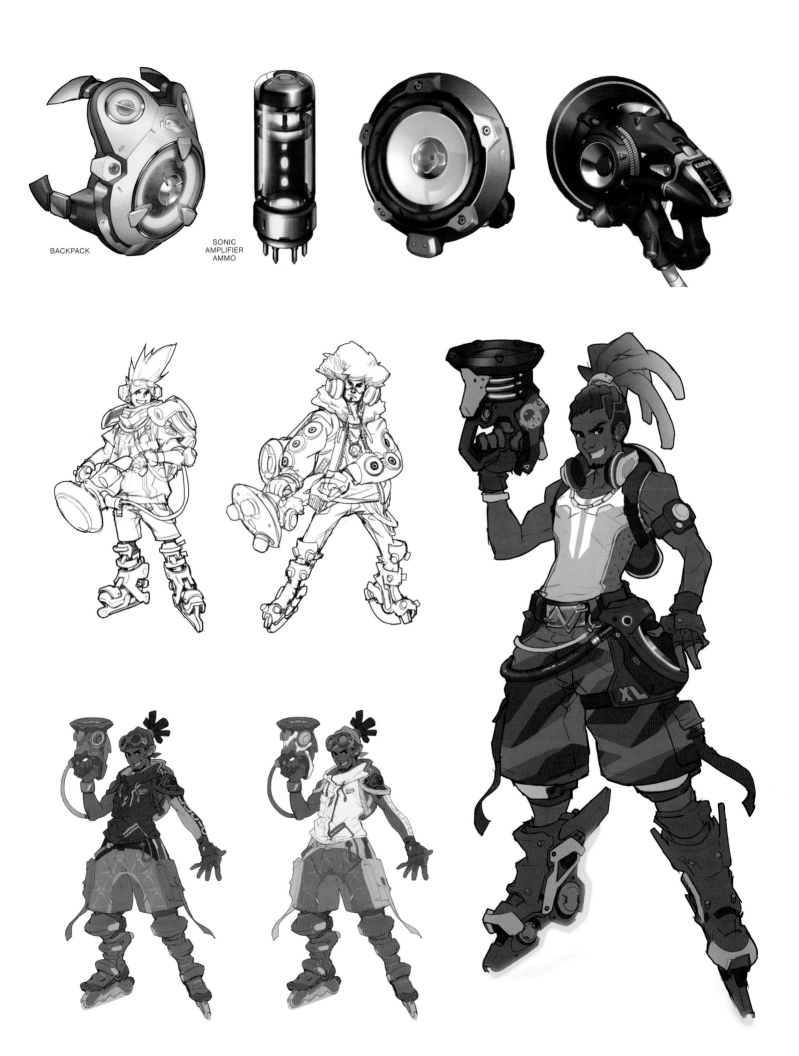

BACKPACK

SONIC
AMPLIFIER
AMMO

TOP LEFT, TOP MIDDLE RIGHT, AND BOTTOM: **ARNOLD TSANG**, TOP MIDDLE LEFT AND TOP RIGHT: **DAVID KANG**

▶ **CHARACTER CONCEPTS**—An early concept of Lúcio featured turntables on his hips and equalizer pants that would light up as he played music. The developers toned down parts of his outfit in later versions because they felt the visuals would be too distracting during gameplay.

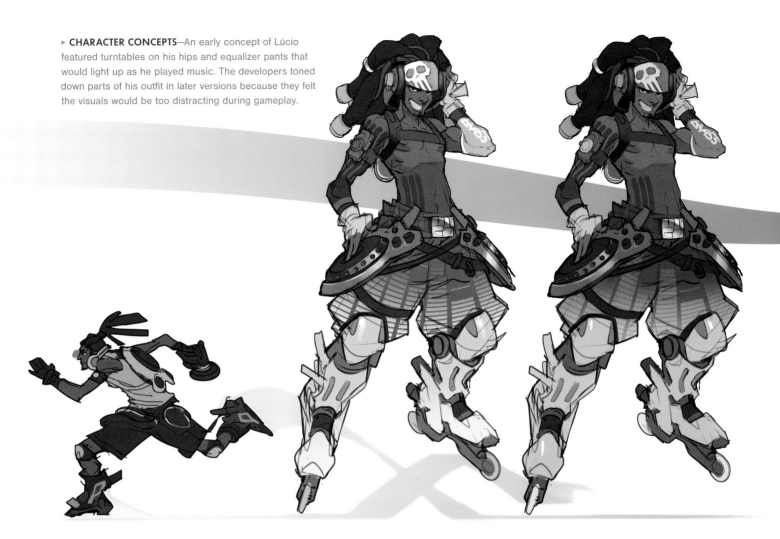

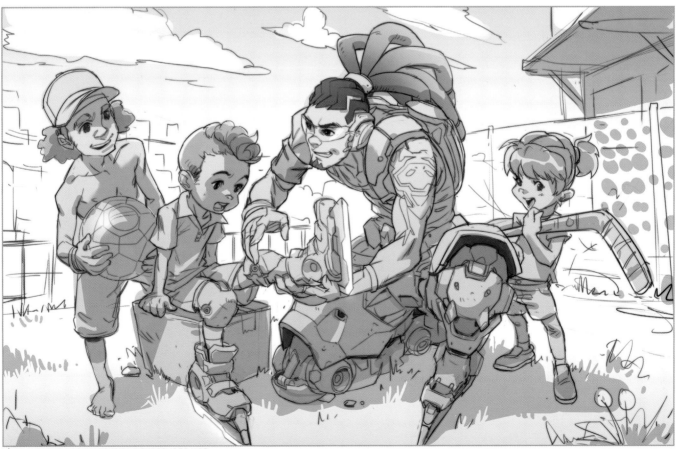

LÚCIO BRINGING HOCKEY TO THE NEIGHBORHOOD KIDS

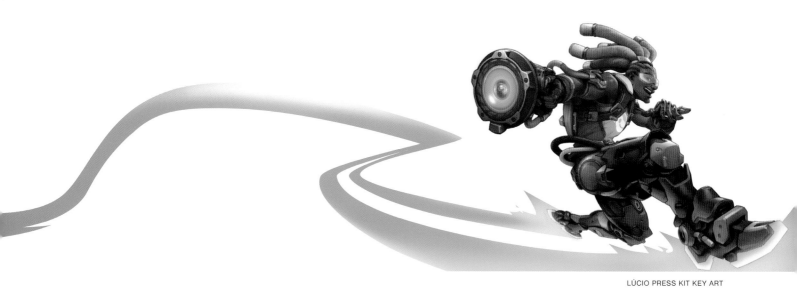

LÚCIO PRESS KIT KEY ART

CROSSFADE VISUAL EFFECT CONCEPT

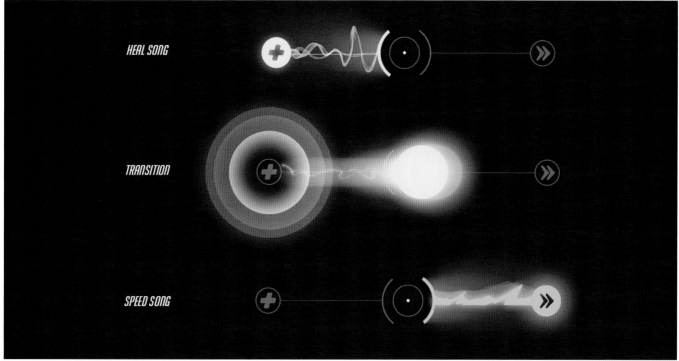

HEAL SONG

TRANSITION

SPEED SONG

CROSSFADE USER INTERFACE CONCEPT

TOP: **BEN ZHANG**, MIDDLE: **ARNOLD TSANG**, BOTTOM: **RANDAL DUMORET**

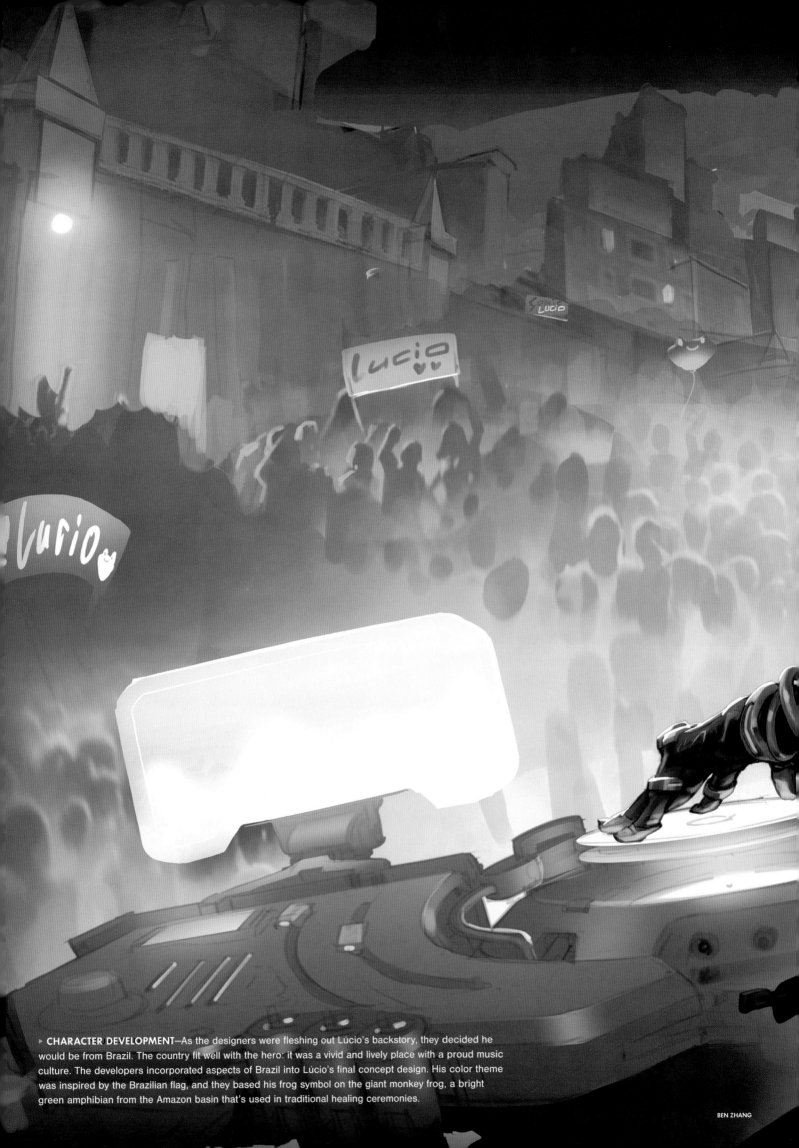

▶ **CHARACTER DEVELOPMENT**—As the designers were fleshing out Lúcio's backstory, they decided he would be from Brazil. The country fit well with the hero: it was a vivid and lively place with a proud music culture. The developers incorporated aspects of Brazil into Lúcio's final concept design. His color theme was inspired by the Brazilian flag, and they based his frog symbol on the giant monkey frog, a bright green amphibian from the Amazon basin that's used in traditional healing ceremonies.

BEN ZHANG

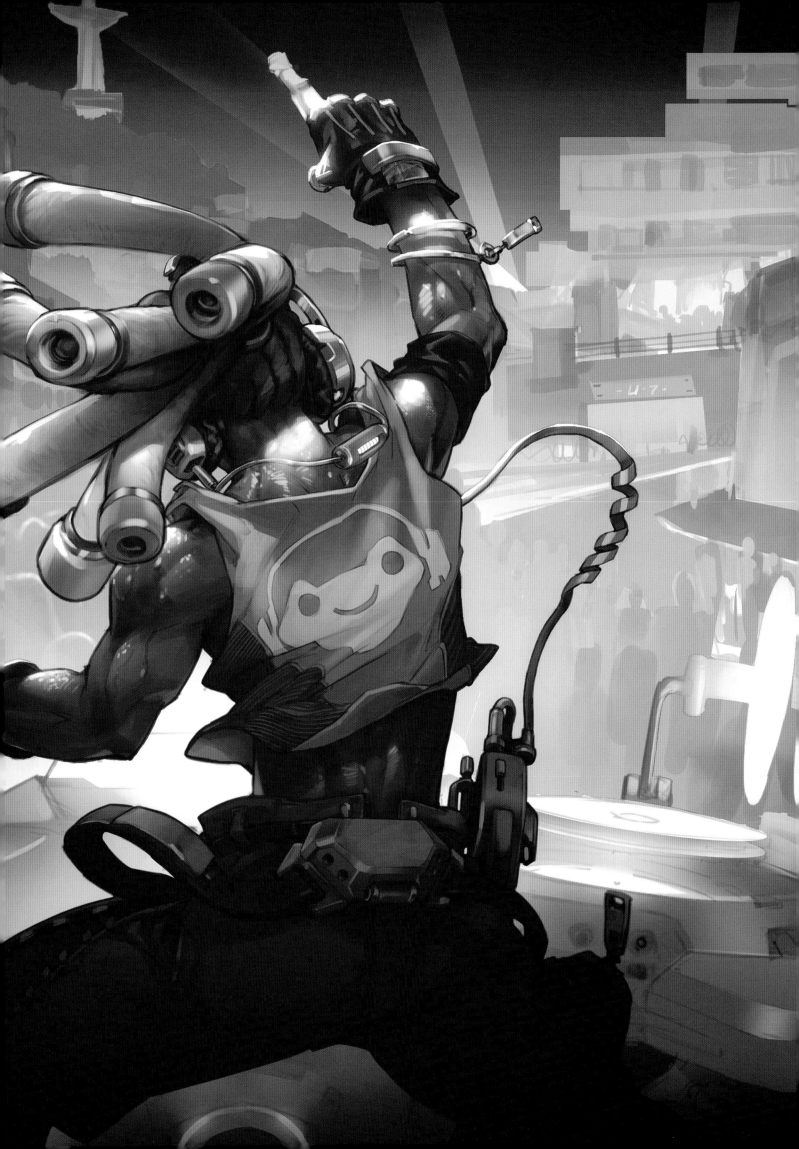

McCREE

Development of the outlaw named McCree began shortly after Titan's cancellation. While the designers were exploring different game concepts to work on, art was created to visualize one of the ideas (next spread, left page). The developers immediately fell in love with the character—McCree—and his blend of sci-fi and the classic gunslinger archetype.

When *Overwatch* later began development, the designers quickly brought McCree into the game. He was everything they wanted in a hero: a character with a strong personality, a distinct visual style, and memorable pop cultural themes.

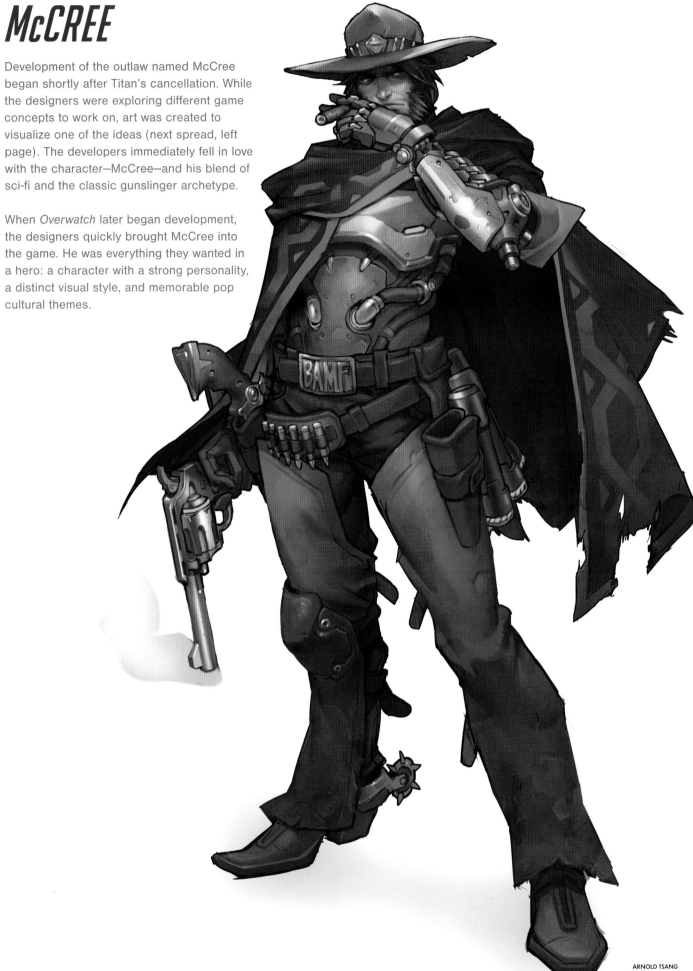

ARNOLD TSANG

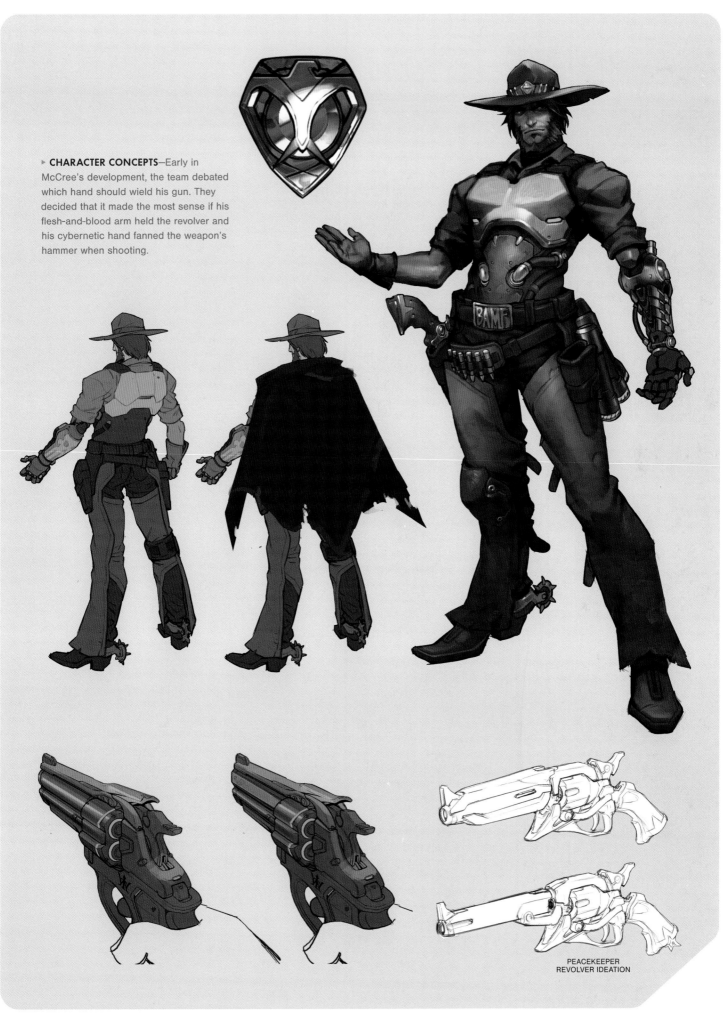

▶ **CHARACTER CONCEPTS**—Early in McCree's development, the team debated which hand should wield his gun. They decided that it made the most sense if his flesh-and-blood arm held the revolver and his cybernetic hand fanned the weapon's hammer when shooting.

PEACEKEEPER
REVOLVER IDEATION

TOP: **ARNOLD TSANG**, BOTTOM LEFT: **DAVID KANG**, BOTTOM RIGHT: **BEN ZHANG**

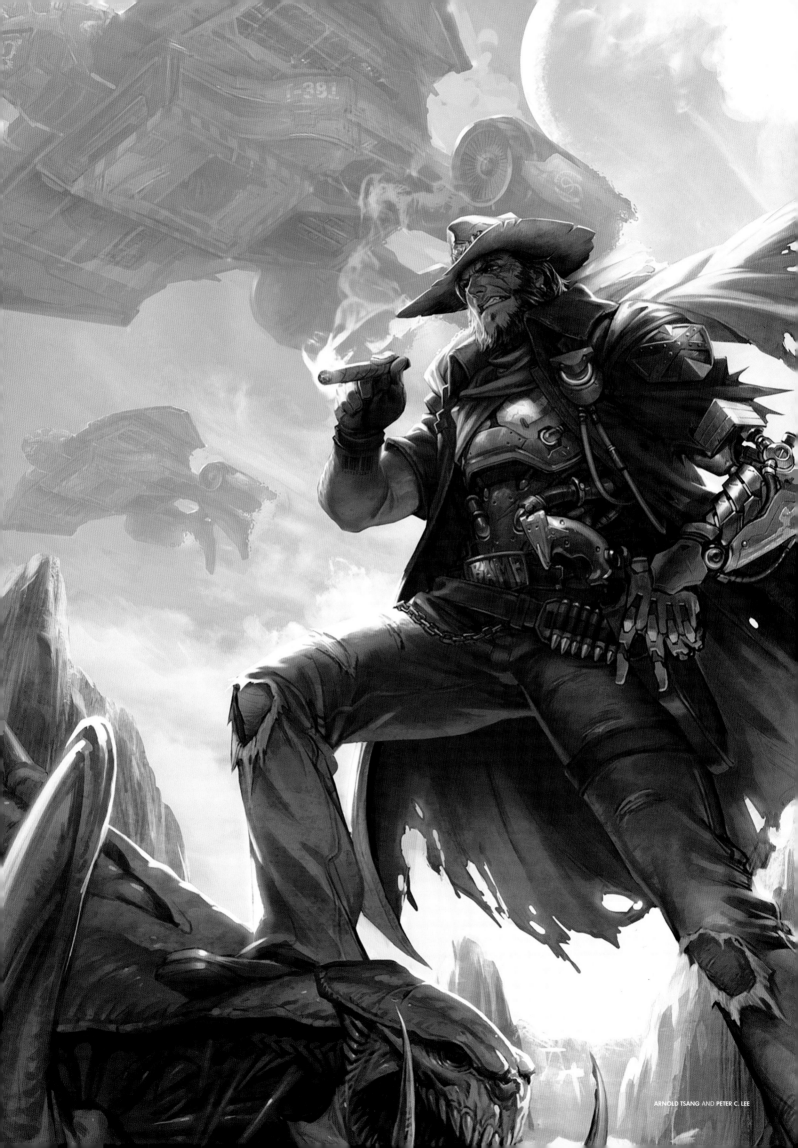

ARNOLD TSANG AND PETER C. LEE

▶ **EARLY IDEATION**—The original artwork of McCree (opposite page) was based on an old *StarCraft* illustration by Chris Metzen (below). The game team was so excited about this first McCree concept that a 3-D model of the character was created (bottom).

The developers made only minor changes between the hero's original concept and his final in-game version. Most of the adjustments involved McCree's outfit, such as replacing his coat with a serape and adding flashbang grenades to his belt.

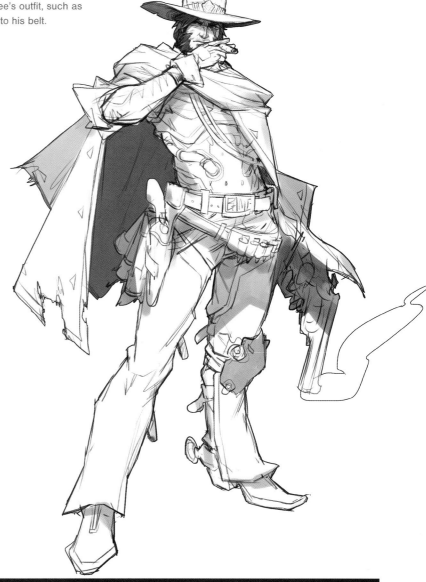

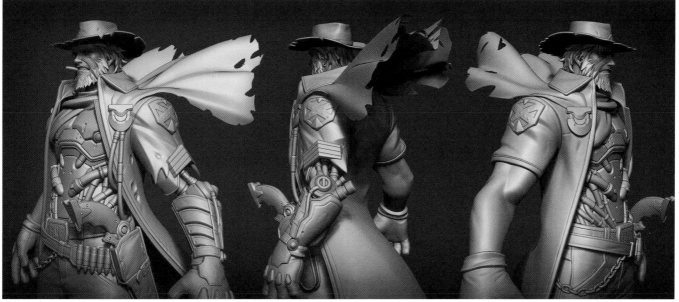

TOP LEFT: **CHRIS METZEN**, TOP RIGHT: **ARNOLD TSANG**, BOTTOM: **RENAUD GALAND**

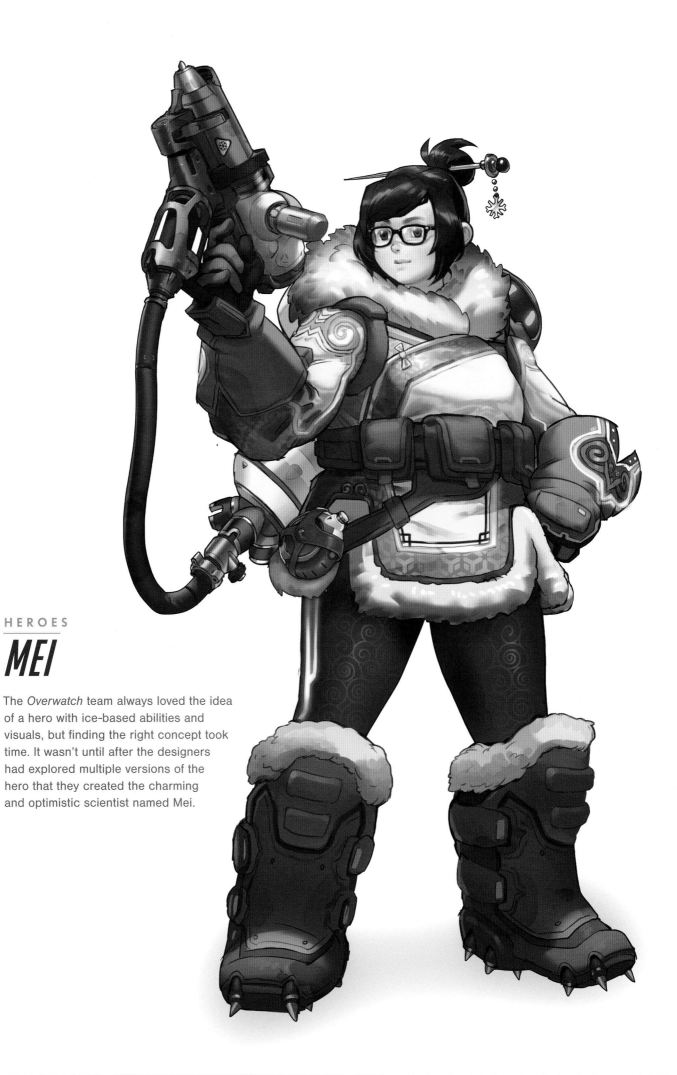

MEI

The *Overwatch* team always loved the idea of a hero with ice-based abilities and visuals, but finding the right concept took time. It wasn't until after the designers had explored multiple versions of the hero that they created the charming and optimistic scientist named Mei.

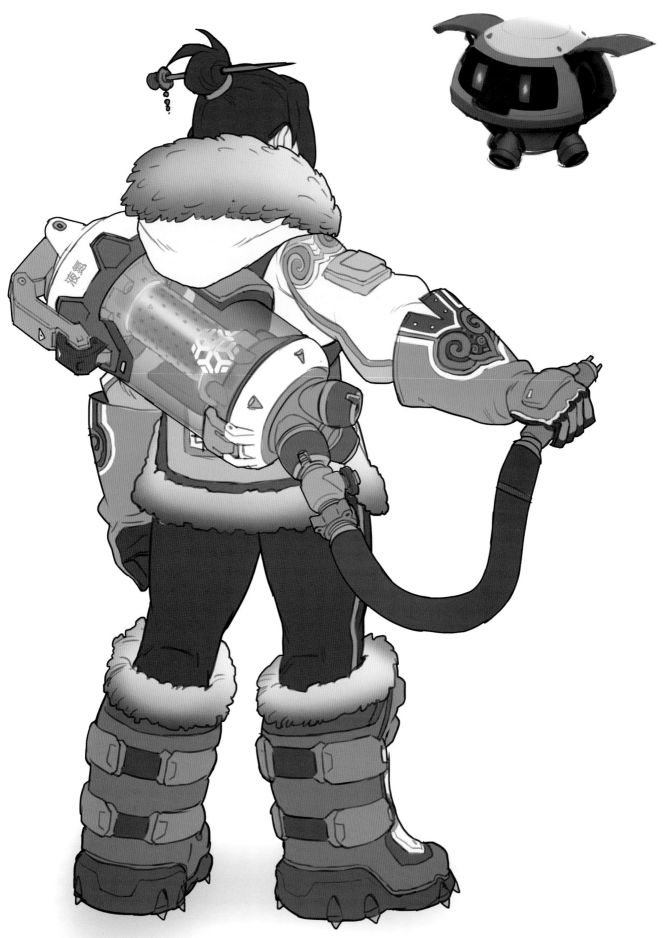

TOP RIGHT: **BEN ZHANG**, REMAINDER OF IMAGES: **ARNOLD TSANG**

▶ **SNOWBALL CONCEPTS**—The *Overwatch* team created Snowball as a way for Mei to use her ultimate ability, Blizzard, and as a fun sidekick that the hero could interact with. The only concern was that the drone might draw too much attention away from Mei herself. To avoid this, the designers experimented with different concepts until they found the right feel for Snowball—something endearing but not overly expressive.

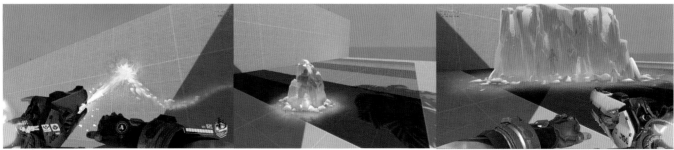

VISUAL EFFECTS CONCEPTS

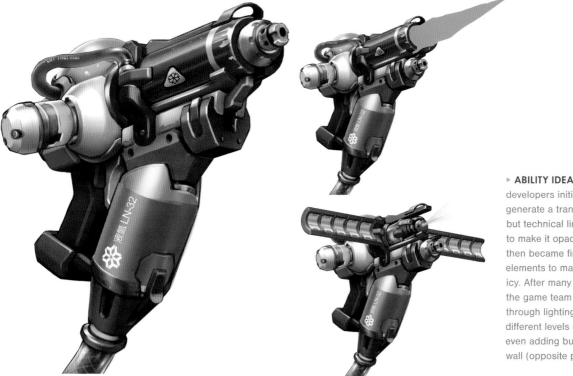

▶ **ABILITY IDEATION**—The developers initially wanted Mei to generate a transparent wall of ice, but technical limitations forced them to make it opaque. The challenge then became finding the right visual elements to make the barrier feel icy. After many rounds of iteration, the game team accomplished this through lighting techniques, using different levels of shininess, and even adding bubbles inside the wall (opposite page, bottom right).

BLIZZARD VISUAL EFFECTS CONCEPTS

ALL IMAGES: **BEN ZHANG**

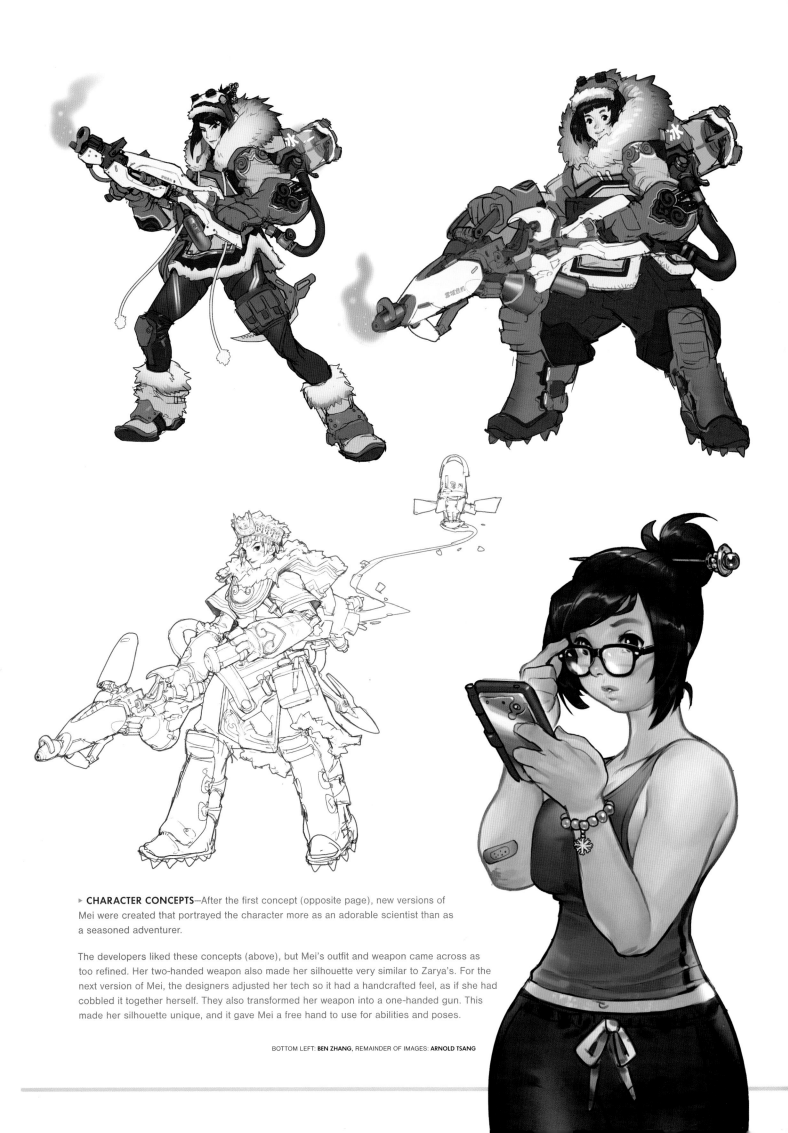

▶ **CHARACTER CONCEPTS**—After the first concept (opposite page), new versions of Mei were created that portrayed the character more as an adorable scientist than as a seasoned adventurer.

The developers liked these concepts (above), but Mei's outfit and weapon came across as too refined. Her two-handed weapon also made her silhouette very similar to Zarya's. For the next version of Mei, the designers adjusted her tech so it had a handcrafted feel, as if she had cobbled it together herself. They also transformed her weapon into a one-handed gun. This made her silhouette unique, and it gave Mei a free hand to use for abilities and poses.

BOTTOM LEFT: **BEN ZHANG**, REMAINDER OF IMAGES: **ARNOLD TSANG**

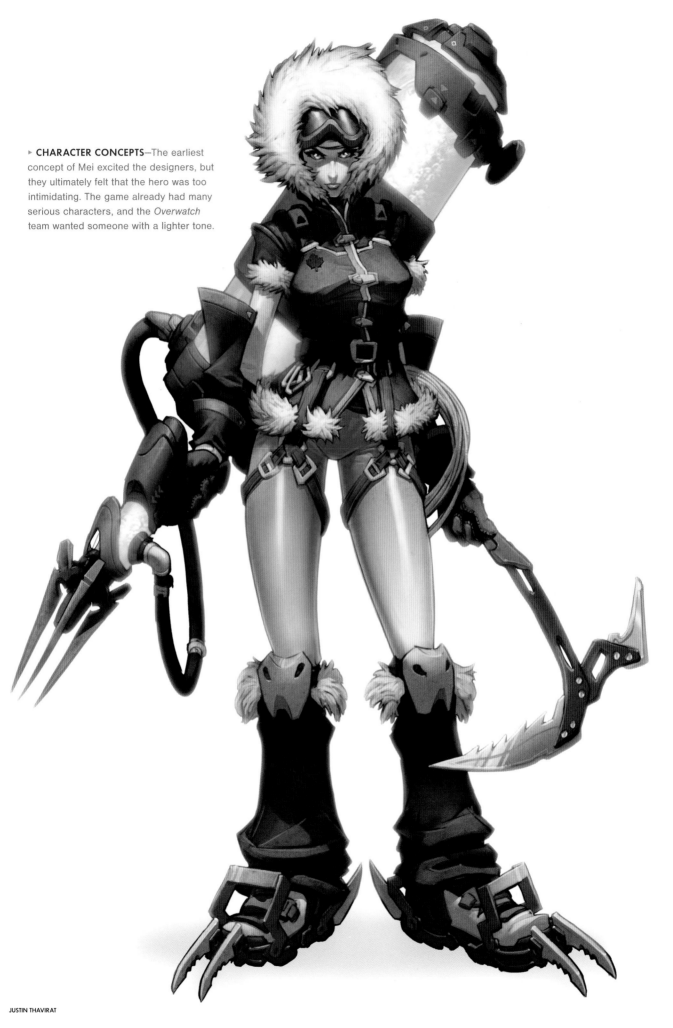

▶ **CHARACTER CONCEPTS**—The earliest concept of Mei excited the designers, but they ultimately felt that the hero was too intimidating. The game already had many serious characters, and the *Overwatch* team wanted someone with a lighter tone.

JUSTIN THAVIRAT

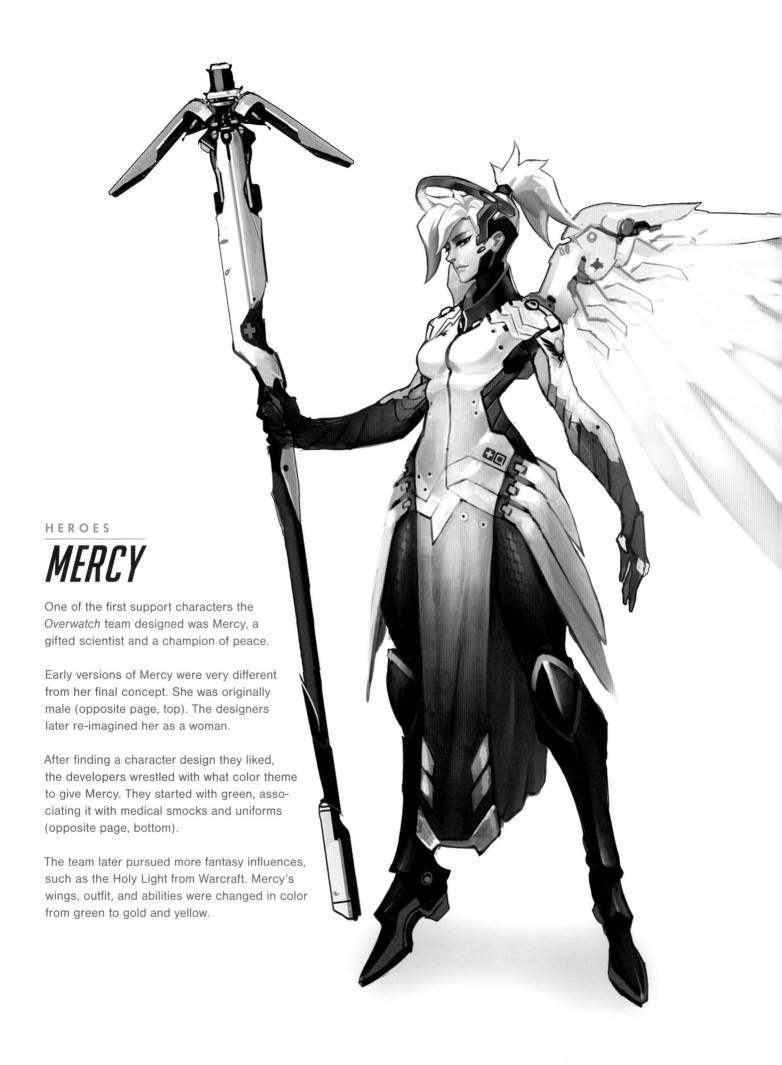

MERCY

One of the first support characters the
Overwatch team designed was Mercy, a
gifted scientist and a champion of peace.

Early versions of Mercy were very different
from her final concept. She was originally
male (opposite page, top). The designers
later re-imagined her as a woman.

After finding a character design they liked,
the developers wrestled with what color theme
to give Mercy. They started with green, asso-
ciating it with medical smocks and uniforms
(opposite page, bottom).

The team later pursued more fantasy influences,
such as the Holy Light from Warcraft. Mercy's
wings, outfit, and abilities were changed in color
from green to gold and yellow.

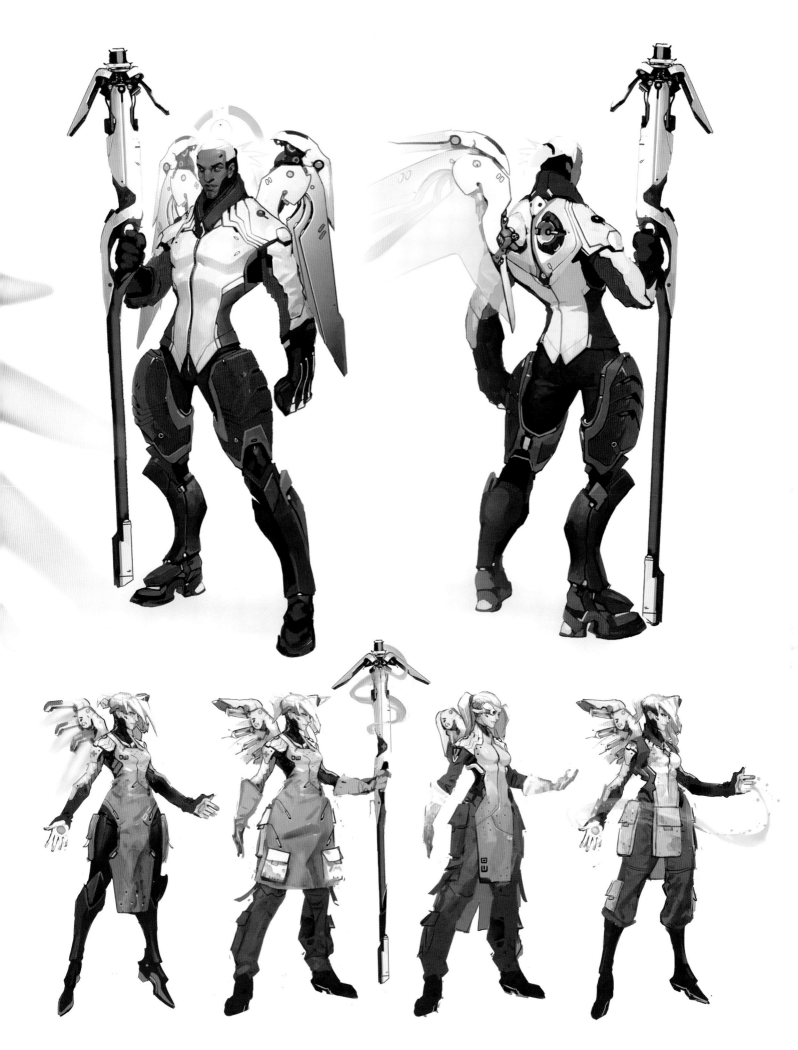

TOP: **LAUREL AUSTIN**, REMAINDER OF IMAGES: **ARNOLD TSANG**

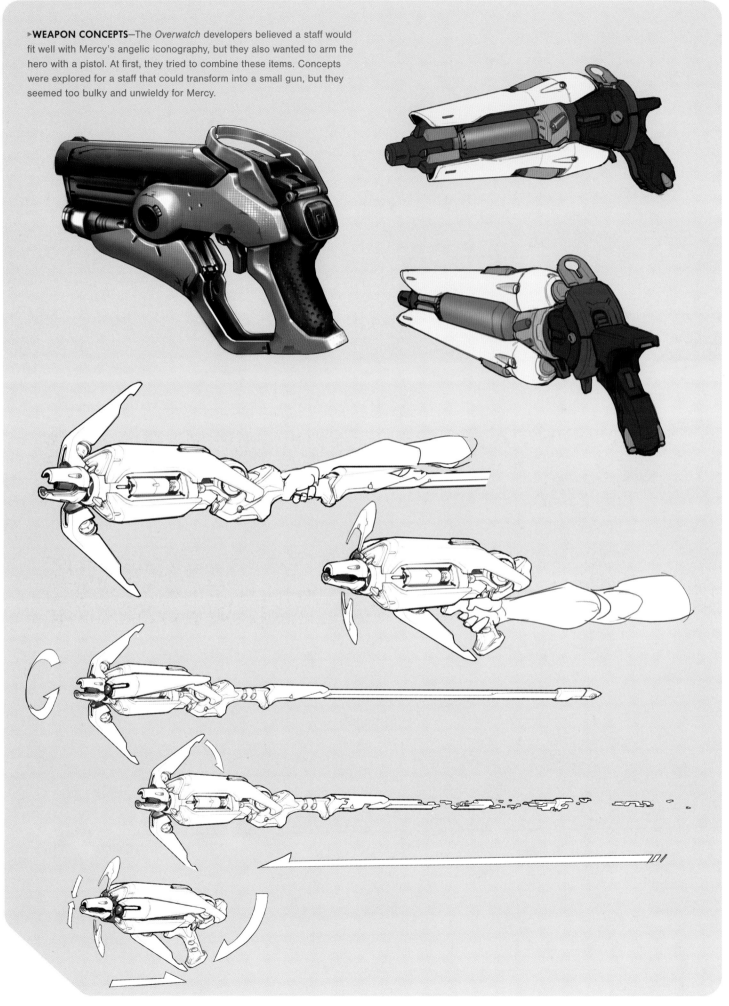

►**WEAPON CONCEPTS**—The *Overwatch* developers believed a staff would fit well with Mercy's angelic iconography, but they also wanted to arm the hero with a pistol. At first, they tried to combine these items. Concepts were explored for a staff that could transform into a small gun, but they seemed too bulky and unwieldy for Mercy.

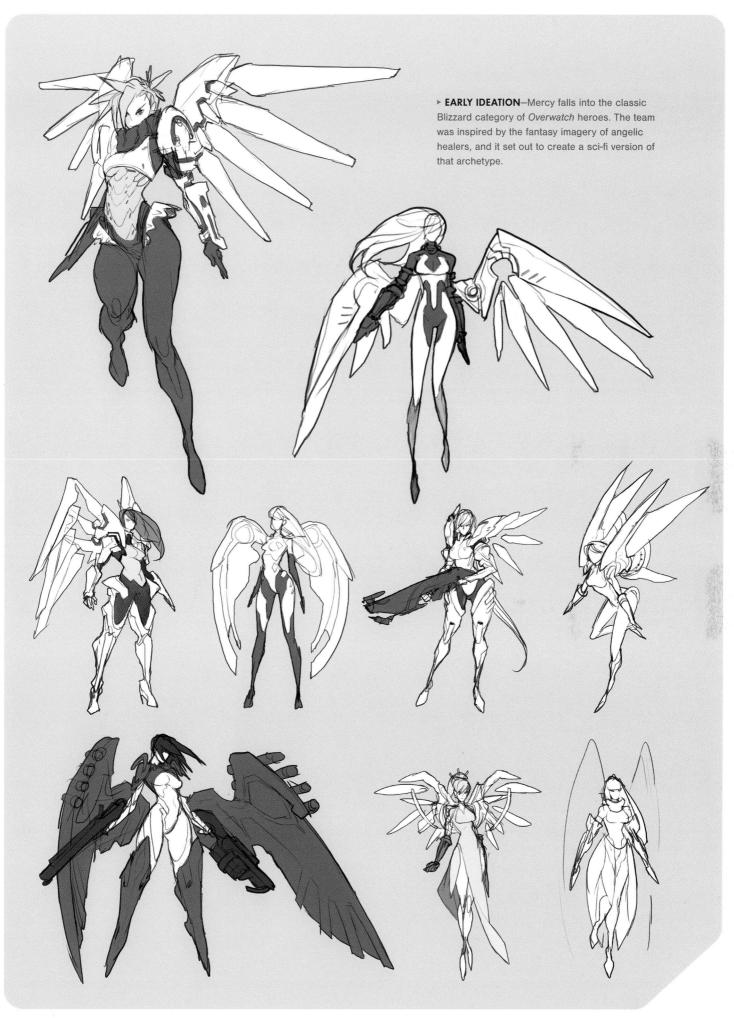

▶ **EARLY IDEATION**—Mercy falls into the classic Blizzard category of *Overwatch* heroes. The team was inspired by the fantasy imagery of angelic healers, and it set out to create a sci-fi version of that archetype.

ALL IMAGES: **ARNOLD TSANG**

ORISA

Orisa was *Overwatch*'s first quadruped hero, a design choice that made her different from existing omnics like Zenyatta and Bastion. She was also the first hero from Numbani. The futuristic African city was unlike any other location in the game, and the designers infused its distinct visual motifs and architecture into Orisa.

After finalizing Orisa's design, the developers moved on to her backstory. They imagined the hero as a recently created artificial intelligence, the robot equivalent of a newborn baby who was still getting used to her abilities and learning her place in the world. Her maker was Efi Oladele (below), a child genius from Numbani who had crafted Orisa to safeguard the city. Though this young girl wasn't a playable character, her presence helped the team expand the story outside of the game.

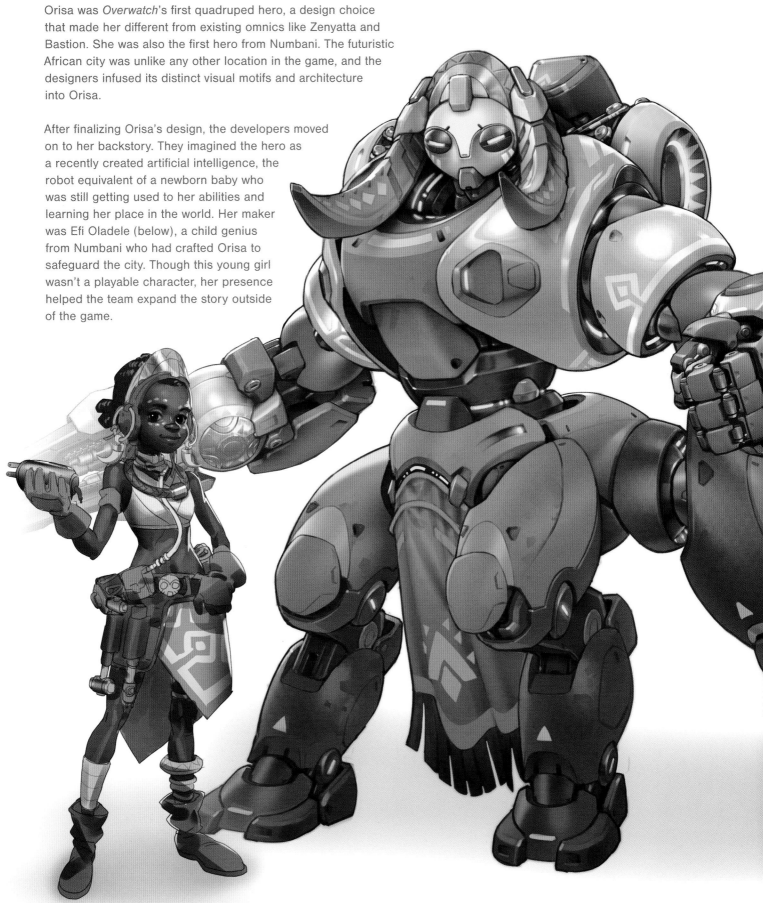

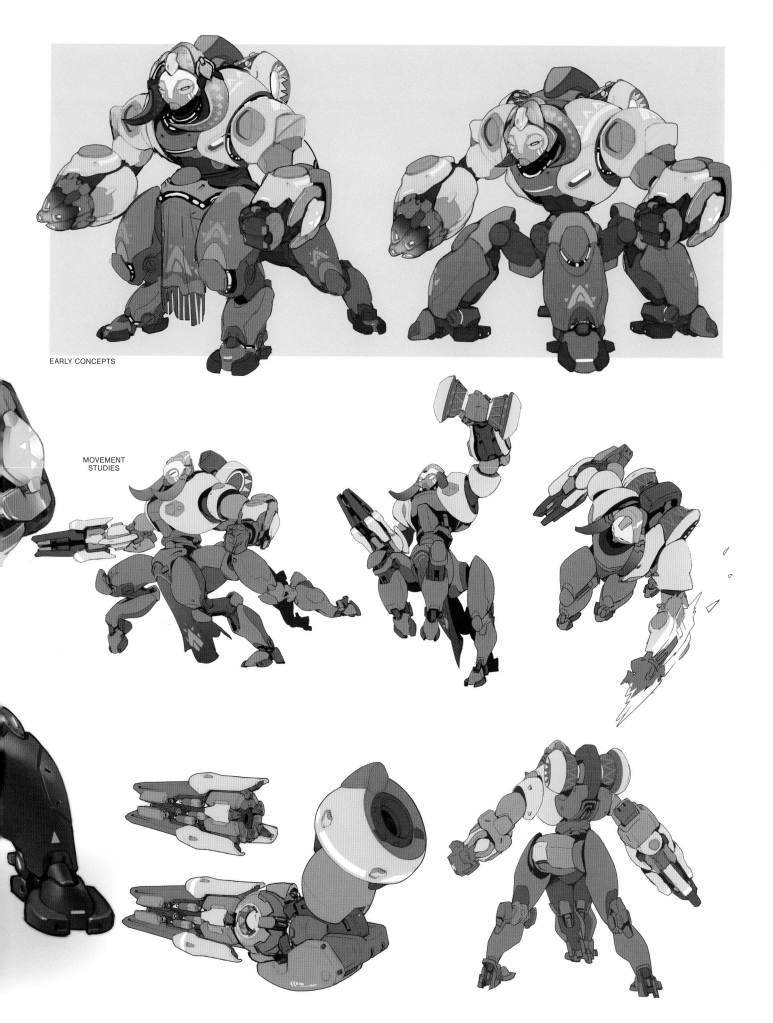

EARLY CONCEPTS

MOVEMENT
STUDIES

TOP LEFT: **ARNOLD TSANG**, TOP RIGHT AND BOTTOM: **BEN ZHANG**

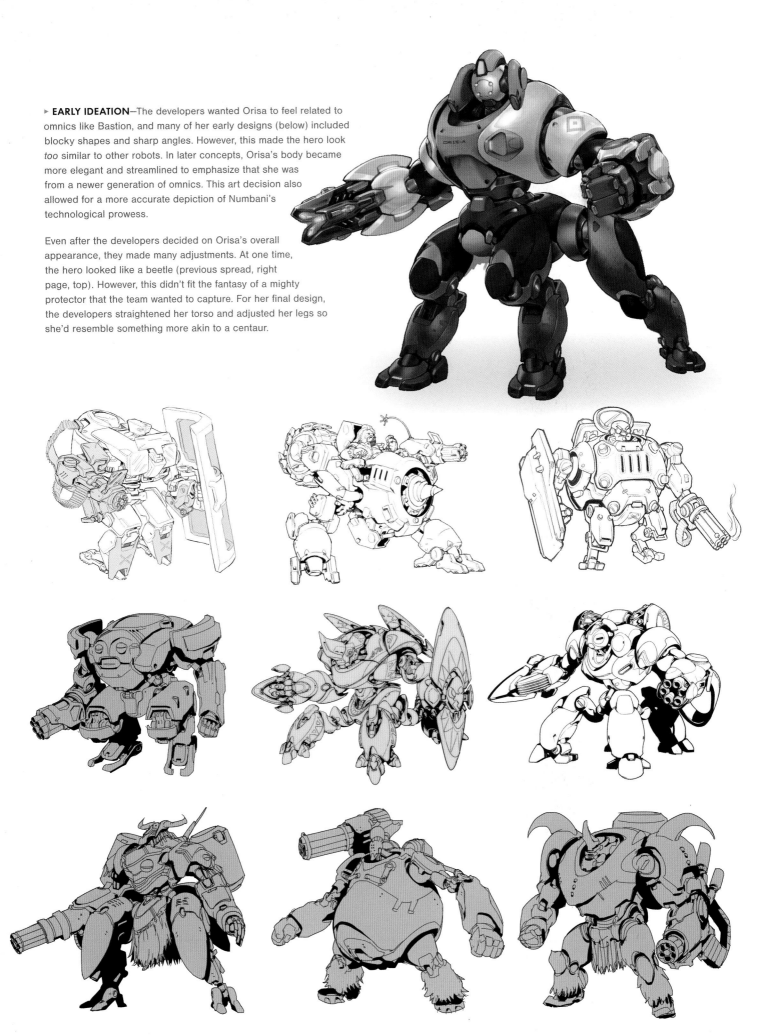

▶ **EARLY IDEATION**—The developers wanted Orisa to feel related to omnics like Bastion, and many of her early designs (below) included blocky shapes and sharp angles. However, this made the hero look *too* similar to other robots. In later concepts, Orisa's body became more elegant and streamlined to emphasize that she was from a newer generation of omnics. This art decision also allowed for a more accurate depiction of Numbani's technological prowess.

Even after the developers decided on Orisa's overall appearance, they made many adjustments. At one time, the hero looked like a beetle (previous spread, right page, top). However, this didn't fit the fantasy of a mighty protector that the team wanted to capture. For her final design, the developers straightened her torso and adjusted her legs so she'd resemble something more akin to a centaur.

ARNOLD TSANG, BEN ZHANG, JOHN POLIDORA, AND **DAVID KANG**

PROTECTIVE BARRIER

SUPERCHARGER

DRIVER MUZZLE FLASH AND IMPACT

HALT!

FUSION DRIVER

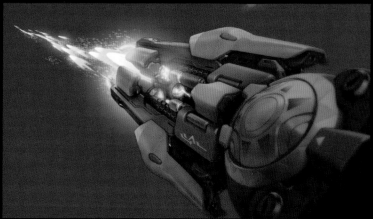

FUSION DRIVER TRACER EFFECT

FUSION DRIVER: HALT!

ALL IMAGES: **BEN ZHANG**

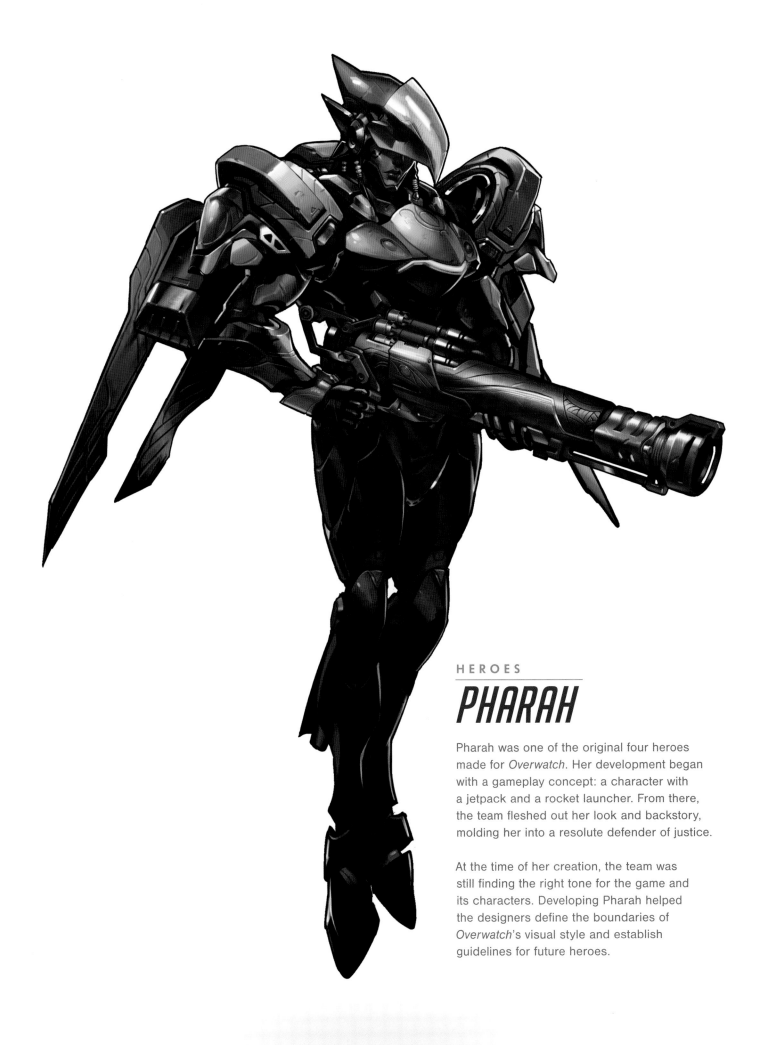

PHARAH

Pharah was one of the original four heroes
made for *Overwatch*. Her development began
with a gameplay concept: a character with
a jetpack and a rocket launcher. From there,
the team fleshed out her look and backstory,
molding her into a resolute defender of justice.

At the time of her creation, the team was
still finding the right tone for the game and
its characters. Developing Pharah helped
the designers define the boundaries of
Overwatch's visual style and establish
guidelines for future heroes.

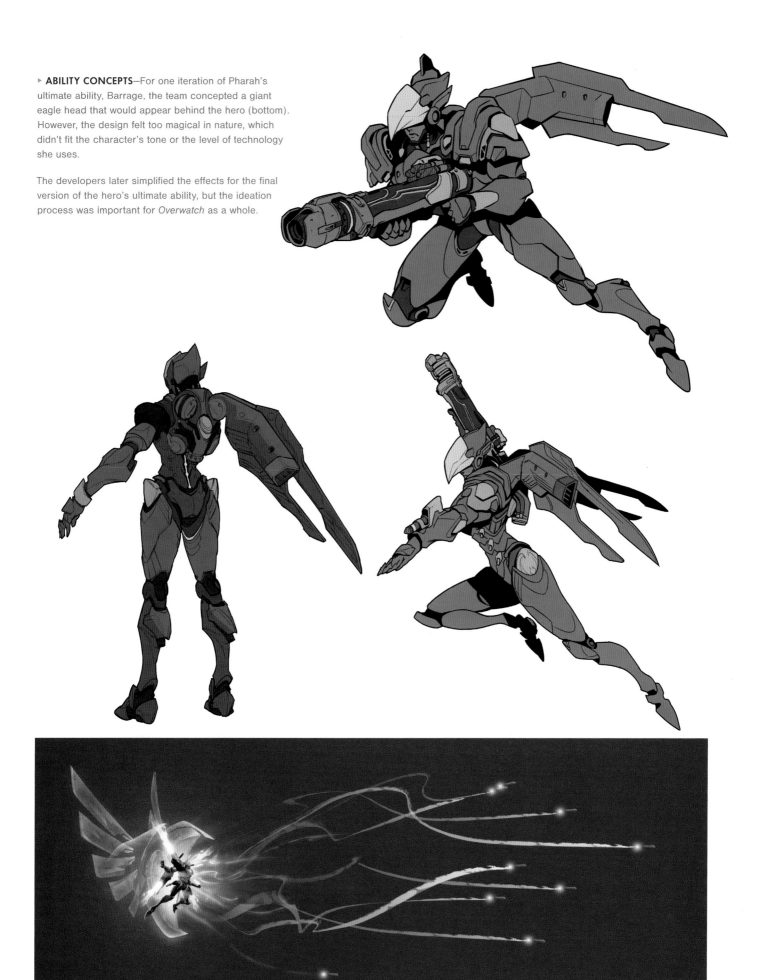

▶ **ABILITY CONCEPTS**—For one iteration of Pharah's ultimate ability, Barrage, the team concepted a giant eagle head that would appear behind the hero (bottom). However, the design felt too magical in nature, which didn't fit the character's tone or the level of technology she uses.

The developers later simplified the effects for the final version of the hero's ultimate ability, but the ideation process was important for *Overwatch* as a whole.

BARRAGE VISUAL EFFECT CONCEPT

BOTTOM: **BEN ZHANG**, REMAINDER OF IMAGES: **ARNOLD TSANG**

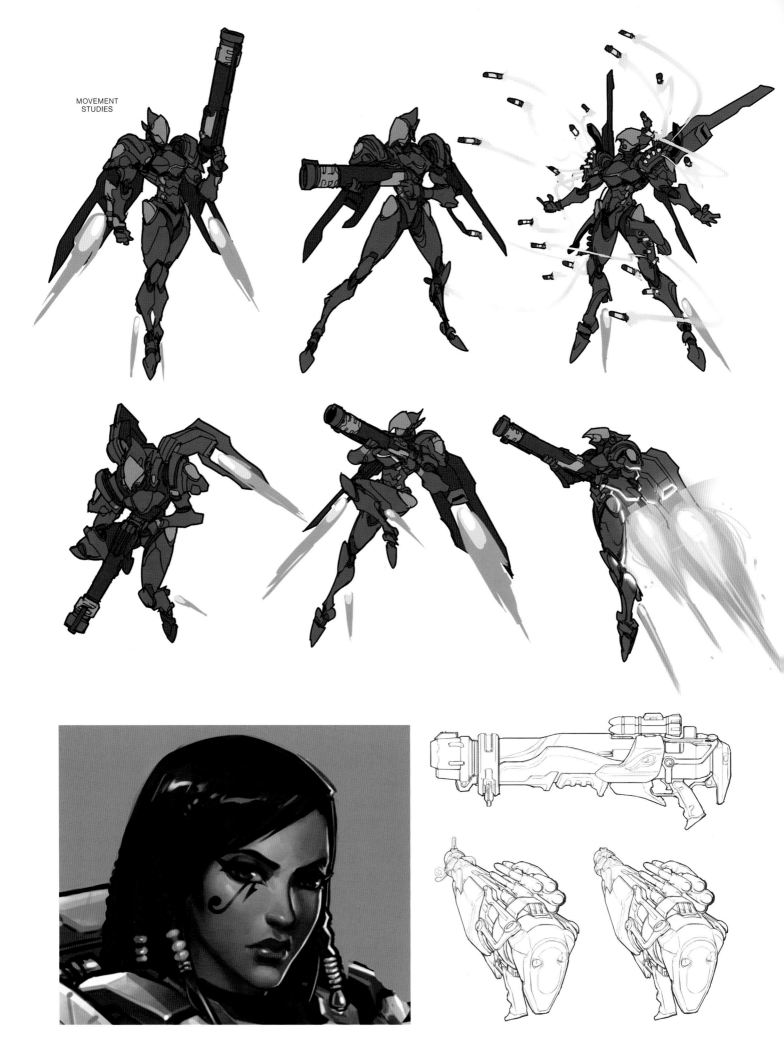

MOVEMENT
STUDIES

BOTTOM RIGHT: **BEN ZHANG**, REMAINDER OF IMAGES: **ARNOLD TSANG**

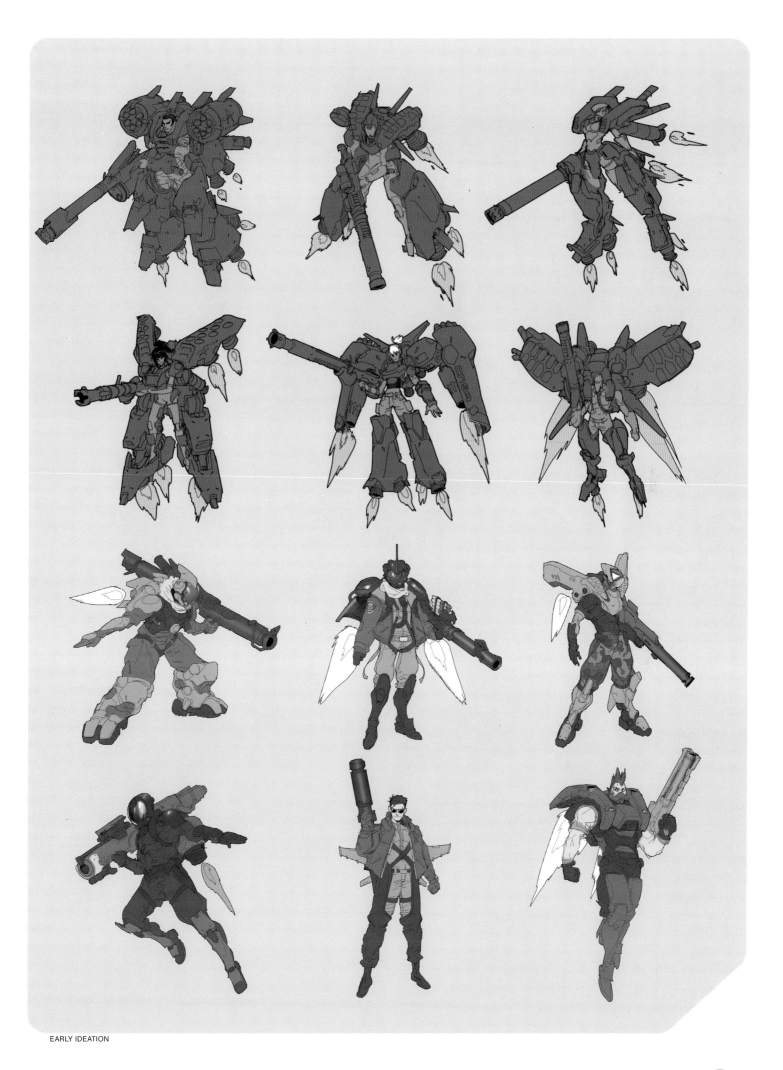

EARLY IDEATION

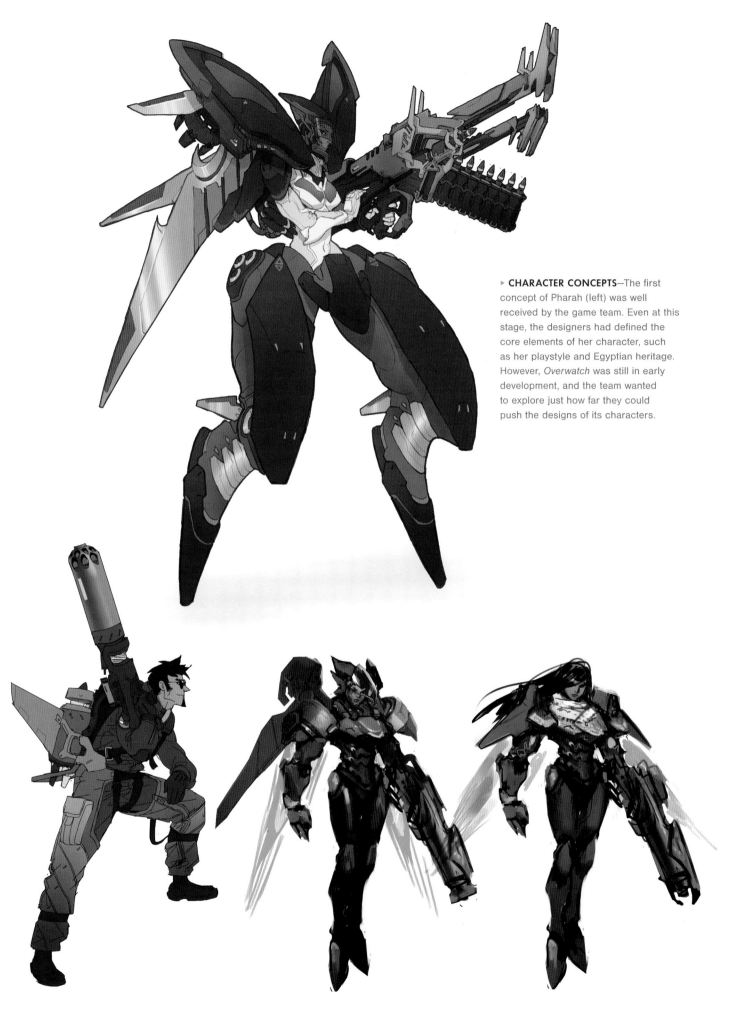

▶ **CHARACTER CONCEPTS**—The first concept of Pharah (left) was well received by the game team. Even at this stage, the designers had defined the core elements of her character, such as her playstyle and Egyptian heritage. However, *Overwatch* was still in early development, and the team wanted to explore just how far they could push the designs of its characters.

TOP: **JUSTIN THAVIRAT**, REMAINDER OF IMAGES: **ARNOLD TSANG**

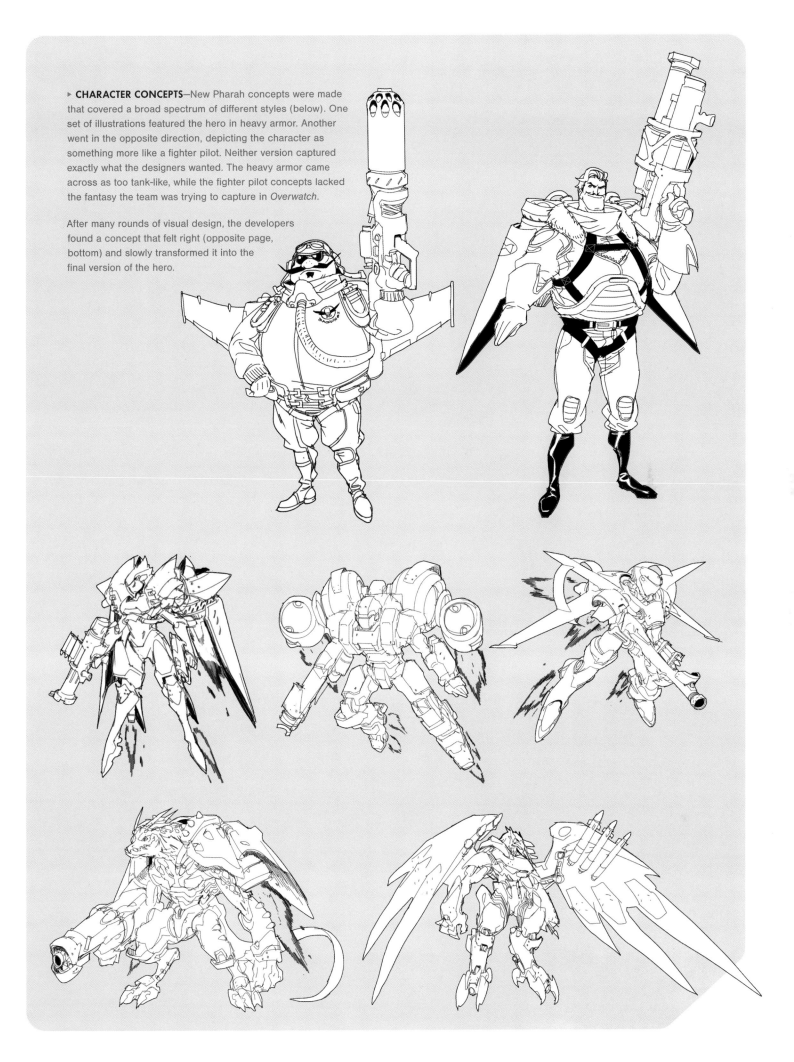

▶ **CHARACTER CONCEPTS**—New Pharah concepts were made that covered a broad spectrum of different styles (below). One set of illustrations featured the hero in heavy armor. Another went in the opposite direction, depicting the character as something more like a fighter pilot. Neither version captured exactly what the designers wanted. The heavy armor came across as too tank-like, while the fighter pilot concepts lacked the fantasy the team was trying to capture in *Overwatch*.

After many rounds of visual design, the developers found a concept that felt right (opposite page, bottom) and slowly transformed it into the final version of the hero.

REAPER

Reaper is a core *Overwatch* villain, a terrifying force of destruction whose motives and powers are shrouded in mystery.

Early in his development, the *Overwatch* team knew that they wanted Reaper to lurk in the shadows, using stealth to outflank and ambush his opponents at close range. Everything about the character's visual design reflected this gameplay style, from his dark hood and clothing to his wraith-like abilities.

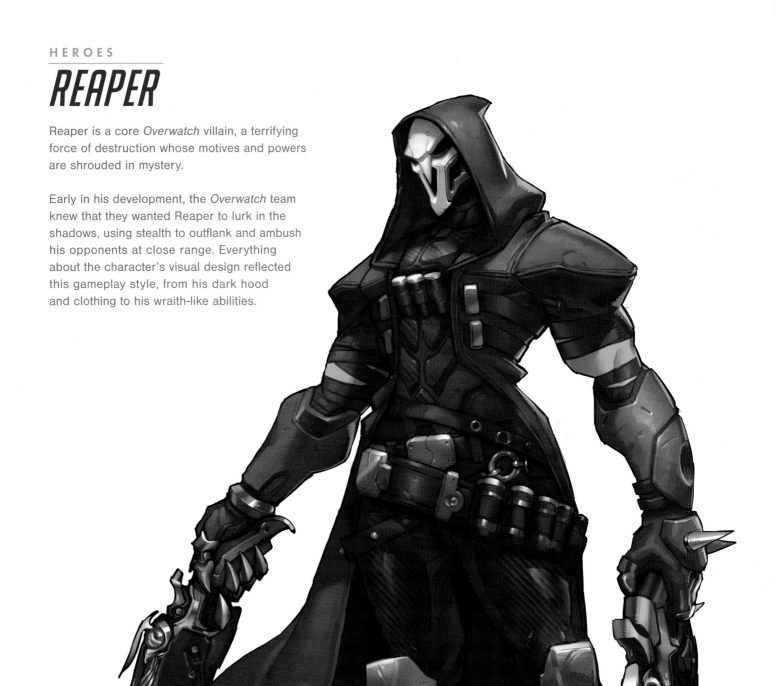

ARNOLD TSANG

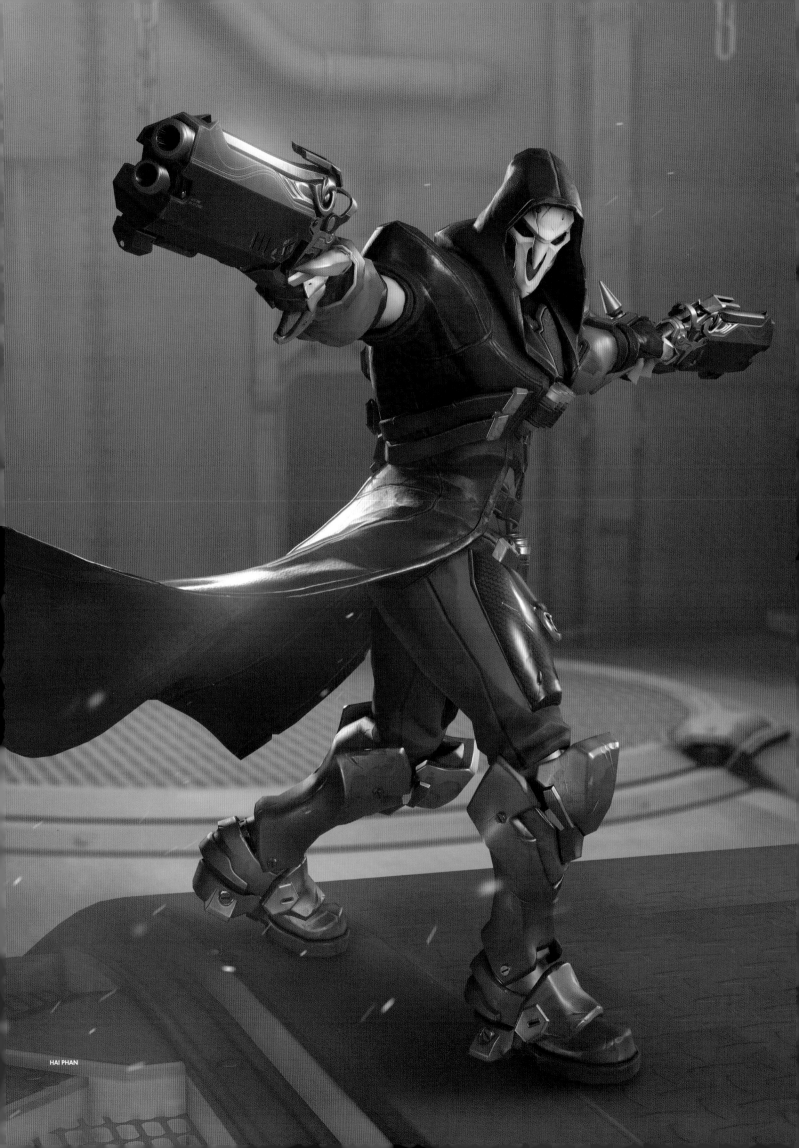

ABILITY CONCEPTS—Before the developers created Reaper's Shadow Step ability, they experimented with other skills for sneaking up on enemies. One of these early ideas was a smoke bomb that the hero could use to distract and disorientate opponents (opposite page, middle). The ability's concept art drew on the color schemes and design elements of Reaper's outfit, weapons, and other skills.

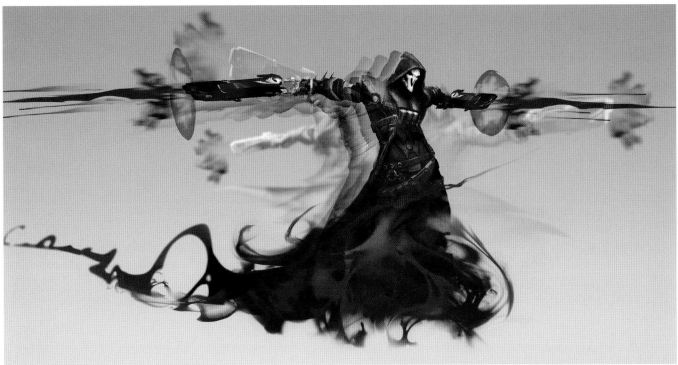

DEATH BLOSSOM

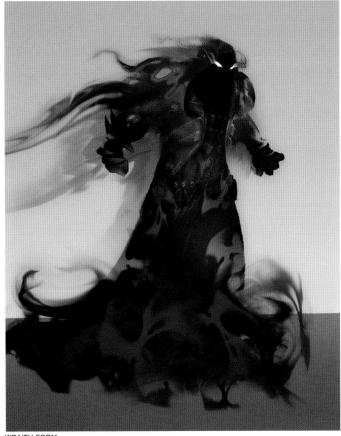

WRAITH FORM

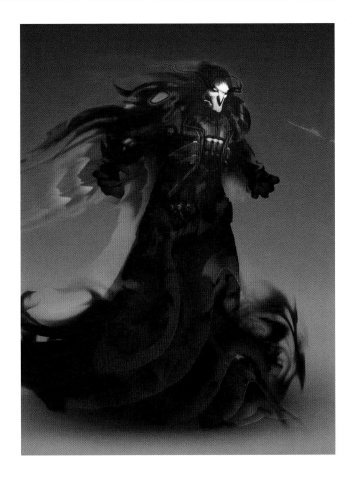

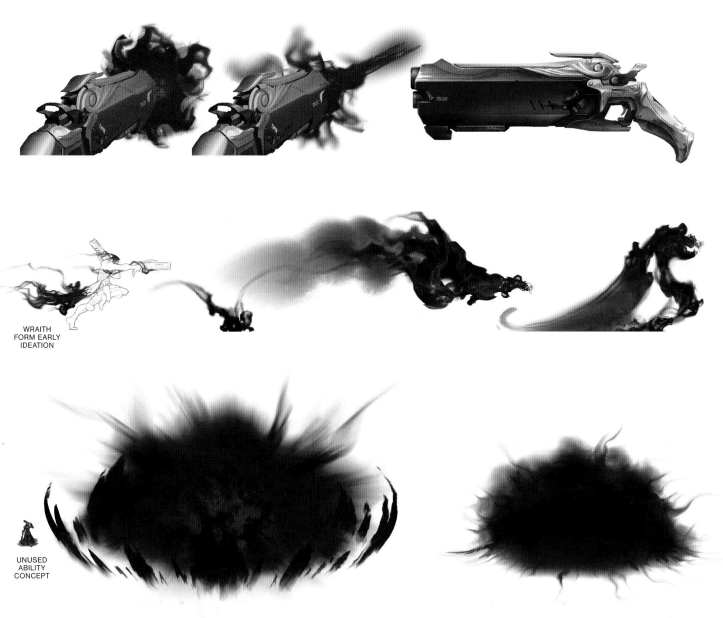

WRAITH
FORM EARLY
IDEATION

UNUSED
ABILITY
CONCEPT

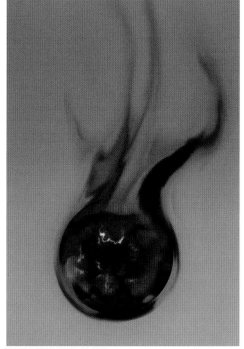

THE REAPING SOUL GLOBE

RESURRECT SOUL GLOBE

▶ **ABILITY CONCEPTS** —The game team toyed with Reaper having a grenade launcher, but they later abandoned the idea. However, hints of that early concept work stuck around. In his final iteration, Reaper wears bandoliers of grenade shells, and the *Overwatch* announcement trailer features the hero using the weapons to attack Winston and Tracer.

There was also a time when Reaper wielded two submachine guns (below), but the game team wanted him to use weapons that would feel heavier and more threatening. Shotguns were the perfect replacement.

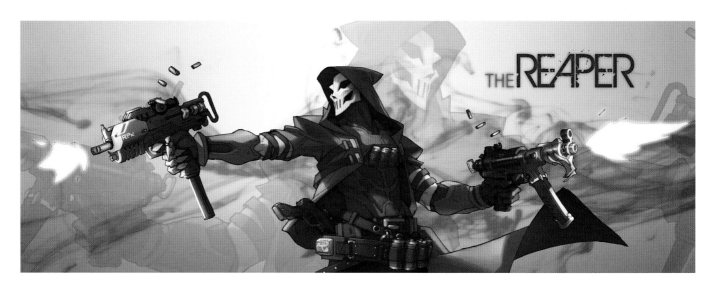

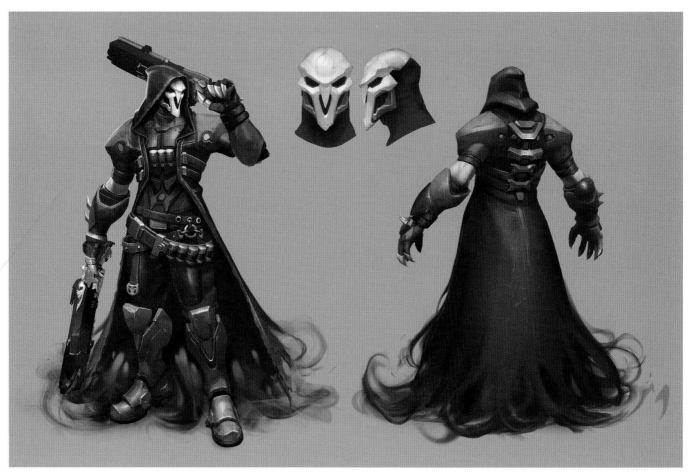

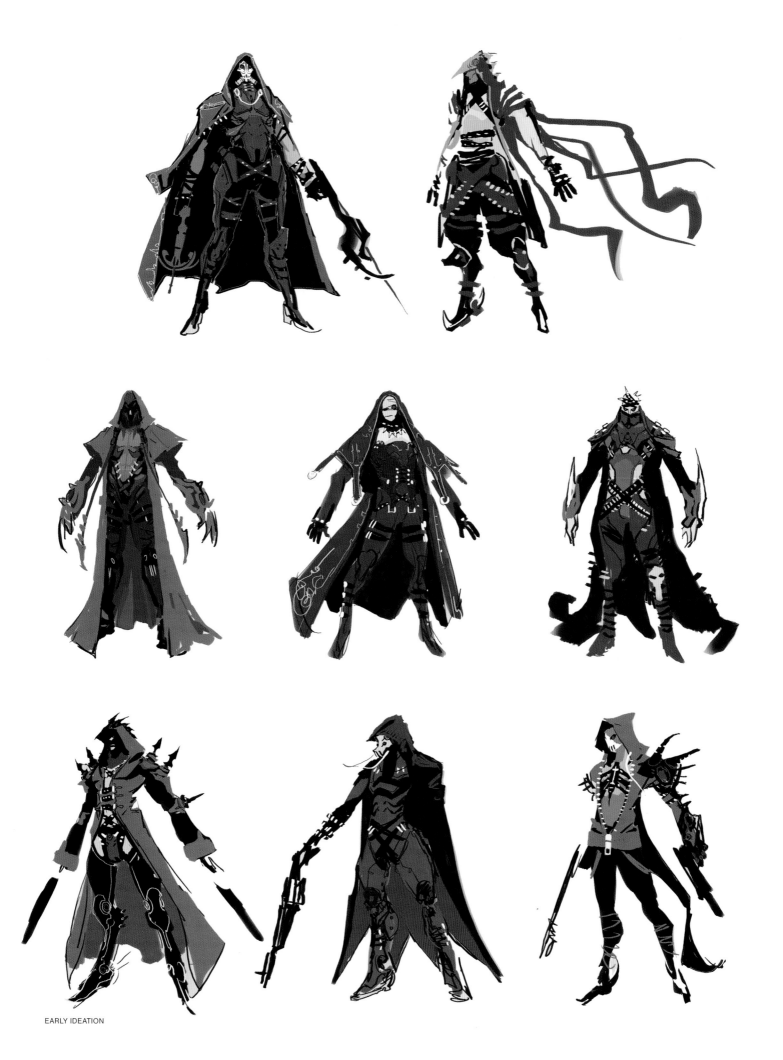

EARLY IDEATION

REINHARDT

Reinhardt was the first tank added to *Overwatch*. The developers always knew they wanted a physically imposing hero in a mech suit, but exactly *how* he would look was an open question.

As the developers experimented with different visual themes for Reinhardt, they looked to other Blizzard games for guidance. They found inspiration in archetypes like Warcraft's armor-clad paladins and StarCraft's marines. These influences led the team to mold Reinhardt into a heroic and courageous knight adorned in futuristic armor. This fusion of different concepts made the hero both familiar and new.

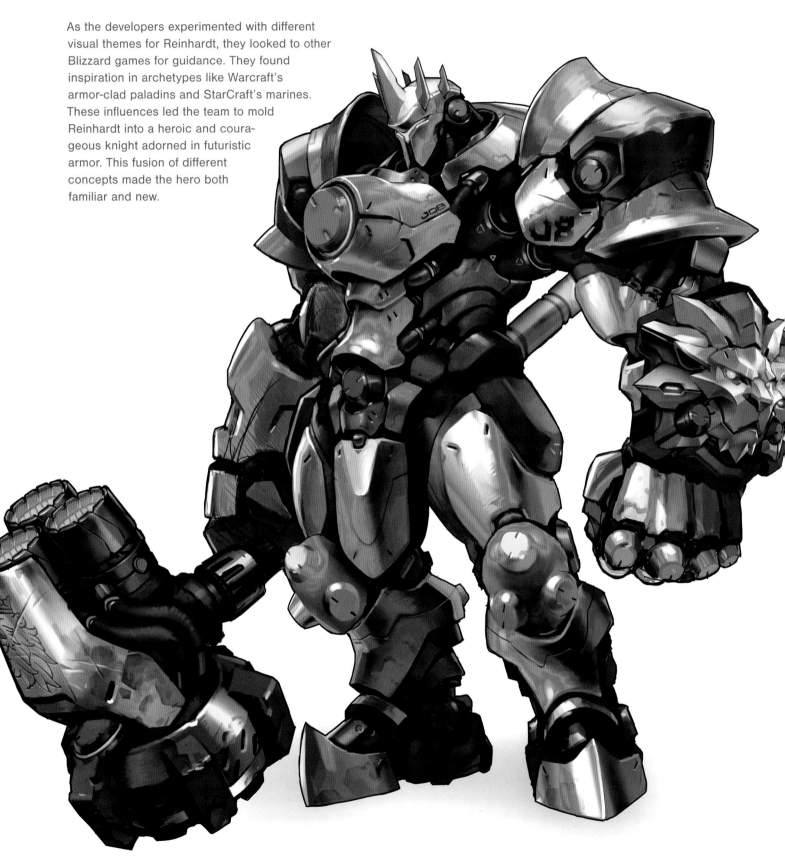

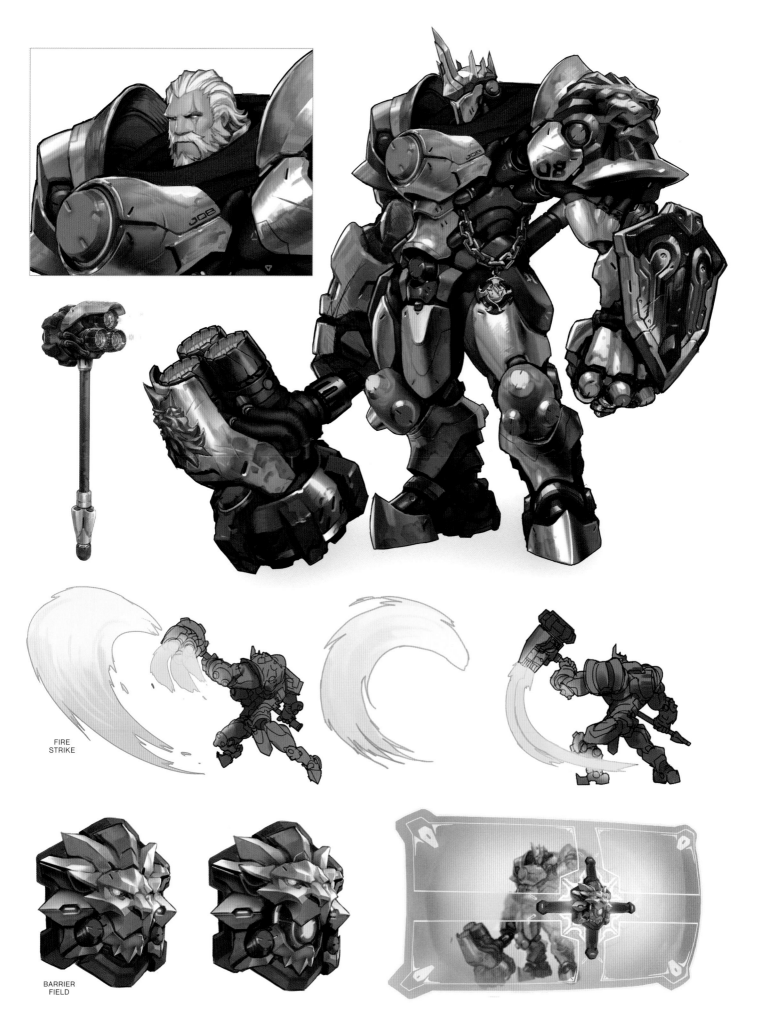

FIRE
STRIKE

BARRIER
FIELD

BOTTOM: **BEN ZHANG**, REMAINDER OF IMAGES: **ARNOLD TSANG**

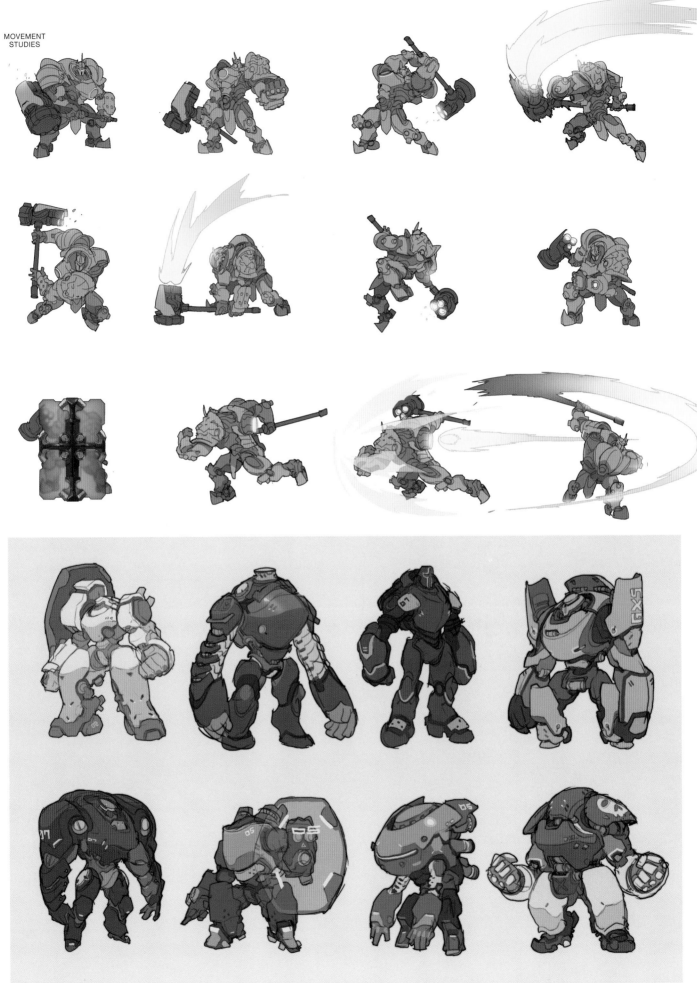

MOVEMENT
STUDIES

EARLY IDEATION

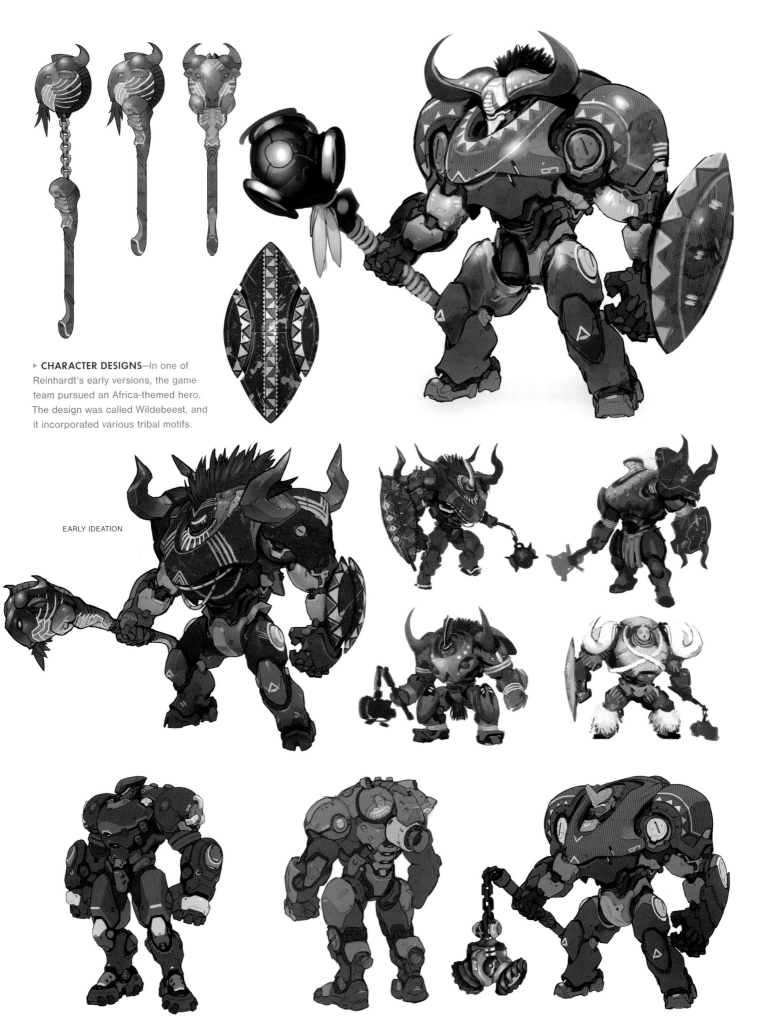

▶ **CHARACTER DESIGNS**—In one of Reinhardt's early versions, the game team pursued an Africa-themed hero. The design was called Wildebeest, and it incorporated various tribal motifs.

EARLY IDEATION

ROADHOG

Art for the ruthless Junker named Roadhog was created very early in development. However, the hero's appearance wasn't finalized until the emergence of another character: Junkrat.

Making Junkrat—a fellow scavenger from the Outback—helped the *Overwatch* designers discover new possibilities for Road-hog. The two heroes had very different personalities, but they were both chaotic and cold-blooded. The designers made them into criminal accomplices, a menacing duo that would launch heists across the world.

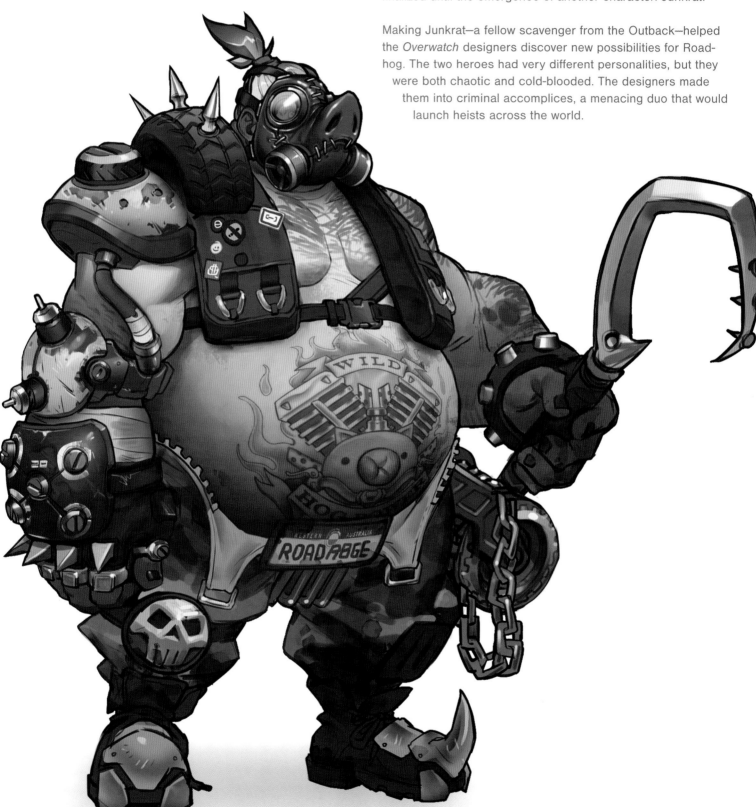

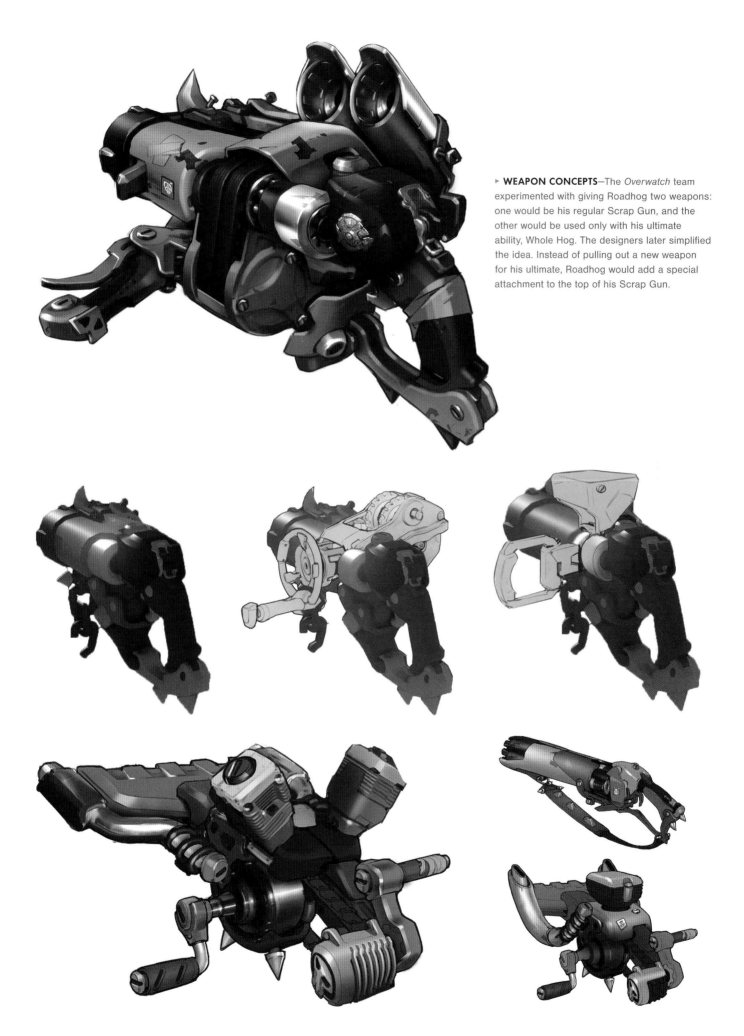

▶ **WEAPON CONCEPTS**—The *Overwatch* team experimented with giving Roadhog two weapons: one would be his regular Scrap Gun, and the other would be used only with his ultimate ability, Whole Hog. The designers later simplified the idea. Instead of pulling out a new weapon for his ultimate, Roadhog would add a special attachment to the top of his Scrap Gun.

ALL IMAGES: **BEN ZHANG**

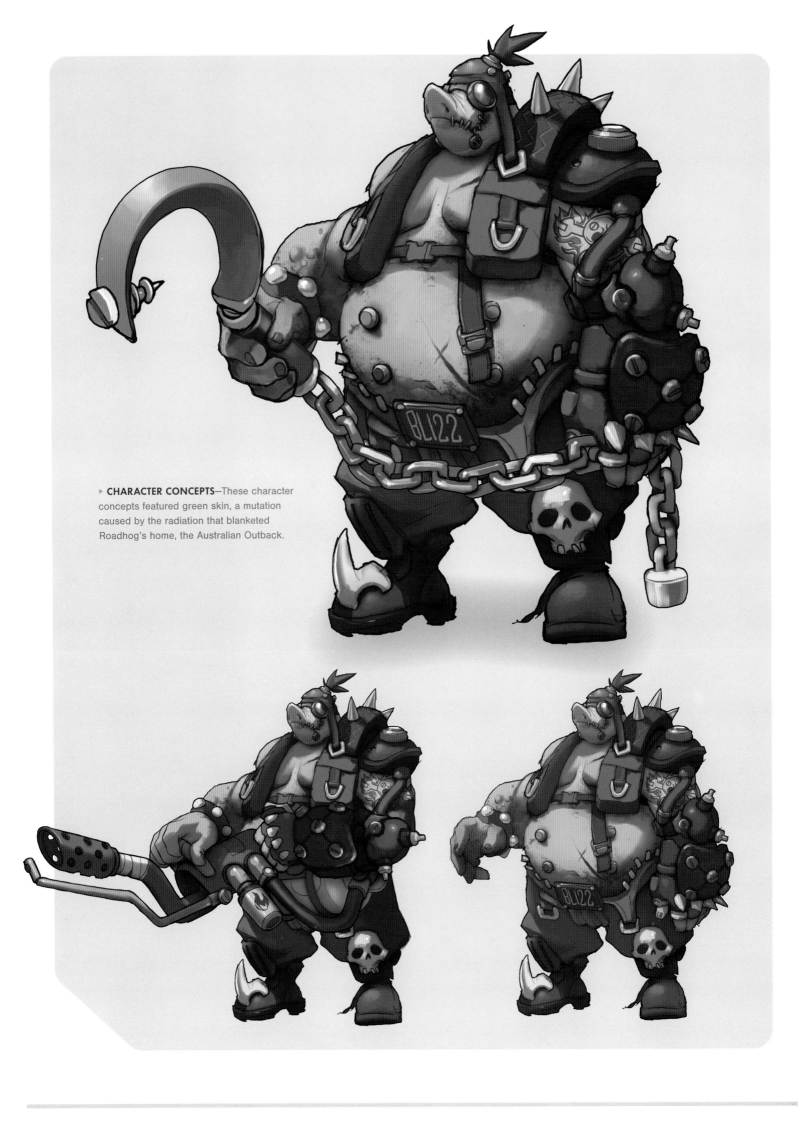

▶ **CHARACTER CONCEPTS**—These character concepts featured green skin, a mutation caused by the radiation that blanketed Roadhog's home, the Australian Outback.

ROADHOG'S
BELLY TATTOO
CONCEPT

TAKE A BREATHER

ALL IMAGES: **ARNOLD TSANG**

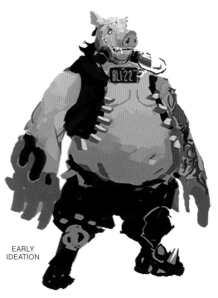

EARLY
IDEATION

SOLDIER: 76

Soldier: 76's origin was different from that of any other *Overwatch* hero. The designers were determined to create a character who would fill two important roles. They wanted someone who would function like a classic soldier—someone players of other first-person shooters would find familiar. The developers also saw this new hero as an opportunity to flesh out *Overwatch*'s backstory.

Chris Metzen, Blizzard's senior vice president of Story and Franchise Development and one of *Overwatch*'s visionaries, had a solution. He'd previously developed a character named Soldier: 76 who seemed like the perfect fit for the team's gameplay and story needs. The designers embraced this hero and developed him into an integral part of *Overwatch*.

Soldier: 76's backstory was one of tragedy. In his former life as Jack Morrison, he served as Overwatch's noble leader. After the organization fell from grace, he became the masked vigilante known as Soldier: 76. His history became the linchpin of *Overwatch*'s entire story, and including him in the game was an important step to broadening the world and bringing it to life.

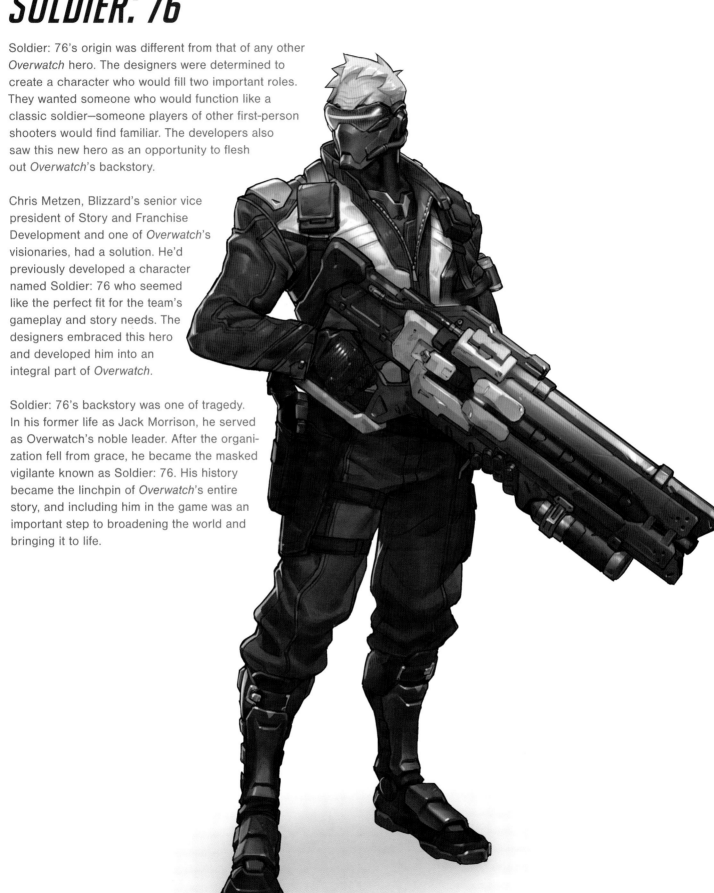

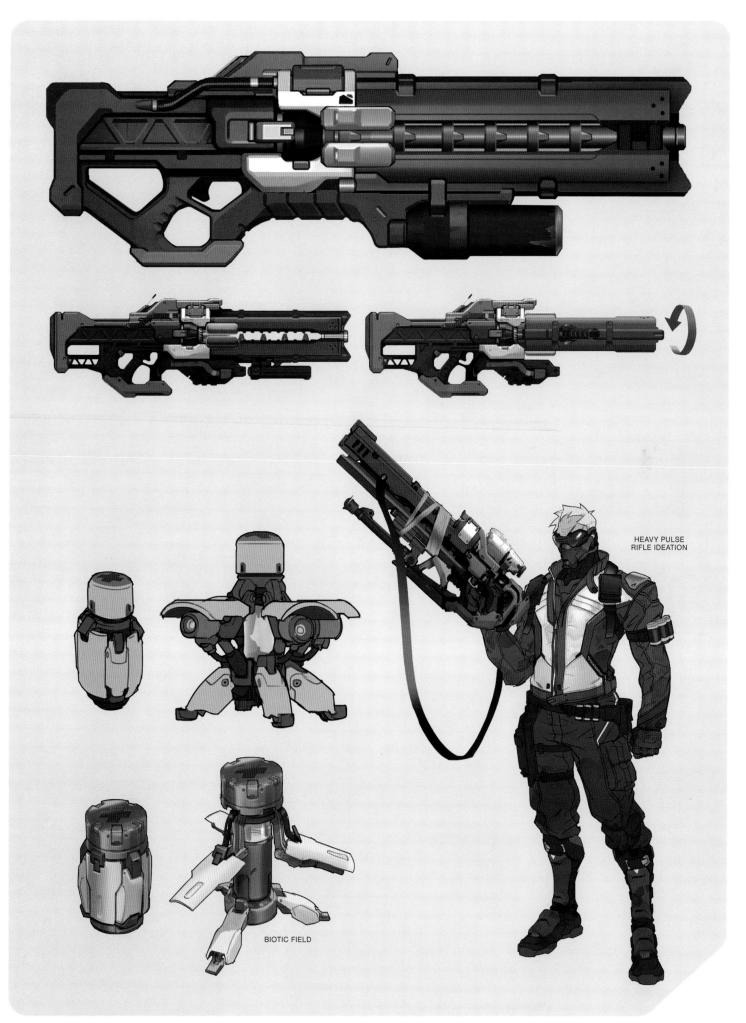

HEAVY PULSE
RIFLE IDEATION

BIOTIC FIELD

TOP: **DAVID KANG**, REMAINDER OF IMAGES: **ARNOLD TSANG**

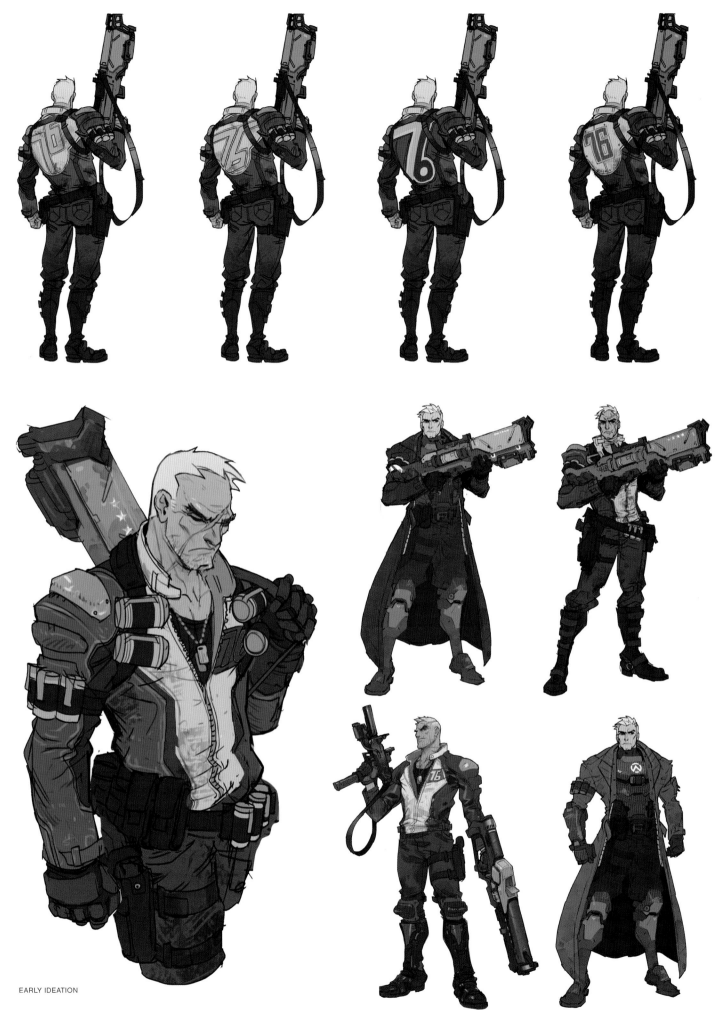

EARLY IDEATION

▶ **CHARACTER CONCEPTS**—Years before *Overwatch*'s development began, Chris Metzen created story and art for Soldier: 76. The game's designers used these concepts to push the hero forward. One of the biggest changes they made was outfitting the character with weapons, devices, and armor that felt more appropriate for the level of technology seen in *Overwatch*.

The next wave of concepts (opposite page) showed his face. This approach was later changed to fit the character's personality. Because Soldier: 76 was a mysterious vigilante, it was important that he hid his identity. The team added a mask to his design, which became an iconic part of Soldier: 76's outfit and a key component of his ultimate ability, Tactical Visor.

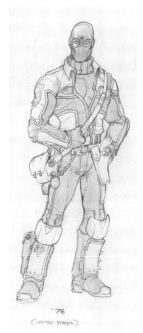
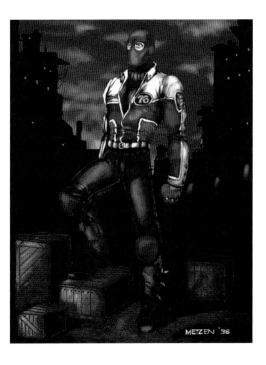

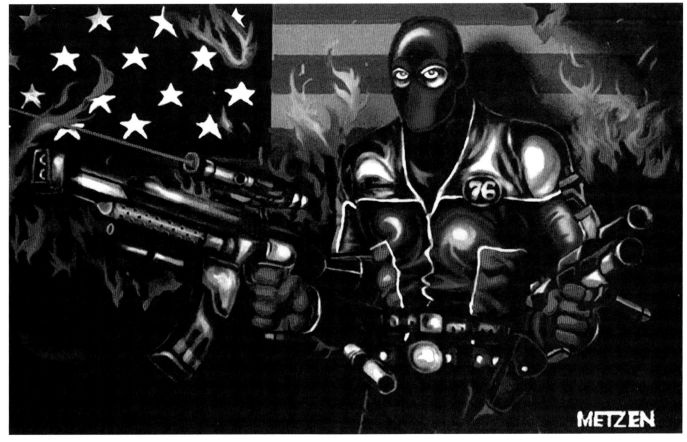

ALL IMAGES: **CHRIS METZEN**

SOMBRA

Sombra went through a drastic evolution from first concept to in-game hero. She was originally called Omniblade (opposite page, bottom left), a Japanese woman with a love of street fashion and throwing daggers. Each of her blades produced a different effect, such as revealing the location of enemies on other parts of the map.

As *Overwatch*'s development moved forward, the game team transferred some of these abilities to the heroes Hanzo and Genji. Omniblade was set aside, but she wasn't forgotten.

The developers revisited her concept art and molded the character into something different: a stealthy and notorious Mexican hacker named Sombra. Instead of wielding daggers, she would manipulate objects and even other characters through her high-tech abilities.

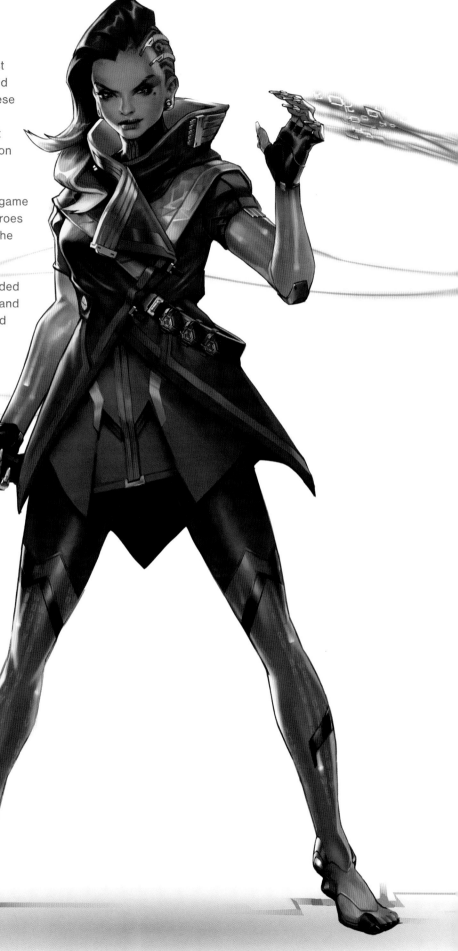

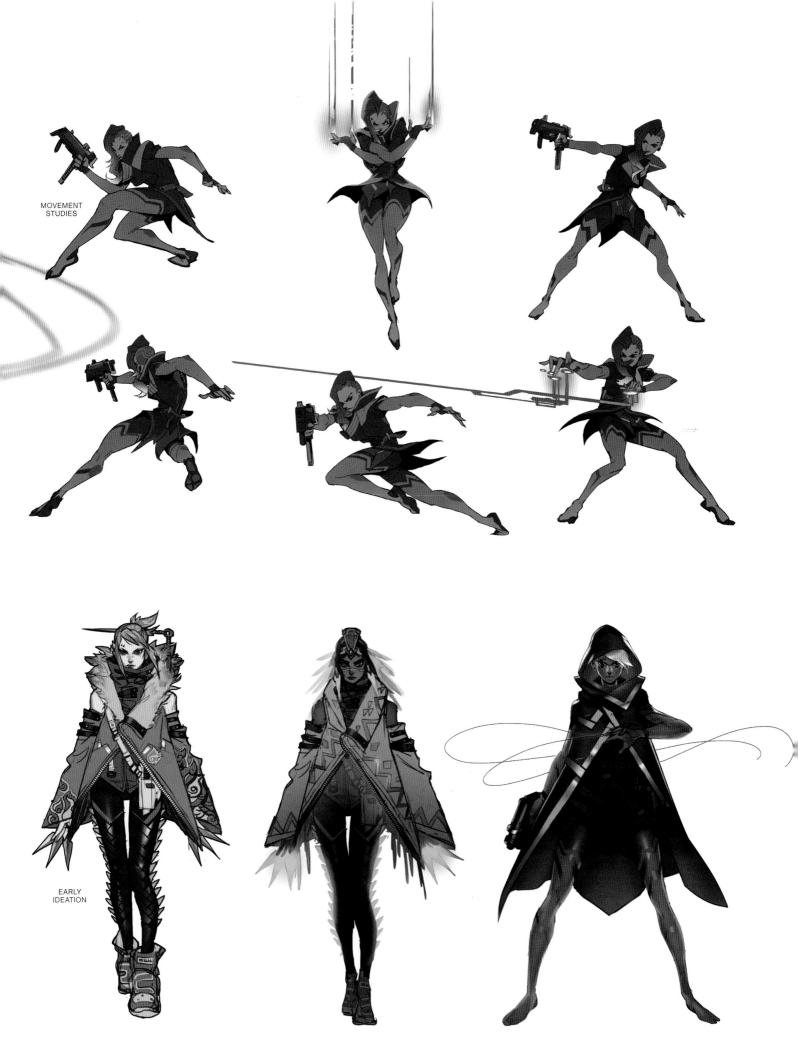

MOVEMENT
STUDIES

EARLY
IDEATION

BOTTOM: **ARNOLD TSANG**, REMAINDER OF IMAGES: **BEN ZHANG**

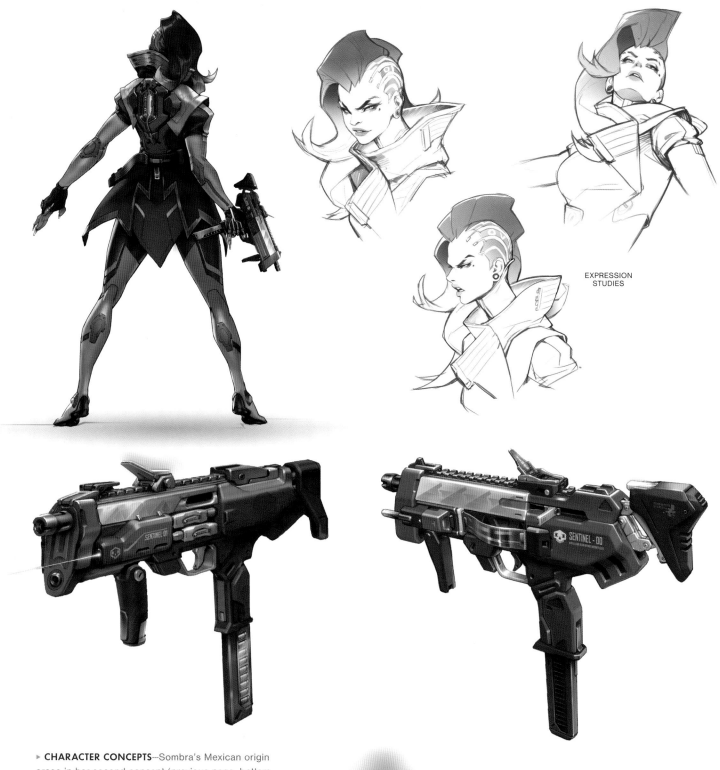

EXPRESSION STUDIES

▶ **CHARACTER CONCEPTS**—Sombra's Mexican origin arose in her second concept (previous page, bottom, middle), which was inspired by traditional Aztec designs. The illustration excited the game team, but the hero still felt too much like the original art.

For the third concept, Sombra's look underwent a major shift (previous page, bottom, right). Energy tendrils were added to her hands to indicate her new hacking abilities, and her entire wardrobe was changed to something befitting a stealthy character.

The only issue was that her clothing resembled Ana's. Sombra's hood was then removed and her coat was shortened to help her stand out as a unique hero.

TRANSLOCATOR

KEYPAD

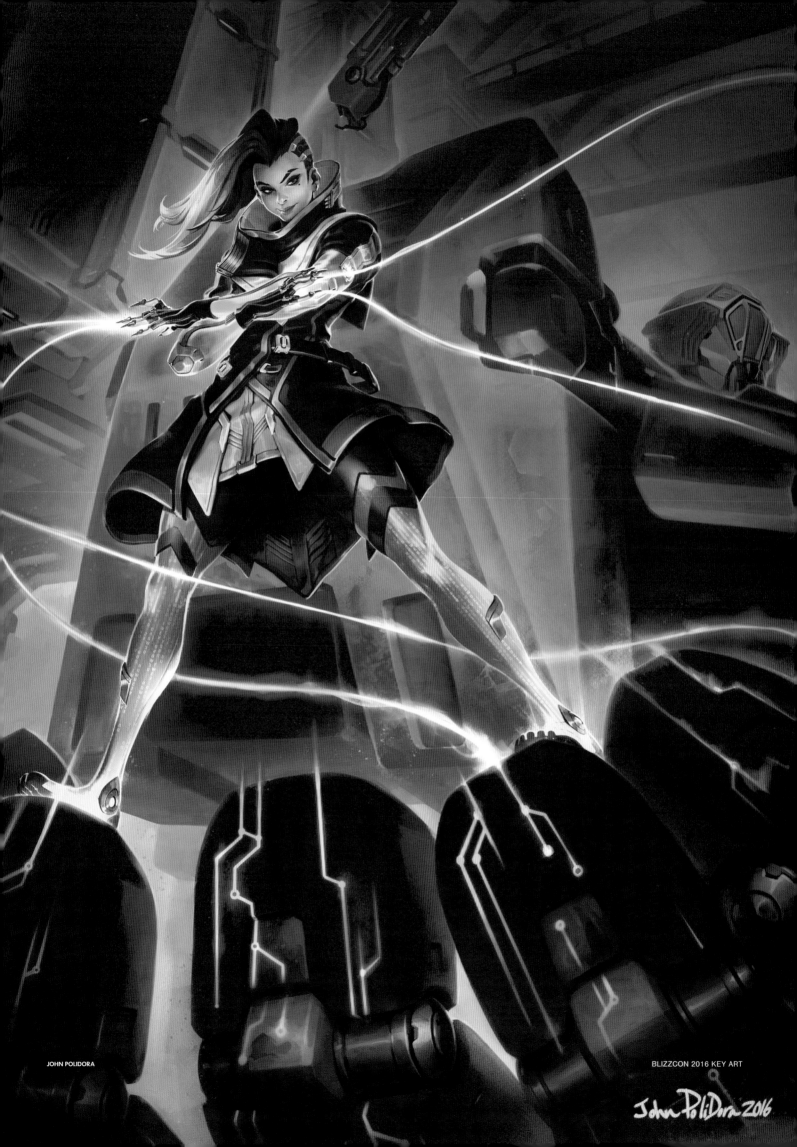

SYMMETRA

During development, the game team set out to incorporate a classic fantasy wizard into *Overwatch*'s sci-fi setting. Their efforts resulted in the Technomancer, a character who could summon objects out of thin air using technology in much the same way that a mage creates items using magic. Early concepts of this idea were created (next spread, right page, bottom) and refined before the developers arrived at the gifted architech named Symmetra.

Elements of her final visual design still reflect the original idea of bringing a wizard into the world of *Overwatch*, such as her robe-like outfit and her ability to bend reality by manipulating hard-light technology.

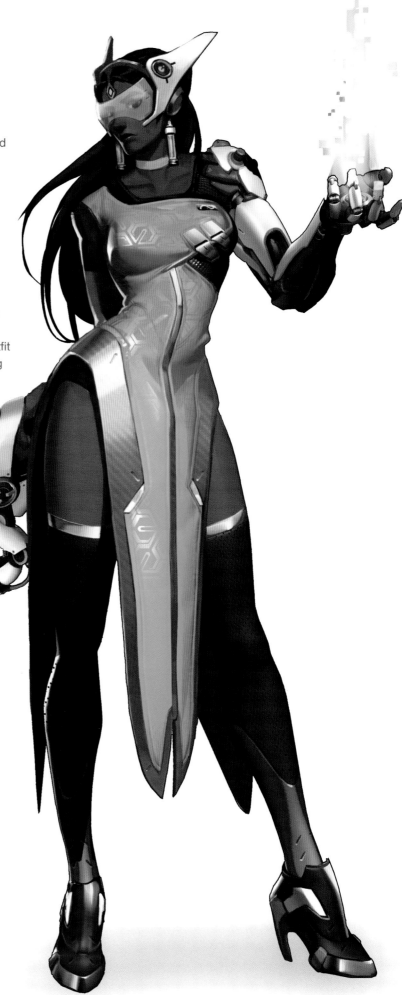

ARNOLD TSANG

▶ **WEAPON DESIGNS**—Early in Symmetra's development, the designers experimented with how she would reload her Photon Projector. Artists created concepts for spherical containers that the hero could remove and insert into her weapon. The shape of these objects was based on the circular designs of Symmetra's Sentry Turrets so there would be cohesion between her equipment and abilities. Ultimately, the game team went away from this reloading mechanic, but the containers remained a visual element on the side of the hero's weapon.

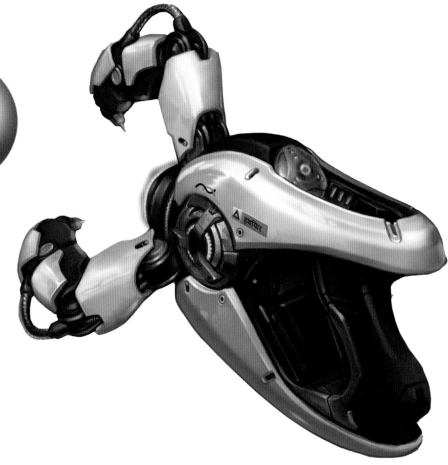

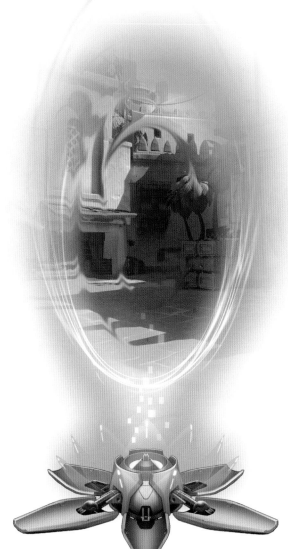

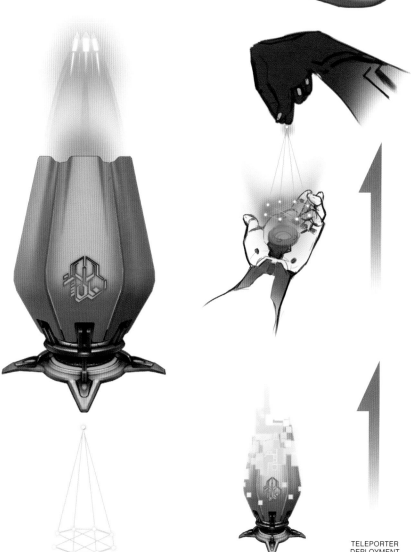

TELEPORTER DEPLOYMENT

TOP: **ROMAN KENNEY**, BOTTOM: **BEN ZHANG**

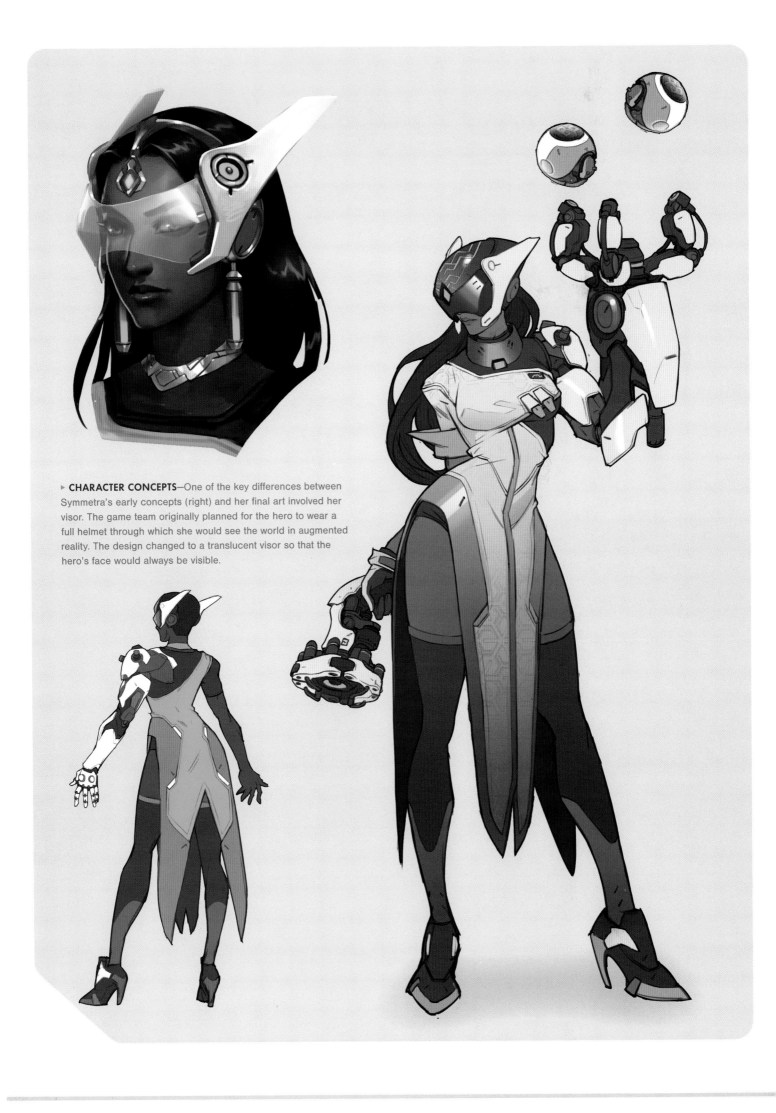

► **CHARACTER CONCEPTS**—One of the key differences between Symmetra's early concepts (right) and her final art involved her visor. The game team originally planned for the hero to wear a full helmet through which she would see the world in augmented reality. The design changed to a translucent visor so that the hero's face would always be visible.

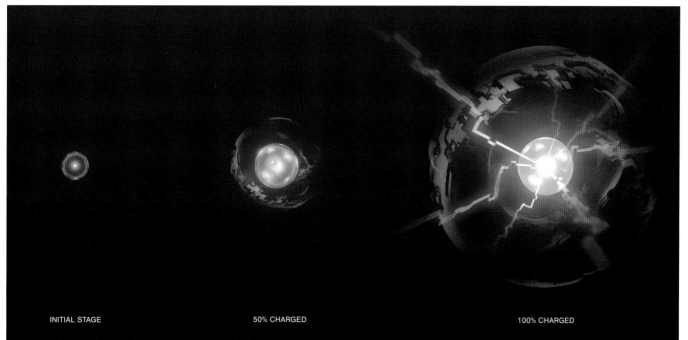

INITIAL STAGE 50% CHARGED 100% CHARGED

PHOTON PROJECTOR ALTERNATE FIRE

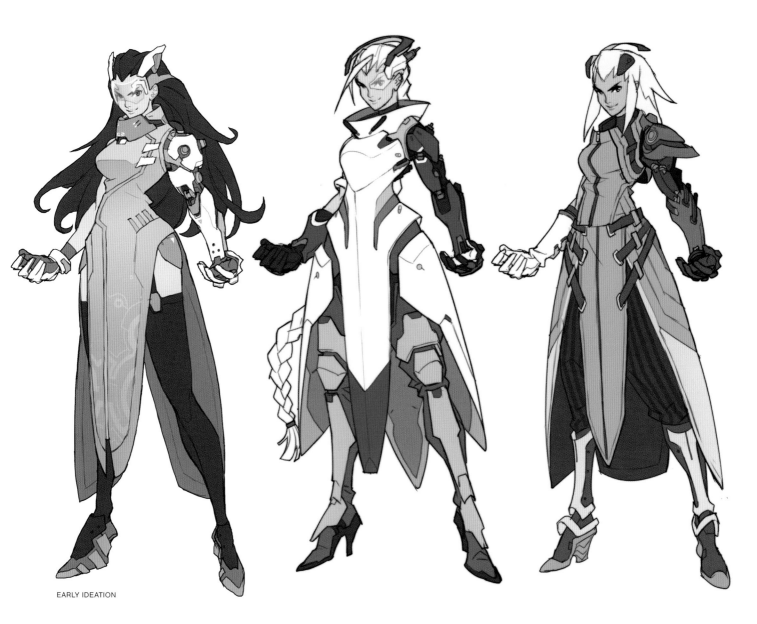

EARLY IDEATION

TOP: **BEN ZHANG**, REMAINDER OF IMAGES: **ARNOLD TSANG**

TORBJÖRN

Creating the brilliant inventor and engineer Torbjörn was another chance for the *Overwatch* team to experiment with the game's art style. How stylized could they make the character while still having him fit in the game? This was among the questions the team asked as they carved out a special place for Torbjörn in the *Overwatch* world.

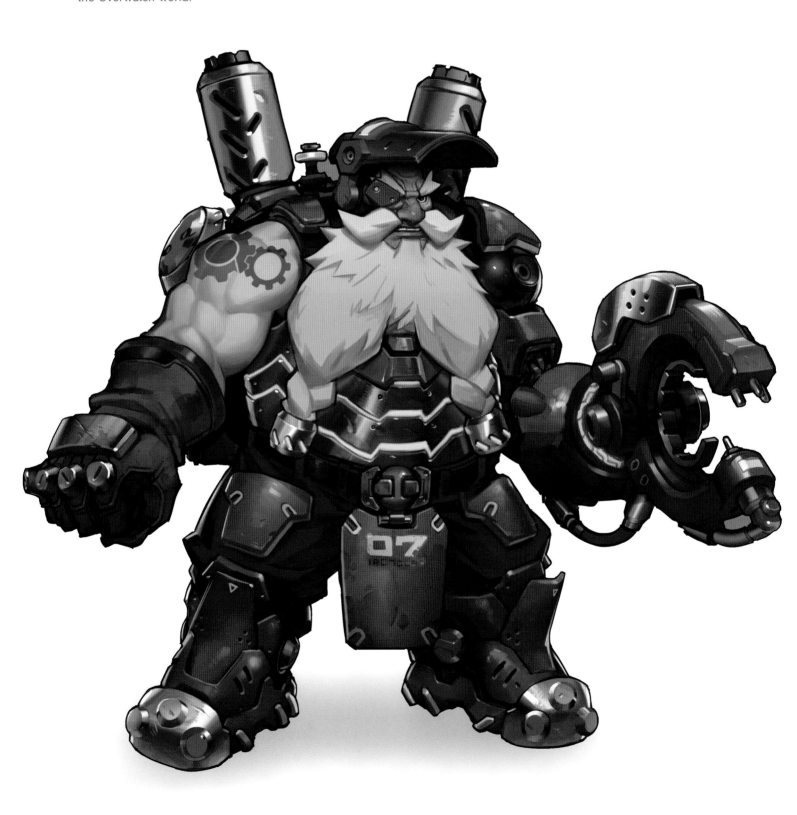

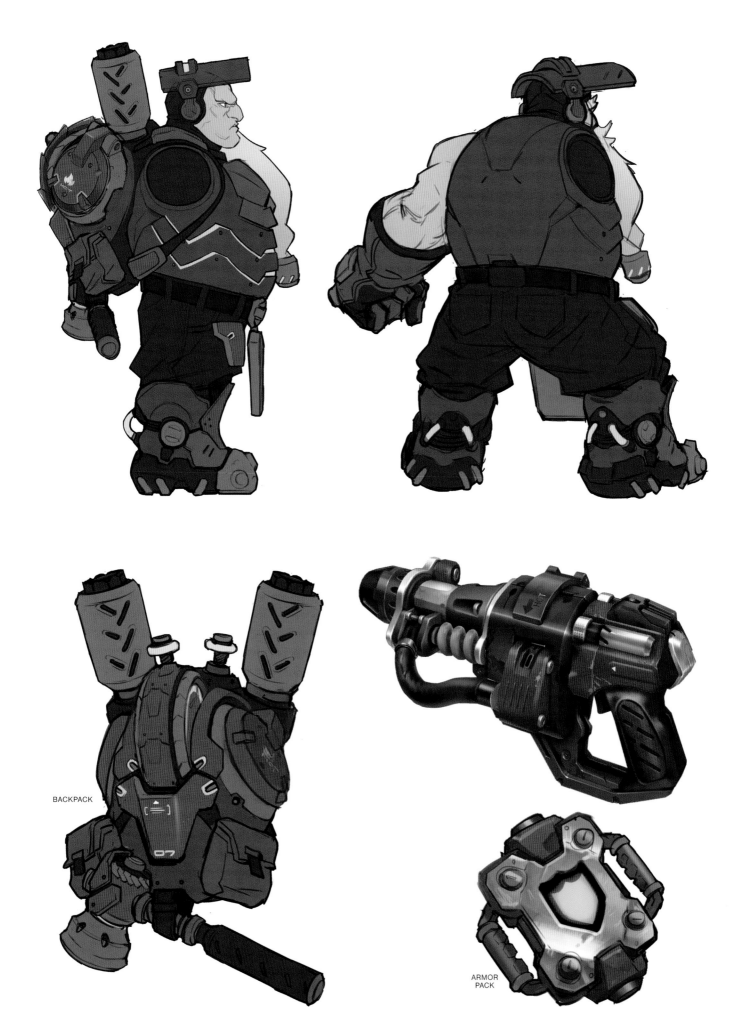

BACKPACK

ARMOR
PACK

ALL IMAGES: **ARNOLD TSANG**

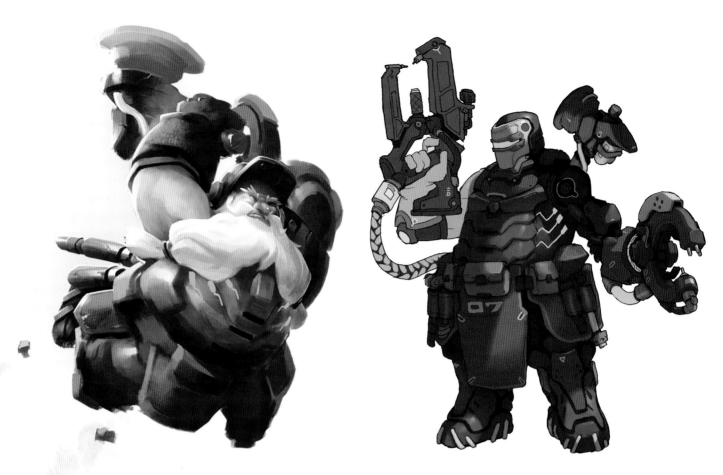

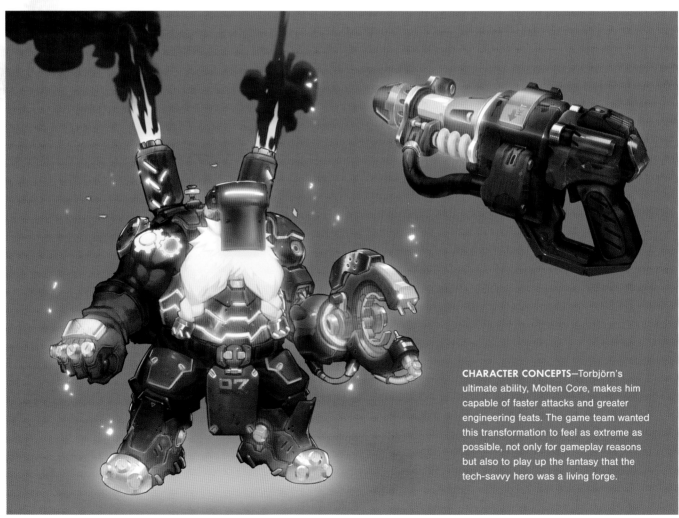

CHARACTER CONCEPTS—Torbjörn's ultimate ability, Molten Core, makes him capable of faster attacks and greater engineering feats. The game team wanted this transformation to feel as extreme as possible, not only for gameplay reasons but also to play up the fantasy that the tech-savvy hero was a living forge.

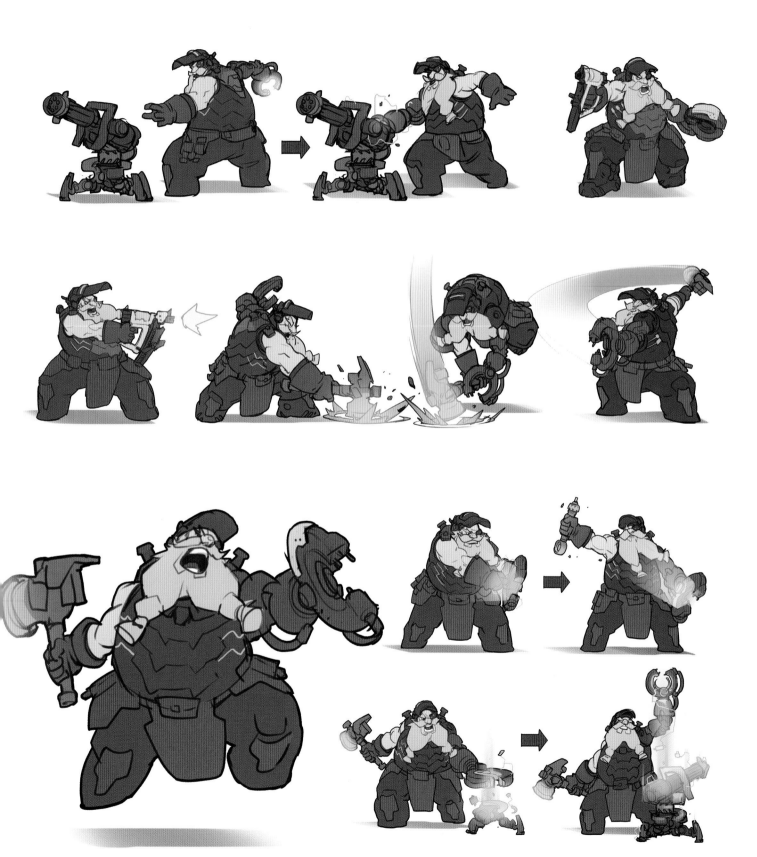

EARLY ABILITY IDEATION

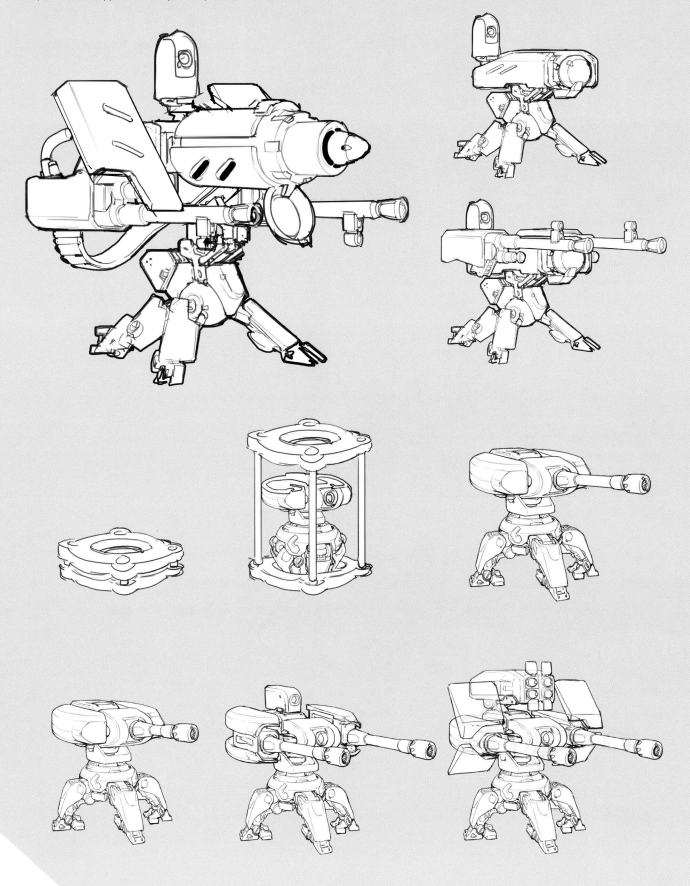

► **ABILITY CONCEPTS**—One of Torbjörn's early abilities was a trap (opposite page, bottom right) that could fire a chain that hooked onto enemy players and kept them within a certain radius of the device. Using it was the type of skill that people either loved or hated. In the end, the team scrapped the ability and replaced it with Armor Pack.

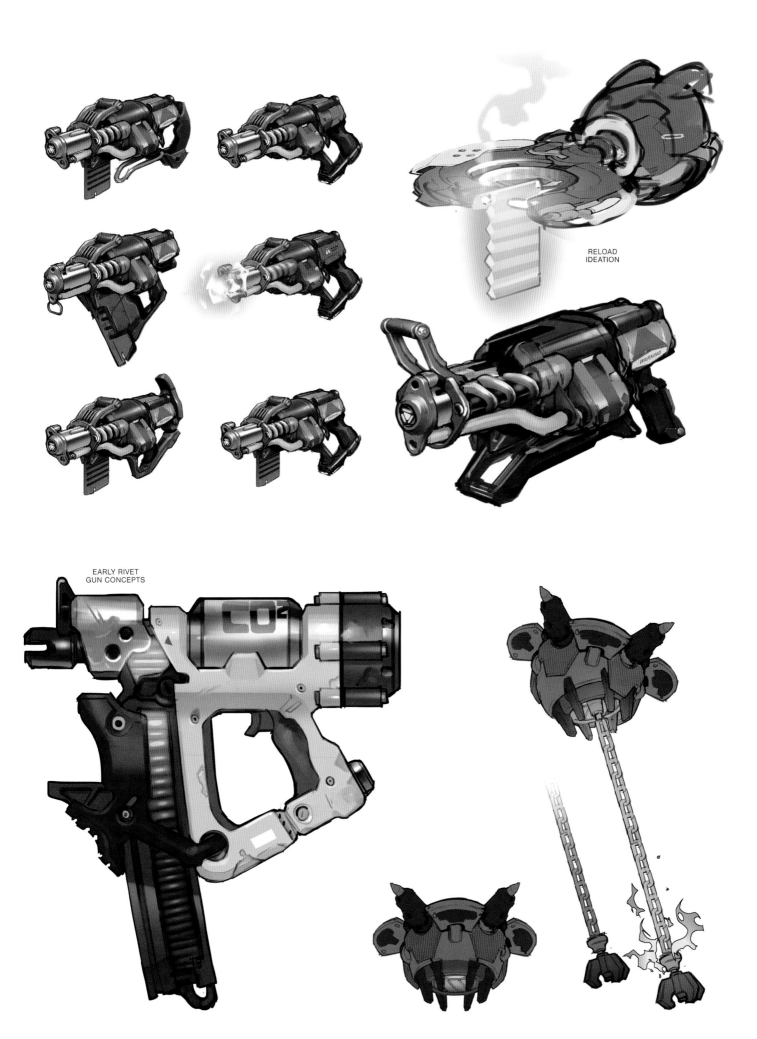

RELOAD
IDEATION

EARLY RIVET
GUN CONCEPTS

LOWER LEFT: **ARNOLD TSANG**, REMAINDER OF IMAGES: **BEN ZHANG**

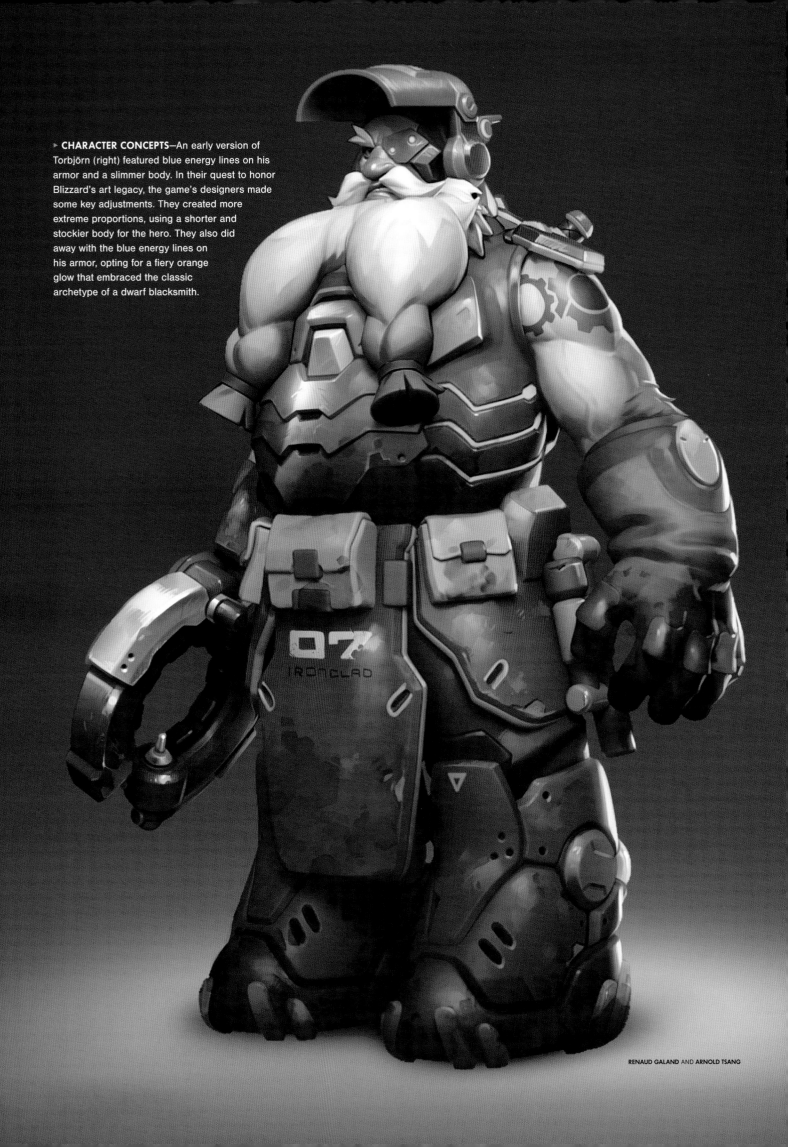

▶ **CHARACTER CONCEPTS**—An early version of Torbjörn (right) featured blue energy lines on his armor and a slimmer body. In their quest to honor Blizzard's art legacy, the game's designers made some key adjustments. They created more extreme proportions, using a shorter and stockier body for the hero. They also did away with the blue energy lines on his armor, opting for a fiery orange glow that embraced the classic archetype of a dwarf blacksmith.

RENAUD GALAND AND **ARNOLD TSANG**

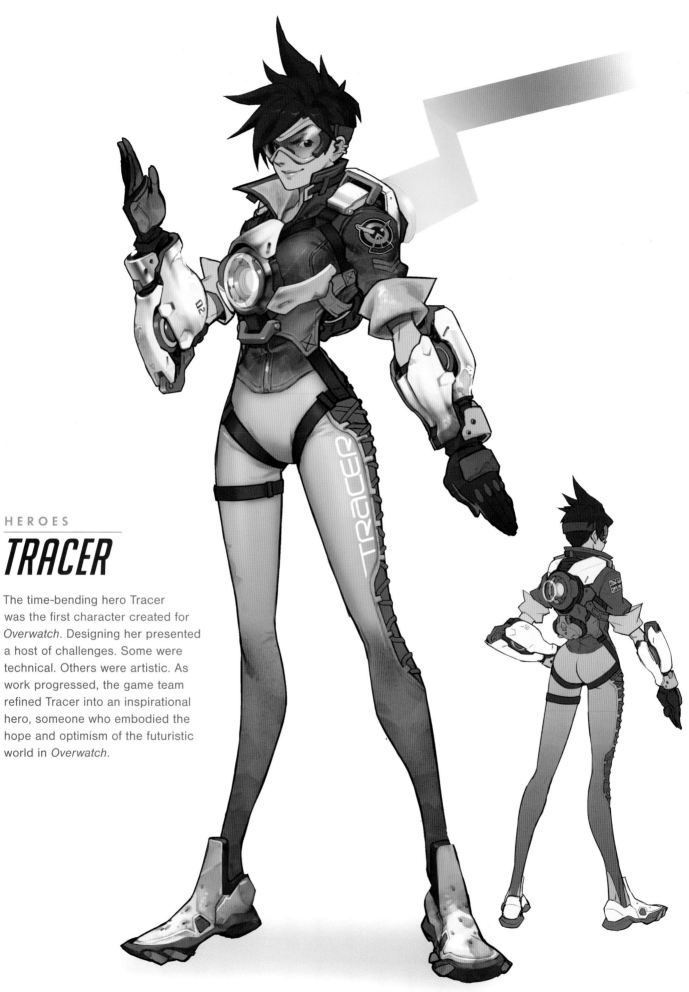

HEROES
TRACER

The time-bending hero Tracer
was the first character created for
Overwatch. Designing her presented
a host of challenges. Some were
technical. Others were artistic. As
work progressed, the game team
refined Tracer into an inspirational
hero, someone who embodied the
hope and optimism of the futuristic
world in *Overwatch*.

ALL IMAGES: **ARNOLD TSANG**

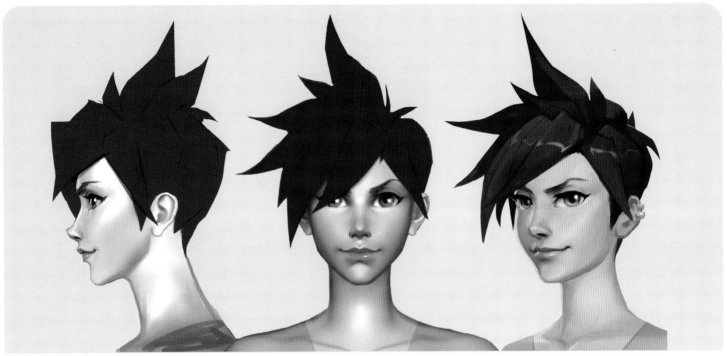

TRACER HEAD CONCEPTS

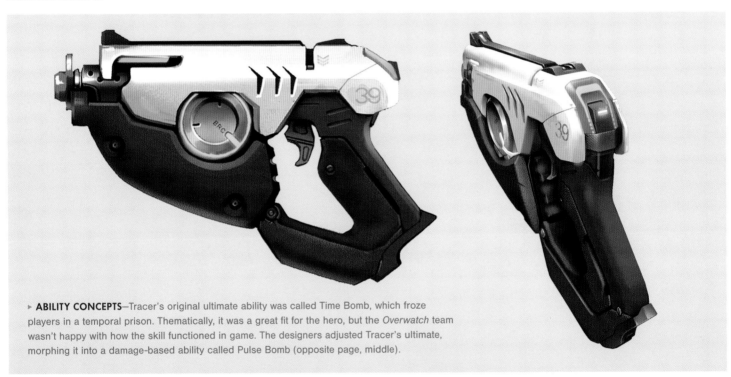

▶ **ABILITY CONCEPTS**—Tracer's original ultimate ability was called Time Bomb, which froze players in a temporal prison. Thematically, it was a great fit for the hero, but the *Overwatch* team wasn't happy with how the skill functioned in game. The designers adjusted Tracer's ultimate, morphing it into a damage-based ability called Pulse Bomb (opposite page, middle).

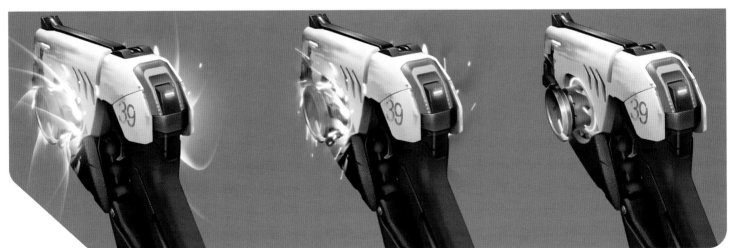

PULSE PISTOLS RELOAD VISUAL EFFECT

TOP: **ARNOLD TSANG**, MIDDLE: **ARNOLD TSANG** AND **BEN ZHANG**, BOTTOM: **BEN ZHANG**

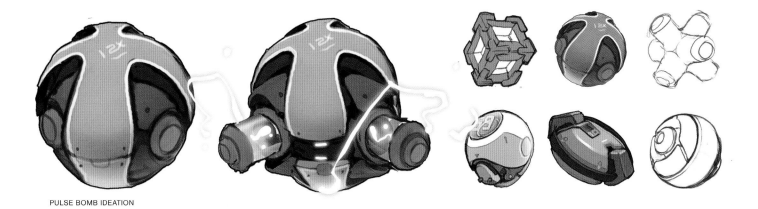

PULSE BOMB IDEATION

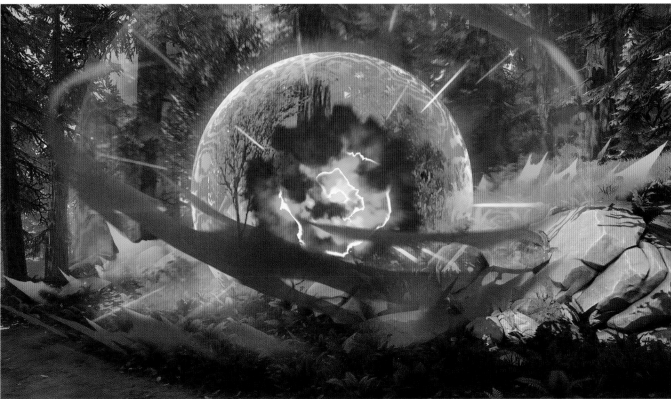

PULSE BOMB VISUAL EFFECT CONCEPT

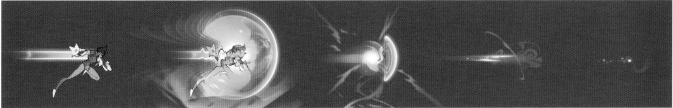

RECALL VISUAL EFFECT CONCEPT

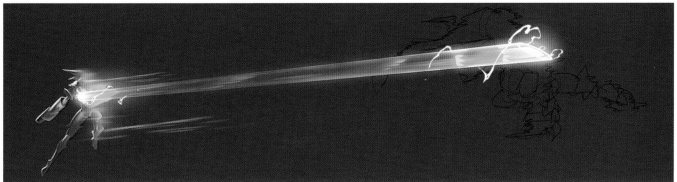

BLINK VISUAL EFFECT CONCEPT

TOP: **ARNOLD TSANG**, REMAINDER OF IMAGES: **BEN ZHANG**

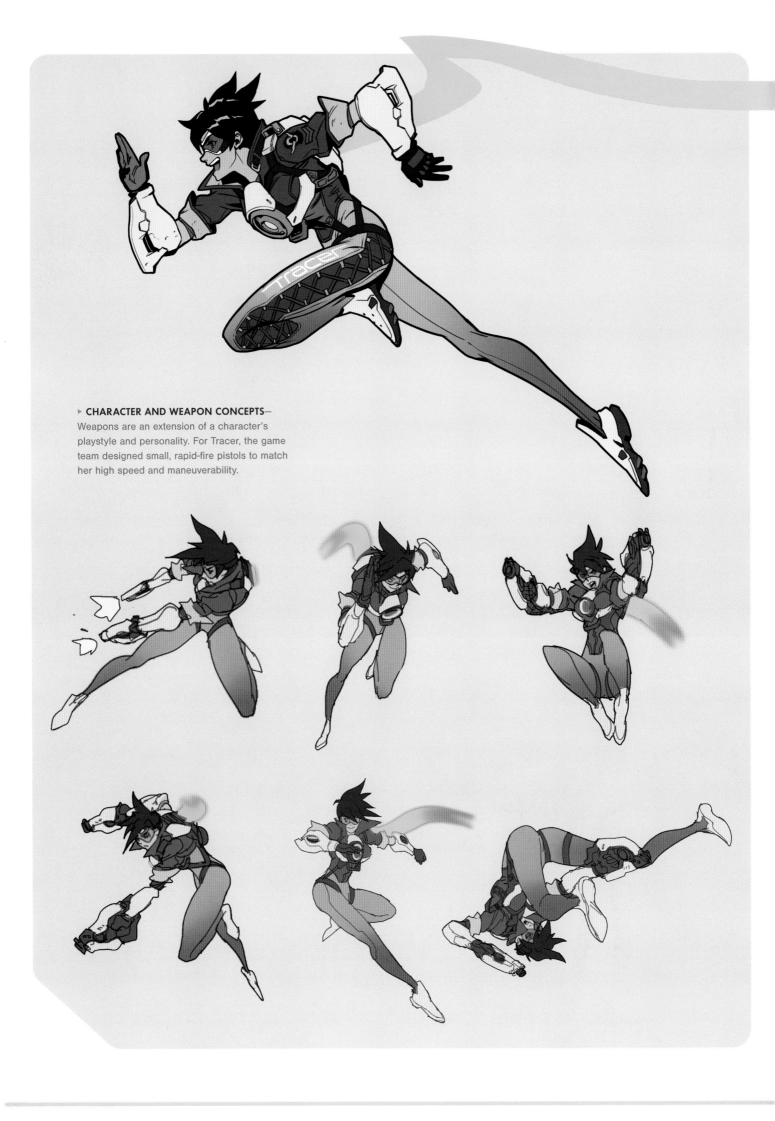

▸ **CHARACTER AND WEAPON CONCEPTS—**
Weapons are an extension of a character's playstyle and personality. For Tracer, the game team designed small, rapid-fire pistols to match her high speed and maneuverability.

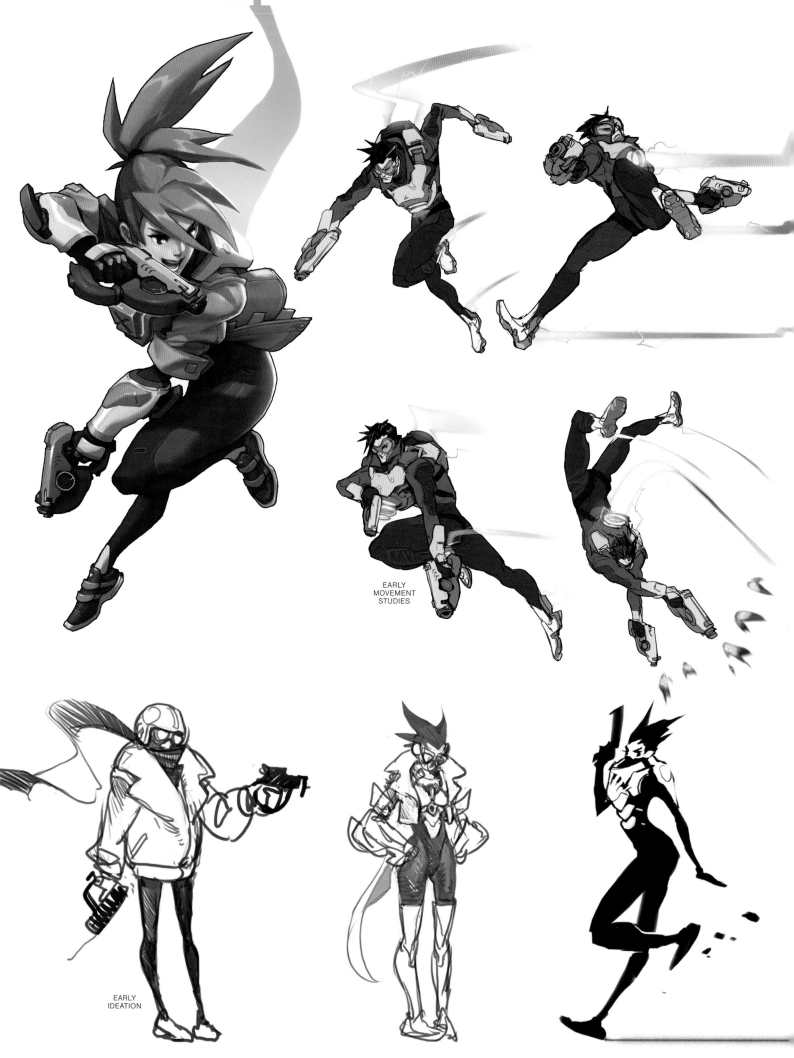

EARLY
MOVEMENT
STUDIES

EARLY
IDEATION

ALL IMAGES: **ARNOLD TSANG**

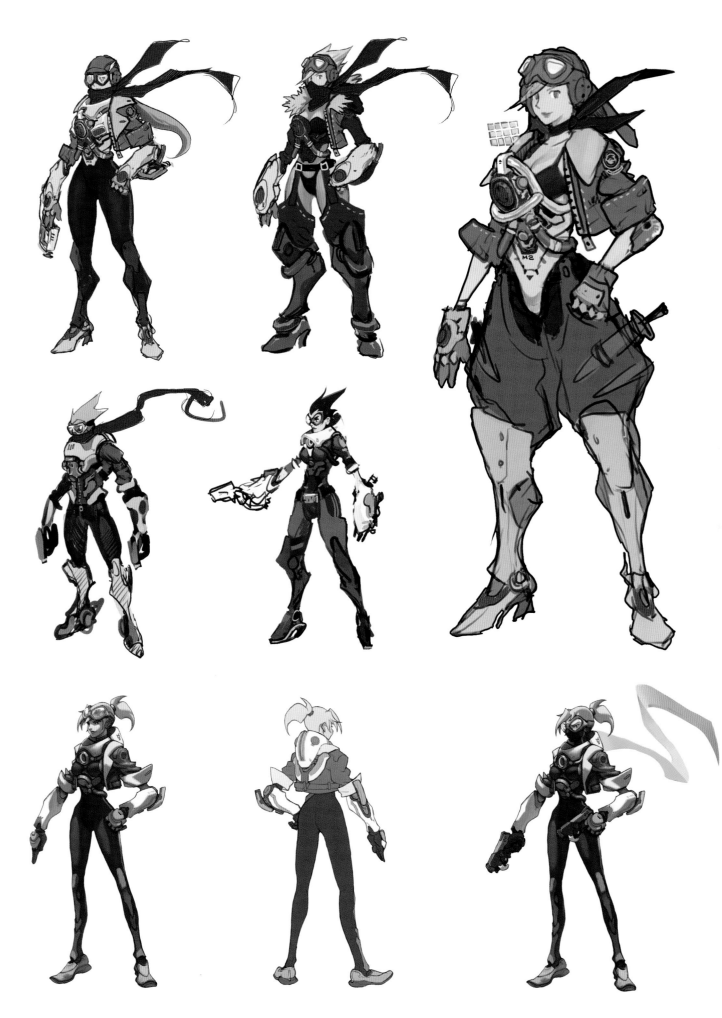

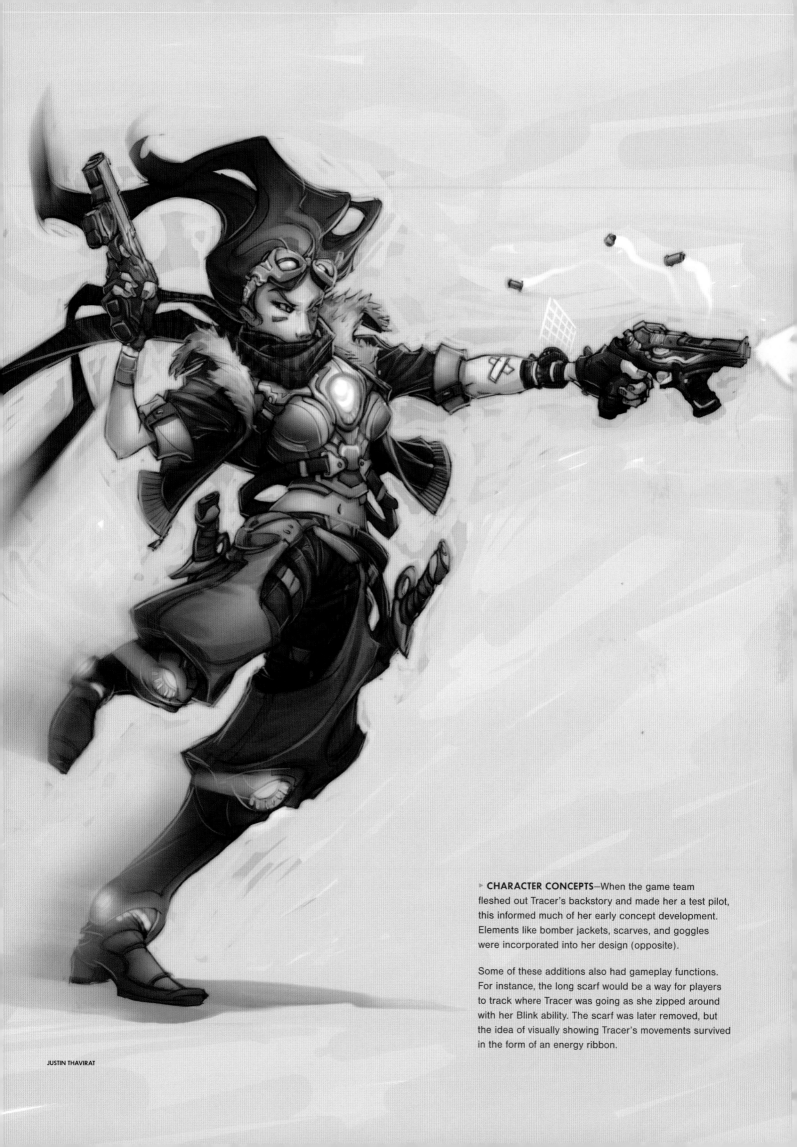

▶ **CHARACTER CONCEPTS**—When the game team fleshed out Tracer's backstory and made her a test pilot, this informed much of her early concept development. Elements like bomber jackets, scarves, and goggles were incorporated into her design (opposite).

Some of these additions also had gameplay functions. For instance, the long scarf would be a way for players to track where Tracer was going as she zipped around with her Blink ability. The scarf was later removed, but the idea of visually showing Tracer's movements survived in the form of an energy ribbon.

JUSTIN THAVIRAT

WIDOWMAKER

The *Overwatch* team always knew they would make a sniper character. The only unknown was what flavor that hero would be. A robot? A human? Someone good? Someone evil?

Drawing on inspiration from the iconic Warcraft character Sylvanas Windrunner, the team created a hero who occupied a darker end of the *Overwatch* spectrum. Her name was Widowmaker, a cold-blooded assassin whose emotions have been suppressed.

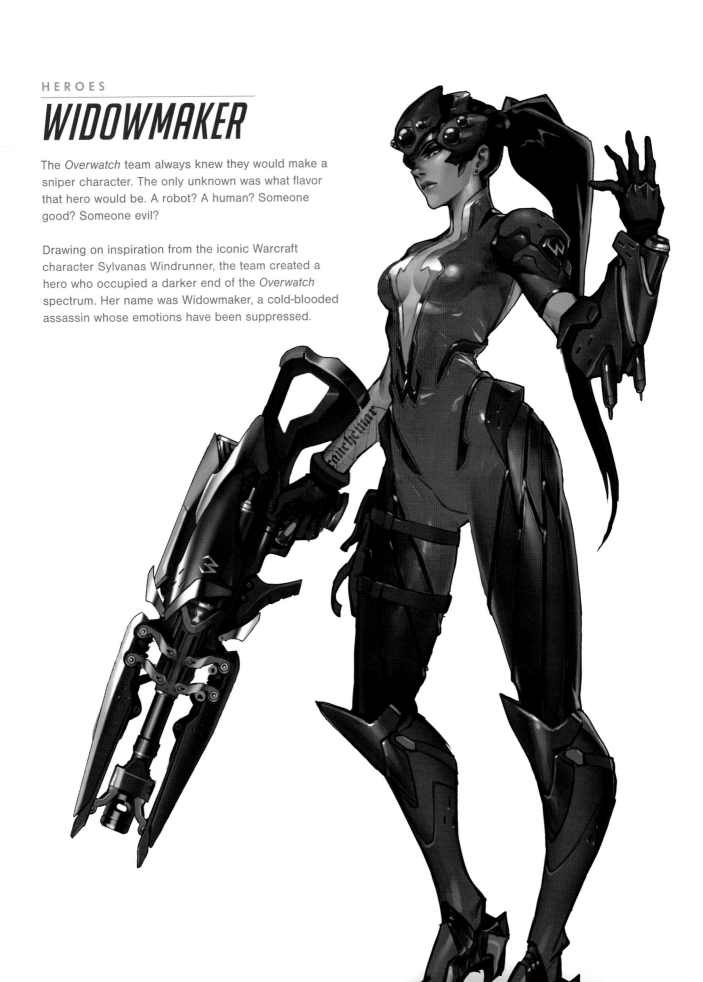

ALL IMAGES: **ARNOLD TSANG**

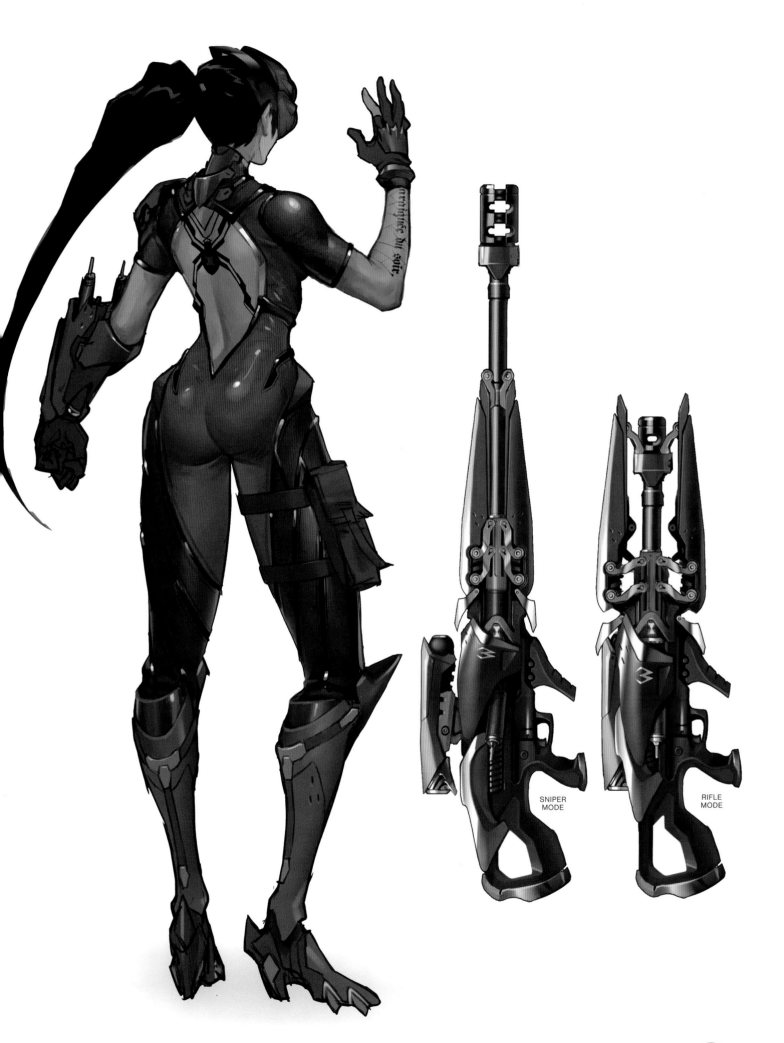

SNIPER
MODE

RIFLE
MODE

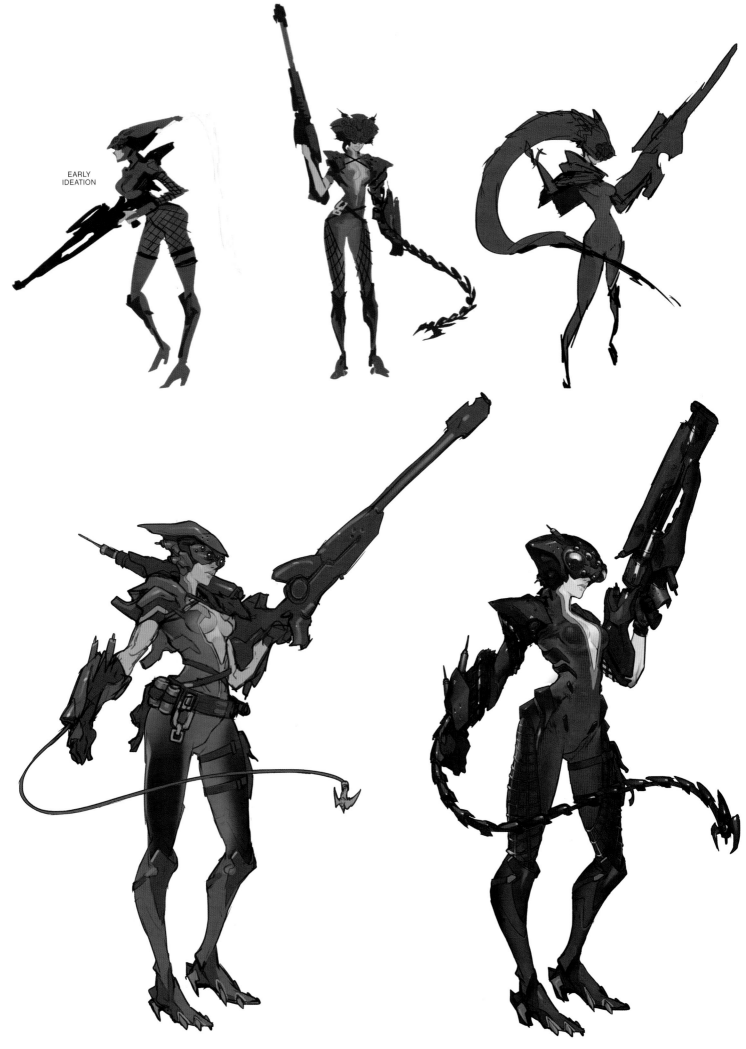

EARLY
IDEATION

▶ **CHARACTER CONCEPTS**—For Widowmaker, the game team wanted the hero to wear optic technology of some kind. Her early concept illustrations embraced this idea, depicting her with multiple red "bug eyes." The developers experimented with how prominent to make this feature (opposite page) before settling on a design that was both subtle and insect-like (below). The red eyepieces reminded the designers of a spider, and subsequent concepts incorporated other visual elements (such as the tattoo on the next spread) to emphasize the arachnid theme.

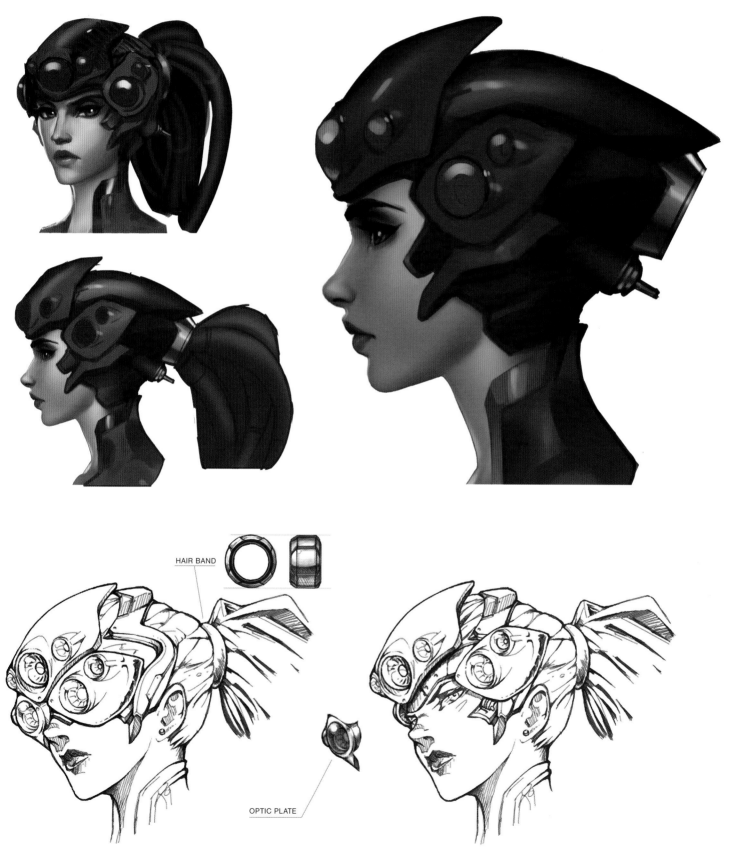

HAIR BAND

OPTIC PLATE

TOP: **ARNOLD TSANG**, BOTTOM: **ROMAN KENNEY**

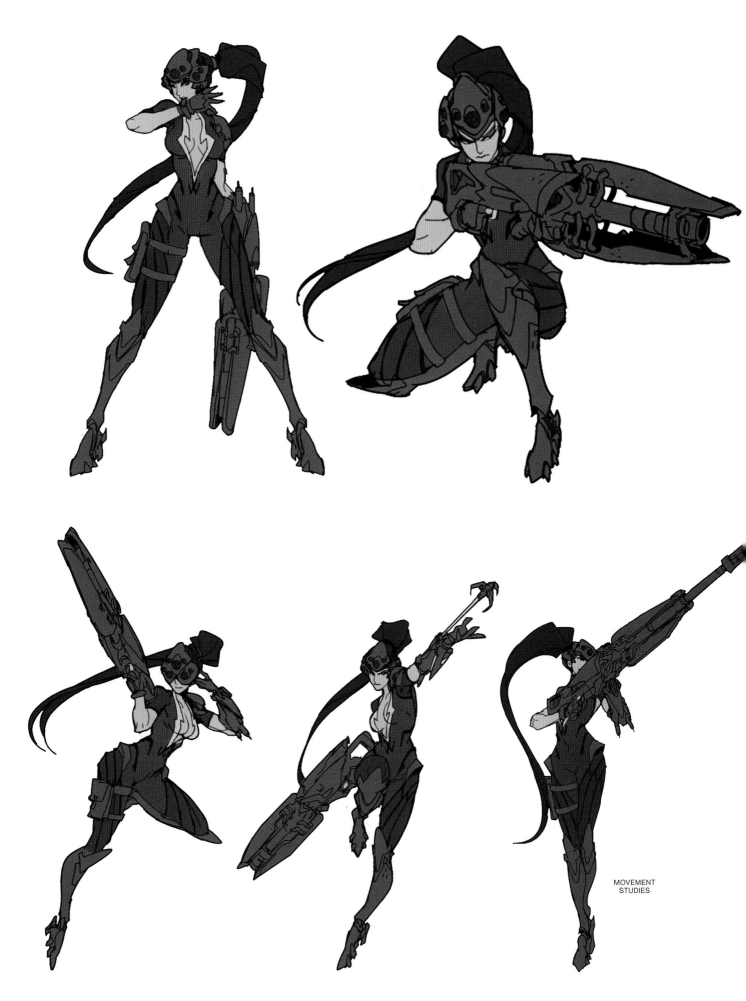

MOVEMENT
STUDIES

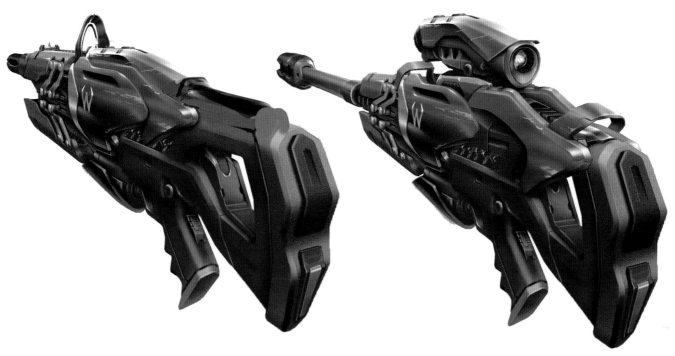

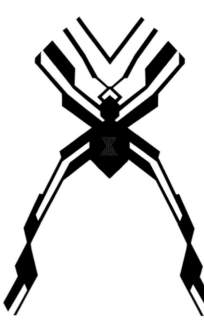

▶ **TATTOO DESIGN**—Widowmaker's arm tattoo is based on the second half of a French saying that translates as "evening spider, hope." The designers altered this phrase to "evening spider, nightmare" to better fit the hero's menacing nature.

LEFT GAUNTLET

GRAPPLING HOOK

TOP: **BEN ZHANG**, MIDDLE: **ARNOLD TSANG**, BOTTOM: **ROMAN KENNEY**

WINSTON

How far could the developers push the designs of *Overwatch*'s heroes? This was a question they asked themselves for a number of characters, but especially for the intelligent, genetically engineered gorilla Winston.

Creating Winston taught the team important lessons about their characters and world. It proved to the designers that they could make unique, non-human characters that would feel at home in *Overwatch* and represent its themes of heroism and a bright future.

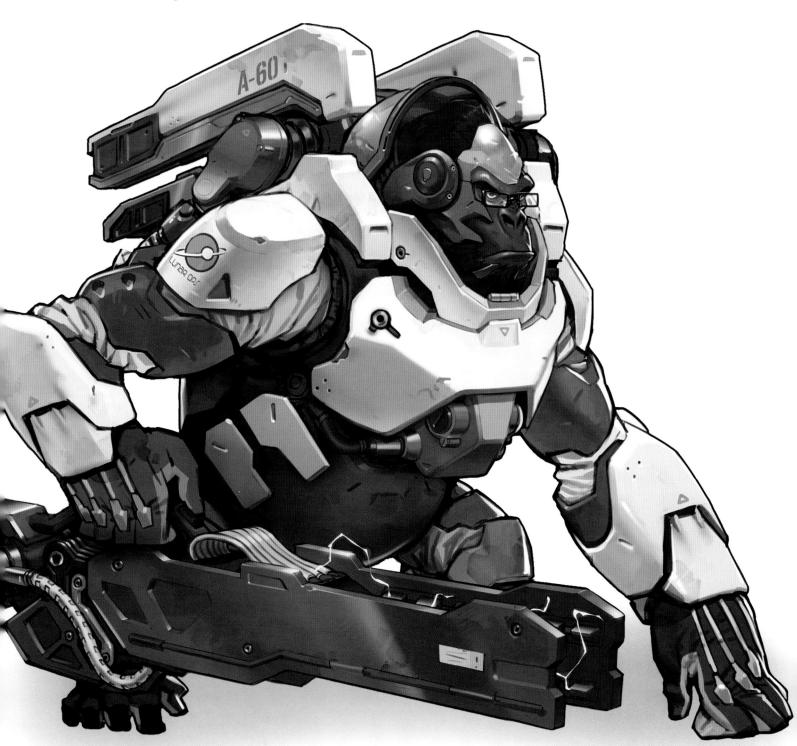

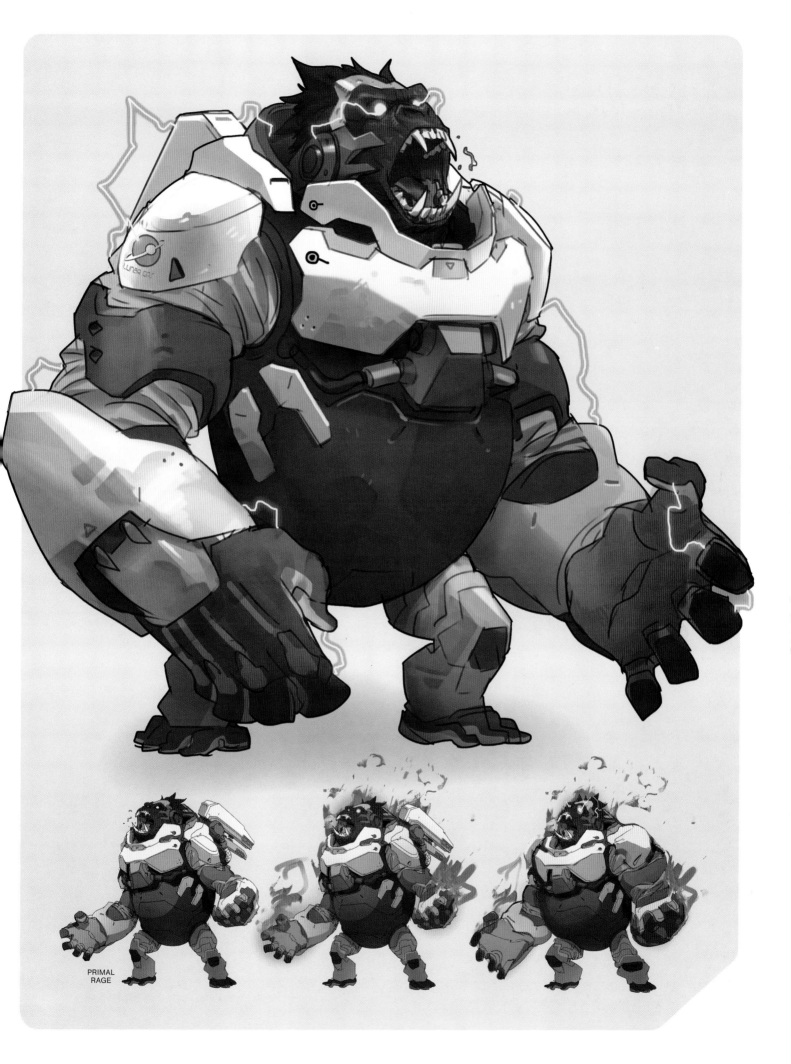

PRIMAL RAGE

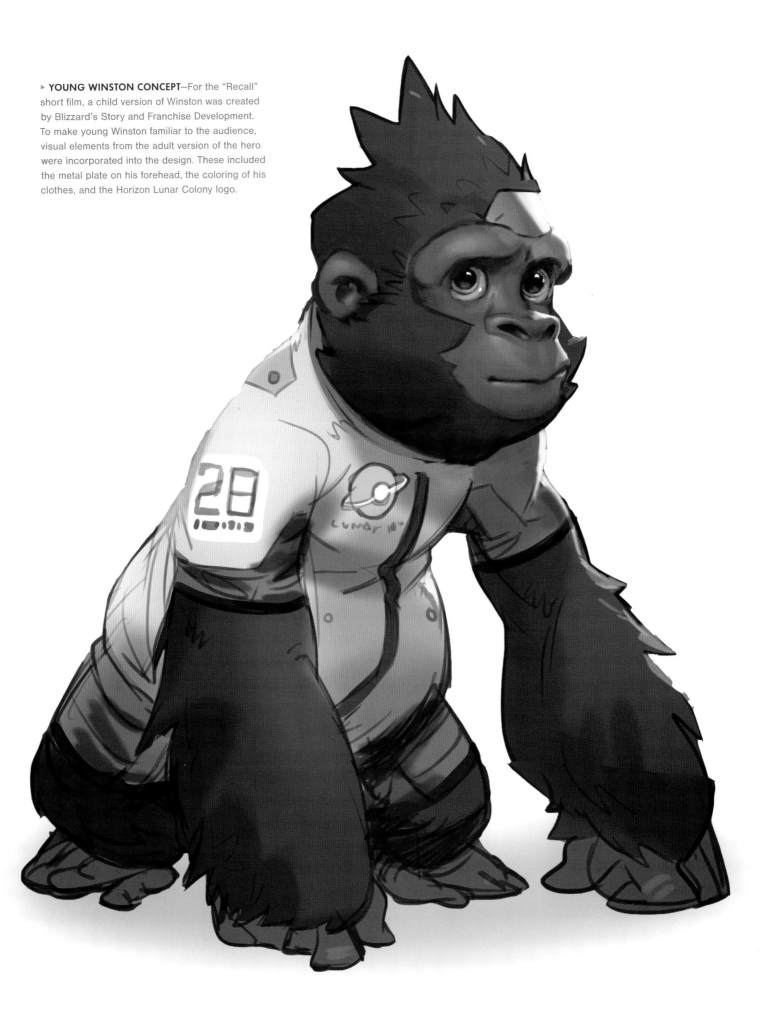

▶ **YOUNG WINSTON CONCEPT**—For the "Recall" short film, a child version of Winston was created by Blizzard's Story and Franchise Development. To make young Winston familiar to the audience, visual elements from the adult version of the hero were incorporated into the design. These included the metal plate on his forehead, the coloring of his clothes, and the Horizon Lunar Colony logo.

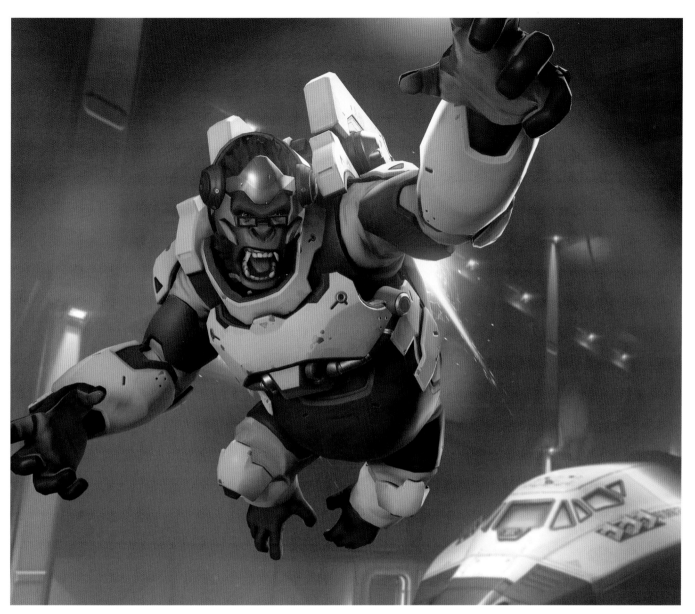

▶ **ANIMATION**—Winston was a difficult hero to animate due to his gorilla-like movements and the giant weapon he carries. Modifying the character for his ultimate ability, Primal Rage, also required meticulous design work. Rather than swap his model when the skill was used, the developers made Winston's body morph and stretch. Though this led to animation challenges, it created a seamless transition between his regular appearance and his Primal Rage form.

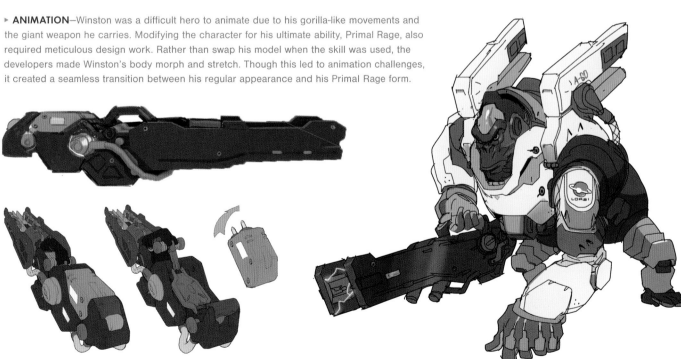

TOP: **MATT TAYLOR**, LOWER LEFT: **BEN ZHANG**, LOWER RIGHT: **ARNOLD TSANG**

HEROES
ZARYA

The team created concept art for Zarya, the celebrated Russian athlete and war hero, before determining her gameplay style.

From a visual standpoint, the developers wanted to make a physically strong female character. Zarya was inspired by weightlifters, and the sport heavily factored into her backstory and design. The tattoo on her shoulder—512—was included as a reference to her weightlifting world record, measured in kilograms.

LOW ENERGY BEAM

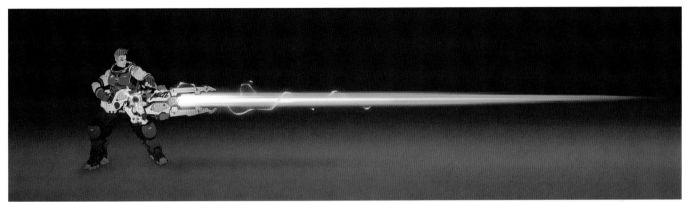

HIGH ENERGY BEAM

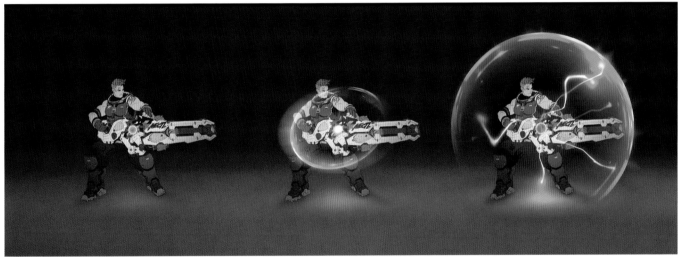

PARTICLE BARRIER

ПРОВОД

PARTICLE CANNON DECALS

ALL IMAGES: **ARNOLD TSANG**

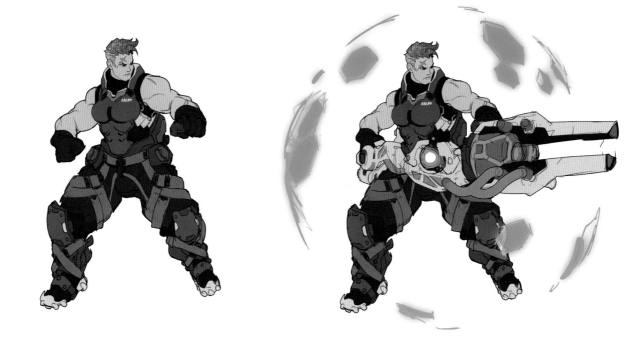

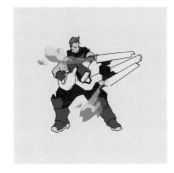

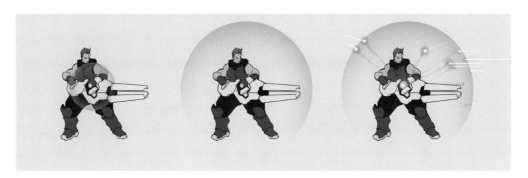

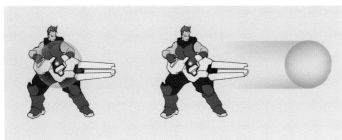

EARLY ABILITY STUDIES

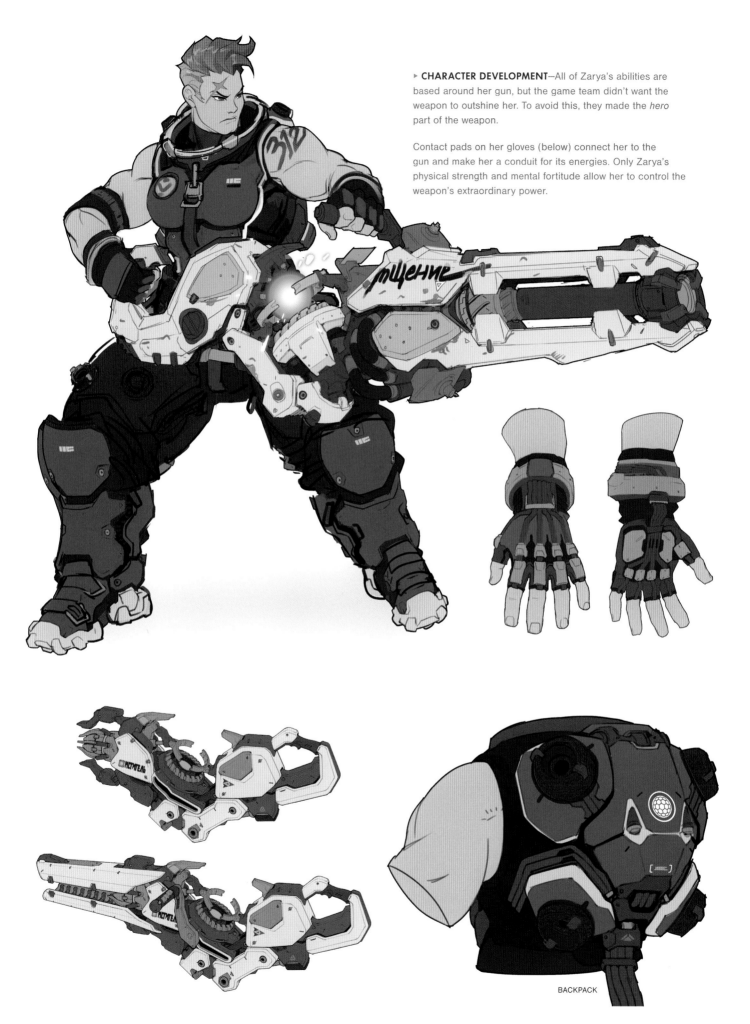

▶ **CHARACTER DEVELOPMENT**—All of Zarya's abilities are based around her gun, but the game team didn't want the weapon to outshine her. To avoid this, they made the *hero* part of the weapon.

Contact pads on her gloves (below) connect her to the gun and make her a conduit for its energies. Only Zarya's physical strength and mental fortitude allow her to control the weapon's extraordinary power.

BACKPACK

ALL IMAGES: **ARNOLD TSANG**

ZENYATTA

Like Zarya, Zenyatta was born purely from concept art. The designers originally had an idea to create a "cyber monk." Early concepts (next spread, left page) depicted him as a physically powerful omnic, but the game team felt this made the hero too much like existing characters.

In the next phase of concepts, Zenyatta transformed from a martial artist to an enlightened sage (opposite page, top). He was also given the ability to levitate, which set him apart from other heroes even more.

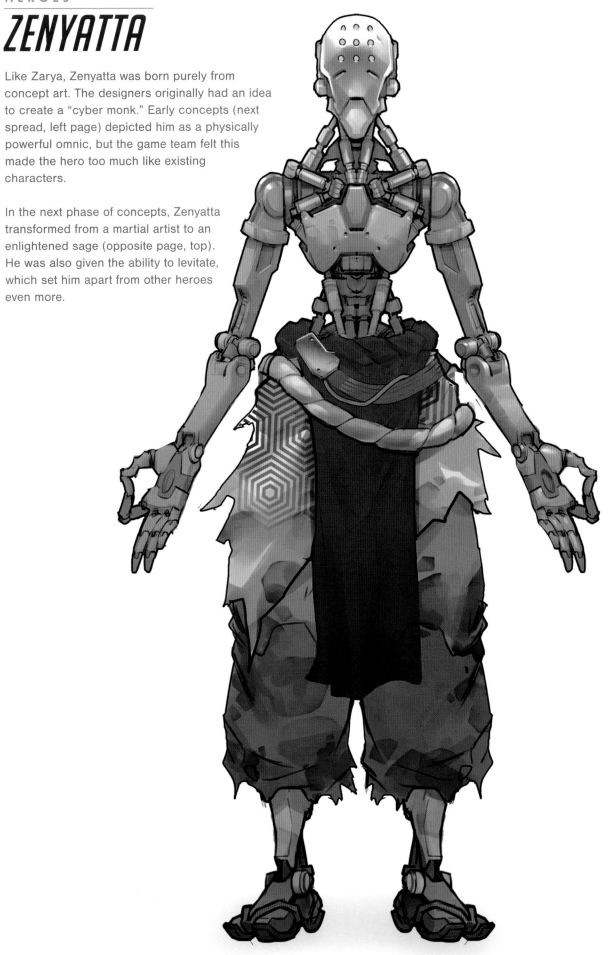

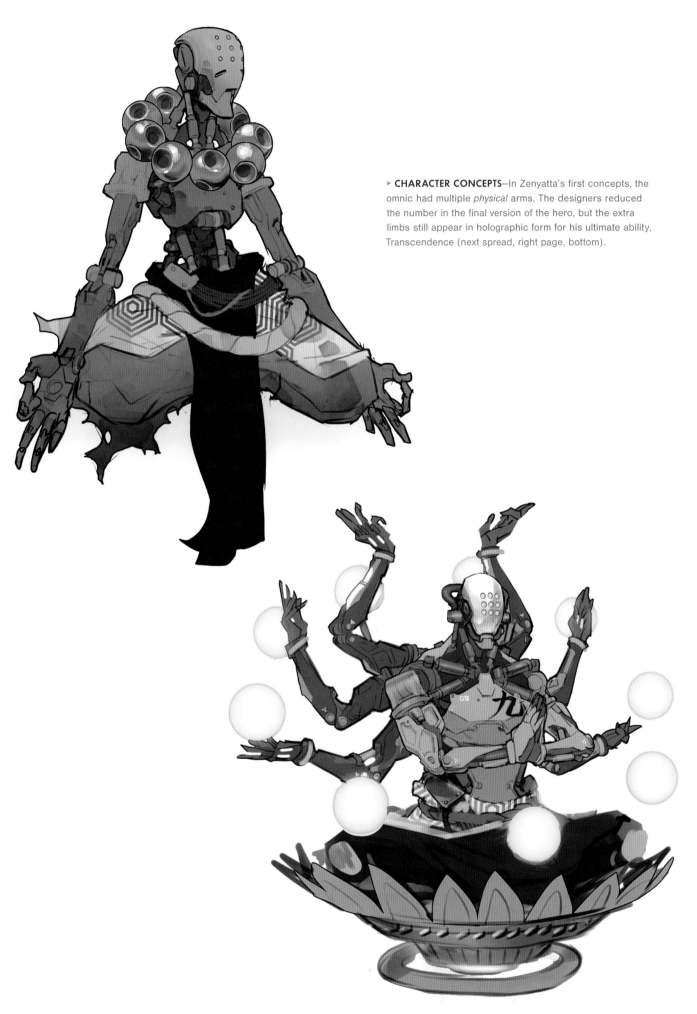

▶ **CHARACTER CONCEPTS**—In Zenyatta's first concepts, the omnic had multiple *physical* arms. The designers reduced the number in the final version of the hero, but the extra limbs still appear in holographic form for his ultimate ability, Transcendence (next spread, right page, bottom).

ALL IMAGES: **ARNOLD TSANG**

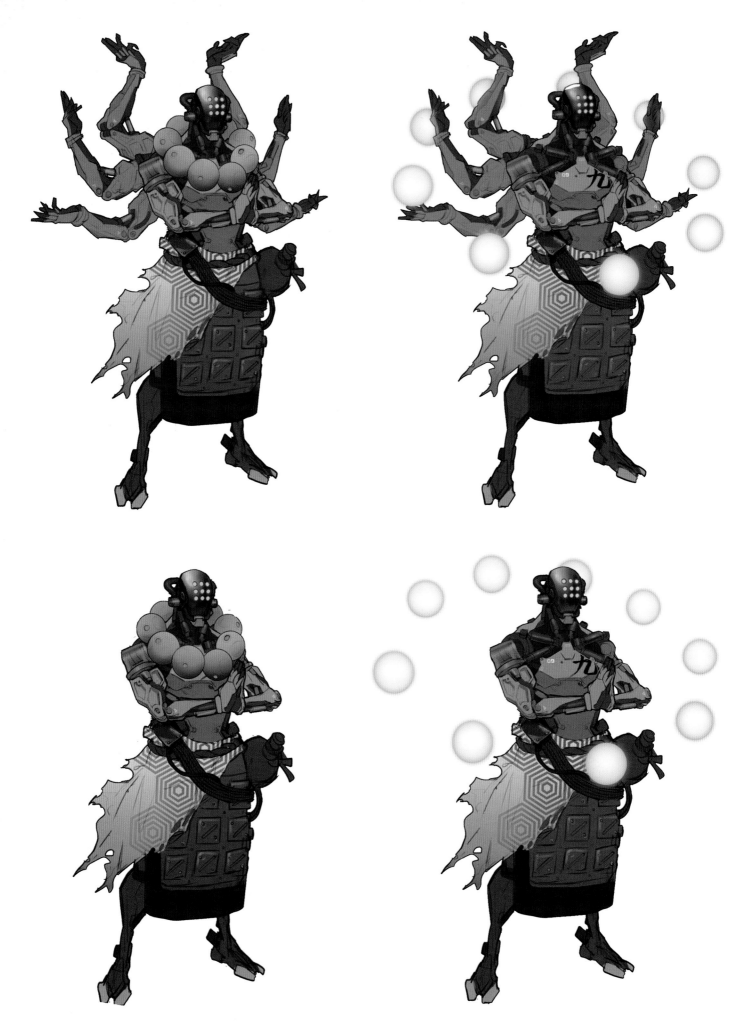

▶ **ABILITY CONCEPTS**—Zenyatta's orbs were initially physical objects that the hero would shoot. This led to several technical challenges, not the least of which was how to depict him reloading. The designers changed the ability so that the orbs would instead fire off spheres of energy. Concept art, like the images below, was important in helping the designers visualize how Zenyatta's attacks would work.

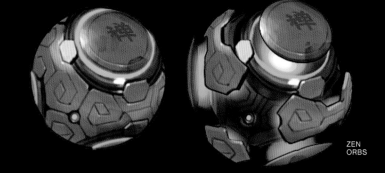

ZEN
ORBS

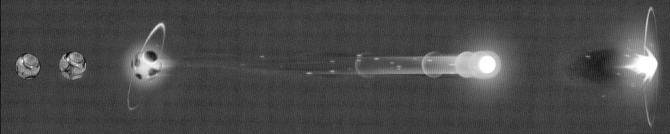

ORB OF DESTRUCTION

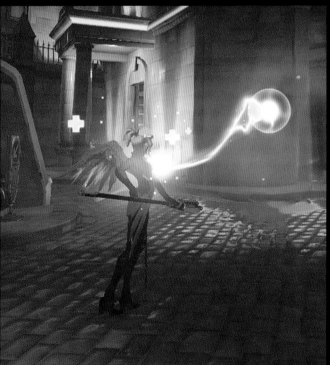

ORB OF HARMONY

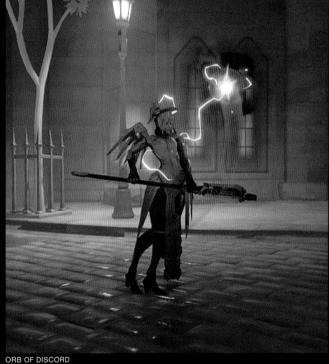

ORB OF DISCORD

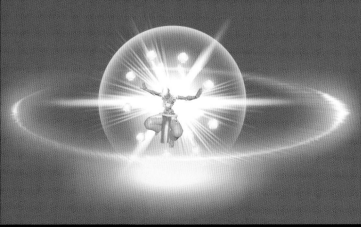

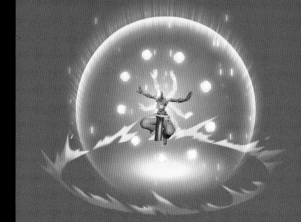

TRANSCENDENCE

MISCELLANEOUS

Along with creating playable heroes, the developers made omnics to populate the game's training mode and events like *Overwatch* Halloween Terror and Uprising. The same art guidelines for crafting heroes were applied to these designs.

Uprising gave the game team an opportunity to explore new types of omnics beyond Bastion and Zenyatta. The developers crafted an army of robots filled with different models that each had its own appearance and function (opposite page). This work also helped the team establish a hierarchy of omnics to draw from in the future.

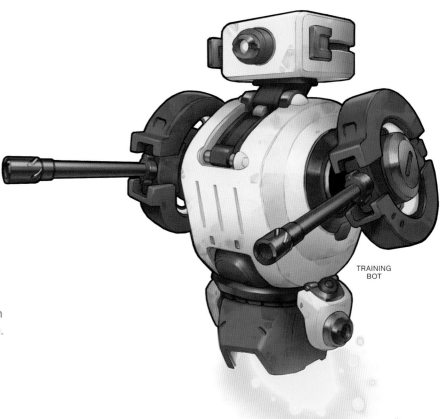

TRAINING BOT

HACK MODE

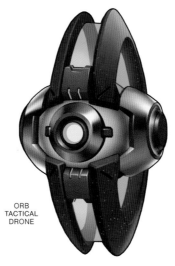

ORB TACTICAL DRONE

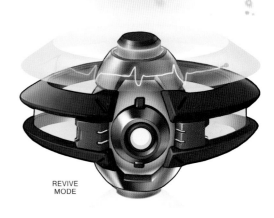

REVIVE MODE

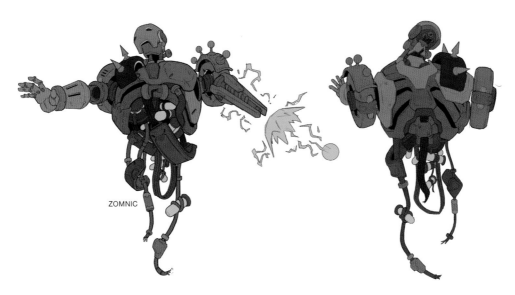

ZOMNIC

NULL SECTOR

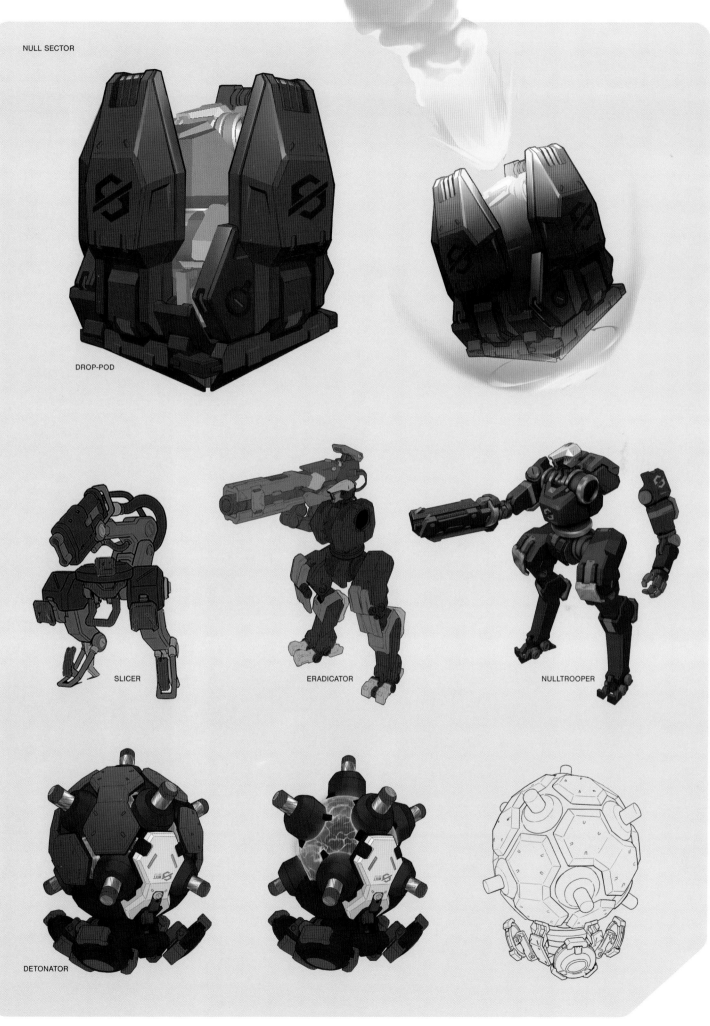

DROP-POD

SLICER

ERADICATOR

NULLTROOPER

DETONATOR

DAVID KANG AND **QIU FANG**

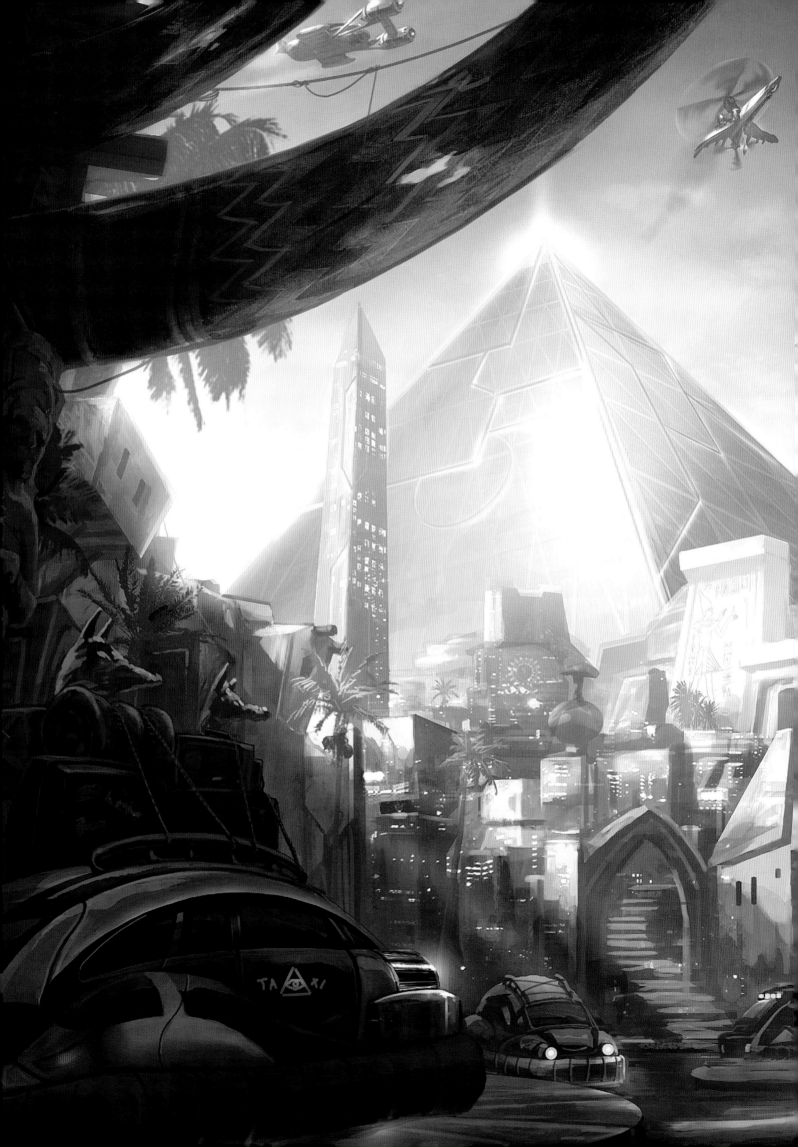

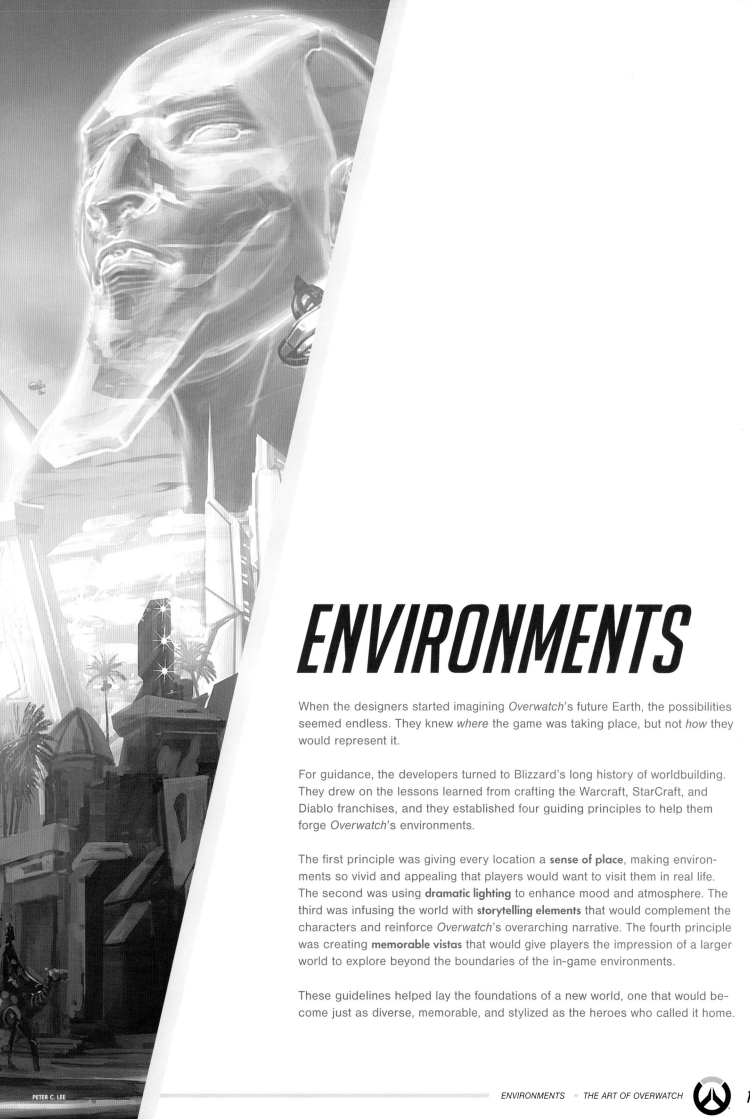

ENVIRONMENTS

When the designers started imagining *Overwatch*'s future Earth, the possibilities seemed endless. They knew *where* the game was taking place, but not *how* they would represent it.

For guidance, the developers turned to Blizzard's long history of worldbuilding. They drew on the lessons learned from crafting the Warcraft, StarCraft, and Diablo franchises, and they established four guiding principles to help them forge *Overwatch*'s environments.

The first principle was giving every location a **sense of place**, making environments so vivid and appealing that players would want to visit them in real life. The second was using **dramatic lighting** to enhance mood and atmosphere. The third was infusing the world with **storytelling elements** that would complement the characters and reinforce *Overwatch*'s overarching narrative. The fourth principle was creating **memorable vistas** that would give players the impression of a larger world to explore beyond the boundaries of the in-game environments.

These guidelines helped lay the foundations of a new world, one that would become just as diverse, memorable, and stylized as the heroes who called it home.

PETER C. LEE

DORADO

Light was an important theme in the charming Mexican city of Dorado. The developers staged the environment during the unveiling of a new power plant. This futuristic building, inspired by Aztec temples, was positioned atop a slope so that players could see it from nearly any point in the area. Other stations were placed along the coastline, giving the impression that they formed a vast power grid.

The designers showed Dorado at night to emphasize the environment's overall theme, and they created the vibrant Festival de la Luz—"Festival of Light"—in the central courtyard (opposite page, middle row). The intensity of light throughout the map was just as bright as day, a decision that made the location's warm reds and golds stand out. Even the sky was colored blue rather than black to enhance this effect.

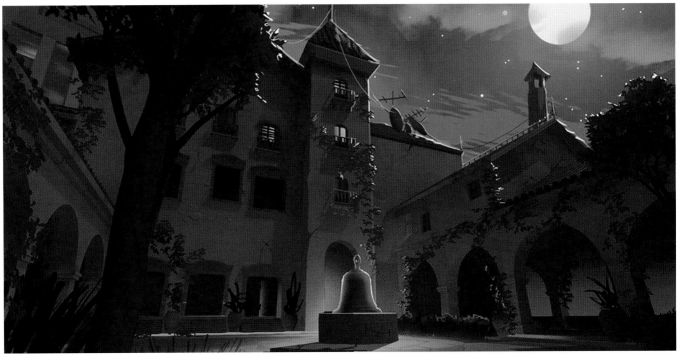

MISIÓN DORADO

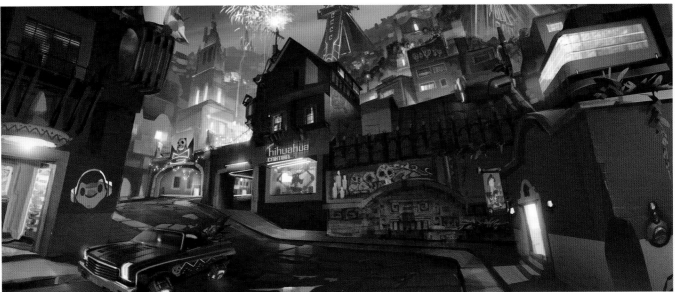

DORADO EARLY IDEATION

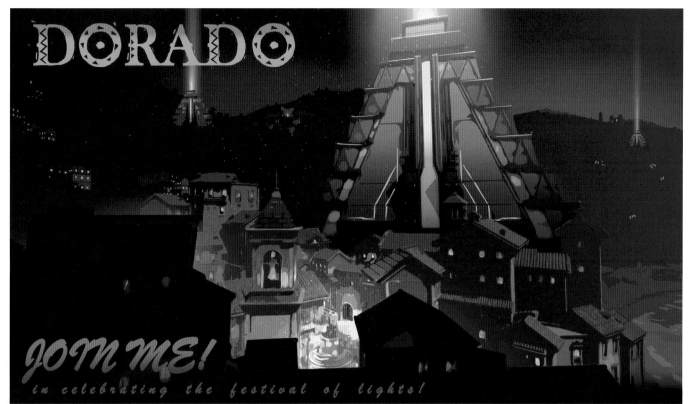

DORADO

JOIN ME!
in celebrating the festival of lights!

POSTCARD

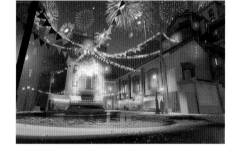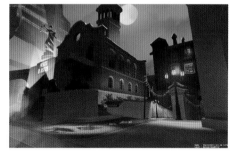

COLOR KEYS

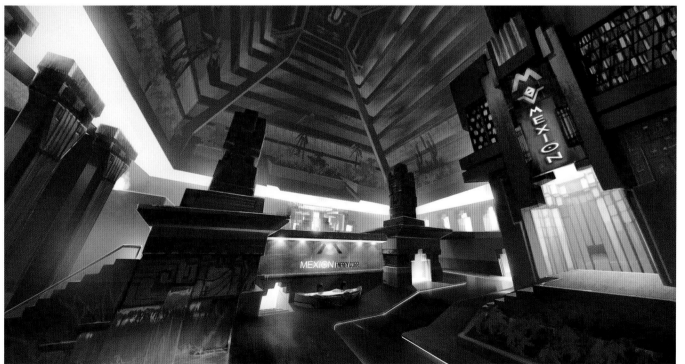

LUMÉRICO ZIGGURAT INTERIOR

TOP: **DAVID KANG**, MIDDLE: **NICK CARVER**, BOTTOM: **BEN ZHANG**

LUMÉRICO LOGO IDEATION

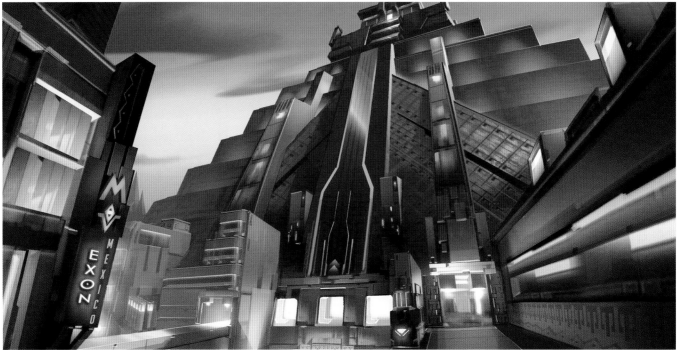

LUMÉRICO ZIGGURAT EXTERIOR

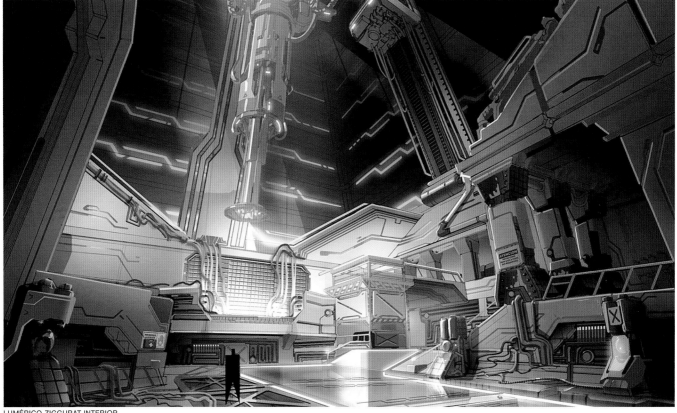

LUMÉRICO ZIGGURAT INTERIOR

TOP: **DAVID KANG**, MIDDLE: **BEN ZHANG**, BOTTOM: **NICK CARVER**

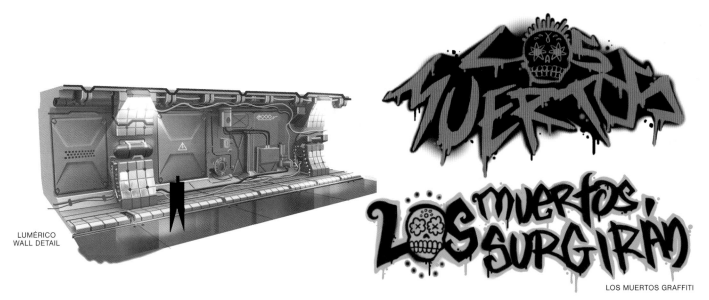

LUMÉRICO
WALL DETAIL

LOS MUERTOS GRAFFITI

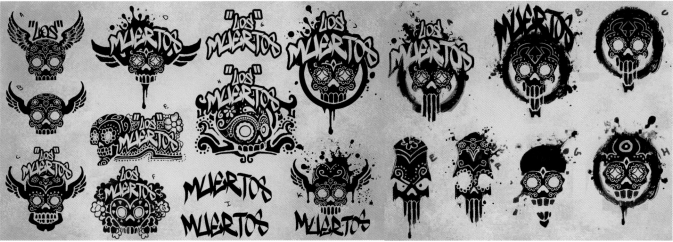

LOS MUERTOS GRAFFITI

BANCO DE DORADO INTERIOR

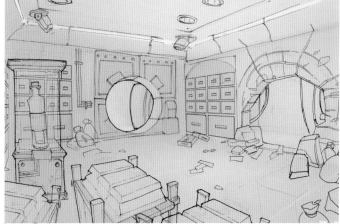

BANCO DE DORADO VAULT

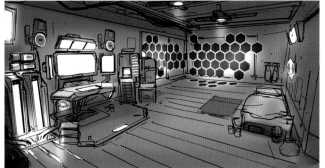

SOMBRA'S HIDEOUT, CASTILLO

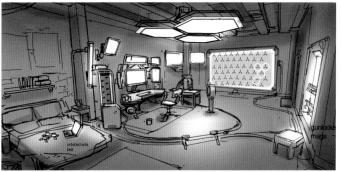

SOMBRA'S HIDEOUT, CASTILLO

TOP LEFT: **NICK CARVER**, TOP RIGHT: **DAVID KANG**, TOP MIDDLE: **AQUATIC MOON**, BOTTOM MIDDLE: **GABRIEL GONZALEZ**, BOTTOM: **AL CRUTCHLEY**

ECOPOINT: ANTARCTICA

Ecopoint: Antarctica was staged in an abandoned scientific outpost blanketed in snow and ice. Making the environment feel right was a challenge, but the developers had an advantage. Ecopoint: Antarctica was smaller than *Overwatch*'s other maps, which meant the team could focus more resources on effects. The developers stylized the surroundings to immerse players in the frozen setting, such as making the snow sparkle even when it was not in direct sunlight.

Though creating a cold and desolate location was a major goal, the team also wanted to tell a story there. The hero

Mei had once lived in the outpost as part of a scientific research team. Hints of her former presence were scattered throughout the map in the form of handwritten notes and abandoned belongings (opposite page). Together, these elements conveyed that Mei had been trapped in the outpost and had used her wits to escape.

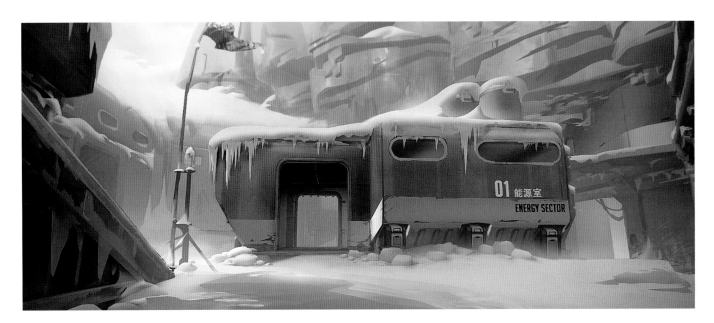

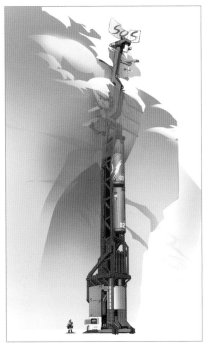

COMMUNICATIONS TOWER

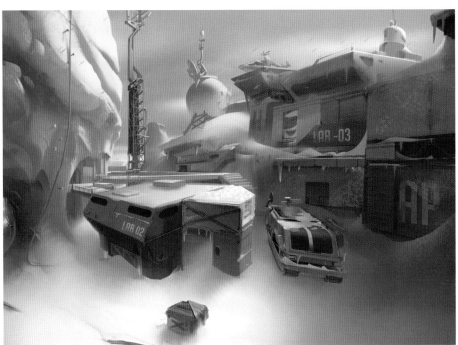

ALL IMAGES: BEN ZHANG

MEI'S BELONGINGS

MEI'S JOURNAL

ALL IMAGES: **ANH DANG**

SNOWBALL DOCKING STATIONS

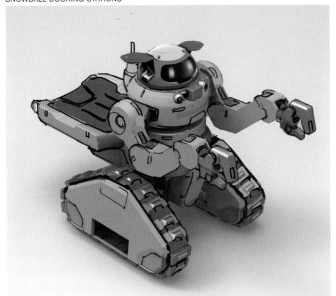

DOCK

CLOSED

UNIT 05

OPEN

UNIT 05

BOTTOM RIGHT: **OSCAR CAFARO**, REMAINDER OF IMAGES: **AL CRUTCHLEY**

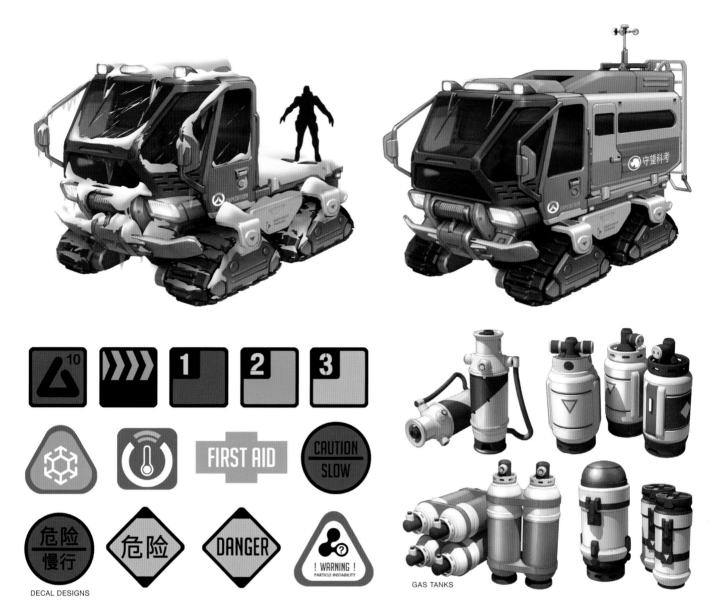

危险
慢行

危险

DANGER

! WARNING !
PARTICLE INSTABILITY

DECAL DESIGNS

守望科考

GAS TANKS

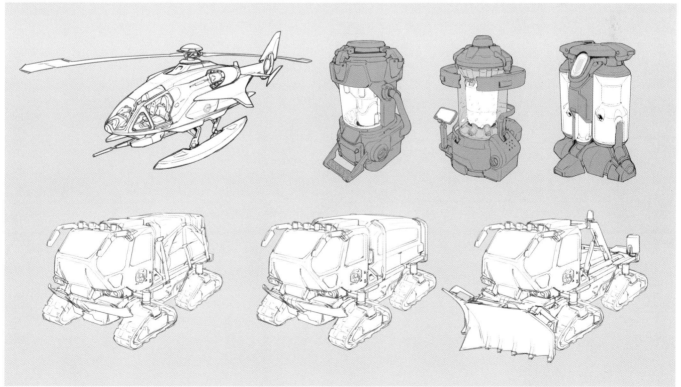

MIDDLE RIGHT: **OSCAR CAFARO**, REMAINDER OF IMAGES: **BEN ZHANG**

ENVIRONMENTS
EICHENWALDE

Early in development, the *Overwatch* team had ideas for two different maps. One was a lush, bright green environment that wasn't in a bustling city. The other was a location centered around a classic castle. The team merged these ideas into Eichenwalde: an old German castle and village overgrown with plant life.

Eichenwalde was the site of a major battle between humans and omnics, and the designers wanted it to feel as if it had suddenly been abandoned. They accomplished this

by filling the environment with damaged buildings and destroyed war machines. Props like furniture and paintings were strategically placed throughout Eichenwalde to give a sense of history and convey that people had once lived there (next spread).

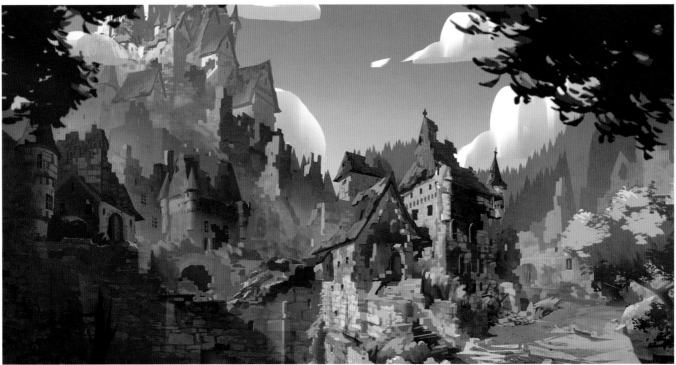

EICHENWALDE CASTLE

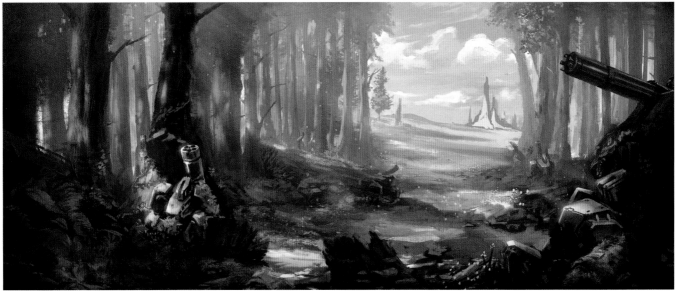

BLACK FOREST

TOP: **ANH DANG**, MIDDLE: **NICK CARVER**, BOTTOM: **PETER C. LEE**

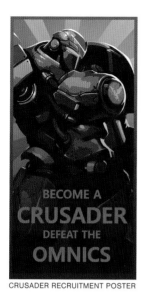

BECOME A
CRUSADER
DEFEAT THE
OMNICS

CRUSADER RECRUITMENT POSTER

BANNER

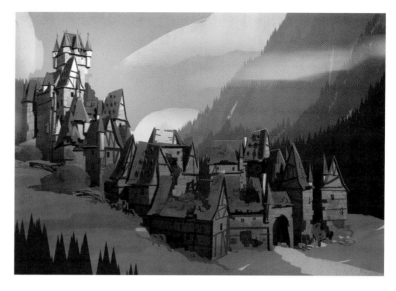

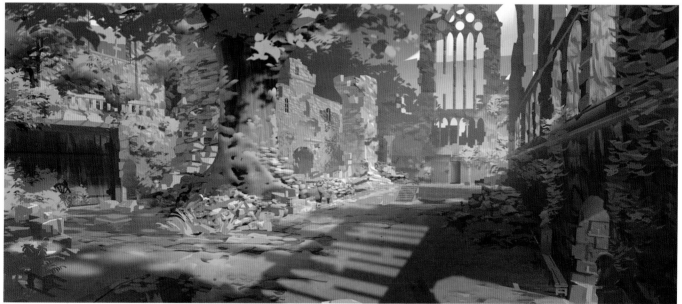

COURTYARD

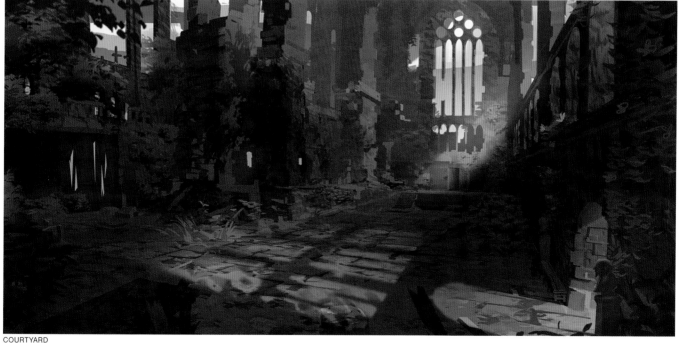

COURTYARD

TOP LEFT: **DION ROGERS**, REMAINDER OF IMAGES: **NICK CARVER**

BRAUEREI MITTAGSKRUG PROPS

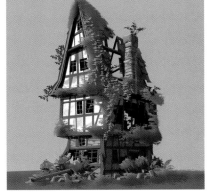

TOWNHOUSE

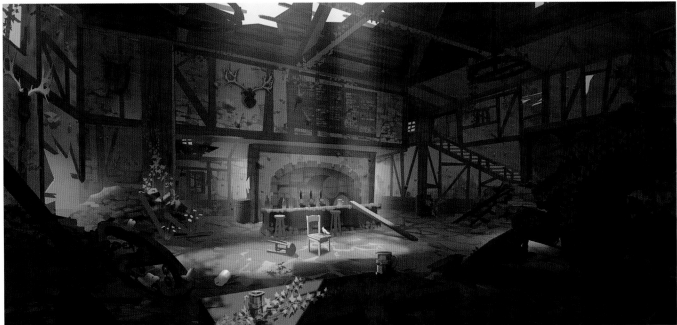

BRAUEREI MITTAGSKRUG INTERIOR

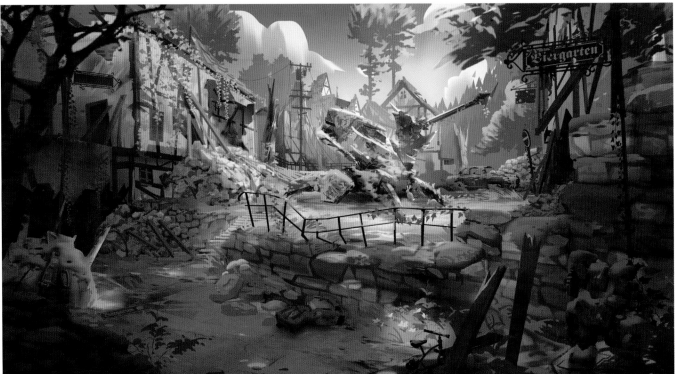

EICHENWALDE VILLAGE

ALL IMAGES: **NICK CARVER**

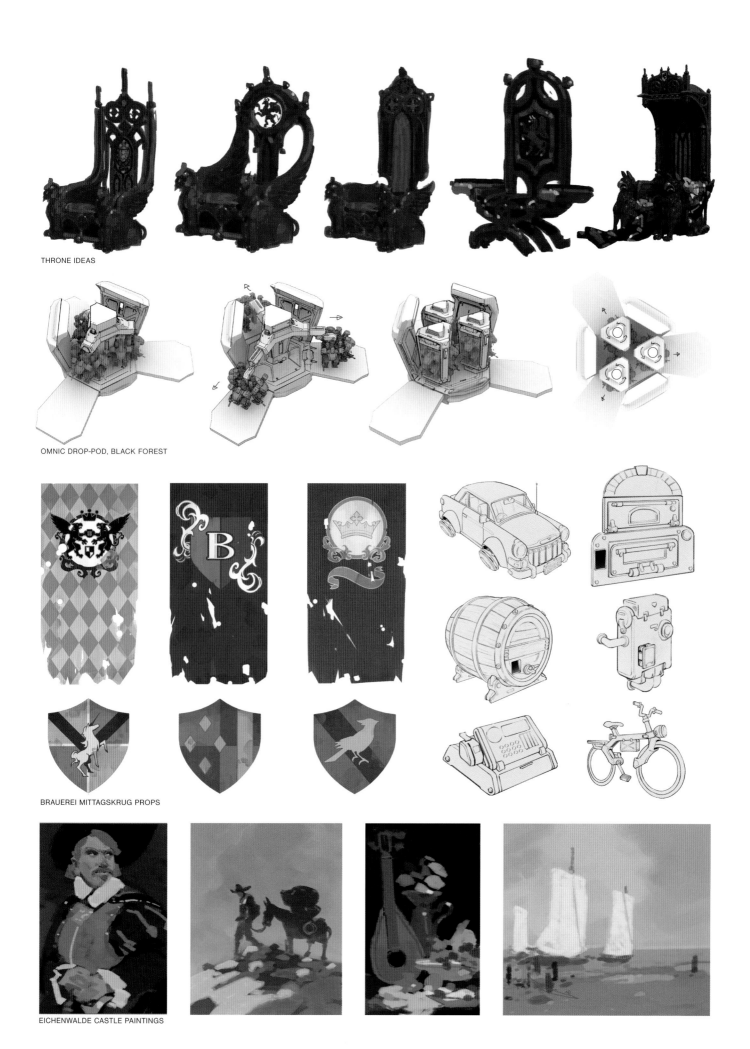

THRONE IDEAS

OMNIC DROP-POD, BLACK FOREST

BRAUEREI MITTAGSKRUG PROPS

EICHENWALDE CASTLE PAINTINGS

TOP AND BOTTOM: **VASILI ZORIN**, MIDDLE TOP: **AL CRUTCHLEY**, MIDDLE BOTTOM LEFT: **ANH DANG**, MIDDLE BOTTOM RIGHT: **DAVID KANG**

HANAMURA

The *Overwatch* team sought to create a mix of old and new for every map, a blend of the past and the future. Hanamura was a prime example of this philosophy. The designers crafted this environment by fusing elements of traditional Japanese architecture with arcades and other modern pop culture motifs (next spread). These contrasting designs also tied into the map's layout. The designers made each area of Hanamura visually distinct, from high-tech streets at one end of the city to the castle courtyard filled with bright pink cherry blossoms.

The cherry blossoms were an important part of Hanamura's overall visual design and theme. Apart from being iconic to Japan, the trees acted as a secondary accent color for the entire environment. To push this effect even more, the developers made the cherry blossoms emit pink light.

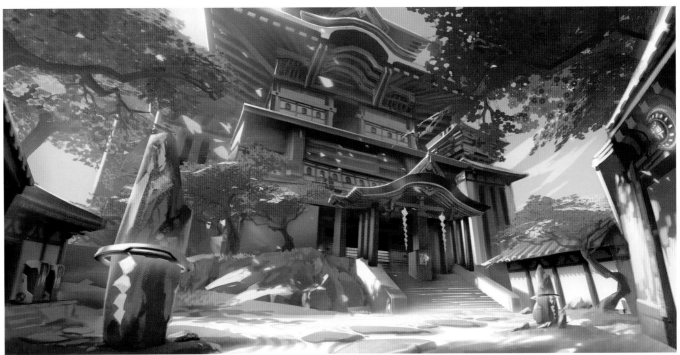

HANAMURA TEMPLE

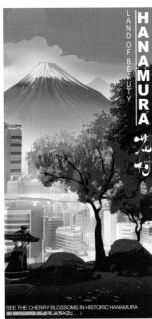

LAND OF BEAUTY

HANAMURA 光村

SEE THE CHERRY BLOSSOMS IN HISTORIC HANAMURA

POSTCARD

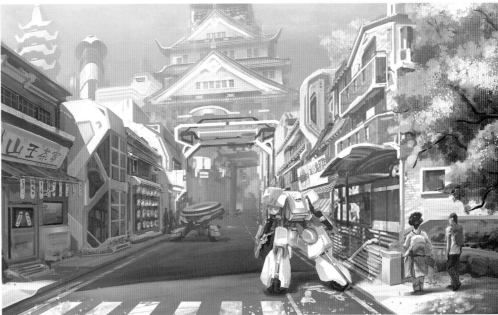

HANAMURA EARLY IDEATION

TOP AND MIDDLE: **BEN ZHANG**, BOTTOM LEFT **DAVID KANG**, BOTTOM RIGHT: **PETER C. LEE**

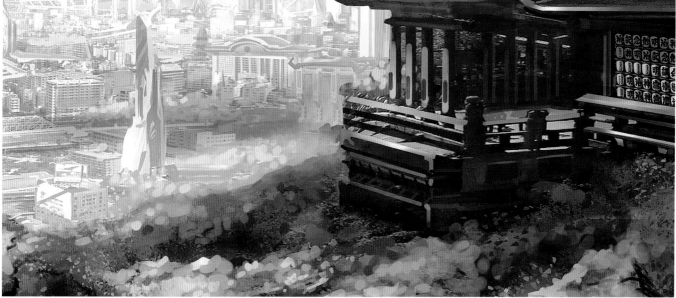

HANAMURA EARLY IDEATION

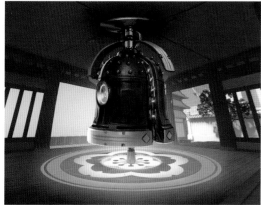

CASTLE BELL

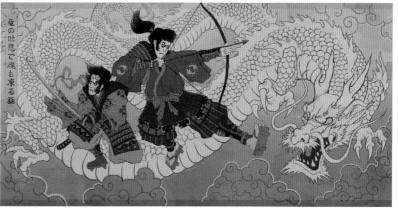

WALL MURAL

TOP AND BOTTOM LEFT: **BEN ZHANG**, MIDDLE: **PETER C. LEE**, BOTTOM RIGHT: **DAVID KANG**

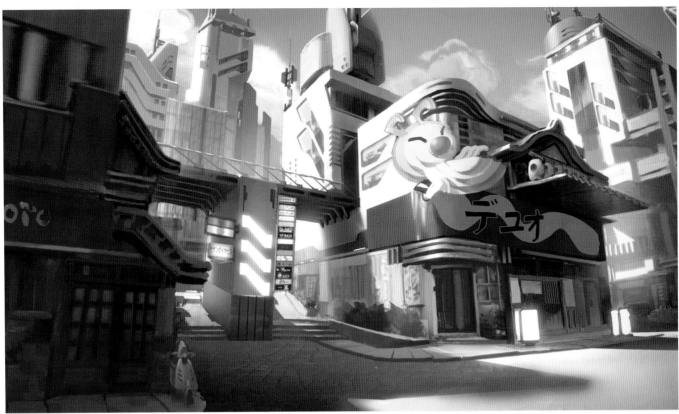

HANAMURA EARLY CONCEPT

TYCHUS

KERRIGAN

TYRAEL

MARINE

GARROSH

SIEGE TANK

VULTURE

TOP: **BEN ZHANG**, BOTTOM: **ARNOLD TSANG**

RIKIMARU
RAMEN SIGN

力丸
RIKIMARU RAMEN SHOP

THE LOST VIKING VI

SUPER SIEGE MODE 3
スーパーシージモード3
LOLOW

ビビの冒険
Vivi's ADVENTURE
LOLOW

SOULSTONE
DEMON-SLAYER
ソウルストーン〜魔討士伝〜
CATCORP

音楽 MANIA
MOTHERSHIP CATCHER

CLAW GAME
AND PRIZES

音楽 MANIA
MOTHERSHIP CATCHER

音楽

VIVI

BEN ZHANG, ARNOLD TSANG, JOHN POLIDORA, AND DAVID KANG

HOLLYWOOD

For Hollywood, the developers went through many iterations before finding the right balance between realism and fantasy. Rather than create a carbon copy of the real place, they wanted to craft an idealized and optimistic vision of it. *Overwatch*'s version of the location included clear landmarks like the Hollywood sign, and it paid homage to the Golden Age of cinema. The map was filled with bright streets, movie posters (bottom), and backlot sets (opposite page) that evoked the image of Hollywood ingrained in pop culture.

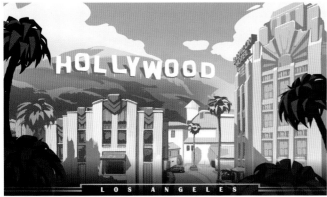

POSTCARD

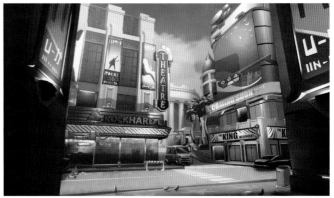

EARLY IDEATION

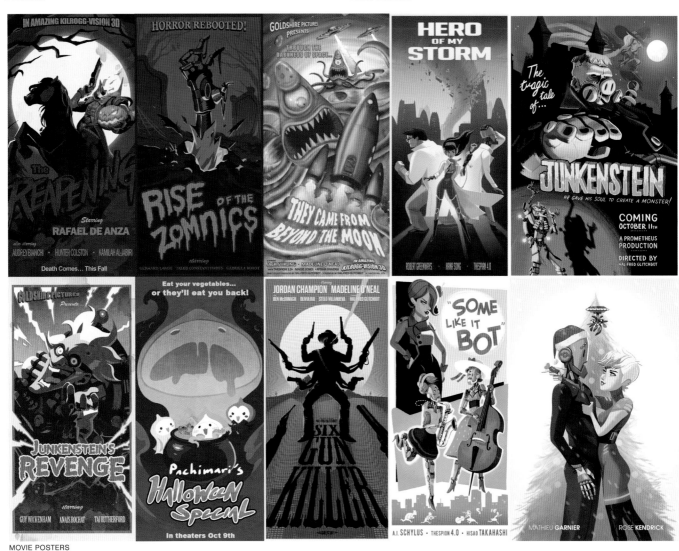

MOVIE POSTERS

TOP AND MIDDLE RIGHT: **BEN ZHANG**, MIDDLE LEFT: **DAVID KANG**, BOTTOM: **ANH DANG, DAVID KANG, ARNOLD TSANG**, AND **HERO COMPLEX GALLERY**

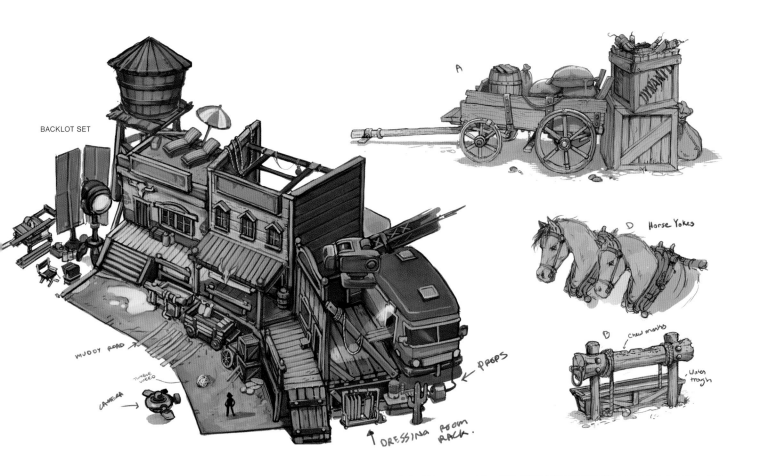

BACKLOT SET

MUDDY ROAD

TUMBLE WEED

CAMERA

PROPS

DRESSING ROOM RACK.

A

D Horse Yokes

chew marks

Water trough

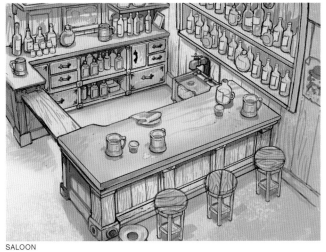

SALOON

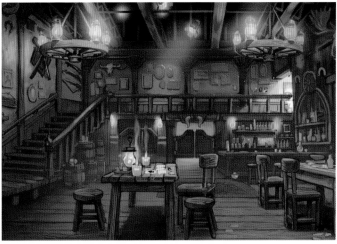

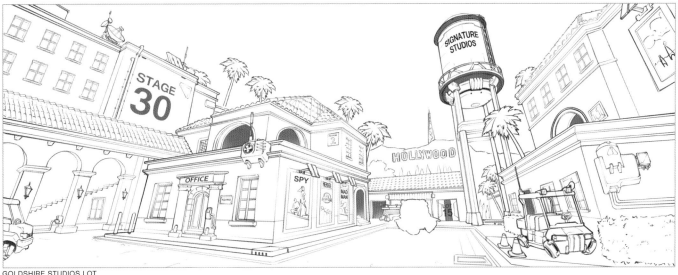

STAGE 30

SIGNATURE STUDIOS

HOLLYWOOD

OFFICE

SPY

GOLDSHIRE STUDIOS LOT

BOTTOM: **DAVID KANG**, REMAINDER OF IMAGES: **AQUATIC MOON**

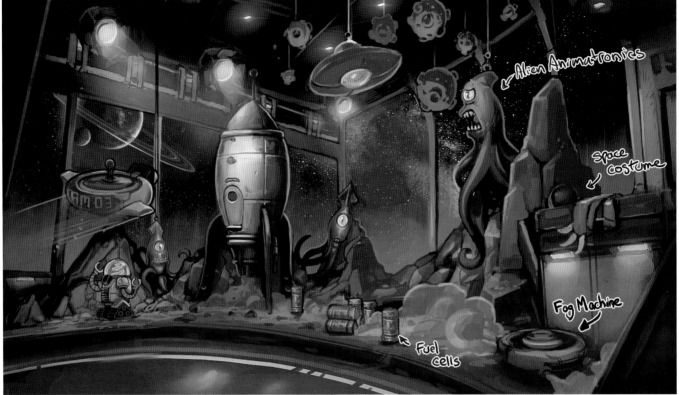

Alien Animatronics

Space Costume

Fog Machine

Fuel cells

SOUND STAGE

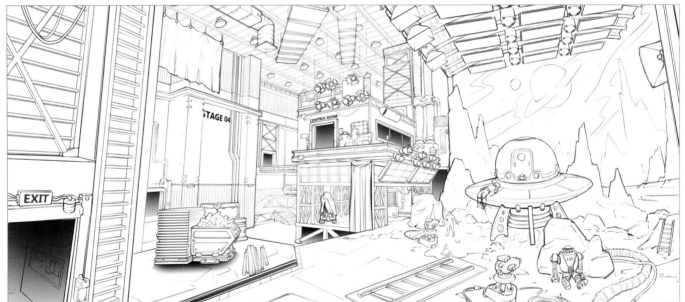

SOUND STAGE

THEATER

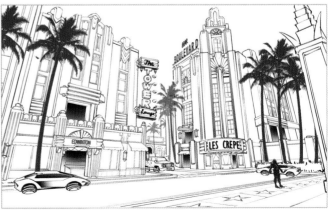

SUNSET PLACE

TOP: **AQUATIC MOON**, BOTTOM: **DAVID KANG**

PROPS

TOP: **NICK CARVER**, BOTTOM: **AQUATIC MOON**

HORIZON LUNAR COLONY

The developers tied most environments to specific heroes. Horizon Lunar Colony was themed around Winston. It was there, in a futuristic moon laboratory, where the gorilla was genetically modified and raised. The game team modeled much of the base's architecture after the animated short "Recall," which told Winston's backstory. Specific locations, like the gorilla's room and an observatory with a view of Earth, also appeared in the short. However, fleshing out the parts of the base not seen in "Recall" required a great deal of work. More concept art was created for Horizon Lunar Colony than any map that had come before it. The team iterated on different styles of technology to capture the right futuristic setting.

Most of the Horizon Lunar Colony map was staged inside the base. In early versions, the developers found that the environment came across as too sterile and uniform. Distinct secondary colors were added to different parts of the map, such as green in the botany area, to make them visually unique. This had gameplay benefits as well. Based on the facility's distinct visuals, players would be able to immediately recognize their location.

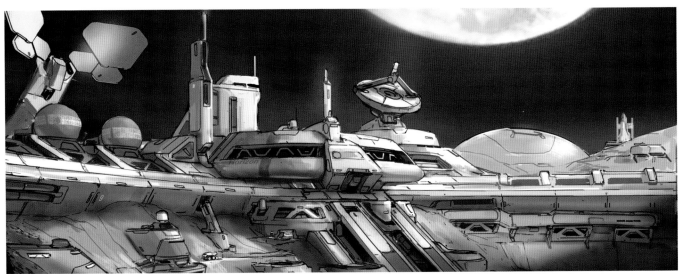

LUNAR COLONY EXTERIOR

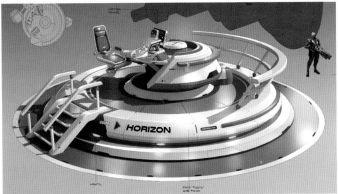

TELESCOPE

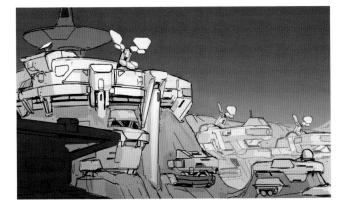

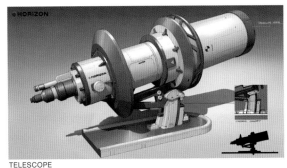

TELESCOPE

TELESCOPE CHAIR

TOP AND MIDDLE RIGHT: **AL CRUTCHLEY**, BOTTOM AND MIDDLE LEFT: **OSCAR CAFARO**

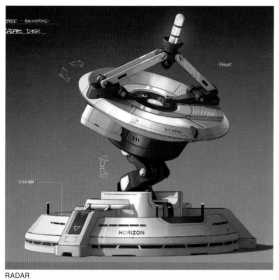

RADAR

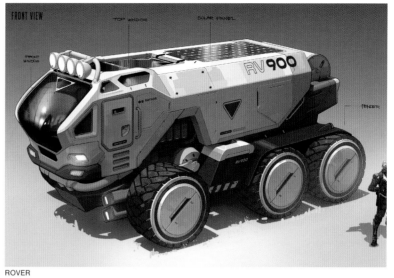

ROVER

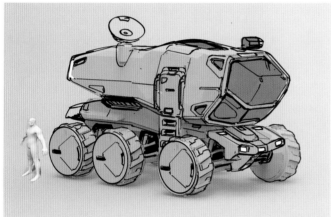

ROVERS

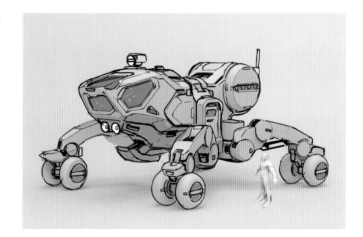

OPERATION DESKS

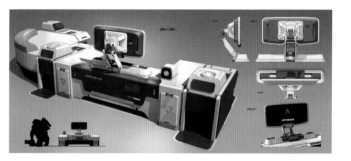

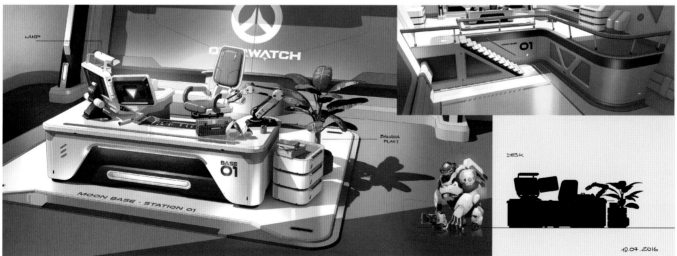

DR. WINSTON'S DESK

ALL IMAGES: **OSCAR CAFARO**

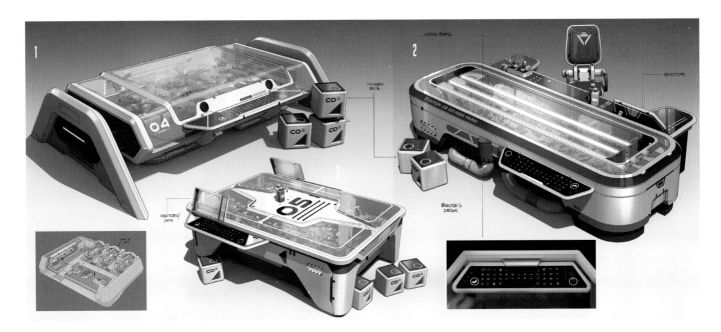

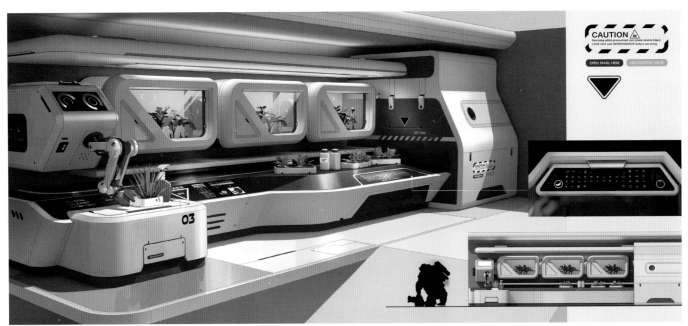

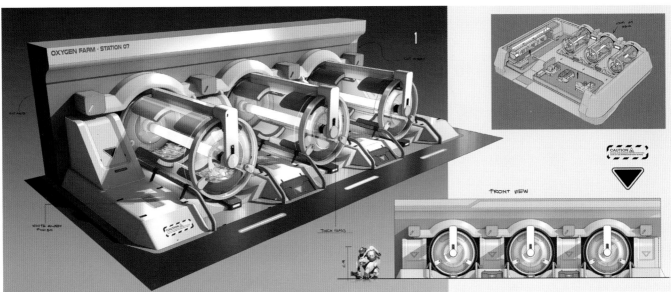

OXYGEN FARM

BOTTOM RIGHT: **AL CRUTCHLEY,** REMAINDER OF IMAGES: **OSCAR CAFARO**

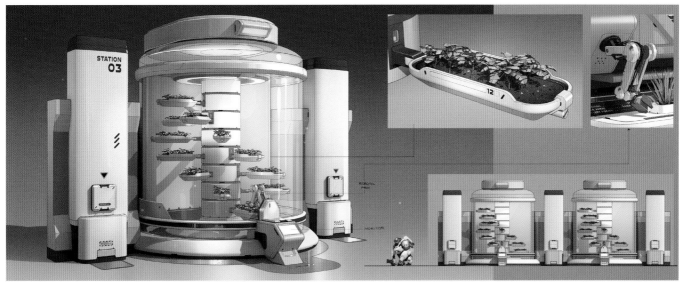

OXYGEN FARM

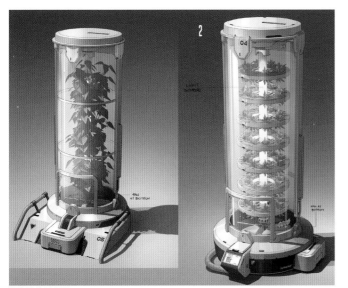

VERTICAL TUBER

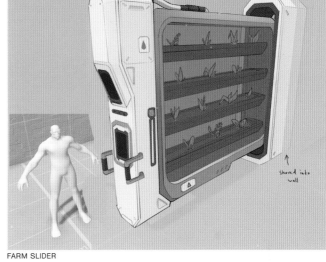

FARM SLIDER

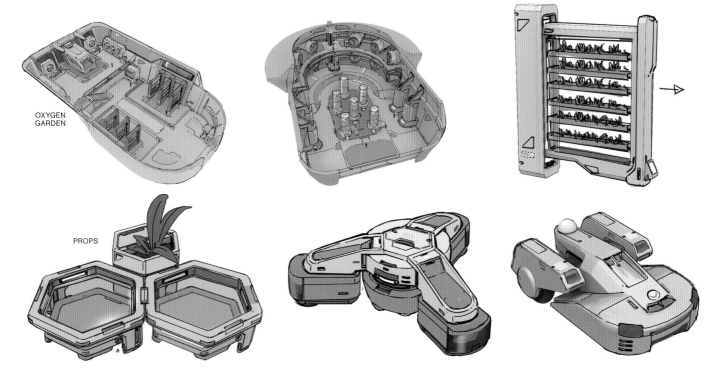

OXYGEN
GARDEN

PROPS

BOTTOM: **AL CRUTCHLEY**, REMAINDER OF IMAGES: **OSCAR CAFARO**

KING'S ROW

King's Row was the second map created for *Overwatch*, following Temple of Anubis. For the latter, the developers wanted a location with bright lighting that embraced a sense of high adventure. King's Row was an opportunity to explore the opposite: a grittier, nighttime setting within a big city. The developers modeled much of the location after London's architecture, but they also incorporated elements of *Overwatch*'s story into the map. At one end of King's Row, they crafted a grimy *city beneath the city* inhabited by London's omnics. This highlighted the violent history and persistent tension between humans and robots that formed the core of the game's overarching backstory.

As King's Row was being developed, the animated short "Alive" was also being made. In the story, Widowmaker assassinates an omnic monk named Mondatta, who was giving a speech to encourage humans and robots to live in peace. The game team integrated aspects of the film into the map, such as placing a memorial near the spot where Mondatta was killed.

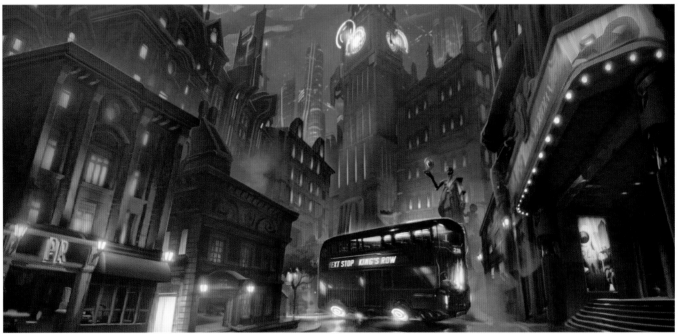

KING'S ROW

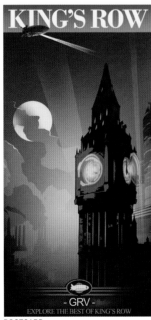

POSTCARD

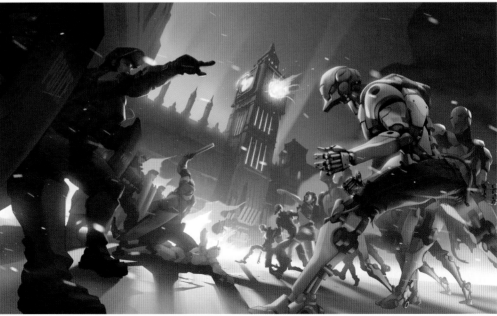

RIOT IN KING'S ROW

BOTTOM LEFT: **DAVID KANG**, REMAINDER OF IMAGES: **BEN ZHANG**

CONSTRUCTION
ROBOT

PAYLOAD, UPRISING

BUILDING DESIGN

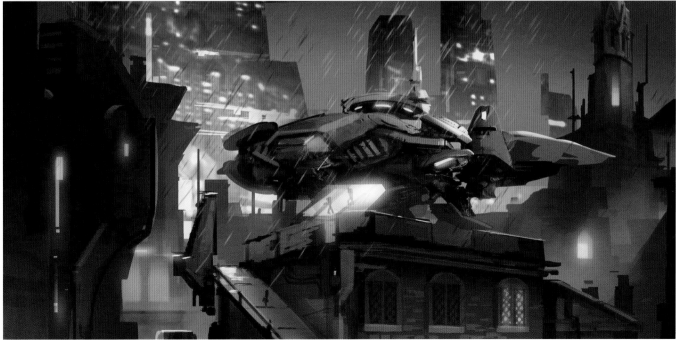

KING'S ROW EARLY IDEATION

APC, UPRISING

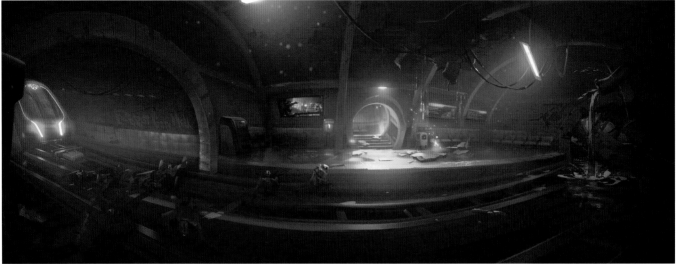

TUBE STATION, UPRISING

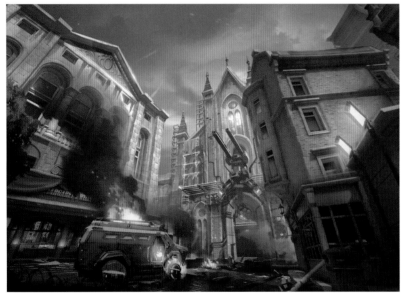

CATHEDRAL, UPRISING

POWER STATION ENTRANCE

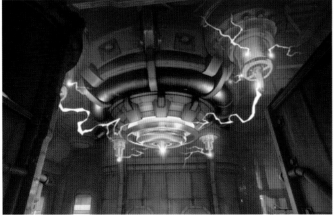

POWER STATION CEILING

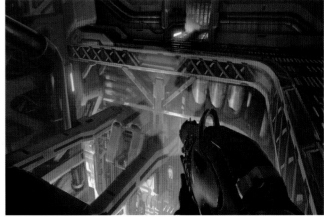

UNDERWORLD

TOP: **AL CRUTCHLEY**, REMAINDER OF IMAGES: **BEN ZHANG**

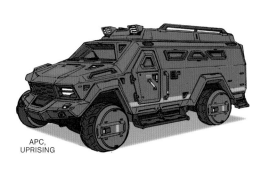

APC,
UPRISING

BUS

PROPS

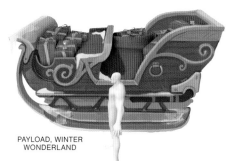

PAYLOAD, WINTER
WONDERLAND

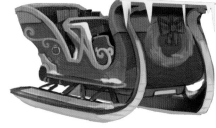

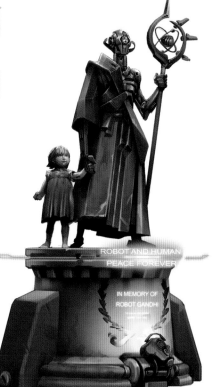

ROBOT AND HUMAN
PEACE FOREVER

IN MEMORY OF
ROBOT GANDHI

POSTERS

OMNIC LANGUAGE STUDY

AL CRUTCHLEY, BEN ZHANG, AND ANH DANG

LIJIANG TOWER

The prospect of creating a futuristic Chinese metropolis thrilled the game team. To capture the majesty of the city, the developers staged the map at night. They also placed it in and around a giant building called Lijiang Tower, which gave an unobstructed view of the metropolis's glittering skyline. The grand vista bolstered the themes of optimism and humanity's quest for advancement.

Though much of Lijiang Tower was high tech, the developers incorporated night market food stalls and traditional Chinese architecture (next spread) into the map. As with many other *Overwatch* environments, this blend of old and new was important for creating a place that evoked a dual sense of familiarity and wonder.

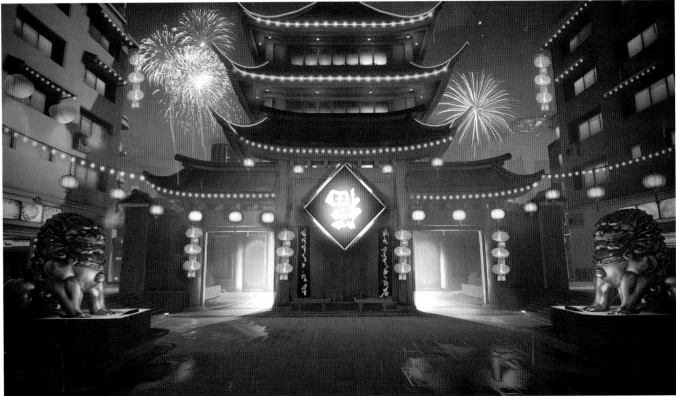

NIGHT MARKET, YEAR OF THE ROOSTER

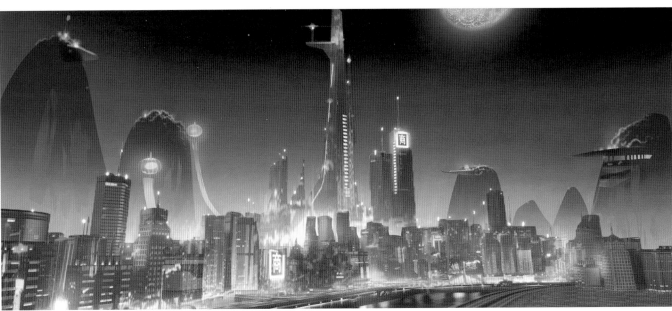

SKYLINE, YEAR OF THE ROOSTER

ALL IMAGES: **BEN ZHANG**

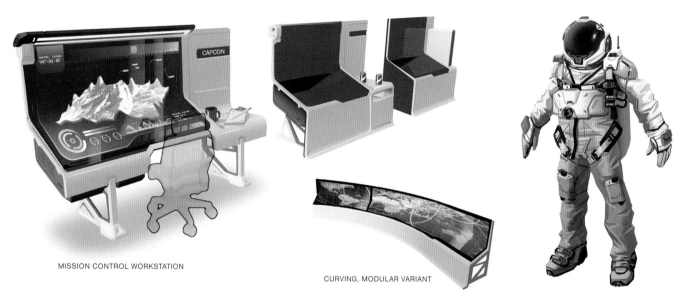

MISSION CONTROL WORKSTATION

CURVING, MODULAR VARIANT

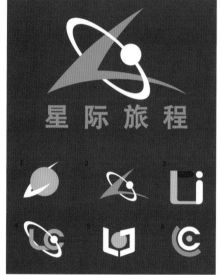

LUCHENG INTERSTELLAR LOGO IDEATION

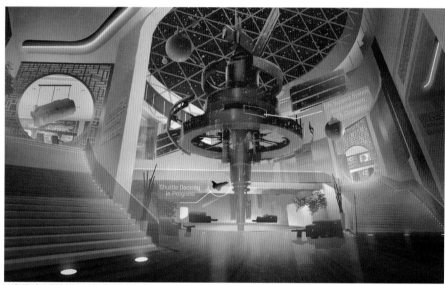

LUCHENG INTERSTELLAR UPPER LEVEL

MOOD SHOT

MOOD SHOT

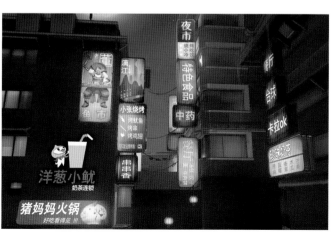

BUILDING FACADES

DAVID KANG, NICK CARVER, AND BEN ZHANG

NIGHT MARKET MENU ITEMS

HAPPY SQUID RESTAURANT

CHINA
Building to the stars

皆大欢喜

POSTCARD

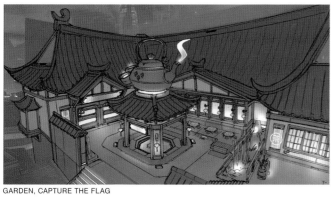
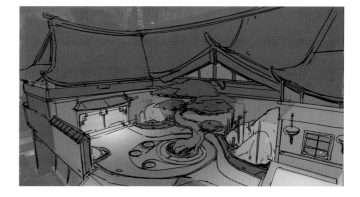

GARDEN, CAPTURE THE FLAG

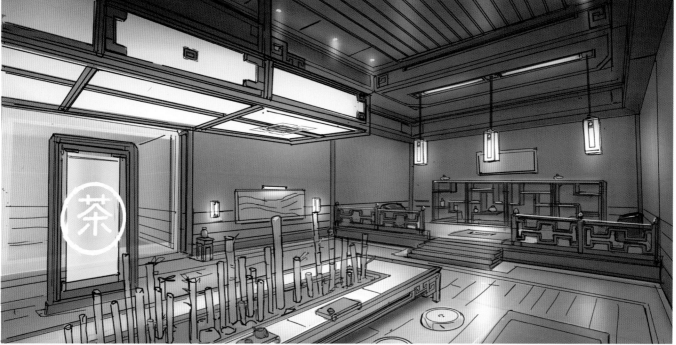

GARDEN INTERIOR, CAPTURE THE FLAG

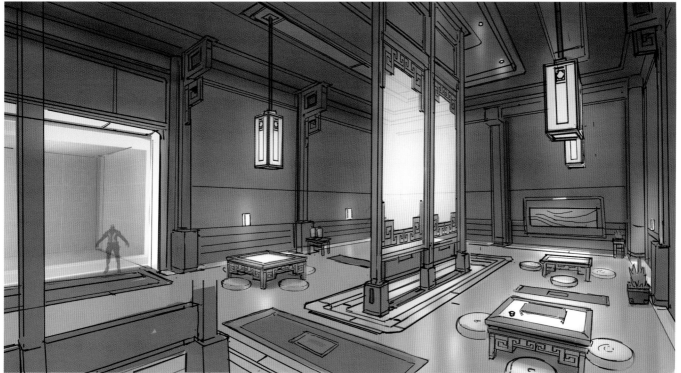

GARDEN INTERIOR, CAPTURE THE FLAG

ALL IMAGES: **AL CRUTCHLEY**

NEPAL

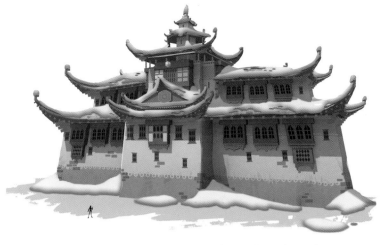

For Nepal, the developers created an environment at the top of the world: a remote mountain setting above the clouds, filled with a sense of mysticism and enlightenment. These qualities were vital themes that tied into the map's underlying story. *Overwatch*'s Nepal is home to the Shambali, an order of omnic monks. Though many of the structures were rustic in appearance, the team included touches of technology and omnic-inspired symbols

(next spread) throughout the map to hint at the robots that dwell atop the mountain.

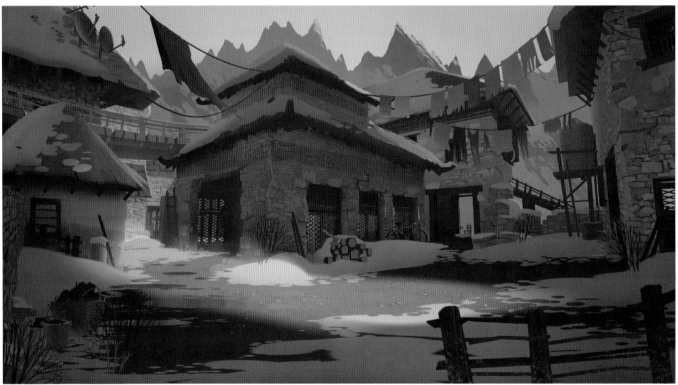

VILLAGE

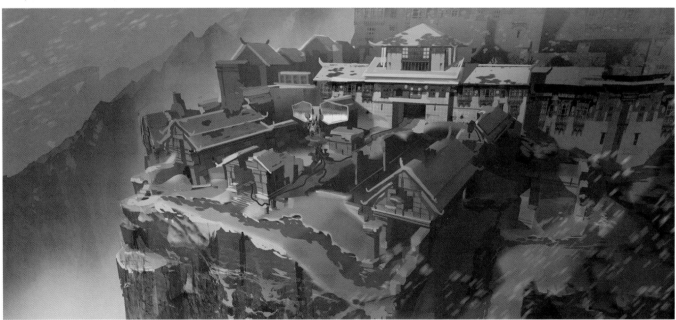

OVERVIEW

ALL IMAGES: **NICK CARVER**

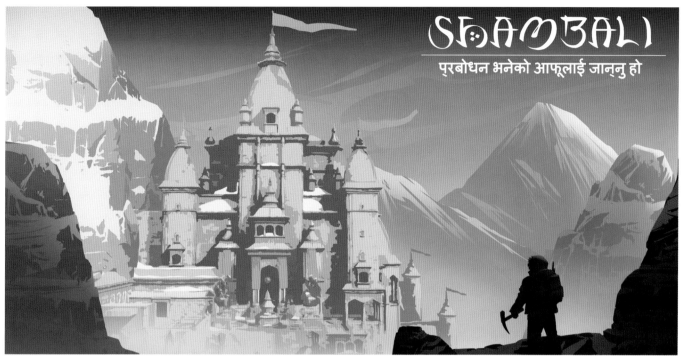

SHAMBALI

परबोधन भनेको आफूलाई जान्नु हो

POSTCARD

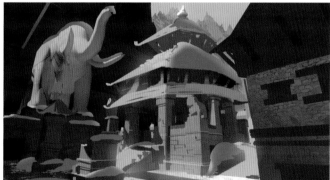

SHRINE COLOR KEY

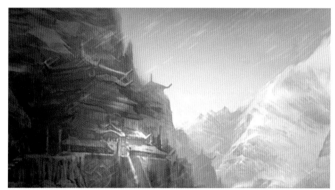

EARLY IDEATION

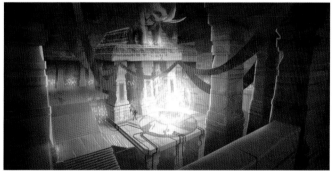

SANCTUM COLOR KEY

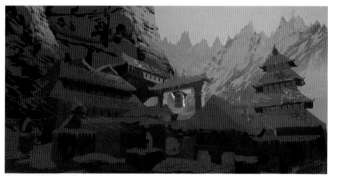

SHRINE COLOR KEY

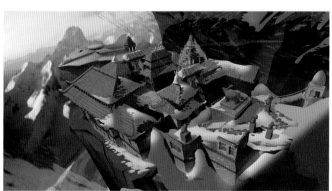

SHRINE COLOR KEY

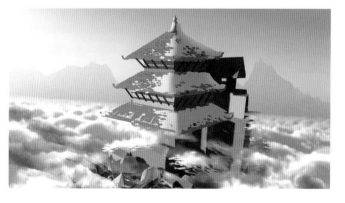

TOP: **DAVID KANG**, REMAINDER OF IMAGES: **NICK CARVER**

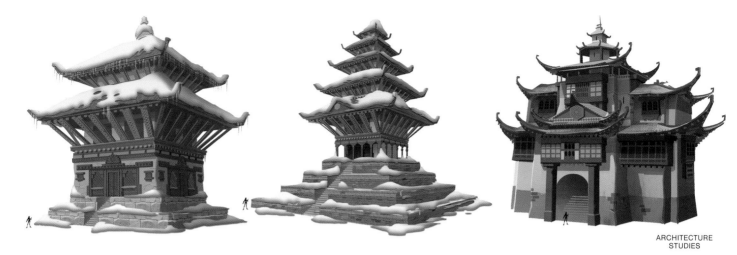

ARCHITECTURE
STUDIES

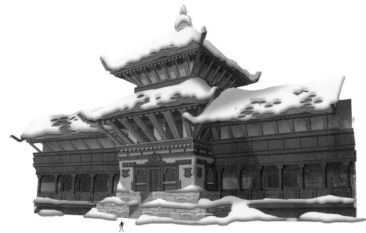

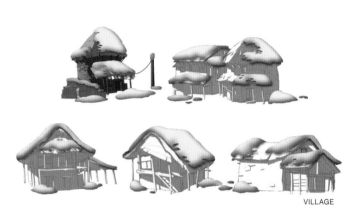

VILLAGE

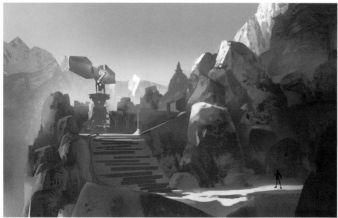

EARLY CONCEPT

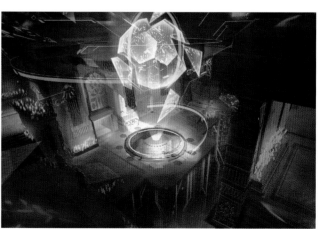

SANCTUM

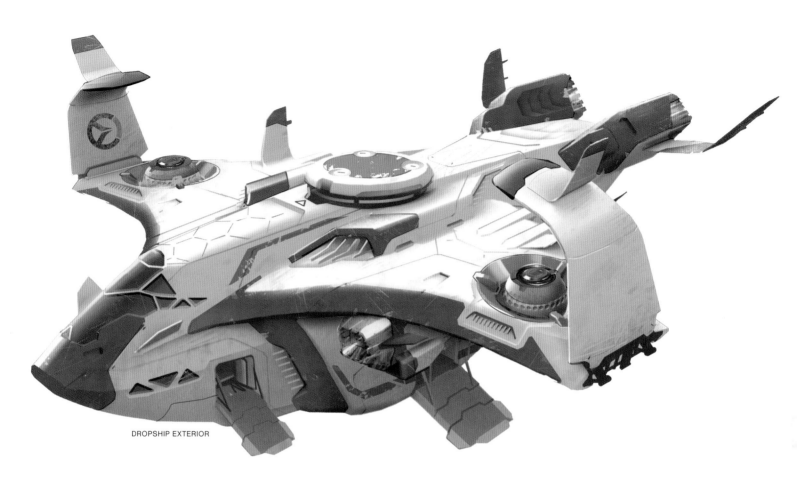

DROPSHIP EXTERIOR

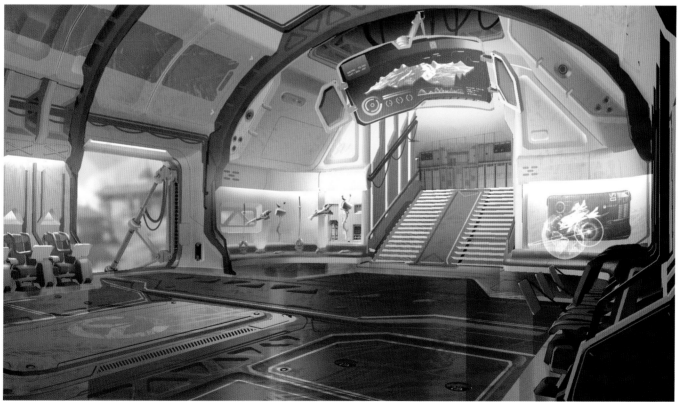

DROPSHIP INTERIOR

ENVIRONMENTS
NUMBANI

From the moment concept art for Numbani appeared (below), the developers were drawn to the idea of creating a highly advanced metropolis in Africa. The city represents hope and harmony; it is a rare location in the *Overwatch* world where humans and omnics live together in peace. As the designers began bringing the environment to life, they went through different iterations. One early idea had Numbani float above the ground. Another featured rectangular buildings with sleek glass surfaces. Ultimately, the team revisited the original concept art and fleshed out a city filled with curved skyscrapers that showed animal and tribal designs.

Because Numbani's aesthetic was so unique, the team looked for ways to make the location relatable. Cafes and other shops were added throughout the map to give the sense of a dynamic place bursting with life. One end of the map featured a transportation hub to demonstrate that Numbani was connected to the rest of the world, rather than an isolated utopia.

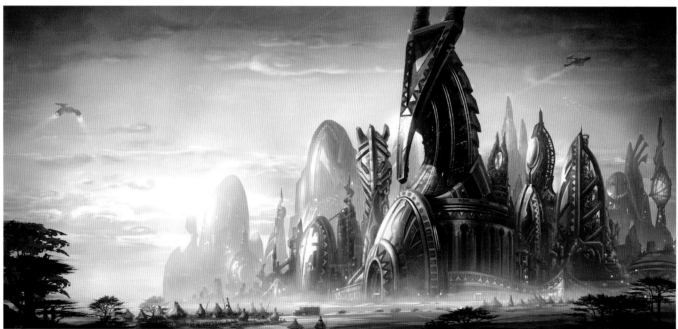

EARLY IDEATION

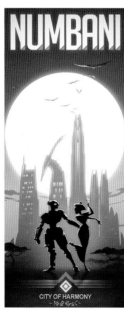

NUMBANI TRAVEL POSTER

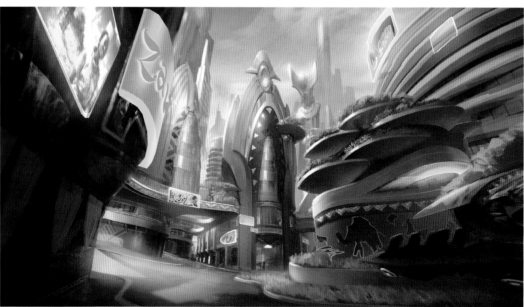

NUMBANI STREETS

MIDDLE: **PETER C. LEE**, REMAINDER OF IMAGES: **BEN ZHANG**

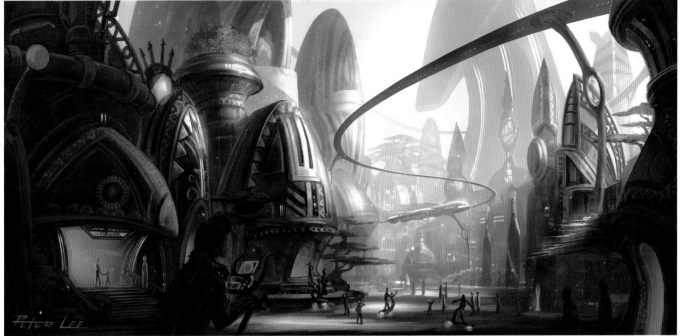
EARLY IDEATION

BUILDING SKETCHES

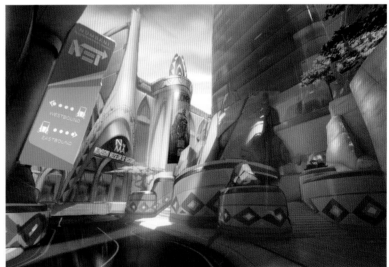
MUSEUM EXTERIOR

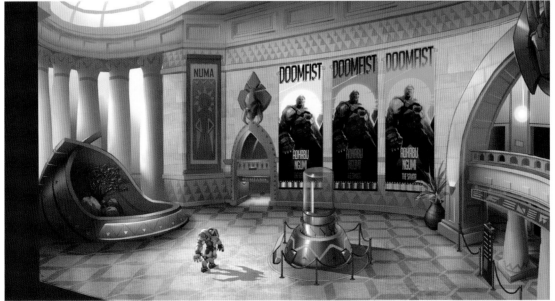
MUSEUM INTERIOR

DOOMFIST POSTER

TOP: **PETER C. LEE**, REMAINDER OF IMAGES: **BEN ZHANG**

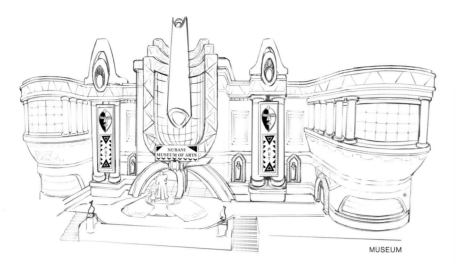

MUSEUM

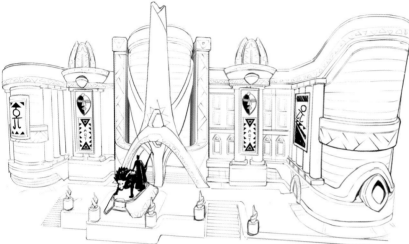

MUSEUM

NUMBANI ELECTROMAGNETIC TRANSIT

WESTBOUND

EASTBOUND

NET
NUMBANI
ELECTROMAGNETIC TRANSIT

NUMBANI TRANSIT MAP

NET

NuMa
Adwe-Airport
Unity Plaza

N - #245275

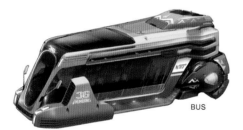

BUS

BUILDING SKETCHES

NUMBANI
VISITORS CENTRE

CHEZ TAJINE
NORTH AFRICAN CUISINE

DUNE
HOTEL + LOUNGE

SIGNAGE

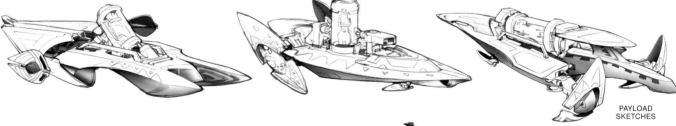

PAYLOAD
SKETCHES

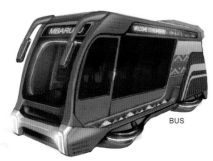

BUS

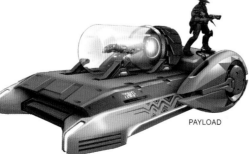

PAYLOAD

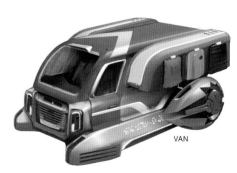

VAN

TOP: **DAVID KANG**, BOTTOM: **BEN ZHANG**

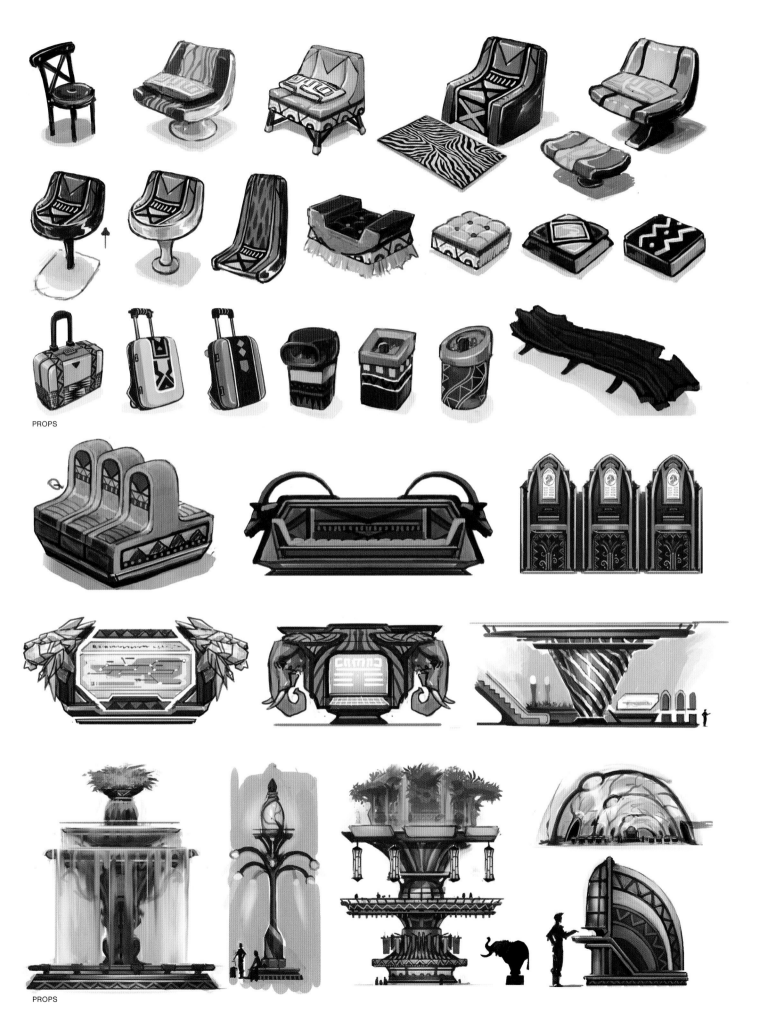

PROPS

PROPS

ALL IMAGES: **AQUATIC MOON**

OASIS

Much like Numbani, Oasis was a chance for the developers to create a futuristic city unique to the world of *Overwatch*. The two maps differed in their settings and what they represented. From its doorways to its wall patterns, Oasis was based on traditional Middle Eastern architecture and motifs. Whereas Numbani was themed around harmony between people and omnics, Oasis embraced the idea of human-centered advancement.

The developers modeled the city to be a place of knowledge and experimentation. In Oasis, people use genetic engineering, cybernetic enhancement, and other augmenting technologies. Automated drones (next spread, top right) and cars were added to emphasize its high-tech setting. Oasis was the first time these design elements were used in an *Overwatch* map.

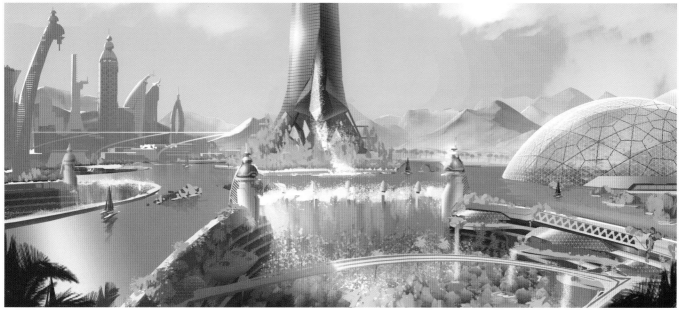

OVERVIEW

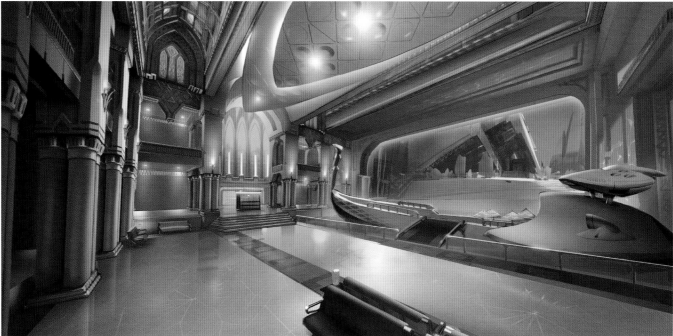

BUILDING INTERIOR

TOP AND BOTTOM: **BEN ZHANG**, MIDDLE: **NICK CARVER**

الزحافة

I-XXX-XXX-7XX2

POSTER

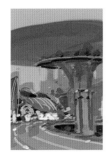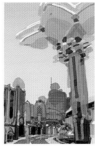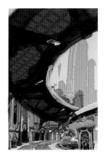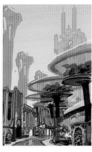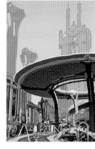
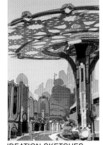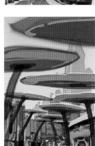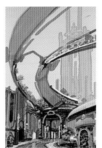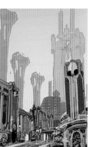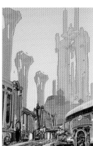

IDEATION SKETCHES

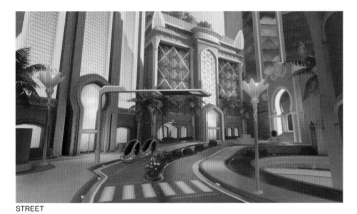

STREET

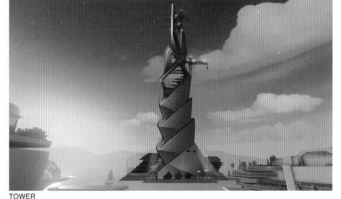

TOWER

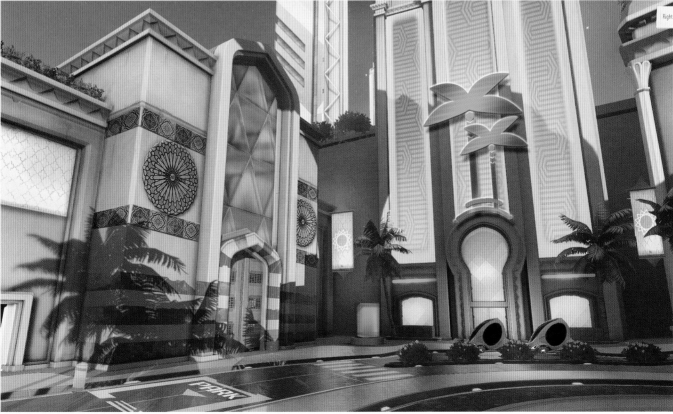

SIGNAGE

TOP LEFT: **ANH DANG,** TOP RIGHT: **VASILI ZORIN,** BOTTOM: **PHILIP WANG**

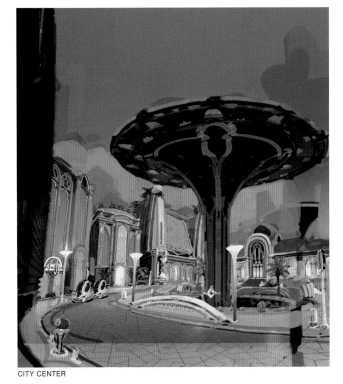

CITY CENTER

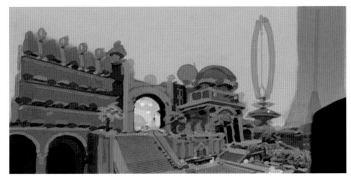

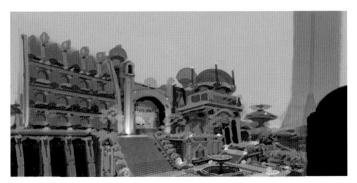

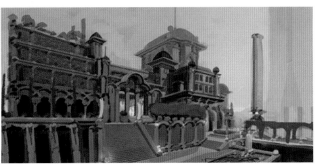

GARDEN

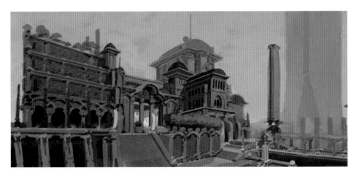

ARCH

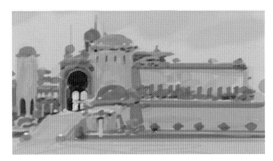

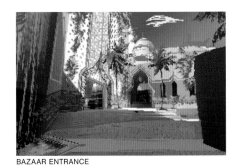

BAZAAR ENTRANCE

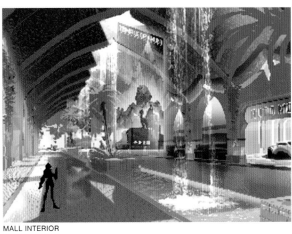

MALL INTERIOR

EARLY IDEATION

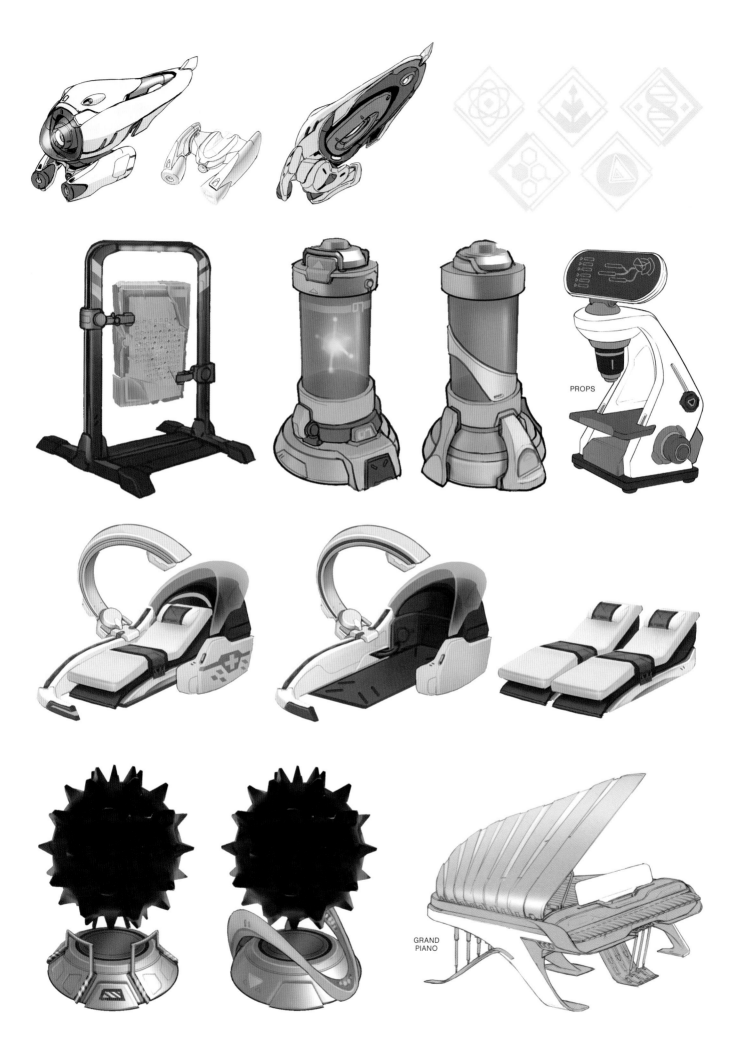

PROPS

GRAND
PIANO

TOP LEFT: **AL CRUTCHLEY**, TOP RIGHT: **ANH DANG**, MIDDLE: **PHILIP WANG**, BOTTOM RIGHT: **BEN ZHANG**

ROUTE 66

The developers crafted Route 66 to evoke the fantasy and adventure of life on the open road. Red rock formations, orange gravel on the ground, and a clear blue sky combined to create a color palette distinct from *Overwatch*'s existing environments. Many of the buildings that were made for the map, from the rustic diner to the cave filled with alien souvenirs, were inspired by places found along the highways of the Southwestern United States.

One goal of Route 66 was establishing the Deadlock Gang. The developers wanted the group to feel like powerful criminals rather than simply a ragtag band of misfits. The key to accomplishing this was building out the gang's elaborate hideout at one end of the map, showing that they are organized and highly resourceful.

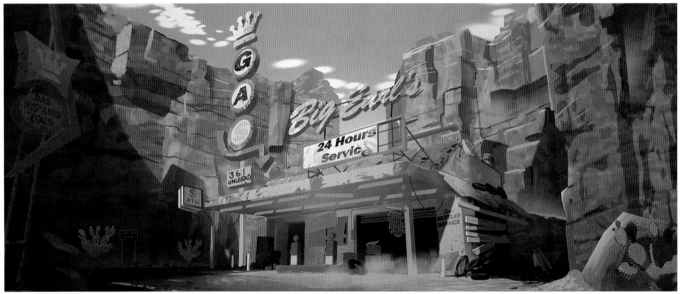

BIG EARL'S

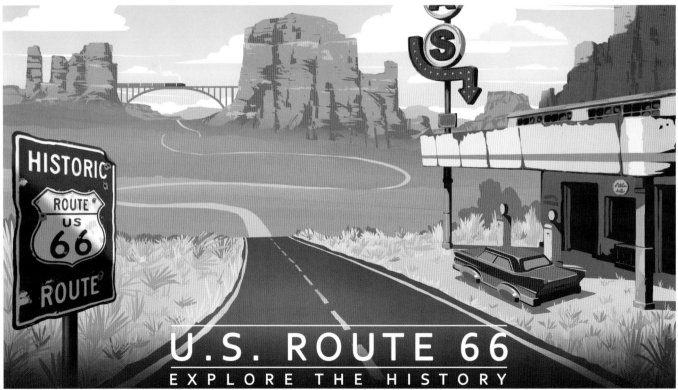

POSTCARD

TOP: **NICK CARVER**, BOTTOM: **DAVID KANG**

BIG RIG

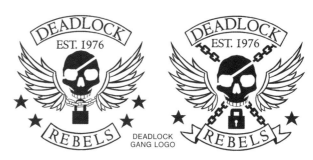
DEADLOCK GANG LOGO

BIG RIG TRAILER ART

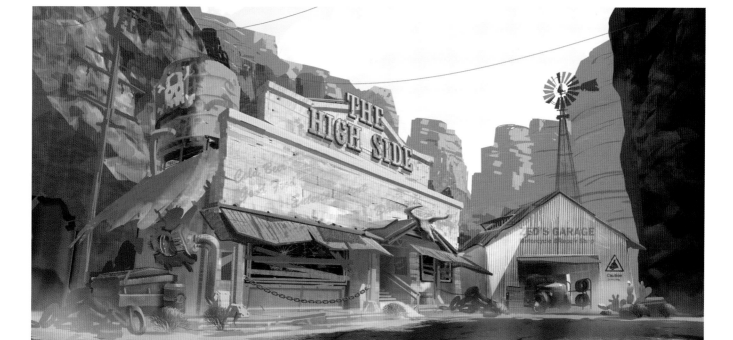
THE HIGH SIDE

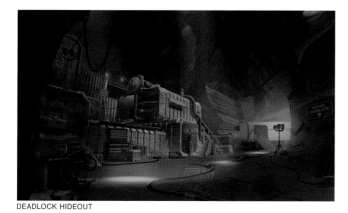
DEADLOCK HIDEOUT

NICK CARVER AND **DAVID KANG**

TEMPLE OF ANUBIS

Temple of Anubis was the first map crafted for *Overwatch*. The team picked this Egypt-based location for many reasons. One was that Temple of Anubis offered the best place to showcase the game's heroes. The desert environment featured bright direct sunlight, which rendered the characters and their designs in vivid detail. Another reason was the map's potential for strong visual motifs. Architectural elements like the Sphinx and the pyramids were identifiable, and they created an atmosphere of adventure.

In making Temple of Anubis, the developers experimented with how far they could exaggerate architecture and push the map's fantasy. They also toyed with adding atmospheric effects like wind-blown sand. What the team learned while creating Temple of Anubis helped them find the right tone and style for the entire world of *Overwatch*.

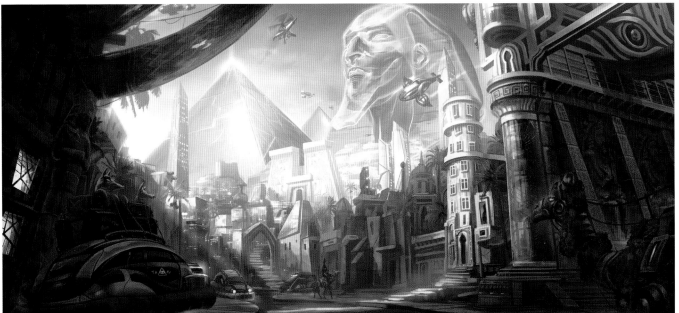

EARLY IDEATION

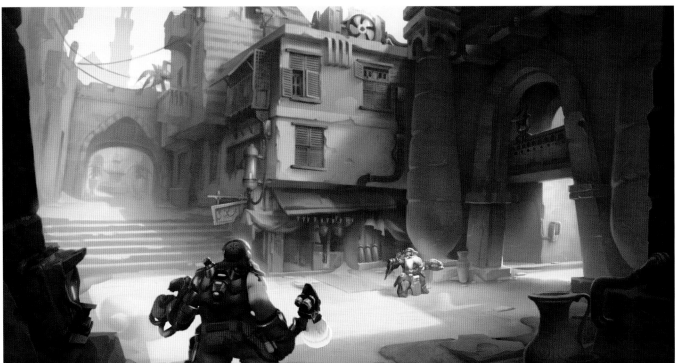

VISUAL TARGET

TOP AND BOTTOM: **BEN ZHANG**, MIDDLE: **PETER C. LEE**

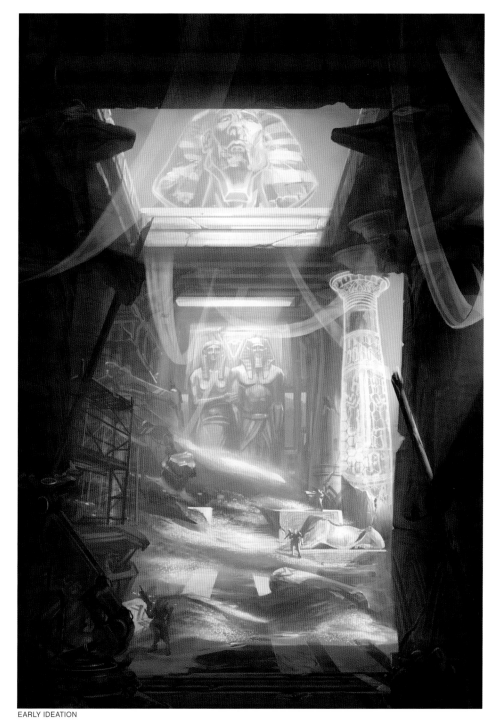

EARLY IDEATION

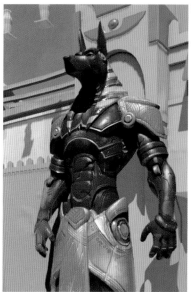

JEWEL OF THE NILE

TRAVEL TO THE LAND OF PHARAOHS

POSTCARD

STATUE

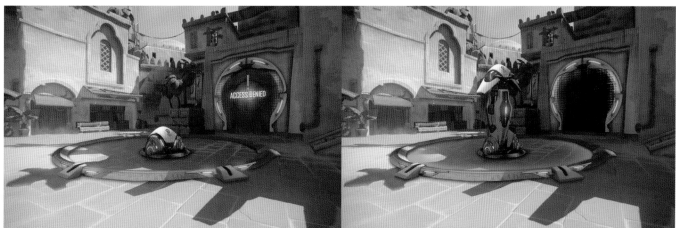

ACCESS DENIED

CAPTURE POINT DEVICE

TOP LEFT: **PETER C. LEE**, TOP RIGHT AND BOTTOM: **BEN ZHANG**, MIDDLE RIGHT: **ARNOLD TSANG**

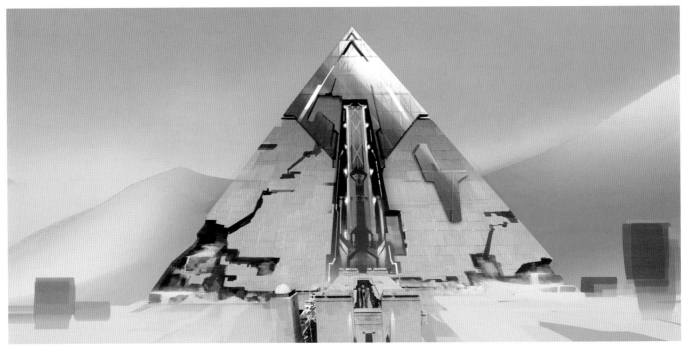
PYRAMID

GATE

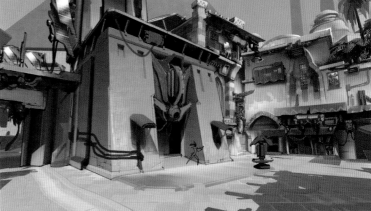
CAPTURE POINT AREA

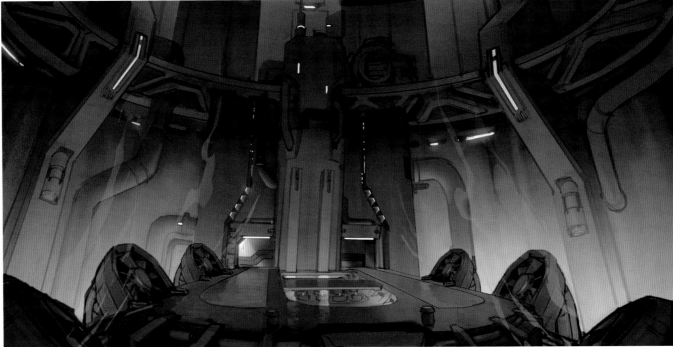
SPAWN ROOM CONCEPT

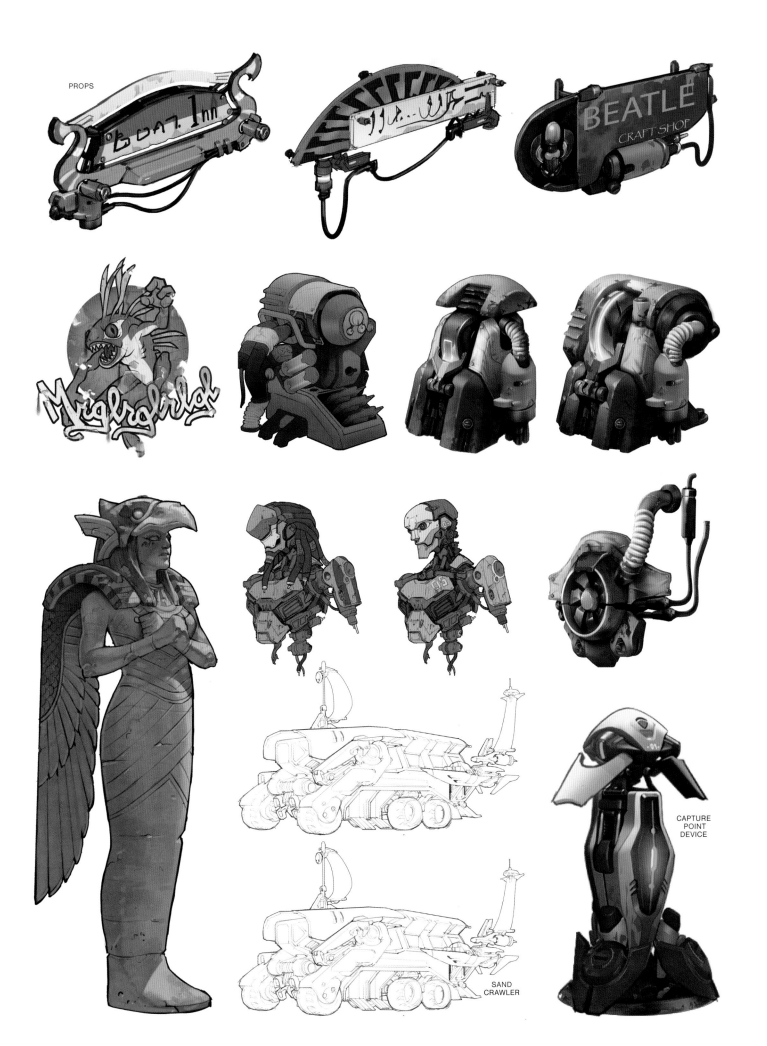

PROPS

BEATLE
CRAFT SHOP

CAPTURE
POINT
DEVICE

SAND
CRAWLER

MIDDLE LEFT AND LOWER LEFT: **ARNOLD TSANG**, REMAINDER OF IMAGES: **BEN ZHANG**

VOLSKAYA INDUSTRIES

With Volskaya Industries, the developers captured a Russian-inspired city in a beautiful snowy environment. The story was a critical component of the map. The team emphasized the country's history of conflict with omnics through wall murals (middle row) and a giant factory producing mechs to fight robots (opposite page, top). It was critical to show that these war machines were controlled by *people* rather than artificial intelligences. To communicate this idea, the developers placed anti-omnic posters throughout the map (opposite page, center) and designed the mechs to have windowed cockpits (opposite page, bottom right).

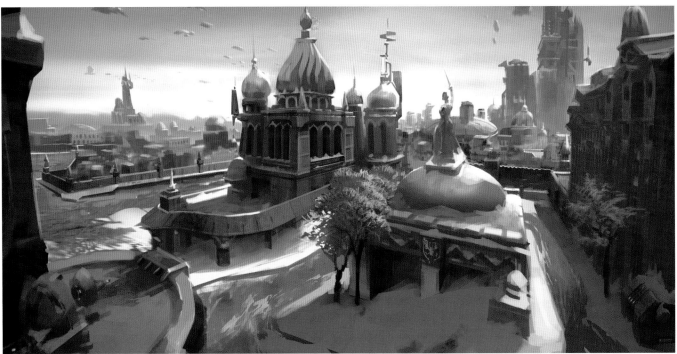

RESIDENTIAL AREA

POSTCARD

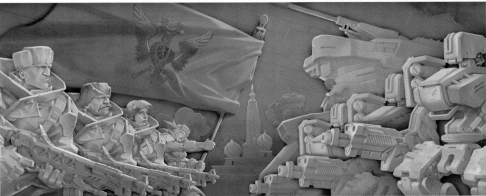

RELIEF PAINTING

SIGNAGE

LOWER LEFT: **DAVID KANG**, REMAINDER OF IMAGES: **BEN ZHANG**

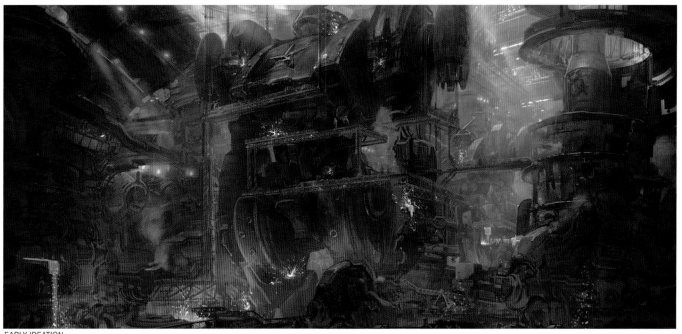

EARLY IDEATION

PROPAGANDA POSTERS

СОЗДАНЫ ЛЮДЬМИ
BUILT BY THE PEOPLE

ВСЕГДА НА СТРАЖЕ
ALWAYS ON GUARD

СОБЛЮДАЙ БДИТЕЛЬНОСТ
BE VIGILANT

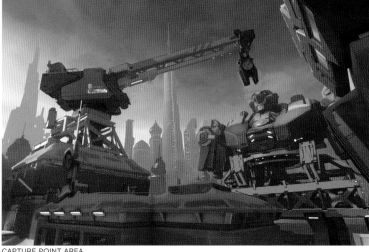

CAPTURE POINT AREA

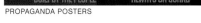

MECH CONCEPTS

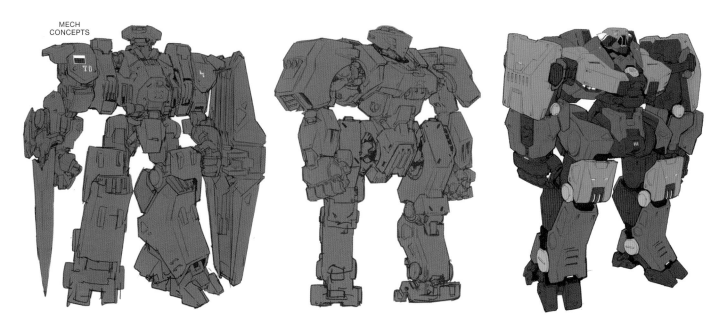

TOP: **PETER C. LEE**, REMAINDER OF IMAGES: **BEN ZHANG**

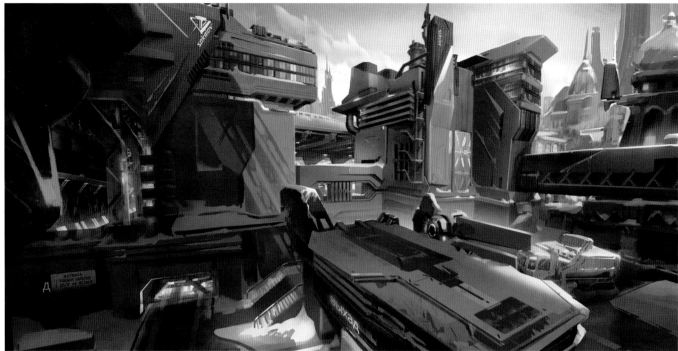

FACTORY EXTERIOR

EARLY IDEATION

MOVING PLATFORM

MIDDLE: **PETER C. LEE**, REMAINDER OF IMAGES: **BEN ZHANG**

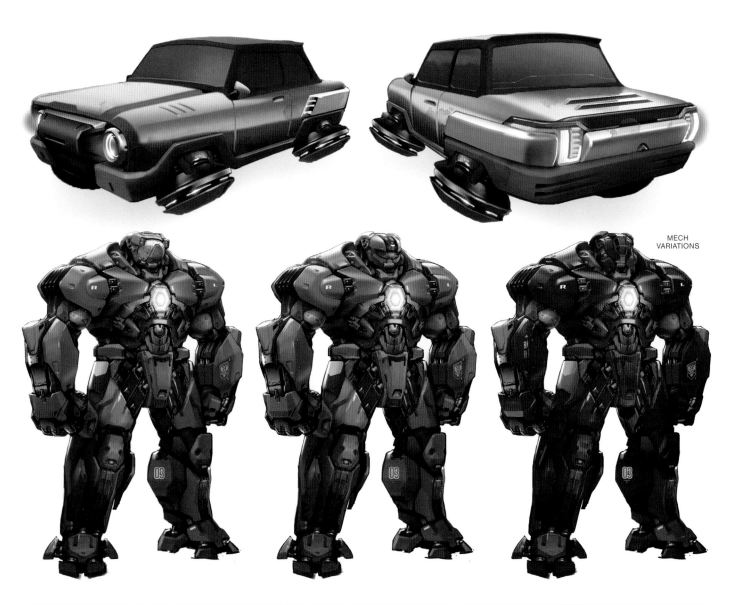

MECH
VARIATIONS

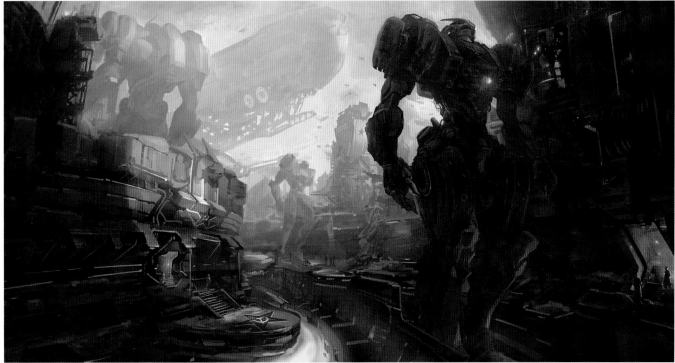

EARLY IDEATION

BOTTOM: **PETER C. LEE**, REMAINDER OF IMAGES: **BEN ZHANG**

WATCHPOINT: GIBRALTAR

Watchpoint: Gibraltar introduced ideas and designs that hadn't appeared in other environments. The map was home to an adult Winston, and the developers added small touches to the environment to indicate his presence. Most of these elements appeared in a lab at one end of the map, where the hero spends his time surveying the state of the world and snacking on peanut butter (next spread, left page). The inclusion of props like photographs and the space capsule was crucial for telling parts of Winston's backstory.

Gibraltar was also the first location set in a base belonging to the Overwatch group. The developers concepted unique architecture, devices, and vehicles to define a clear visual style for the organization.

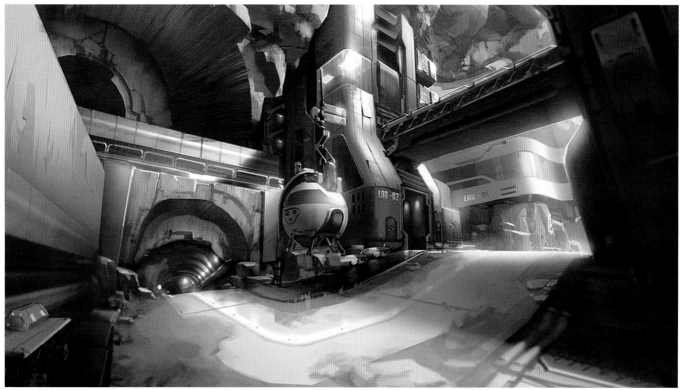

WATCHPOINT: GIBRALTAR EXTERIOR

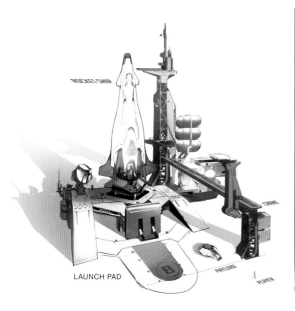

LAUNCH PAD

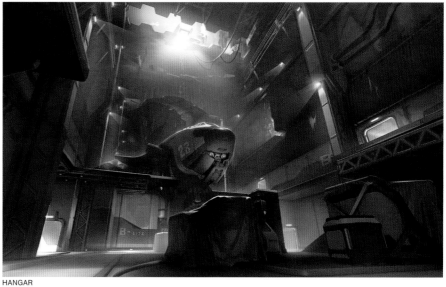

HANGAR

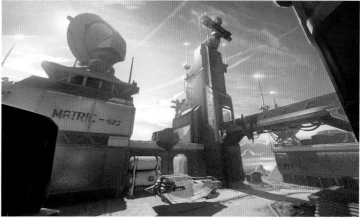

ENVIRONMENT PAINTOVER

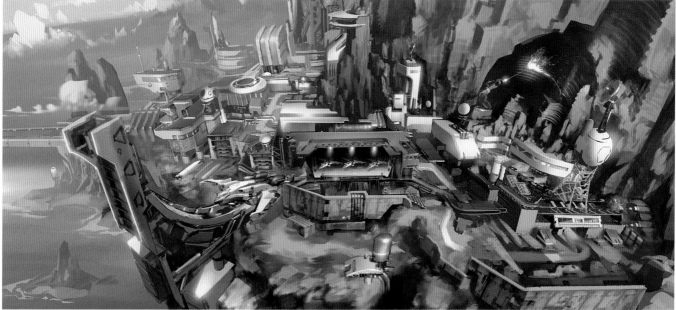

MAP OVERVIEW

POSTCARD

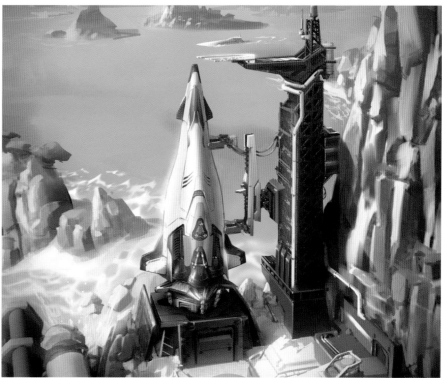

LAUNCH PAD

LOWER LEFT: **DAVID KANG**, REMAINDER OF IMAGES: **BEN ZHANG**

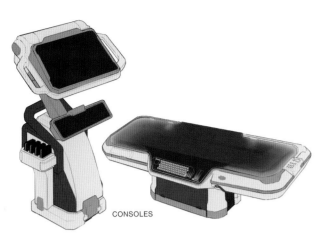

CONSOLES

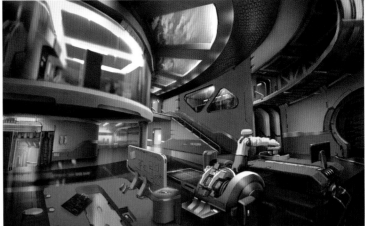

WINSTON'S LAB

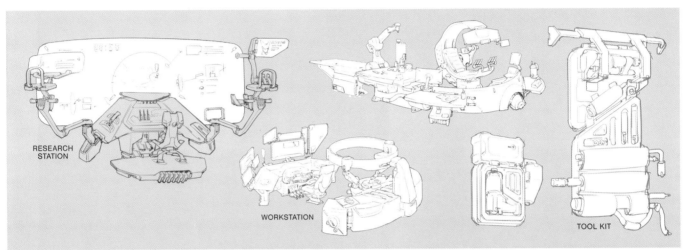

RESEARCH STATION

WORKSTATION

TOOL KIT

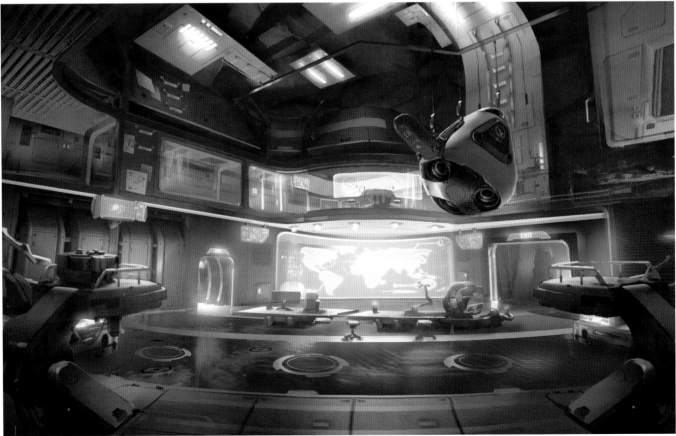

WINSTON'S LAB

TOP RIGHT: **DAVID KANG**, REMAINDER OF IMAGES: **BEN ZHANG**

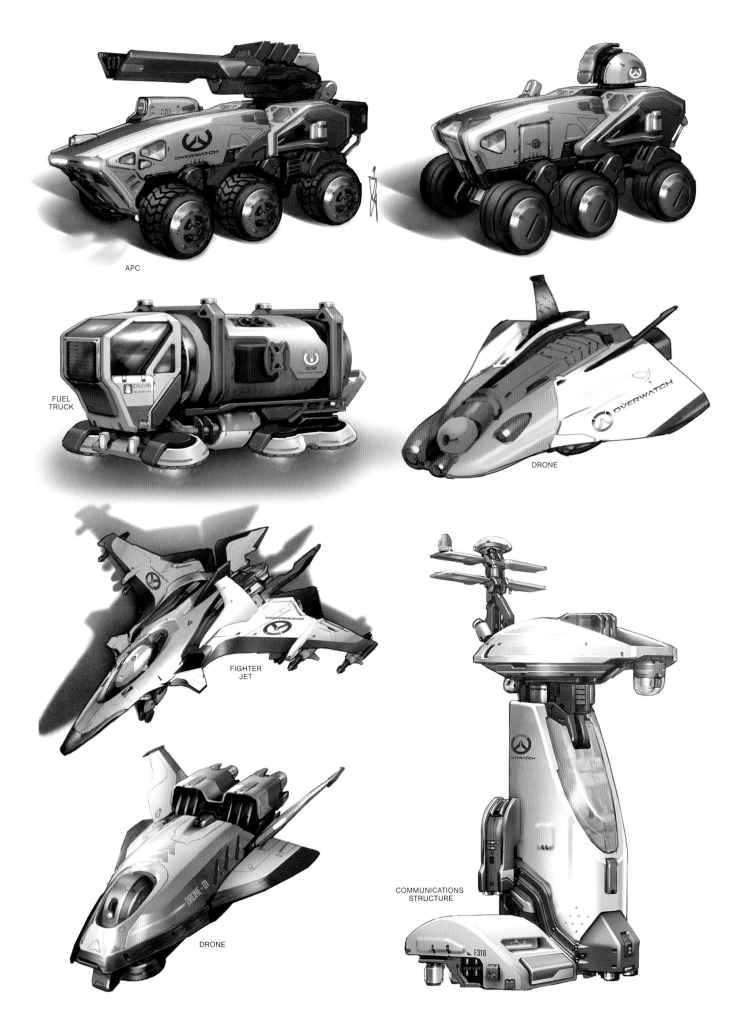

APC

FUEL
TRUCK

DRONE

FIGHTER
JET

DRONE

COMMUNICATIONS
STRUCTURE

F318

ALL IMAGES: **BEN ZHANG**

DROPSHIP

WORKSTATION HUD

PROPS

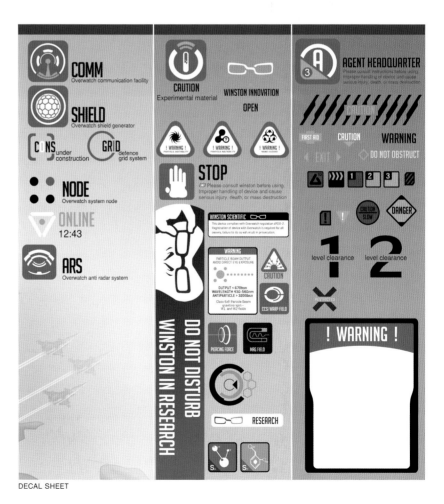

DECAL SHEET

TOP AND BOTTOM: **BEN ZHANG**, MIDDLE: **DAVID KANG**

ILIOS

Ilios was the last map the game team created before *Overwatch*'s release. At this point in development, the designers had made everything from a secret base carved into the heart of Gibraltar to the bustling metropolis around Lijiang Tower. For Ilios, their goal was to craft something conceptually simpler, an idyllic Greek vacation spot hugged by the deep blue Mediterranean Sea. Having a down-to-

earth location served as a welcome contrast to the game's high-tech maps. However, Ilios wasn't completely without its futuristic touches. The developers added hints of technology throughout the map to make it feel like part of the *Overwatch* world.

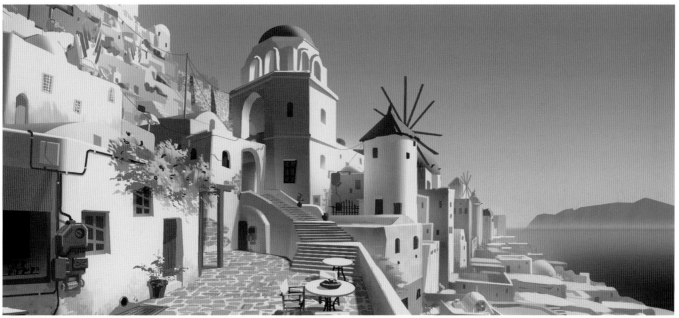

LIGHTHOUSE

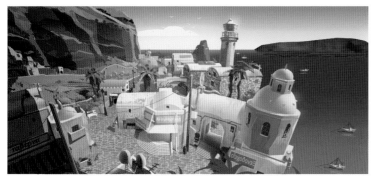

LIGHTHOUSE

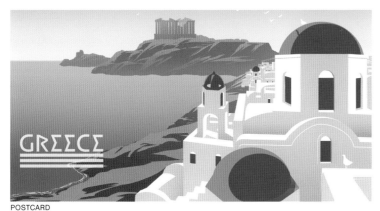

GREECE

POSTCARD

WINDMILL

LOWER LEFT: **DAVID KANG**, REMAINDER OF IMAGES: **NICK CARVER**

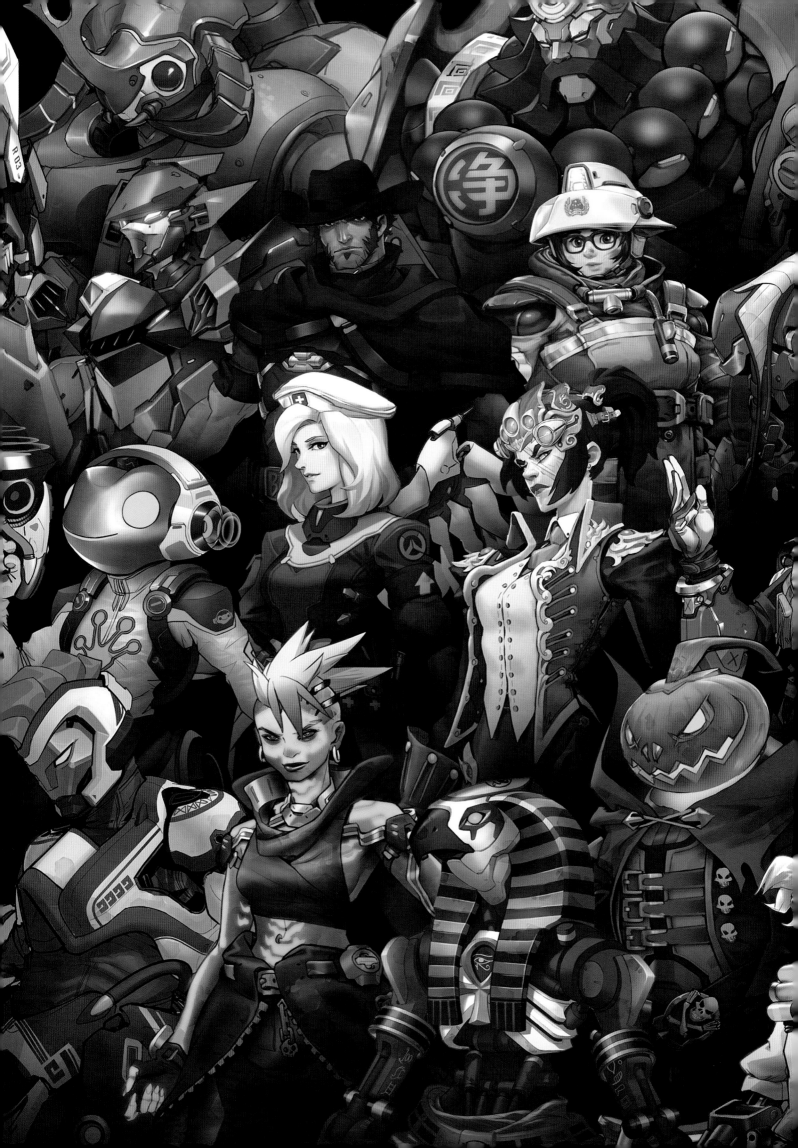

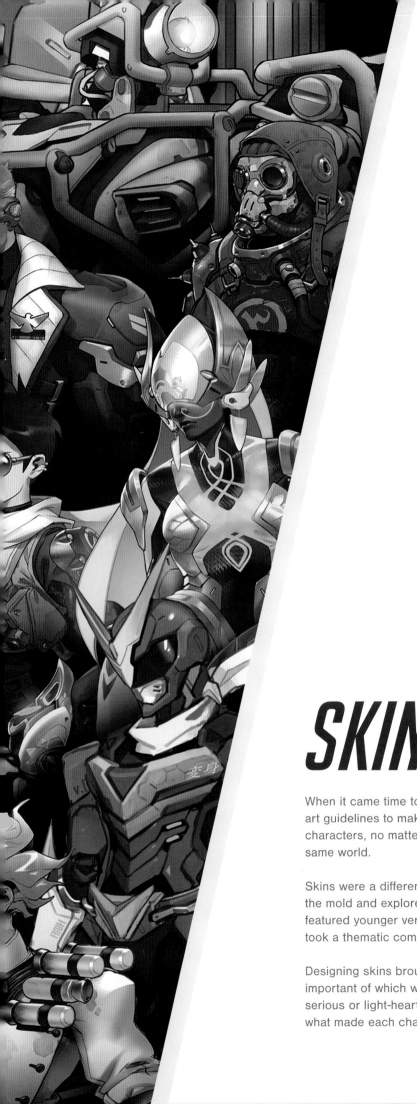

SKINS

When it came time to design heroes, the *Overwatch* developers established art guidelines to make the game stylistically cohesive. They wanted their characters, no matter how diverse they were, to feel like they all inhabited the same world.

Skins were a different story. They gave the designers an opportunity to break the mold and explore the characters from new perspectives. Some skins featured younger versions of the heroes that tied into their backstories. Others took a thematic component from a character and pushed it to the extreme.

Designing skins brought its own technical and artistic challenges—the most important of which was preserving the heroes' identities. Whether skins were serious or light-hearted, the developers always made sure they celebrated what made each character special and stayed true to who they were.

ANA

Among the influences for Ana were post-apocalyptic themes and imagery. The designers wanted her to feel rugged and resourceful, like someone who lives on the outskirts of society. The team took this core inspiration and crafted an entire skin—Wasteland (below, right)—around the idea. Strap, pipe, and canister designs were used to emphasize that the character had been scrounging up whatever materials she could find to survive.

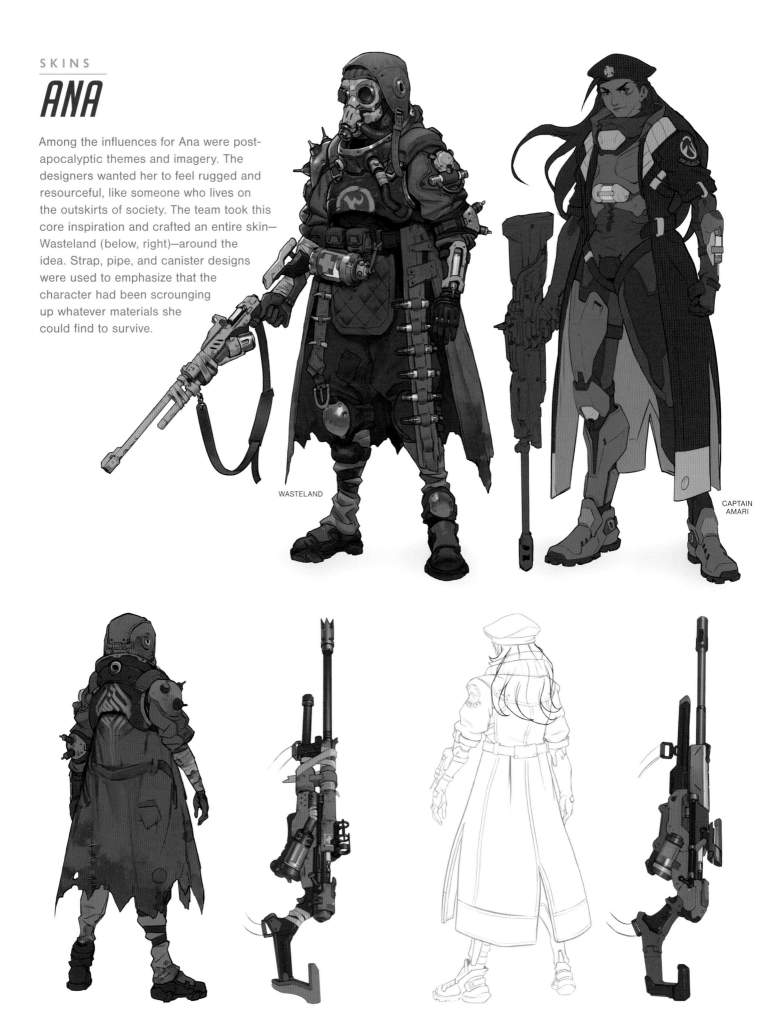

WASTELAND

CAPTAIN AMARI

TOP LEFT AND LOWER LEFT: **ARNOLD TSANG**, TOP RIGHT: **BEN ZHANG**, LOWER RIGHT: **DAVID KANG**

BASTION

For Bastion's skins, the developers created concept art for each of the robot's configurations: recon, sentry, and tank. It was crucial that each mode felt not only unique, but also consistent with the skin's overall theme. These designs also had to fit Bastion's existing animations so the new skins would flow seamlessly during transformation.

Another factor to consider when creating Bastion's skins was adjusting the look of the robot's feathered companion, Ganymede. Changes to the bird were usually made after the hero's concepts were finalized. This way, the team could tie Ganymede's appearance into Bastion's design, such as with the woodpecker and the Antique skin (bottom).

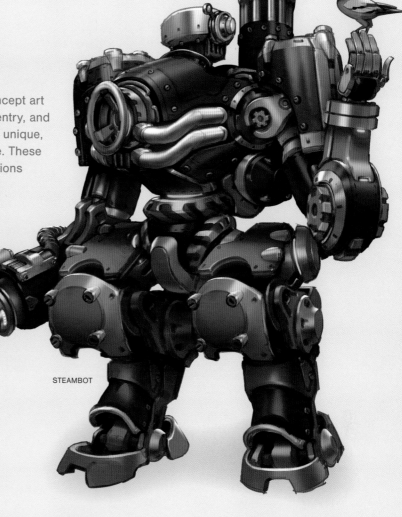

STEAMBOT

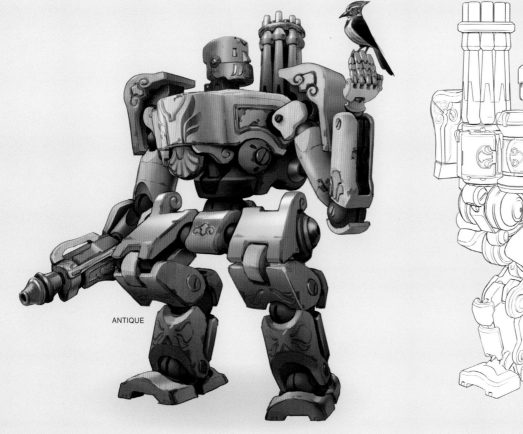

ANTIQUE

TOP: **BEN ZHANG**, LOWER LEFT: **BEN ZHANG** AND **DAVID KANG**, LOWER RIGHT: **DAVID KANG**

D.VA

Designing D.Va's skins entailed creating something
new for both the mech *and* the pilot. The game
team never wanted one to outshine the other.
Individually, the hero and her trusty
machine had to look distinct, but they
also needed to feel like two parts of
a greater whole. The developers
accomplished this by creating
color schemes and design
motifs that they could share
between D.Va and her mech, such
as with the Junker skin (opposite page).

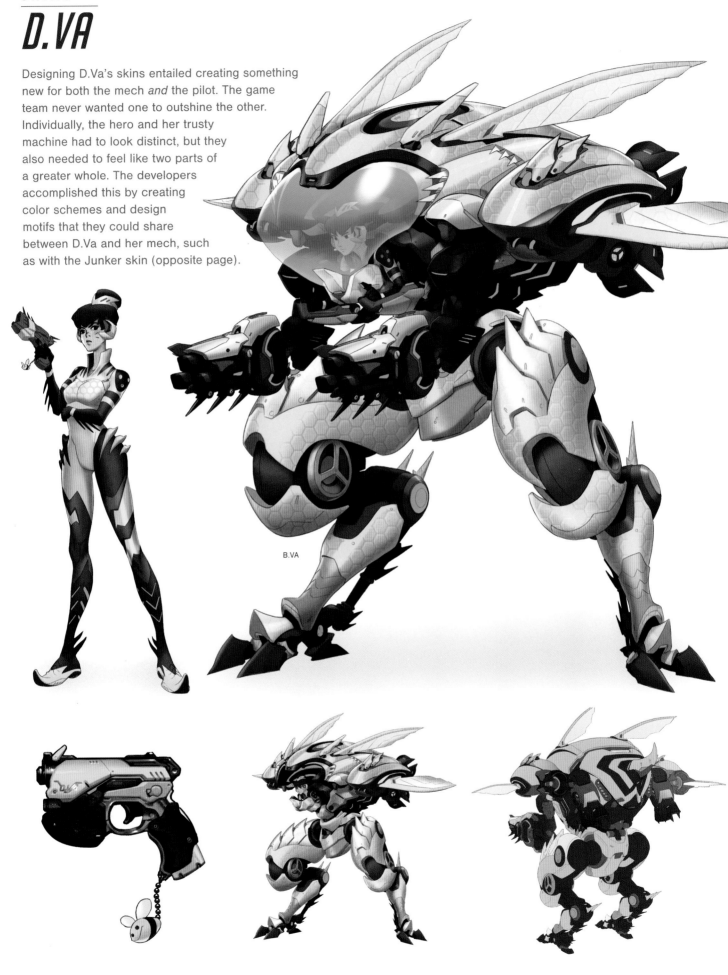

B.VA

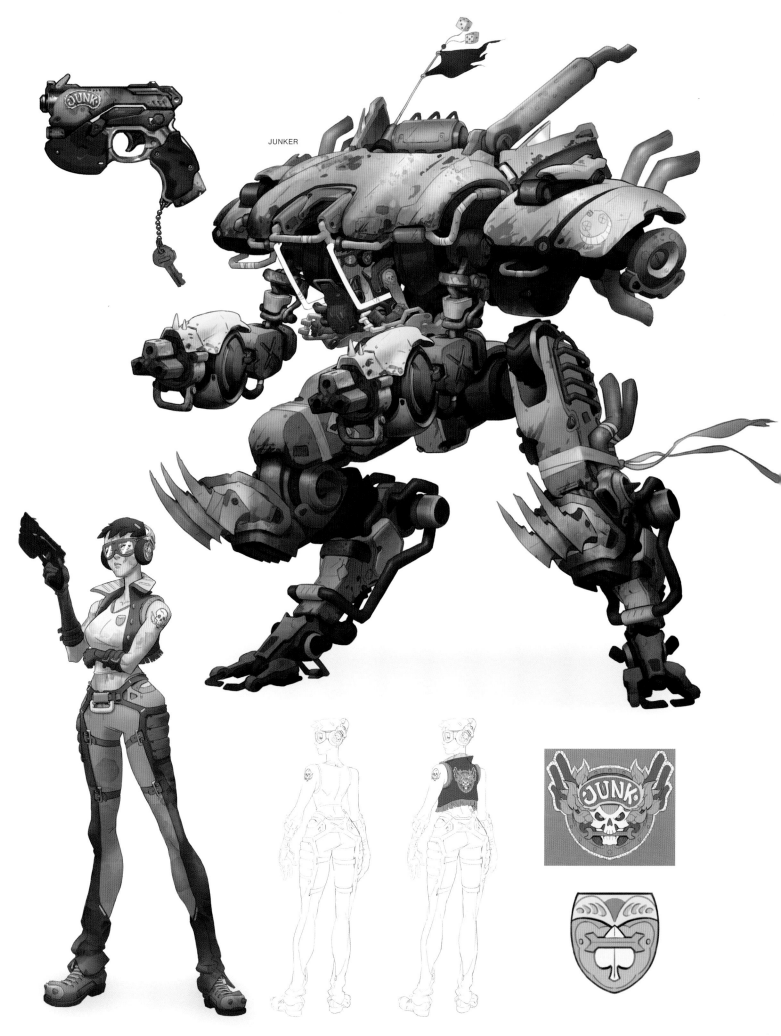

JUNKER

ALL IMAGES: **JOHN POLIDORA**

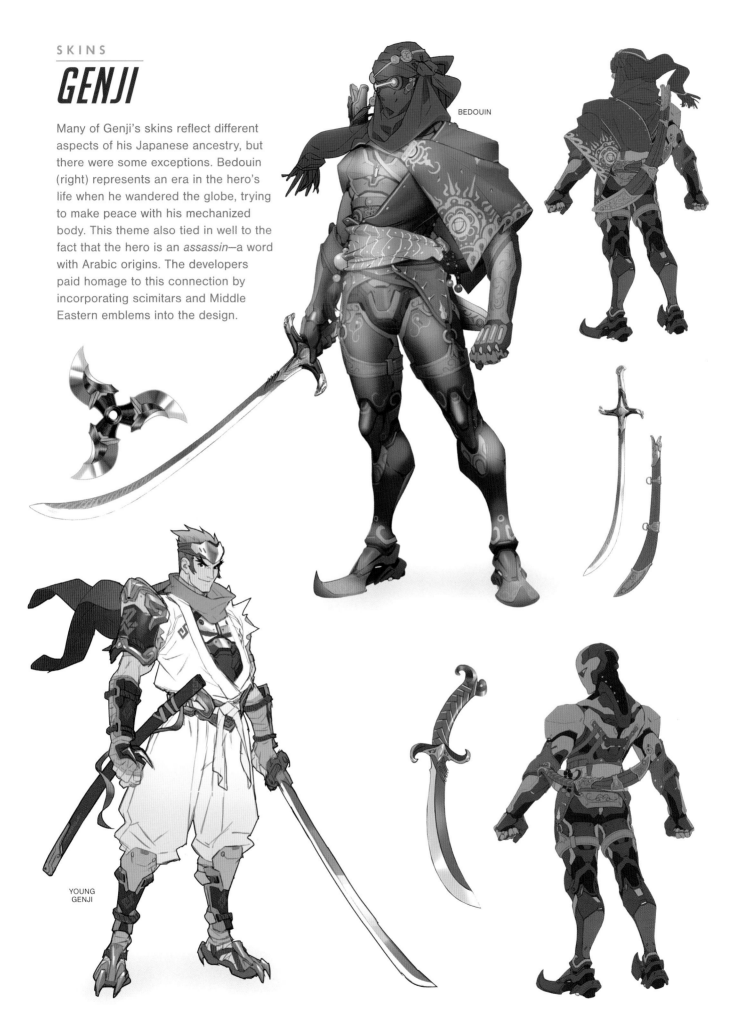

SKINS
GENJI

Many of Genji's skins reflect different aspects of his Japanese ancestry, but there were some exceptions. Bedouin (right) represents an era in the hero's life when he wandered the globe, trying to make peace with his mechanized body. This theme also tied in well to the fact that the hero is an *assassin*—a word with Arabic origins. The developers paid homage to this connection by incorporating scimitars and Middle Eastern emblems into the design.

BEDOUIN

YOUNG GENJI

TOP: **JOHN POLIDORA** AND **ARNOLD TSANG**, BOTTOM: **ARNOLD TSANG**

HANZO

The game team rendered young versions of Hanzo (bottom right) and Genji (opposite page, bottom left) to further both brothers' backstories and their relationship. Early on, the developers took steps to ensure that the heroes looked similar but unmistakable. For Hanzo, they based his bow and half-sleeve outfit on those of traditional Japanese archers. They also made the color and style of his hair different from Genji, which had the dual benefits of visually setting them apart and emphasizing their different personalities.

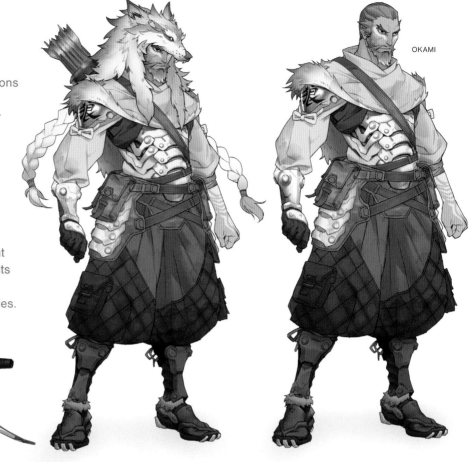

OKAMI

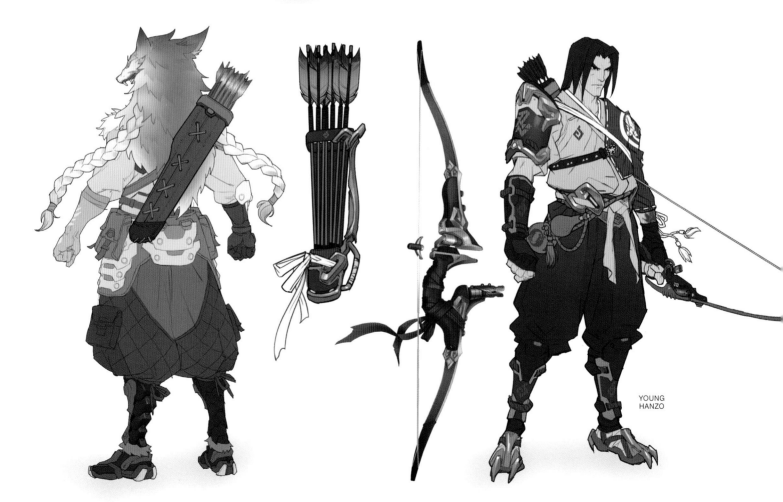

YOUNG HANZO

ALL IMAGES: **ARNOLD TSANG**

JUNKRAT

Making skins can involve changing *every* part of a hero's appearance, including weapons and devices. For Junkrat, that meant creating new designs for his Frag Launcher, Concussion Mine, Steel Trap, and RIP-Tire that reflected the skin's theme.

When formulating these skins, the developers were also careful to honor the core fantasy of the character. They made all of Junkrat's skins consistent with his personality: an unpredictable madman who leaves a trail of destruction in his wake.

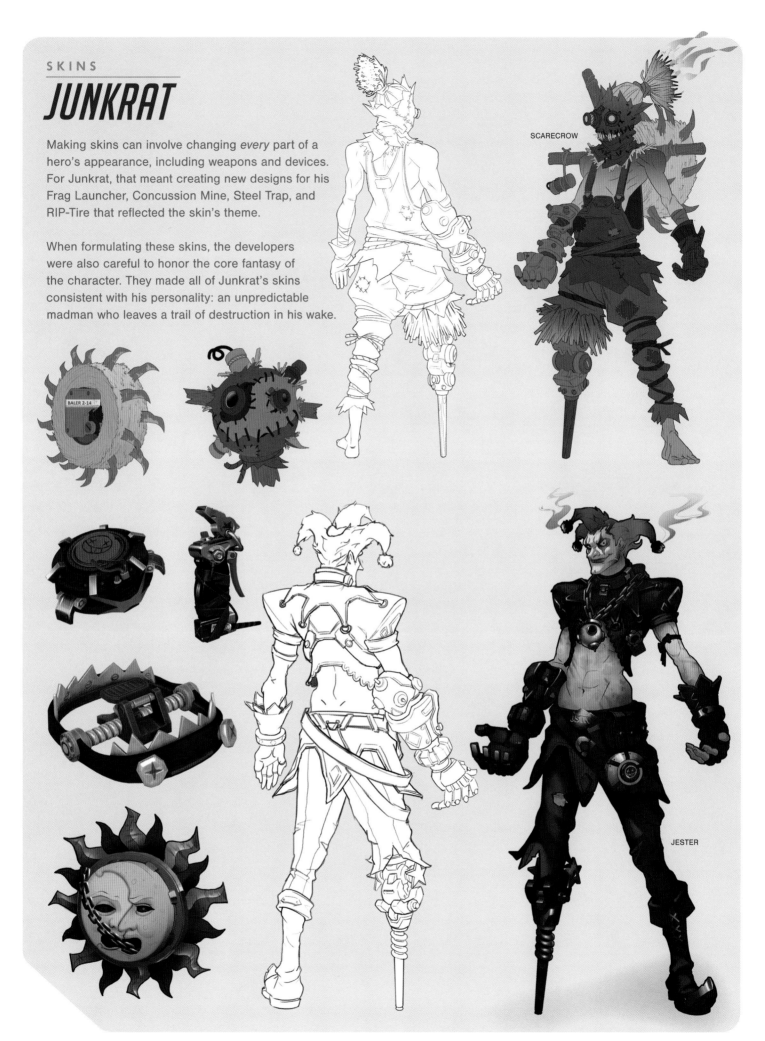

SCARECROW

JESTER

TOP RIGHT: **DAVID KANG** AND **ARNOLD TSANG**, REMAINDER OF IMAGES: **DAVID KANG**

LÚCIO

The developers focused on musical and athletic themes for Lúcio's skins. For designs like Ribbit (bottom left), they looked to EDM and techno music for inspiration. Some of these ideas originated from the hero's backstory. Breakaway (below) was based on Lúcio's favorite sport: hockey.

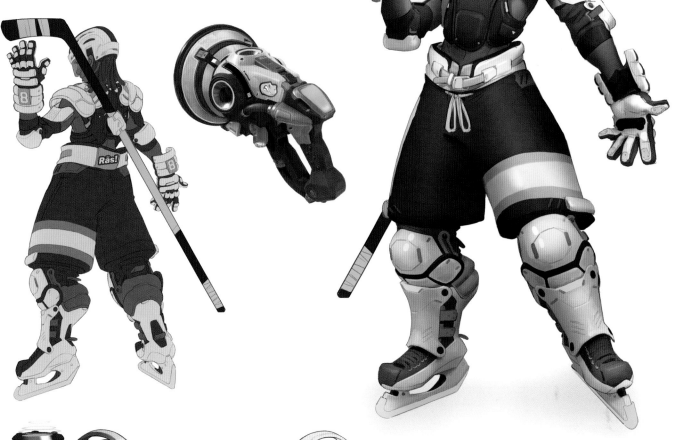

BREAKAWAY

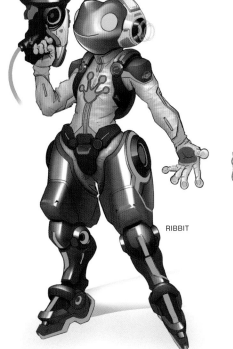

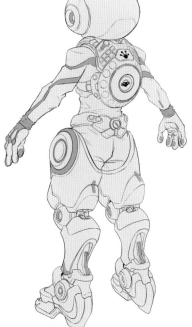

RIBBIT

TOP: **JOHN POLIDORA**, BOTTOM: **DAVID KANG**

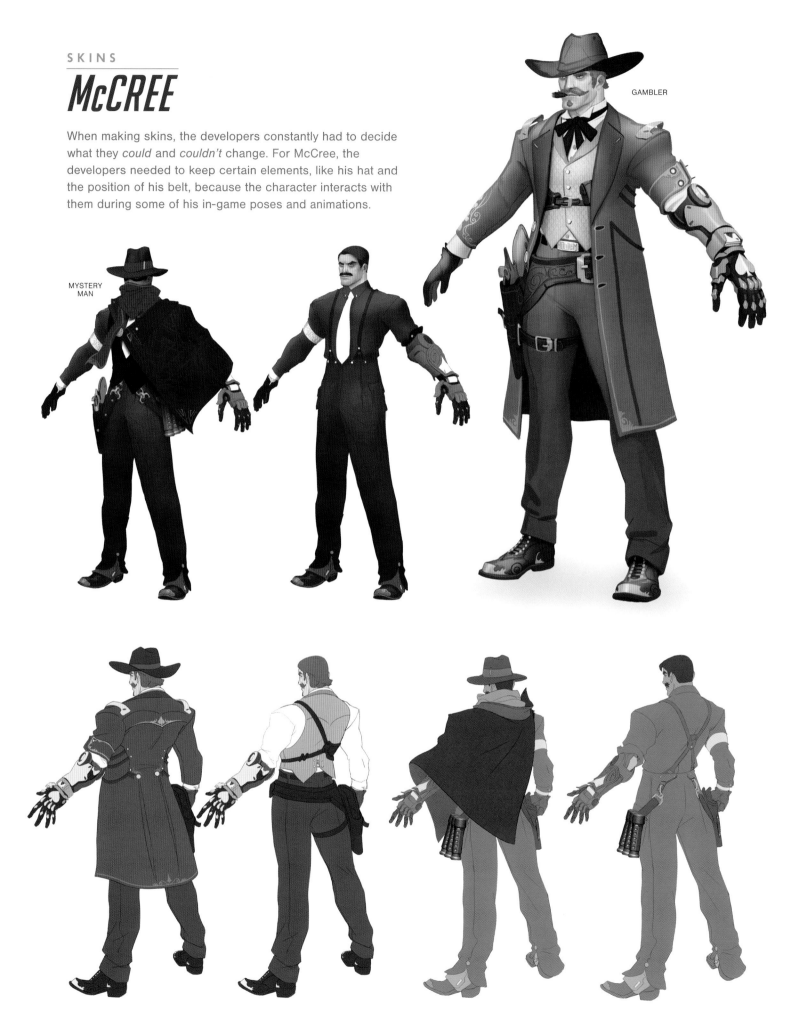

McCREE

When making skins, the developers constantly had to decide what they *could* and *couldn't* change. For McCree, the developers needed to keep certain elements, like his hat and the position of his belt, because the character interacts with them during some of his in-game poses and animations.

GAMBLER

MYSTERY
MAN

ALL IMAGES: **JOHN POLIDORA**

SKINS
MEI

Mei's skins were based on everything from her Chinese heritage to her abilities. Reimagining her as a firefighter for the Rescue Mei skin seemed like a great fit for her weapon and ice-based skills (below). The bulky jacket and boots also matched the size and shape of Mei's standard appearance, allowing the designers to keep her distinct silhouette intact.

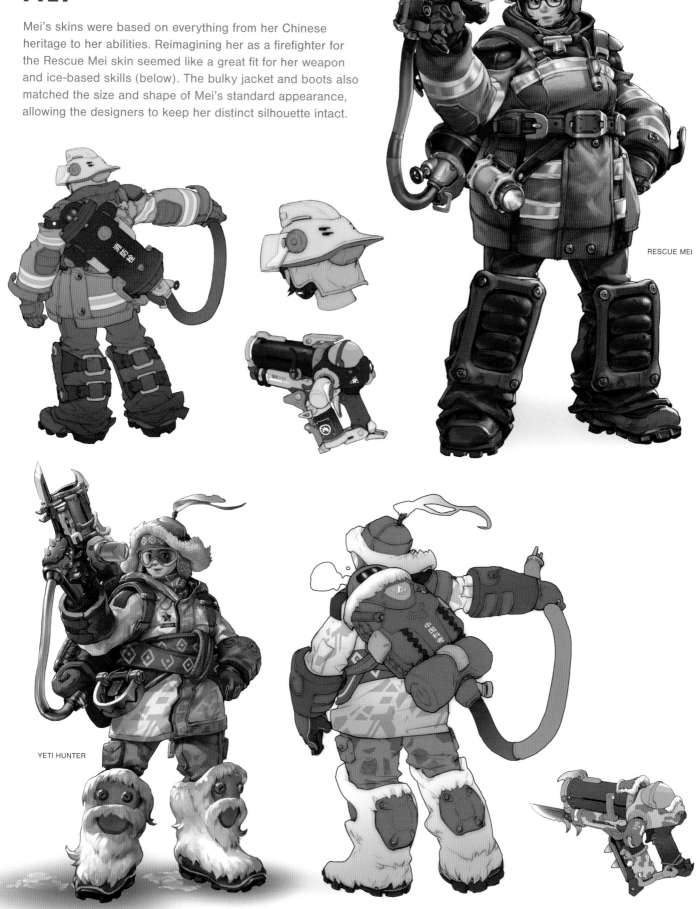

RESCUE MEI

YETI HUNTER

ALL IMAGES: **BEN ZHANG**

SKINS
MERCY

The developers drew from Mercy's fantasy influences to create skins that incorporated decorative pieces rather than high-tech features. Valkyrie (right) was based on the Norse mythological beings that had the power to resurrect fallen warriors or shepherd them to Valhalla. Devil (bottom) was a direct inversion of the angelic themes that inspired her standard outfit. Sharp angles and gothic designs were used in this ensemble to contrast with the smooth edges and futuristic look of her normal appearance.

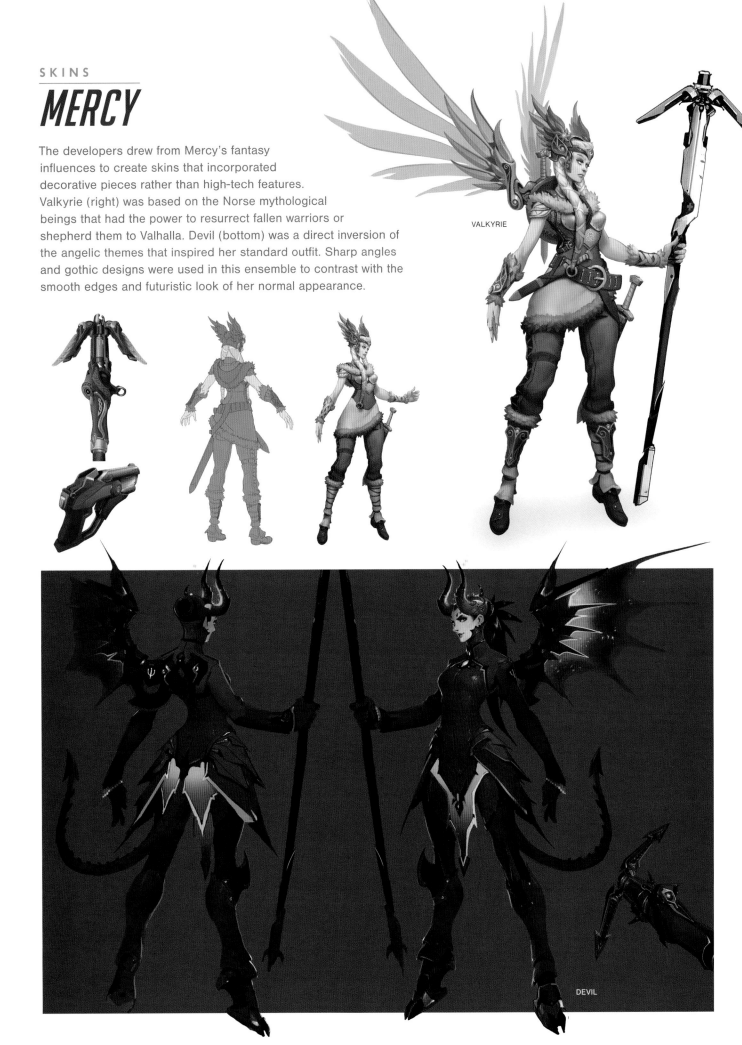

VALKYRIE

DEVIL

TOP: **JOHN POLIDORA**, BOTTOM: **LAUREL AUSTIN**

ORISA

In some of Orisa's early concept art, her hunched posture and bulky body resembled those of a beetle. The developers went away from this idea for her final appearance, straightening her torso to make her feel mightier and more heroic. However, her beetle-like origins were embraced for the Dynastinae skin (right). The Protector skin (bottom) headed in the opposite direction, favoring sleek shapes and holographic elements.

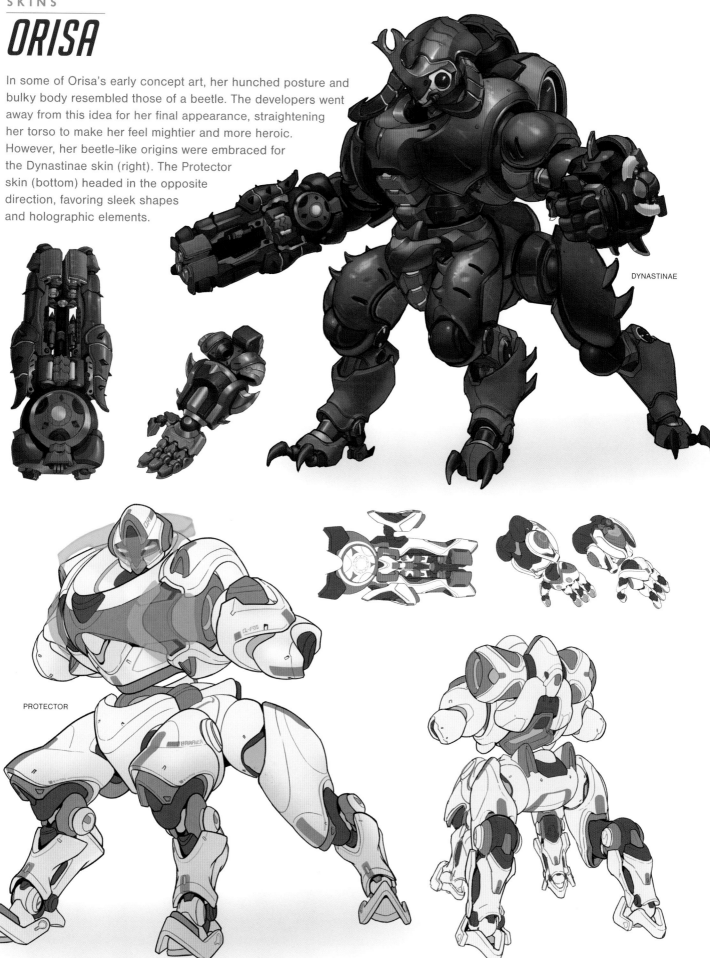

DYNASTINAE

PROTECTOR

TOP: **MORTEN SKAALVIK**, BOTTOM: **QIU FANG**

PHARAH

Pharah's Thunderbird skin (below) was based on the art motifs of the indigenous peoples who inhabit the Pacific Northwest coast of North America. More than just a unique design, this skin also tied into the hero's multicultural origins: her mother is Egyptian, and her father is from an indigenous culture in the Pacific Northwest coast.

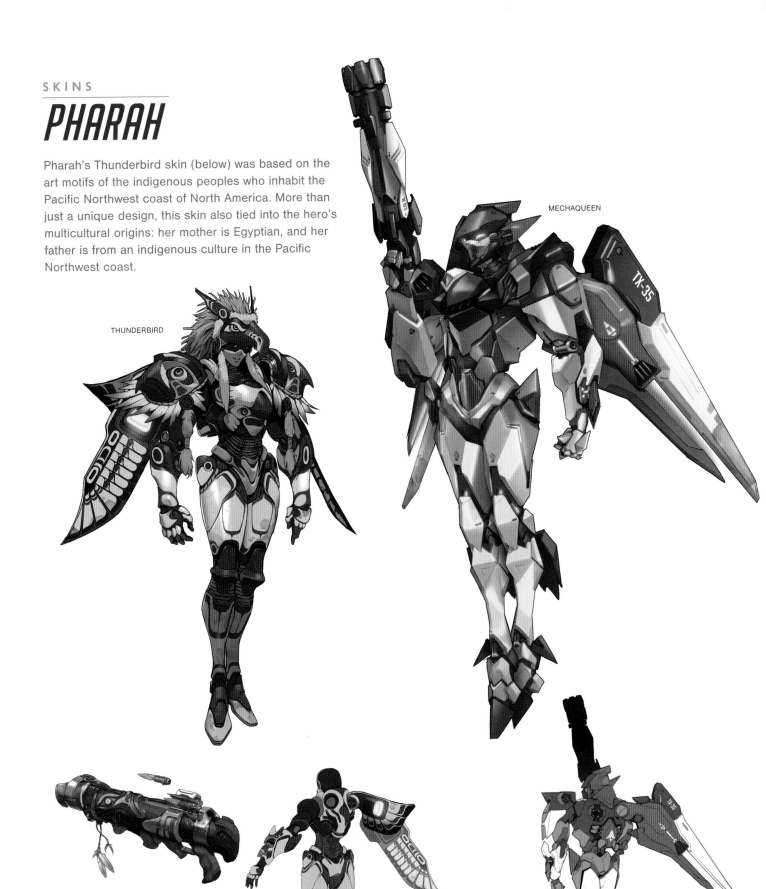

THUNDERBIRD

MECHAQUEEN

SHOULDER
ARMOR

REAPER

Reaper's Mariachi skin included a hat, greatly altering his normal appearance. The developers were concerned that it might look too much like McCree from a distance. In the end, Reaper's unique posture and in-game animations made him easily recognizable despite the changes to his outfit.

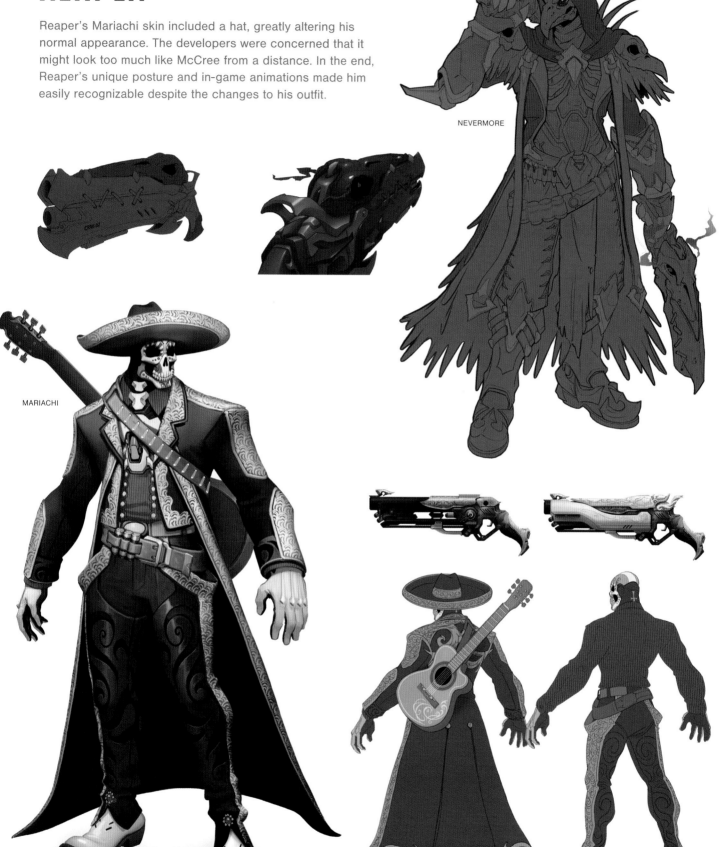

NEVERMORE

MARIACHI

TOP: **DAVID KANG**, BOTTOM: **JOHN POLIDORA**

REINHARDT

During Reinhardt's early concepting, the developers were planning on using a golden lion theme for the hero's standard appearance. They ultimately toned back these elements in Reinhardt's final version, but they didn't abandon the original idea. They still loved the concept of a lion-themed version of the hero, and this vision was later realized as the Lionhardt skin (right).

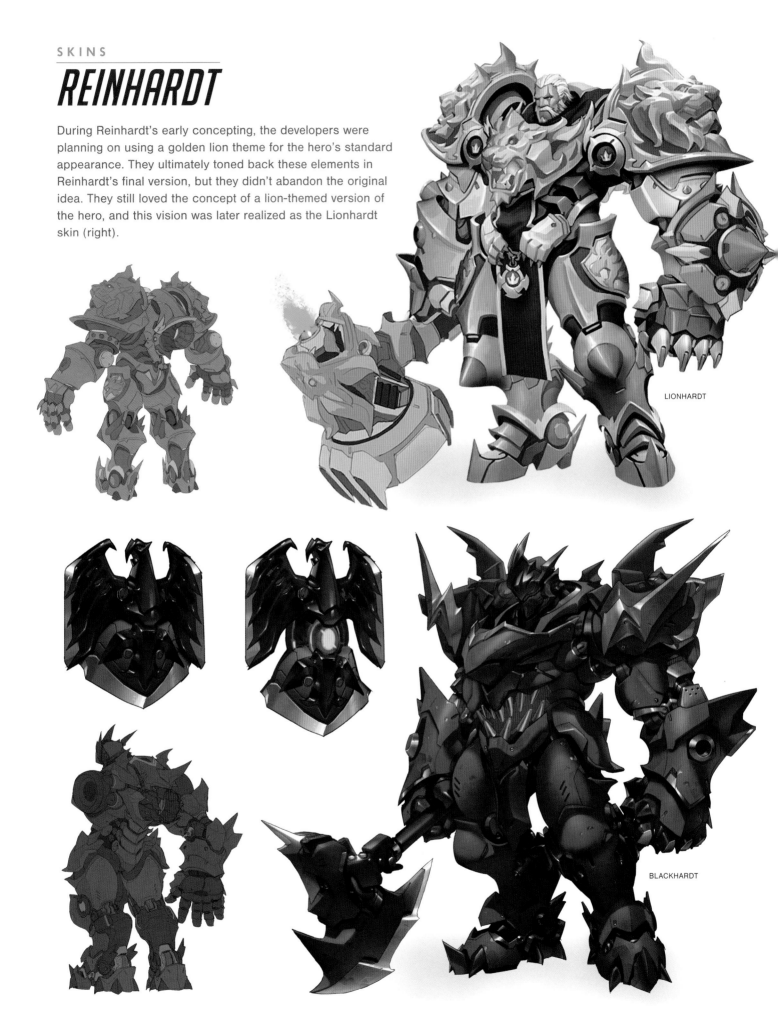

LIONHARDT

BLACKHARDT

TOP: **JOHN POLIDORA**, BOTTOM: **ARNOLD TSANG** AND **JOHN POLIDORA**

ROADHOG

When creating skins based on other cultures, the developers conduct thorough research. For the Toa appearance (below), they consulted a Maori tattoo artist to ensure Roadhog's designs were authentic. While working with this contact, the developers also learned the proper number of feathers that a warrior should wear: three. The final version of Toa was updated to reflect this, which gave the skin another layer of accuracy.

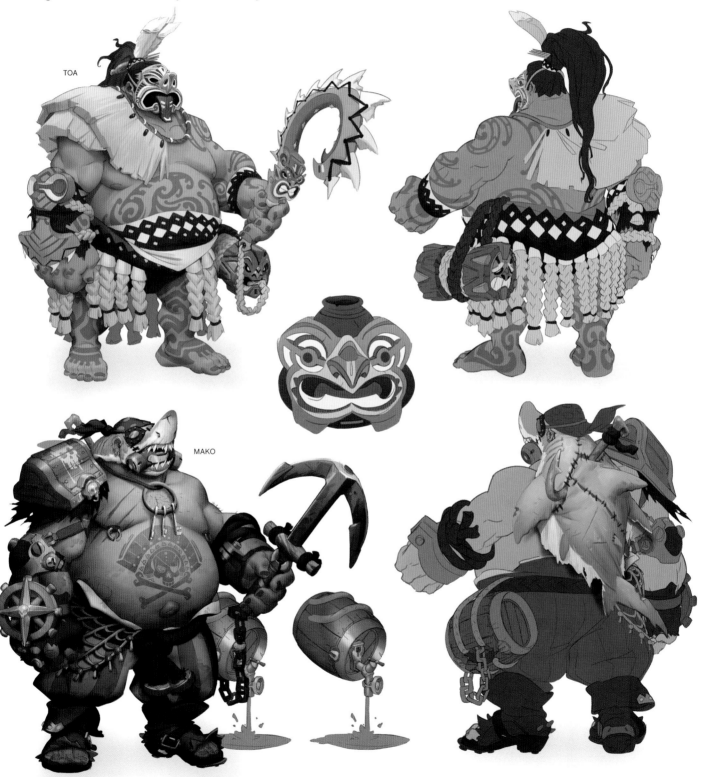

TOA

MAKO

ALL IMAGES: **JOHN POLIDORA**

SOLDIER: 76

The game team always wanted to do a skin for Soldier: 76 themed around the '70s era, but everyone had different ideas about what that meant stylistically. Eventually, two skins emerged from these discussions: Commando: 76 (bottom) and Daredevil: 76 (right). Though they both have very distinct tones, they were both influenced by clothing and designs from the 1970s.

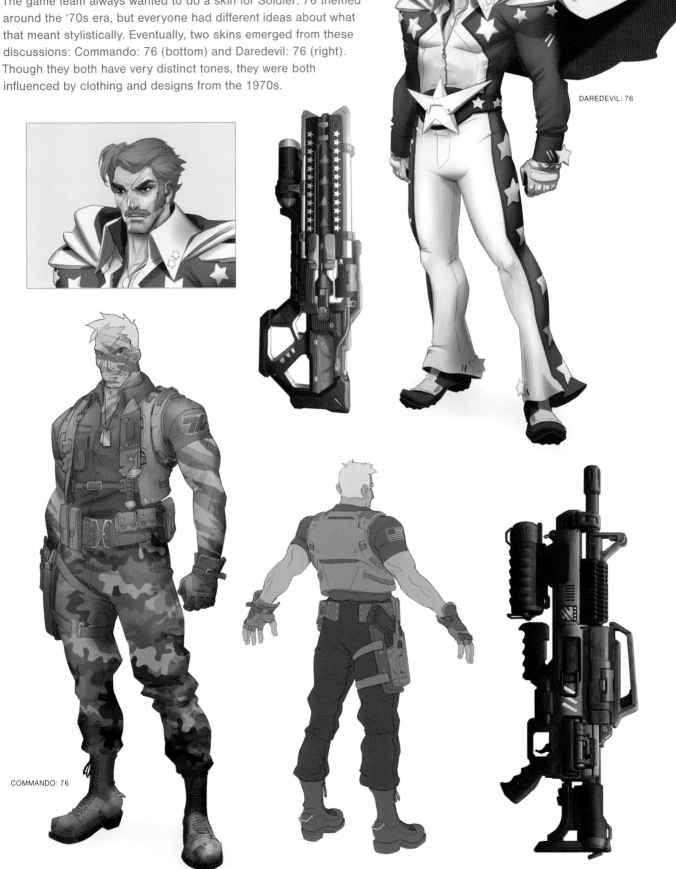

DAREDEVIL: 76

COMMANDO: 76

SOMBRA

The developers wanted Sombra's skins to express her unparalleled personality: a mix of smart, agile, and dangerous. Los Muertos (bottom) accomplished this and more. The skin tied into the hero's backstory, when Sombra's hacking prowess was employed by the Los Muertos gang in Mexico.

One of the challenges with building this appearance was Sombra's tattoos. The developers had to adjust their design tools and create new technology to support glowing effects on the character's skin.

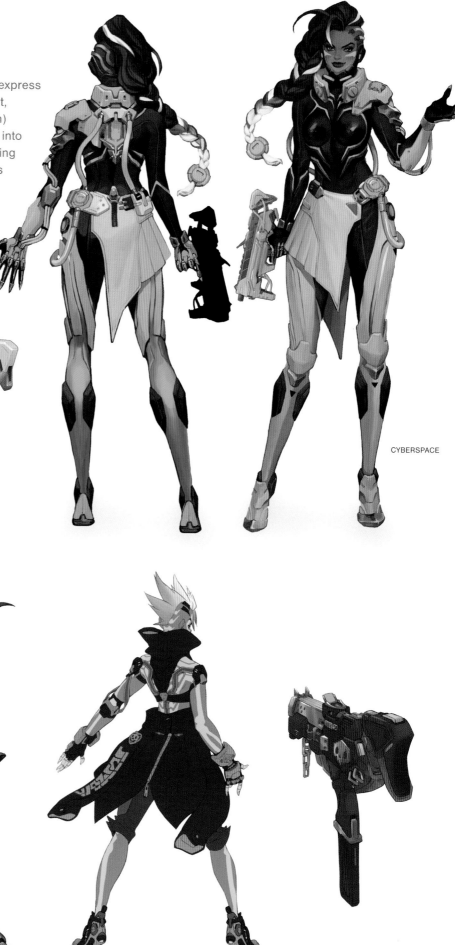

CYBERSPACE

LOS MUERTOS

TOP: **JUNGAH LEE**, BOTTOM: **JOHN POLIDORA**

SYMMETRA

Symmetra is a highly skilled architech who works for the Vishkar Corporation. To express this aspect of her character, the developers reimagined the hero in an outfit that would befit someone working in a scientific laboratory. The design went through several iterations before the team found a futuristic look that matched *Overwatch*'s tone (bottom).

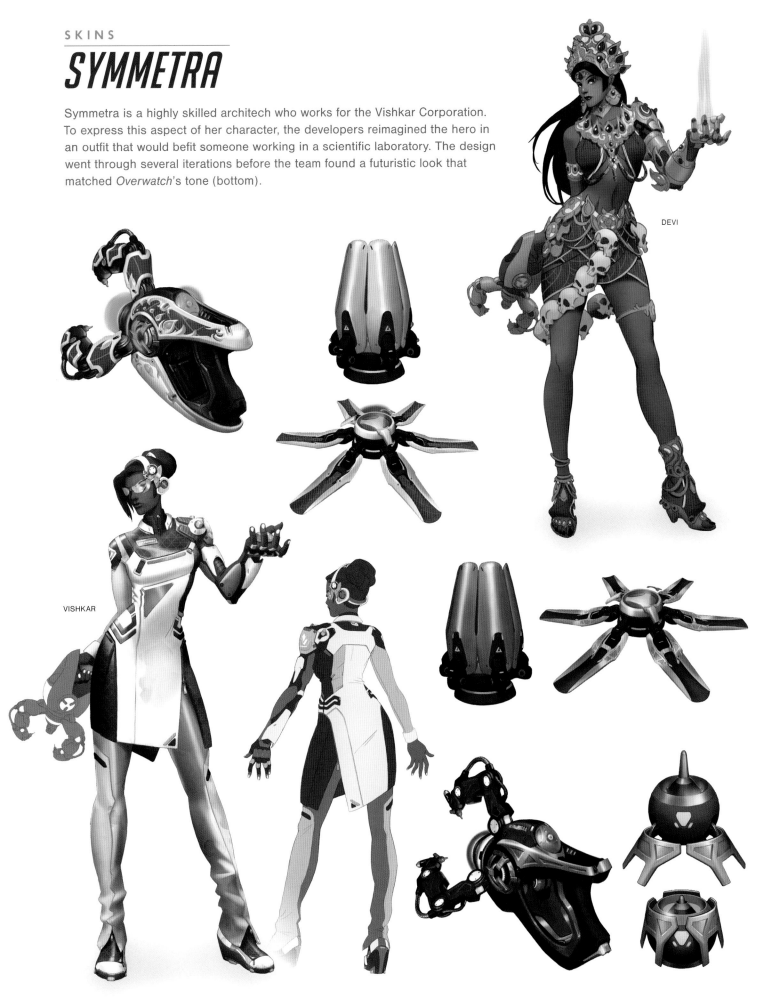

DEVI

VISHKAR

ALL IMAGES: **JOHN POLIDORA**

TORBJÖRN

Torbjörn's long beard, short stature, and eyepatch made him the perfect fit for the pirate-themed Blackbeard skin (bottom). Apart from simply changing the hero's wardrobe, the developers also animated the wheel on his back so that it would constantly spin during gameplay.

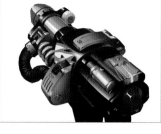

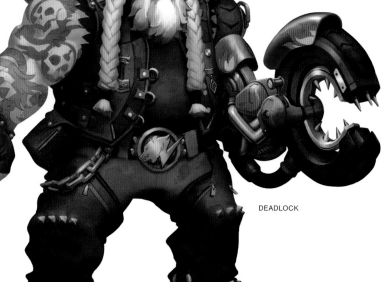

DEADLOCK

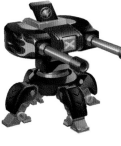

BLACKBEARD

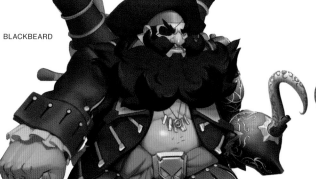

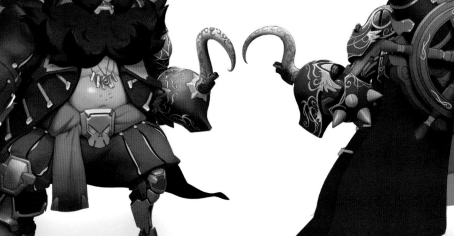

TRACER

When experimenting with skins for Tracer, the designers found inspiration in the punk rock movement of the 1970s. This musical genre fit the hero's spunky personality, and it also had ties to her home country of England. Tracer's pistols and gauntlets were modeled after guitars, while her hairstyle and clothing were based on popular designs and trends of punk rock culture.

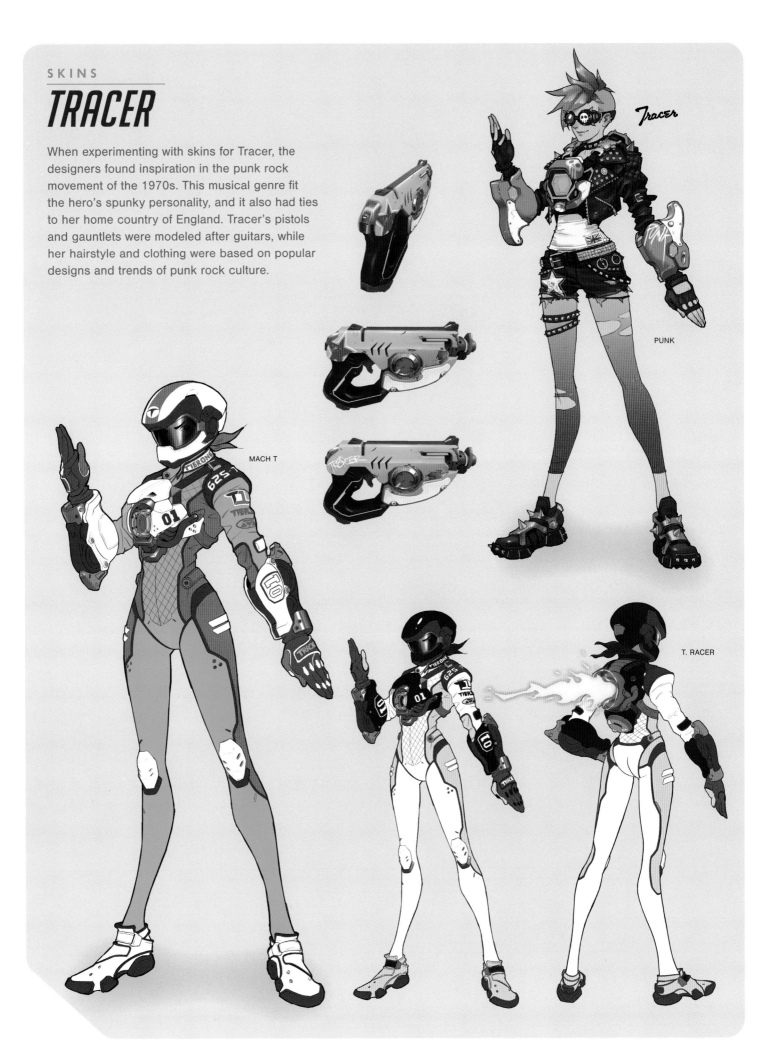

PUNK

MACH T

T. RACER

TOP RIGHT: **ARNOLD TSANG**, REMAINDER OF IMAGES: **DAVID KANG**

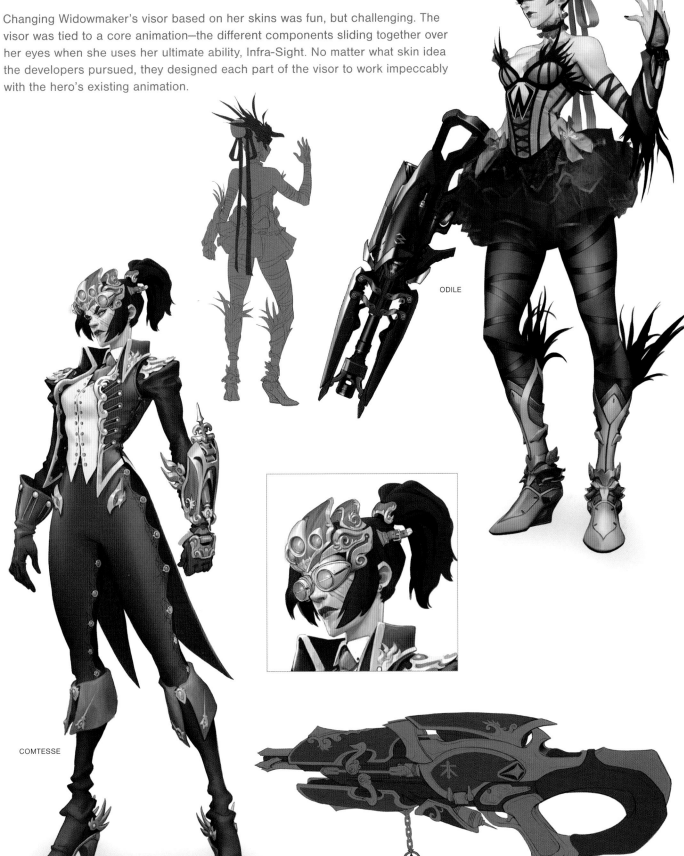

WIDOWMAKER

Changing Widowmaker's visor based on her skins was fun, but challenging. The visor was tied to a core animation—the different components sliding together over her eyes when she uses her ultimate ability, Infra-Sight. No matter what skin idea the developers pursued, they designed each part of the visor to work impeccably with the hero's existing animation.

ODILE

COMTESSE

LEFT: **JOHN POLIDORA**, RIGHT: **JOHN POLIDORA** AND **ROMAN KENNEY**, LOWER RIGHT: **DAVID KANG**

SKINS
WINSTON

Some heroes feel more appropriate for serious skins. Others, like Winston, lend themselves to light-hearted ones. Though many of these skins are fun in nature, they still honor the core facets of his personality and backstory. One example is the Explorer skin (right), which the developers created to tie into Winston's primate origins as well as his love of knowledge, adventure, and discovery.

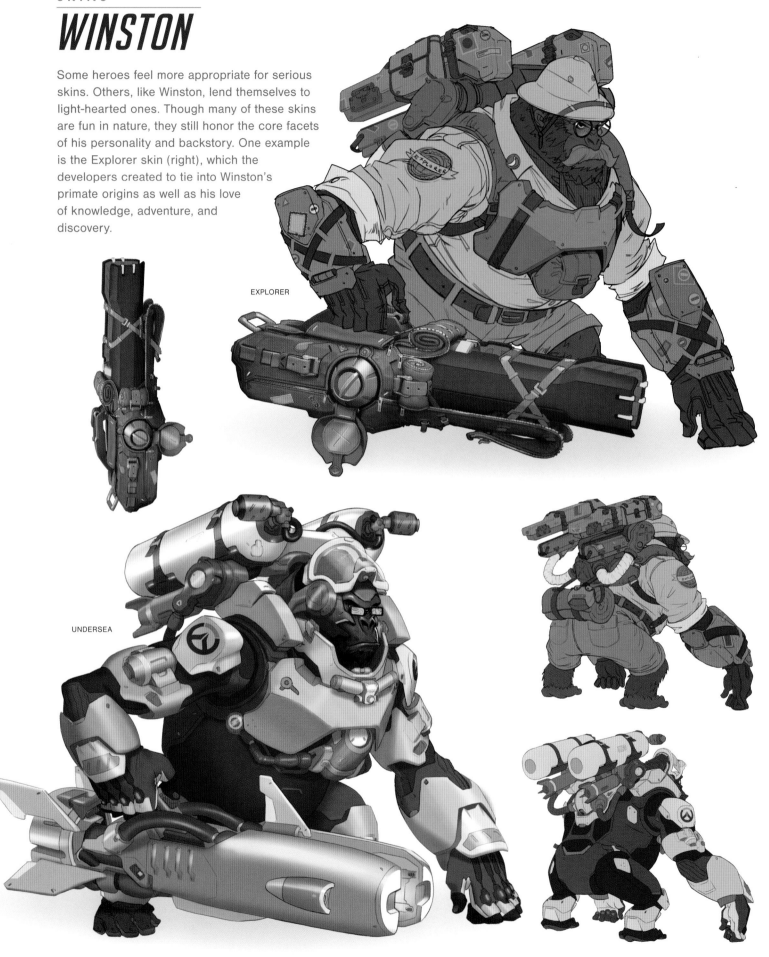

EXPLORER

UNDERSEA

ARNOLD TSANG, JOHN POLIDORA, AND DAVID KANG

ZARYA

The developers often craft skins around a character's backstory. For Zarya, the Siberian Front (bottom) design conveyed her Russian heritage and service to her homeland in the Russian Defense Forces.

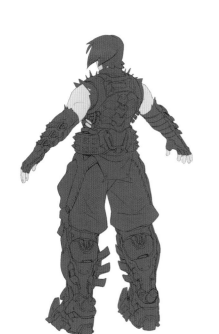

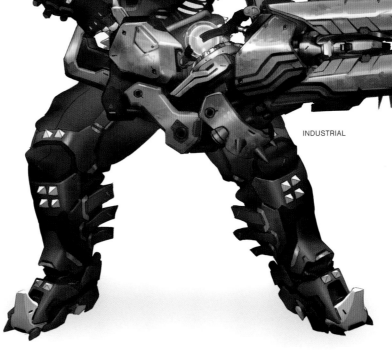

INDUSTRIAL

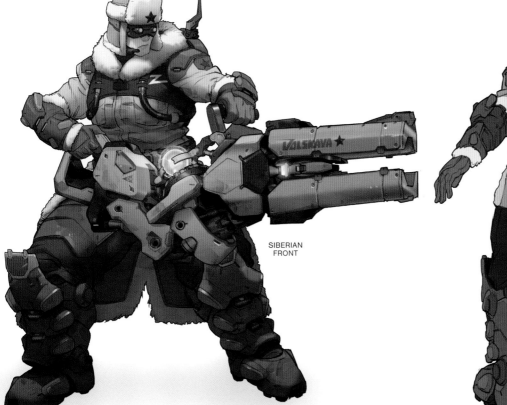

SIBERIAN FRONT

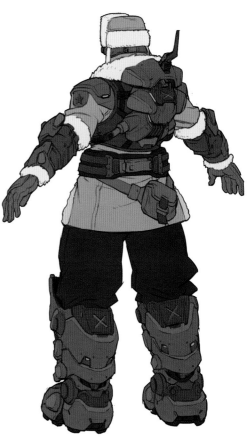

TOP: **JOHN POLIDORA**, BOTTOM: **ARNOLD TSANG**

ZENYATTA

Many of Zenyatta's skins were based on enlightened mythological figures, which the game team felt represented the hero's sage-like qualities. This presented many different themes and ideas to explore while concepting his appearances. However, the developers were very careful with one factor of Zenyatta's character: his orbs.

Because the animations for Zenyatta's orbs are so intricate, the developers avoided making major changes to their shapes. Instead, they applied new textures and patterns to the spheres that reflected each skin.

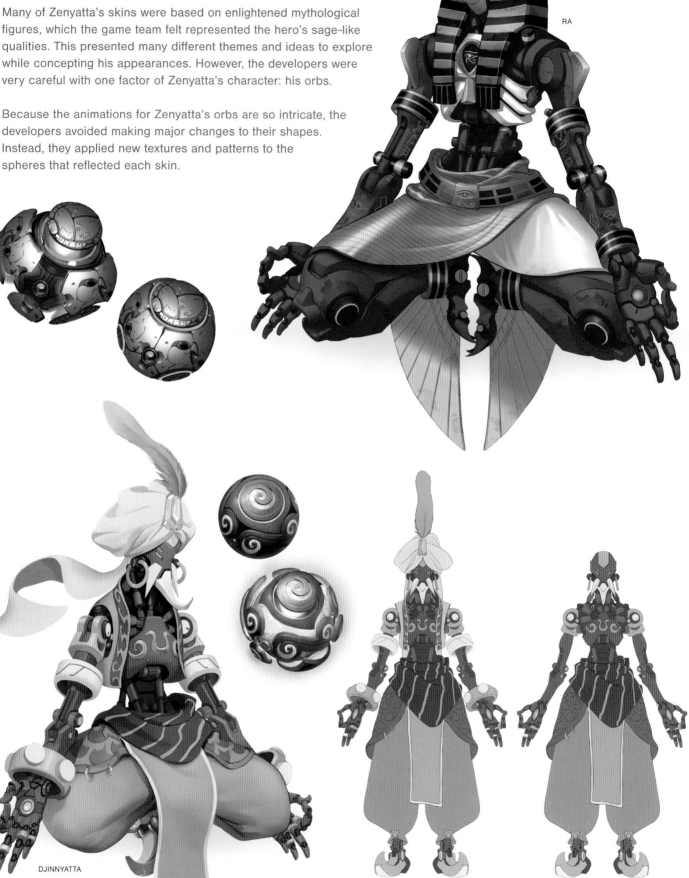

RA

DJINNYATTA

LOWER LEFT: **JOHN POLIDORA** AND **ARNOLD TSANG**, REMAINDER OF IMAGES: **JOHN POLIDORA**

OVERWATCH: ORIGINS EDITION

The *Origins Edition* skins were an opportunity to reveal backstories for some of the characters. Tracer's Slipstream appearance (right) depicts her when she was a test pilot for a prototype teleporting fighter. Her aviator shades, vest, and the large pocket on her thigh were all inspired by fighter pilot uniforms.

But perhaps the most important part of her wardrobe was her scarf. This skin portrays Tracer before she wore a chronal accelerator, meaning that she would not create a trail of blue energy when zipping around the map with her Blink ability. The scarf was included to take the place of that art element, allowing other players to still visually track where Tracer was moving.

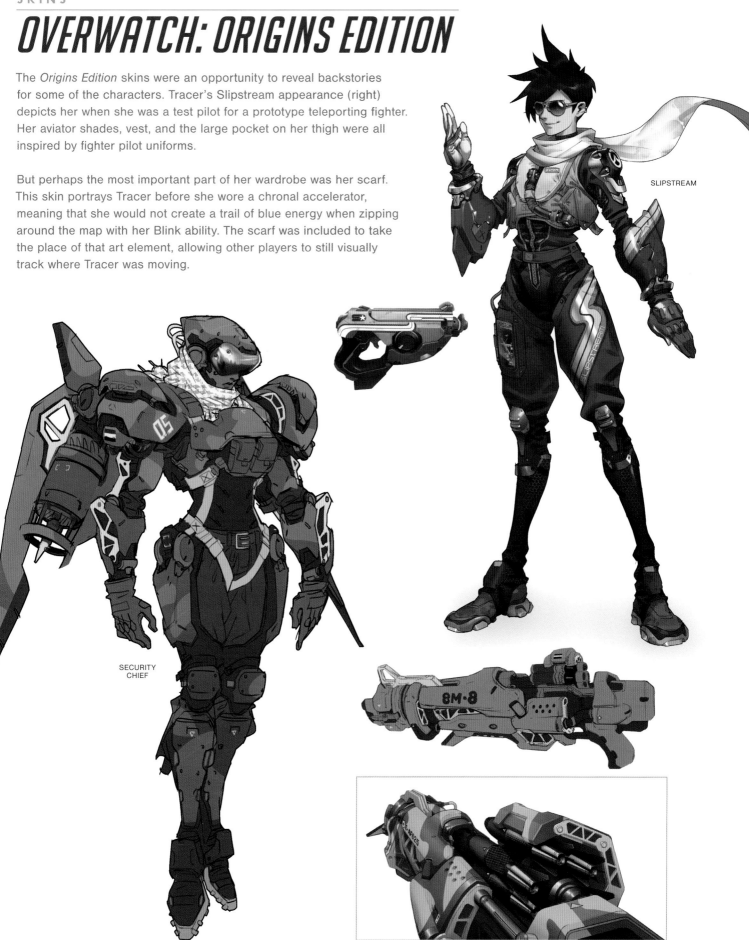

SLIPSTREAM

SECURITY
CHIEF

ARNOLD TSANG AND **DAVID KANG**

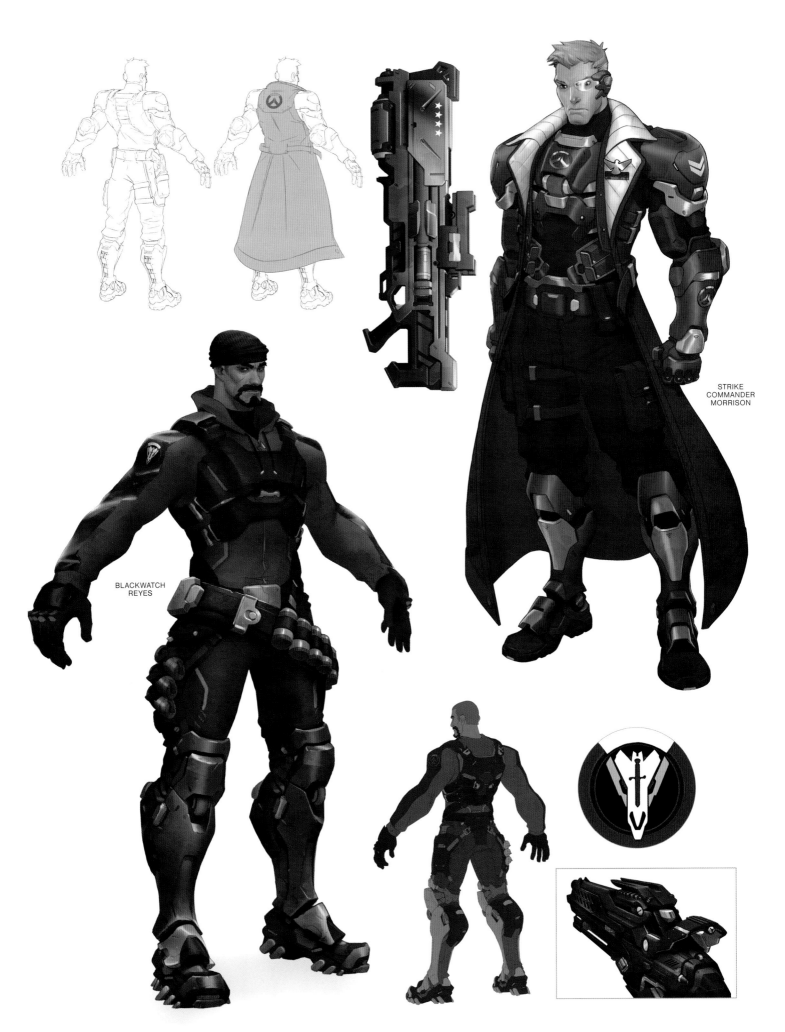

STRIKE
COMMANDER
MORRISON

BLACKWATCH
REYES

ALL IMAGES: **JOHN POLIDORA**

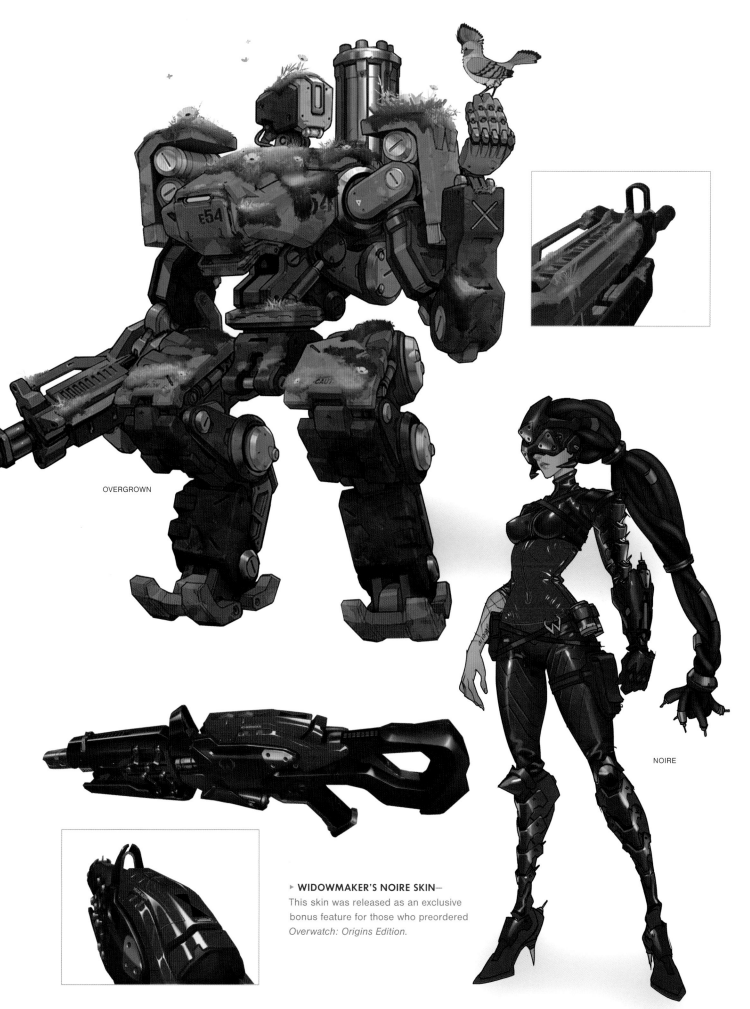

OVERGROWN

NOIRE

▶ **WIDOWMAKER'S NOIRE SKIN—**
This skin was released as an exclusive
bonus feature for those who preordered
Overwatch: Origins Edition.

LOWER RIGHT: **ARNOLD TSANG**, REMAINDER OF IMAGES: **DAVID KANG**

HEROES OF THE STORM

After *Overwatch*'s release, some of its heroes began appearing in another Blizzard game: *Heroes of the Storm.* The developers crafted skins that featured in both titles, and they married them to the characters' countries of origin. Genji's mask (right) was based on styles and color schemes seen in Japanese Noh theater. D.Va's skin (bottom) reflected the look of police cars and uniforms in South Korea.

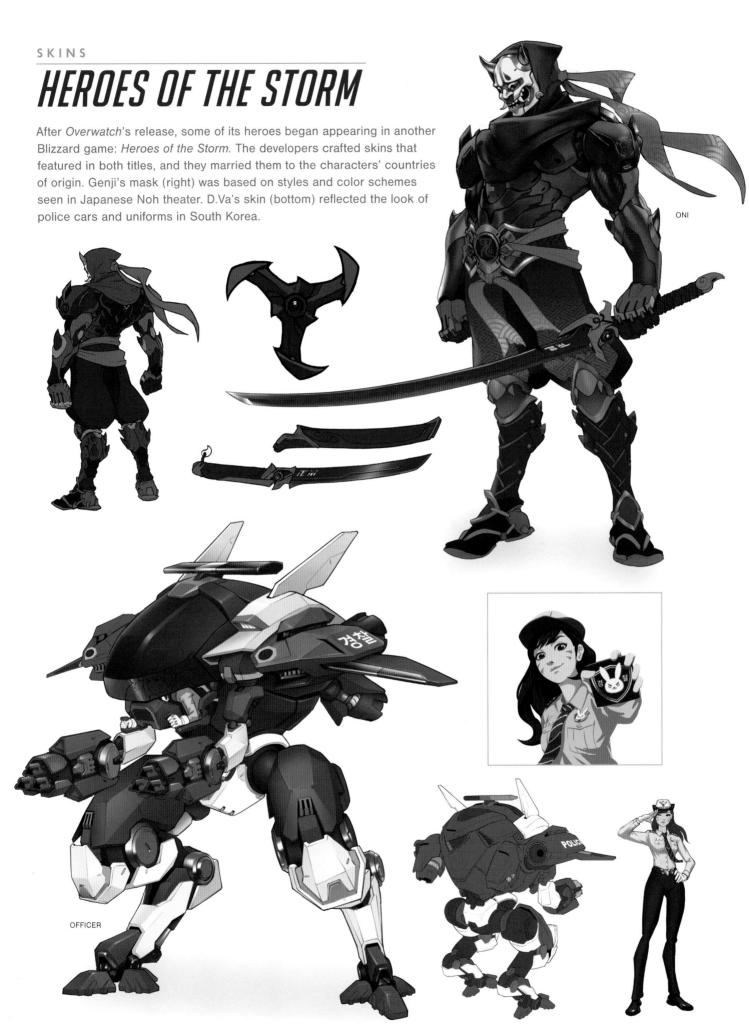

ONI

OFFICER

TOP: **BEN ZHANG**, SWORDS: **BEN ZHANG** AND **ROMAN KENNEY**, BOTTOM: **DAVID KANG**

SUMMER GAMES

The Summer Games skins drew inspiration from the heroes' nationalities, as well as sports that fit their playstyles and personalities. Some of these designs required major changes to the characters' standard outfits. For Zarya (below), every detail of her appearance was altered to fit the sports theme: she adopted the color scheme of the Russian flag, and her belt and leg armor morphed into equipment a professional weightlifter would use. Even her particle cannon was upgraded with weight plates.

SELEÇÃO

CHAMPION

TRACK AND FIELD

BEN ZHANG AND **JOHN POLIDORA**

OVERWATCH HALLOWEEN TERROR

To bolster the *Overwatch* Halloween Terror event, the developers produced stories and skins inspired by steampunk and classic horror aesthetics. The backstory for the in-game event told of a mad scientist named Dr. Junkenstein (bottom) who brought a hideous monster to life (opposite page, top). The game team incorporated similar design elements into both skins, such as Tesla coils and valve meters, to make the heroes feel stylistically cohesive.

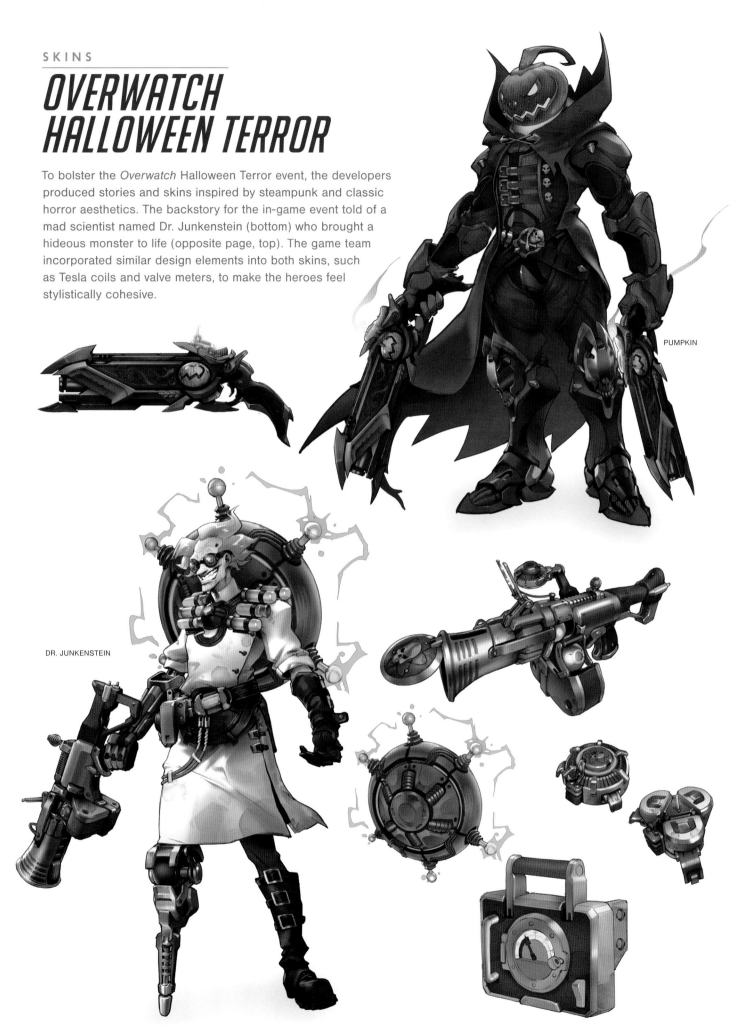

PUMPKIN

DR. JUNKENSTEIN

ALL IMAGES: **BEN ZHANG**

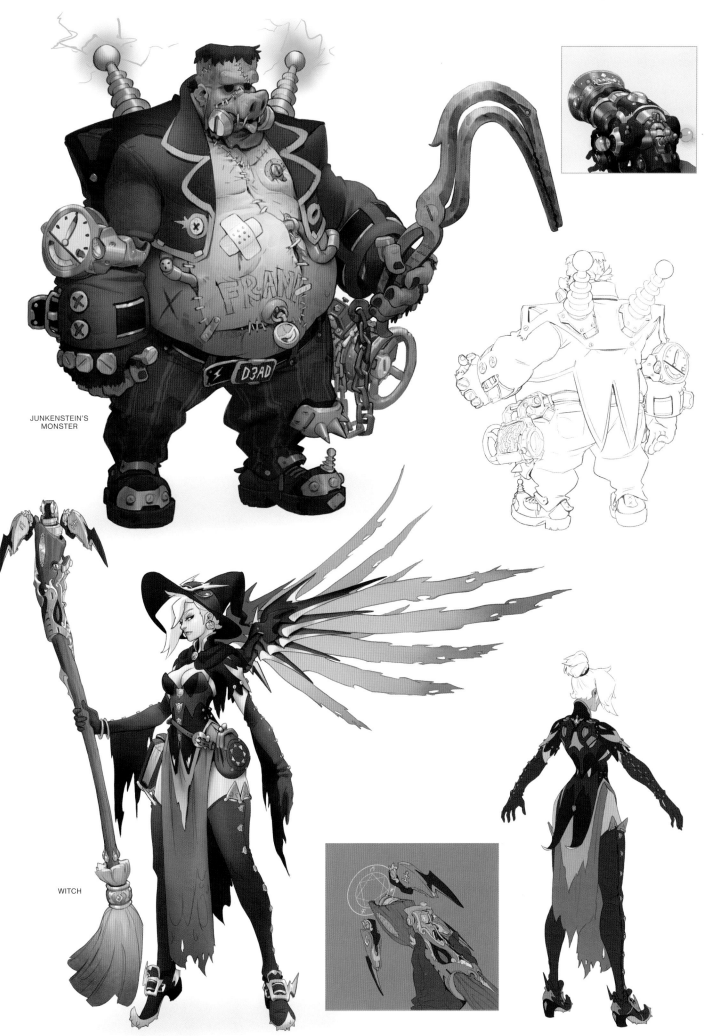

JUNKENSTEIN'S
MONSTER

WITCH

ALL IMAGES: **JOHN POLIDORA**

WINTER WONDERLAND

The Winter Wonderland event gave the developers a chance to reimagine the heroes in light-hearted, festive ways. One of the most crucial parts of building these skins was designing the weapons.

Because *Overwatch* is a first-person shooter, the hero's weapon is something that players always see. That means every pistol, shotgun, and hammer must represent an extension of a hero's skin.

For Winston's skin (below), the developers created a gun built from scraps of wood, tape, and discarded tech—things that a primitive Yeti roaming the snowy mountains might stumble across.

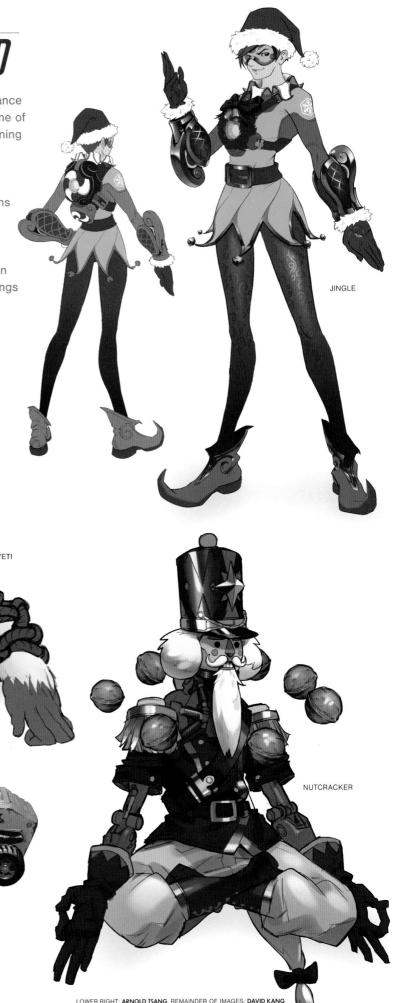

JINGLE

YETI

NUTCRACKER

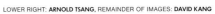

LOWER RIGHT: **ARNOLD TSANG**, REMAINDER OF IMAGES: **DAVID KANG**

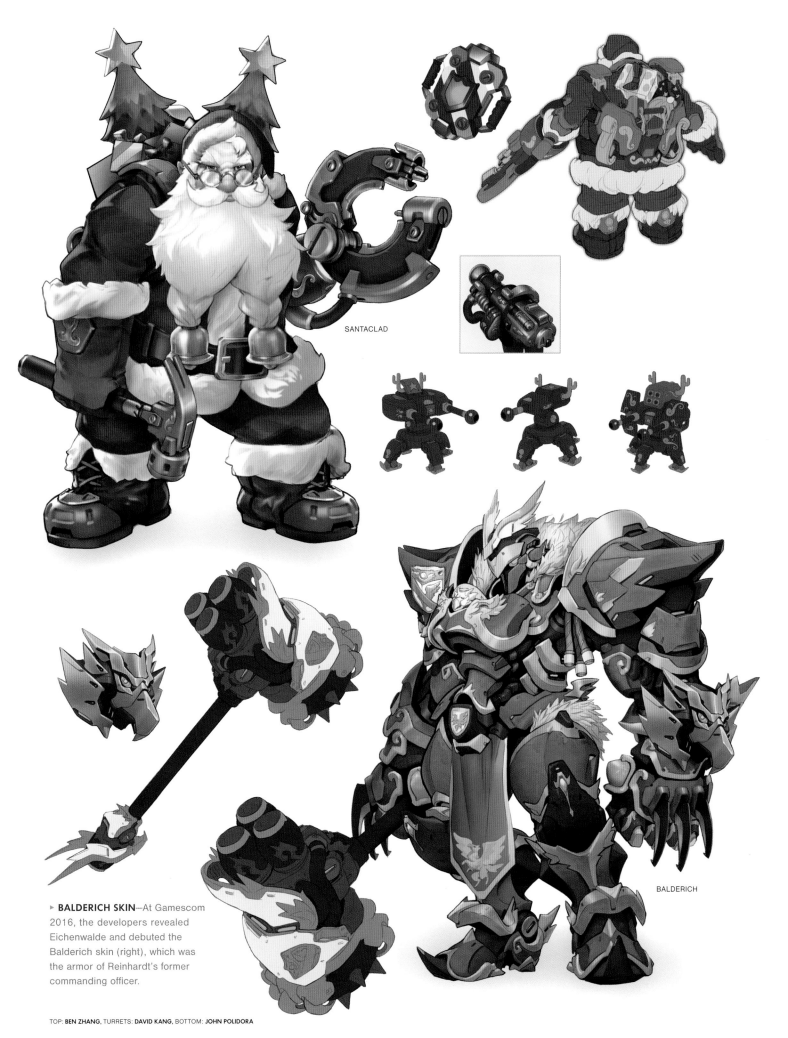

SANTACLAD

BALDERICH

▶ **BALDERICH SKIN**—At Gamescom 2016, the developers revealed Eichenwalde and debuted the Balderich skin (right), which was the armor of Reinhardt's former commanding officer.

TOP: **BEN ZHANG**, TURRETS: **DAVID KANG**, BOTTOM: **JOHN POLIDORA**

YEAR OF THE ROOSTER

Most of the skins released for the Year of the Rooster event were influenced by characters from classic Chinese folktales. Mei's Chang'e appearance (next spread, left page, bottom) was based on one such individual: a goddess who lives in the moon. Apart from changing her clothing, the developers also redesigned Snowball to resemble the moon goddess's rabbit companion.

PALANQUIN

SANZANG

TOP: **DAVID KANG**, BOTTOM: **BEN ZHANG** AND **ARNOLD TSANG**

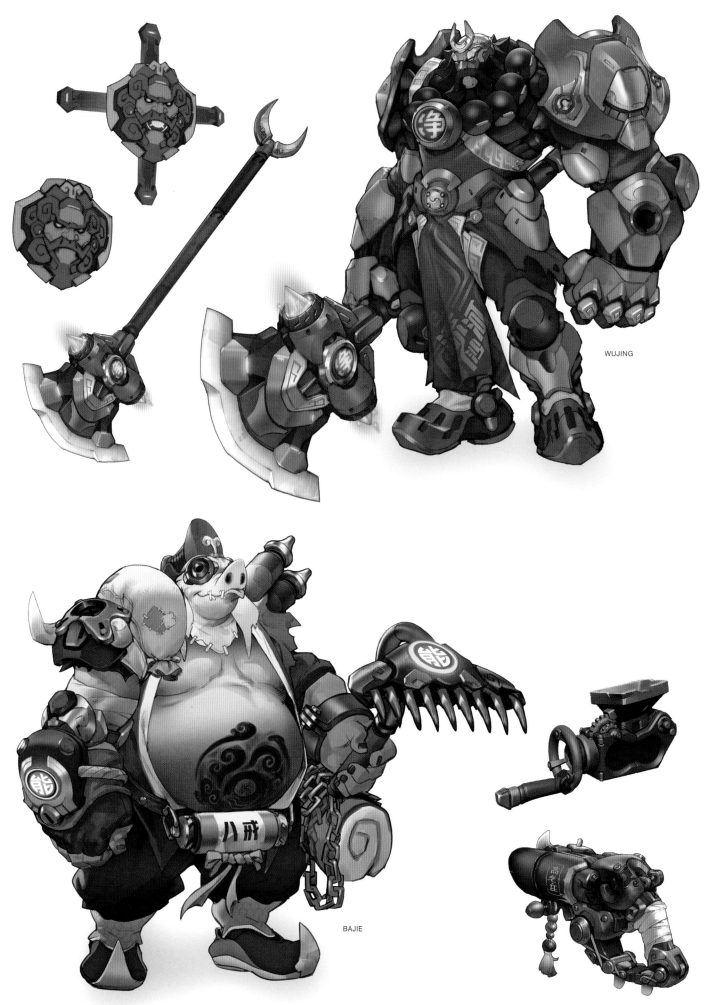

WUJING

BAJIE

ALL IMAGES: **BEN ZHANG**

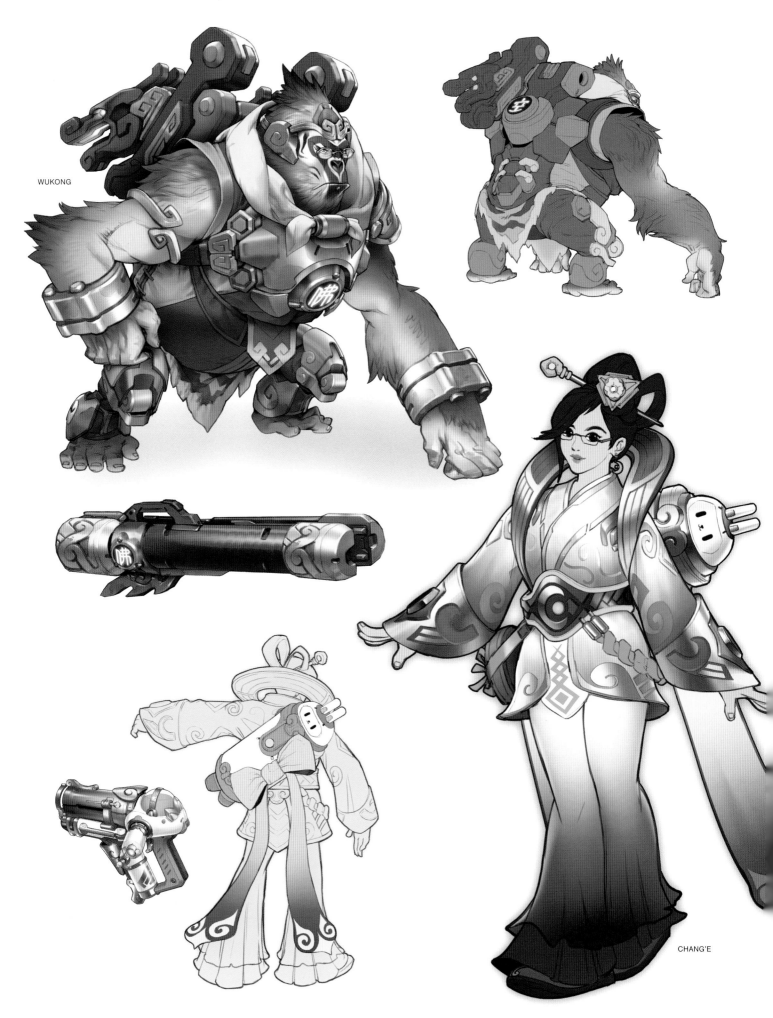

WUKONG

CHANG'E

TOP: **BEN ZHANG**, BOTTOM: **BEN ZHANG** AND **DAVID KANG**

UPRISING

Much like the *Origins Edition* skins, the designs released for the Uprising event offered a glimpse into a pivotal period of the characters' lives. One of the most extreme designs belonged to Genji. After his brother, Hanzo, nearly killed him, he was taken in by Overwatch and given a new body (below). The experience left the hero embittered and angry, constantly at war with the cybernetics that were now a part of him.

When designing a skin for this part of Genji's story, the developers used his outfit to mirror his turbulent state of mind. They made his armor feel like a mishmash of parts, symbolizing the hero's struggle to accept what he has become. The use of red throughout the skin also helped to emphasize his uncontrollable rage.

TALON
WIDOWMAKER

BLACKWATCH

▶ **WIDOWMAKER'S TALON SKIN**—The developers created an early concept of the Talon skin (above) based on Widowmaker's appearance in the "Legacy" comic. However, it ended up feeling too much like the hero's standard look. The team made the final version of Talon more distinct by removing Widowmaker's helmet and changing the color of her skin.

TOP: **BEN ZHANG** AND **DAVID KANG**, BOTTOM LEFT: **ARNOLD TSANG**, BOTTOM RIGHT: **DAVID KANG**

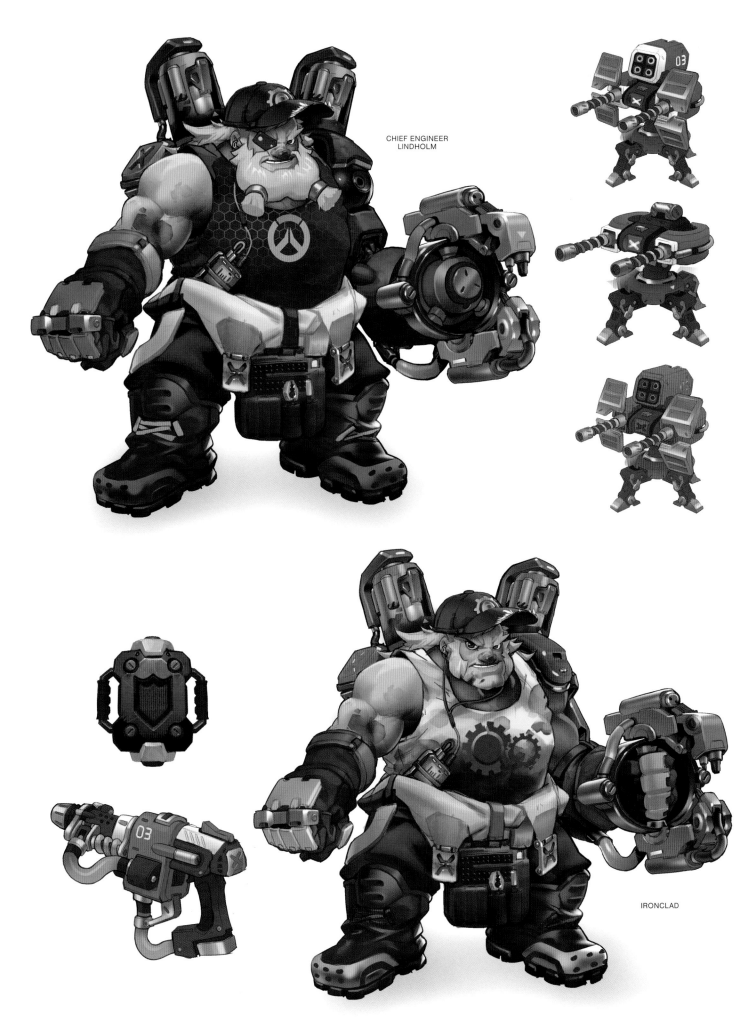

CHIEF ENGINEER
LINDHOLM

IRONCLAD

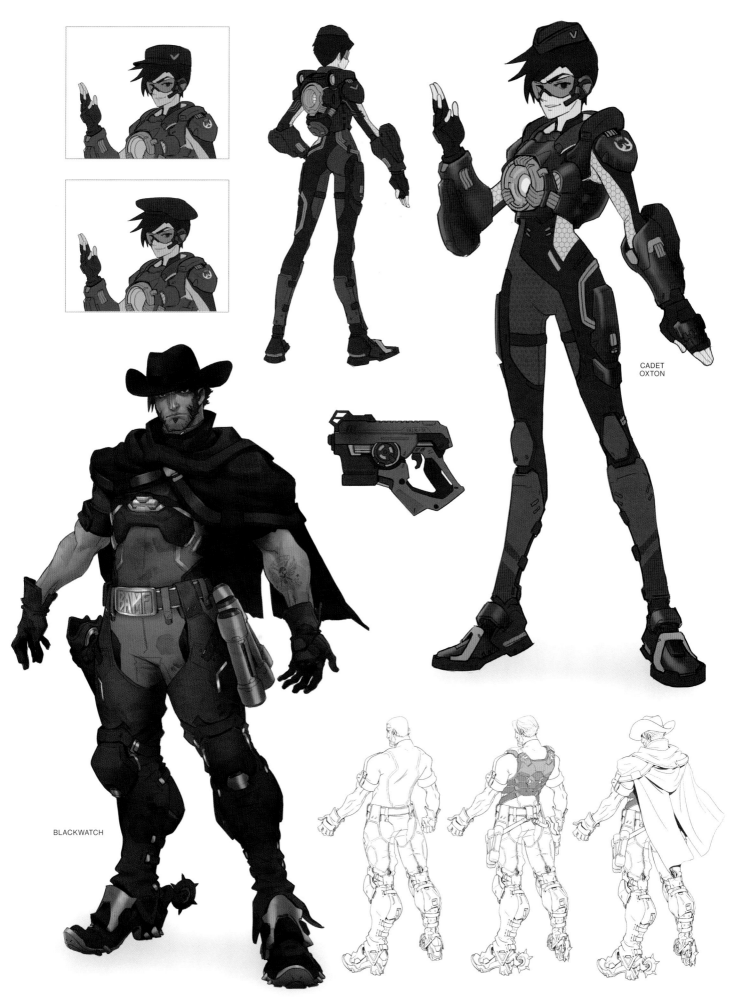

CADET
OXTON

BLACKWATCH

TOP: **ANH DANG**, BOTTOM: **JOHN POLIDORA**

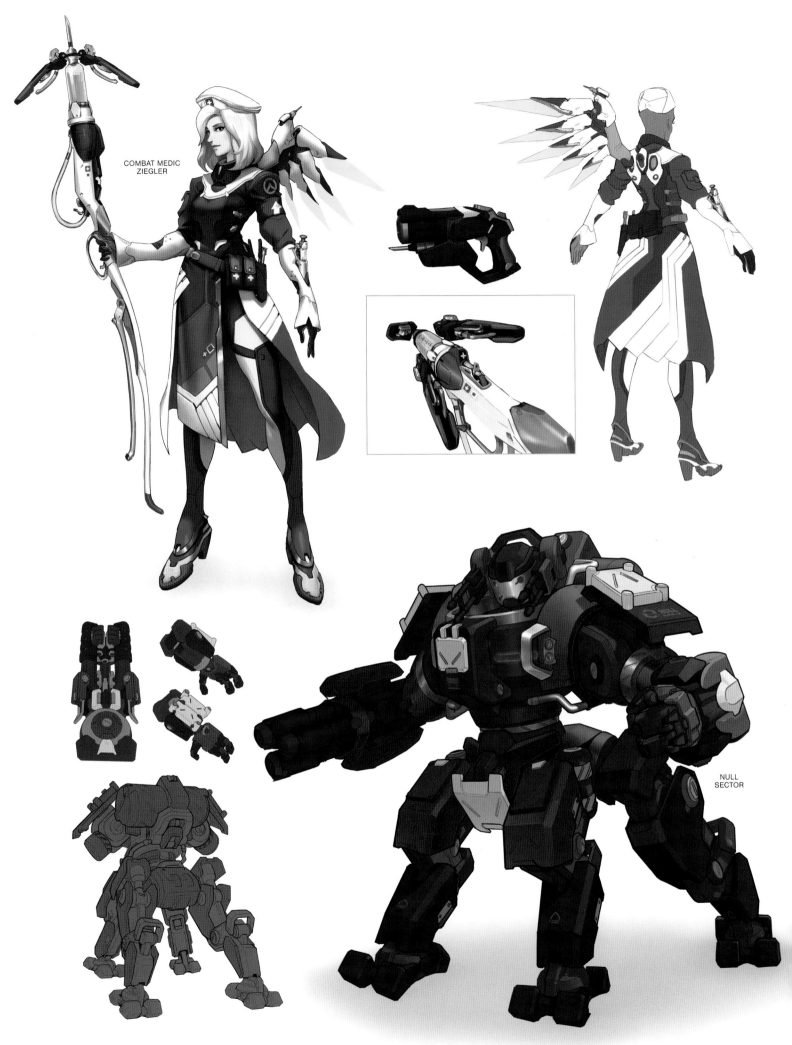

COMBAT MEDIC
ZIEGLER

NULL
SECTOR

JOHN POLIDORA, ARNOLD TSANG, ANH DANG, AND QIU FANG

OVERWATCH: ANNIVERSARY

Many of *Overwatch*'s character designers were inspired by the cyberpunk aesthetic and genre. For the *Overwatch*: Anniversary event, the developers took those influences and expanded them into entire skins, such as Cyborg: 76 (page 241, bottom right), Oasis (right), Cyberian (next spread, bottom left), and Cyberninja (page 241, top left).

Though futuristic motifs were used in all the skins, each one retained its own distinct flavor. For example, Symmetra's Oasis skin drew inspiration from the sleek architecture and gold tones of Oasis itself, a high-tech city in Iraq. Lotus flower petals—a significant symbol in the hero's country of origin, India—were also incorporated into her photon projector, armor, and clothing.

OASIS

BEDOUIN

DAVID KANG, BEN ZHANG, HICHAM HABCHI, AND MORTEN SKAALVIK

SENTAI

CYBERIAN

TOP: **ANH DANG**, BOTTOM: **QIU FANG**

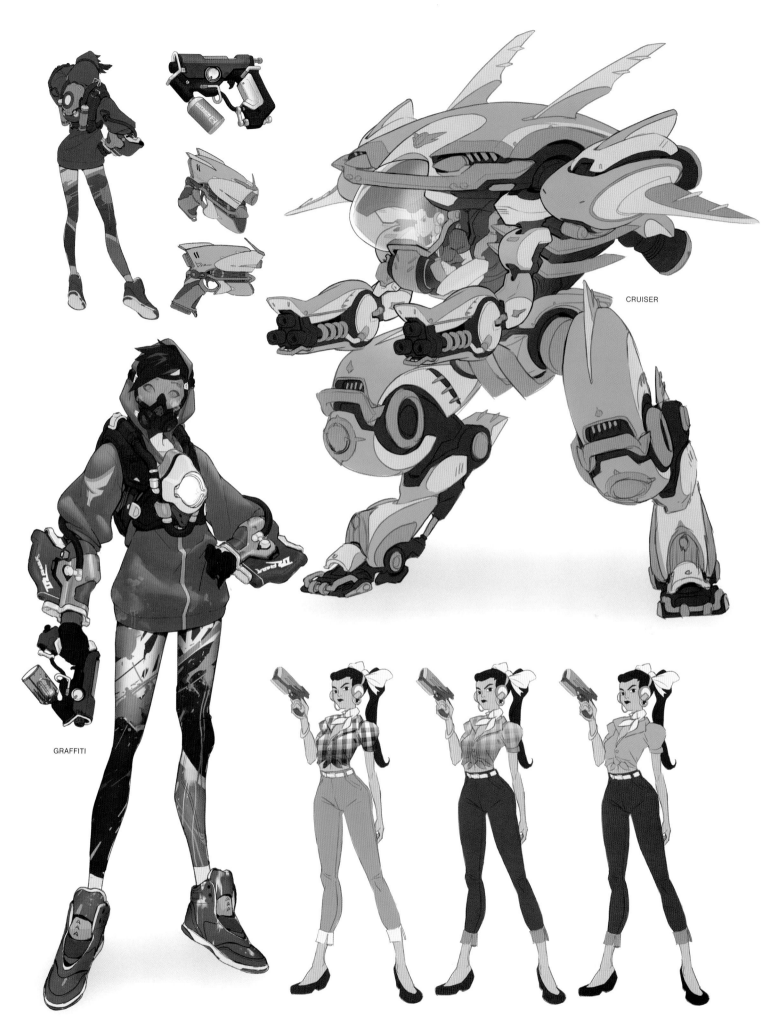

CRUISER

GRAFFITI

LEFT: **QIU FANG**, RIGHT: **JOHN POLIDORA**

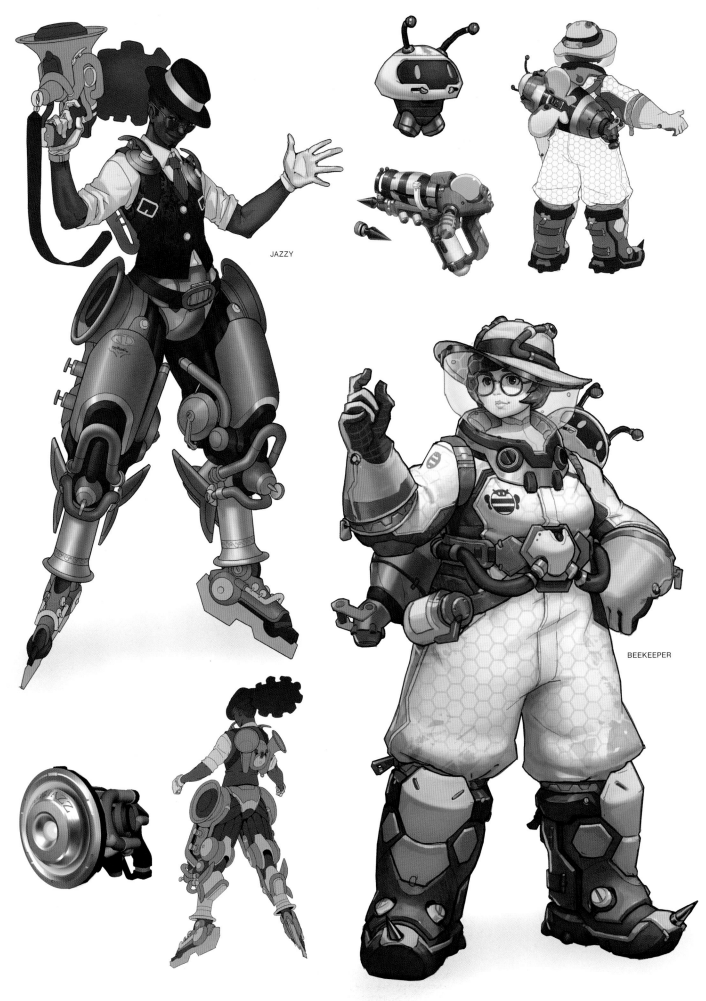

JAZZY

BEEKEEPER

LEFT: QIU FANG, RIGHT: MORTEN SKAALVIK

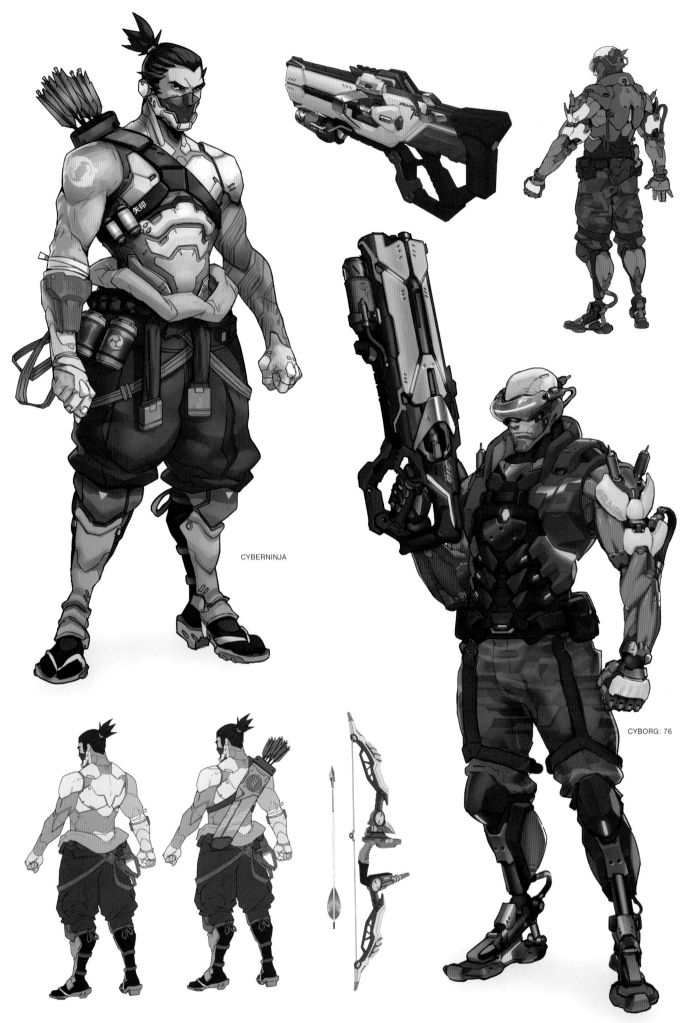

CYBERNINJA

CYBORG: 76

LEFT: **HICHAM HABCHI**, RIGHT: **ARNOLD TSANG**, GUN: **DAVID KANG**

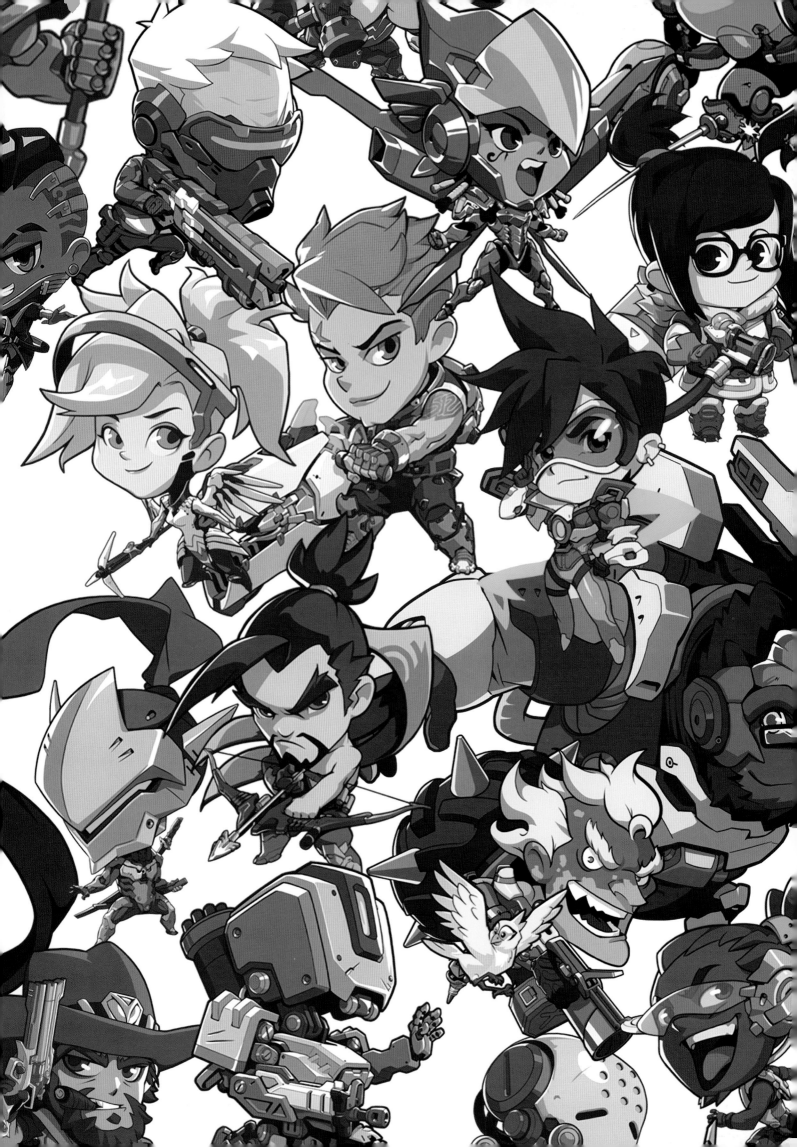

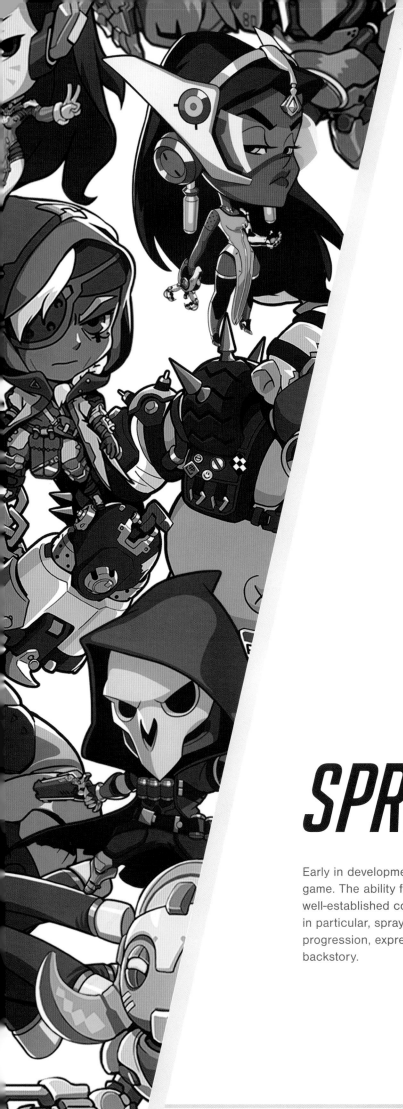

SPRAYS

Early in development, the *Overwatch* team decided to put sprays in the game. The ability for players to leave their mark on the world was a fun and well-established convention of the first-person shooter genre. For *Overwatch* in particular, sprays offered the game team a way to reward players for progression, express the characters through different art styles, and reveal backstory.

ANA

Some sprays are themed around a hero's alternate skins. Others express a character's heritage. A few, like the image of a shrike (second row, third column), do both.

This bird has the same name as one of Ana's skins, and it's also native to her home country, Egypt. The text on the animal's back is a type of Arabic calligraphy where a word—in this case, "shrike"—is written to form a stylized design.

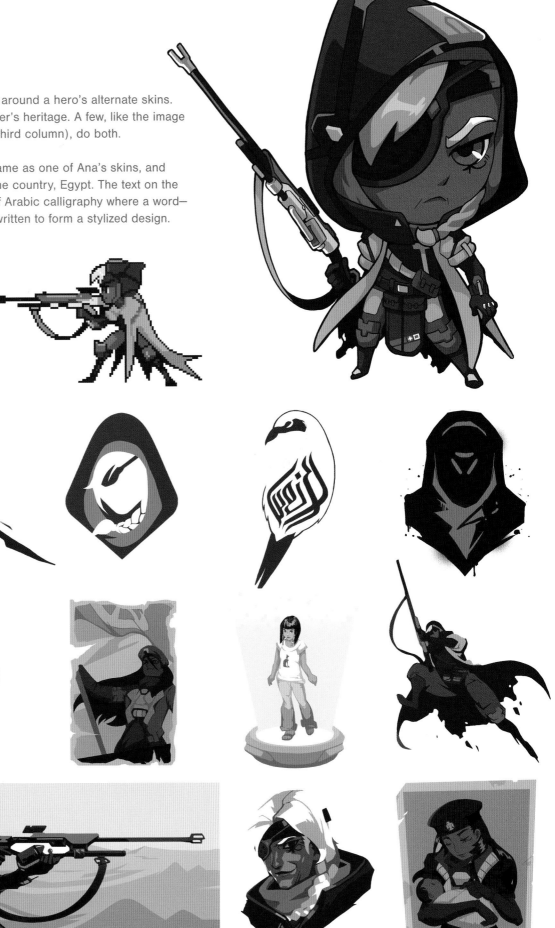

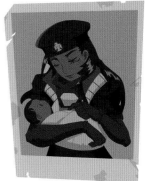

ANH DANG, ARNOLD TSANG, AND JOHN POLIDORA

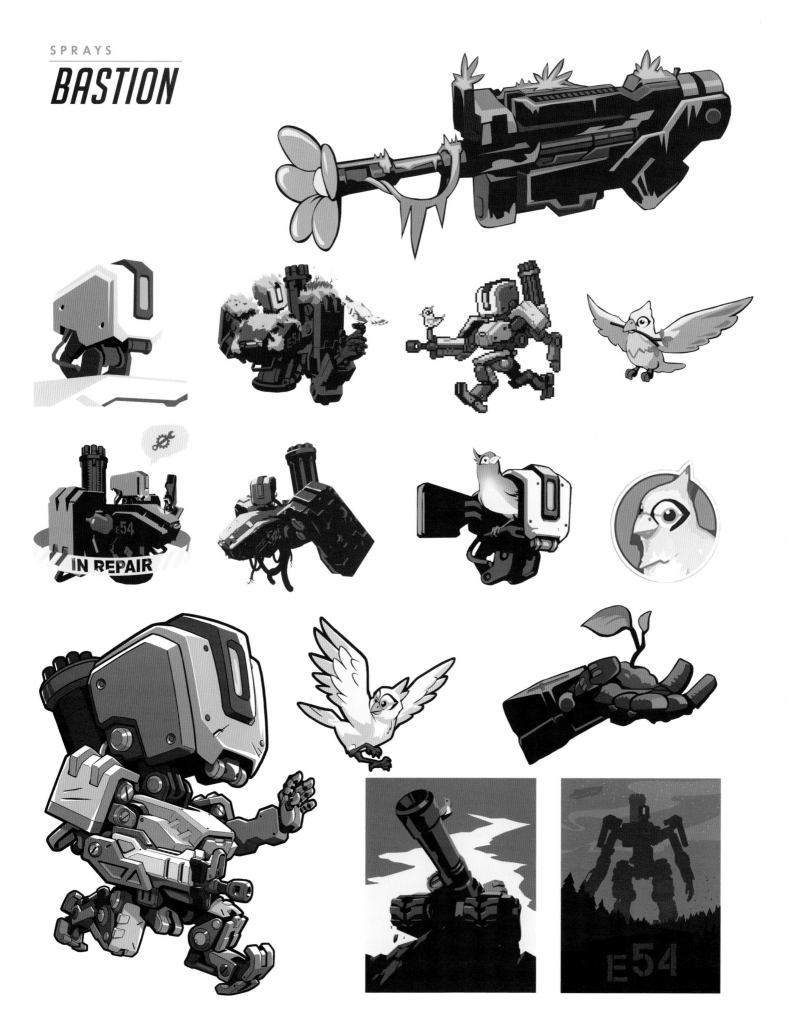

AQUATIC MOON, PAUL WARZECHA, JOHN POLIDORA, DAVID KANG, ARNOLD TSANG, BEN ZHANG, AND BLACK ZEBRA STUDIO

IN REPAIR

E54

SPRAYS
D.VA

Cute But Deadly art (top right) is a spray style that's used for all heroes. The game team liked these illustrations because they portrayed *Overwatch*'s characters in a lighthearted way while still preserving the essence of their unique personalities.

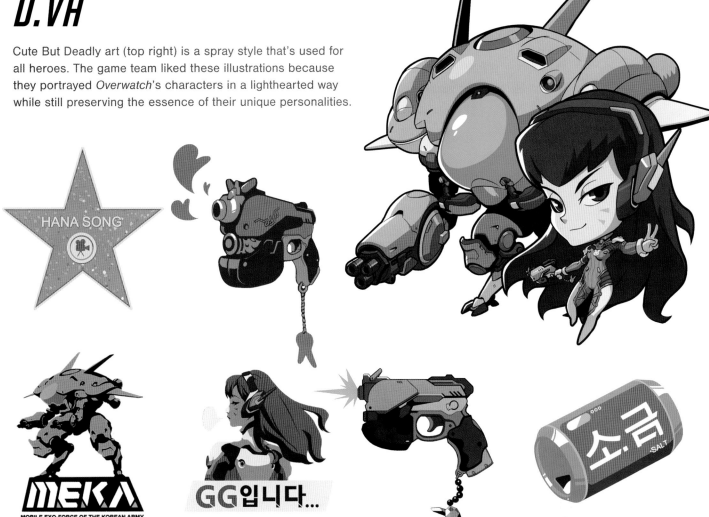

HANA SONG

MEKA
MOBILE EXO-FORCE OF THE KOREAN ARMY

GG입니다...

소·금
SALT

갓게임스

nano COLA

핑크빛 자신감
나노 콜라와 함께!

나노콜라 송하나♡

GG

파워업!

ARNOLD TSANG, JOHN POLIDORA, DAVID KANG, ANH DANG, AND SAMANTHA RUSSO.

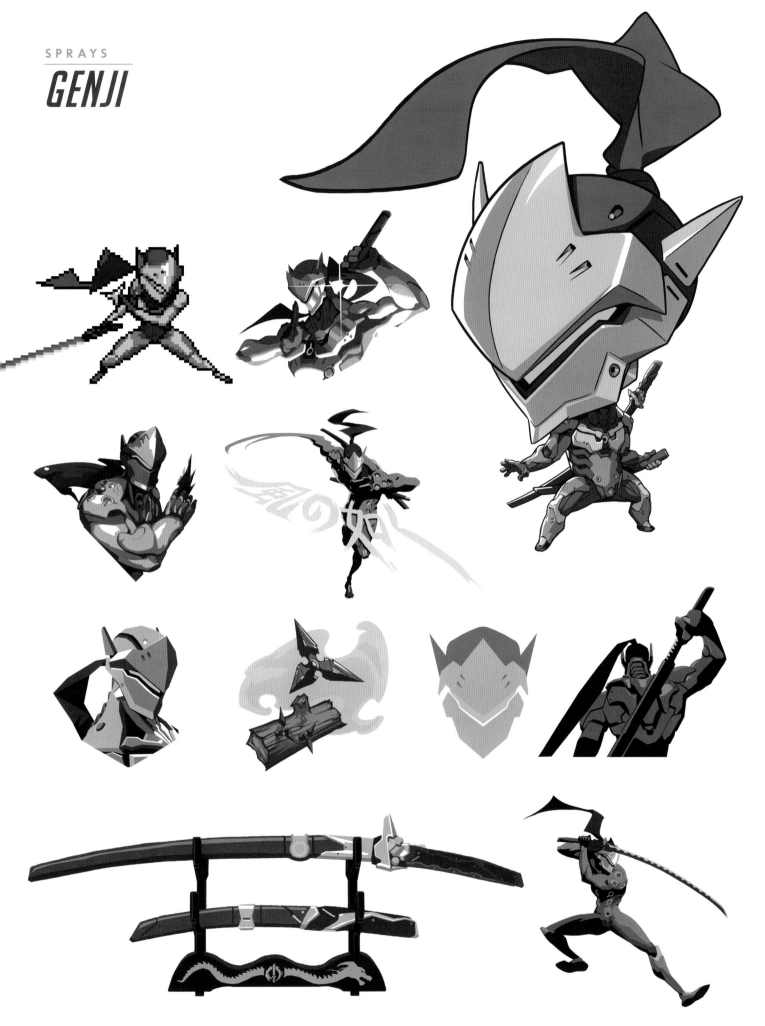

ARNOLD TSANG, BEN ZHANG, JOHN POLIDORA, PAUL WARZECHA, BLACK ZEBRA STUDIO, AND ANDREW ERICKSON

HANZO

The *Overwatch* team created certain sprays that multiple players are meant to combine, such as the yin and yang symbols of Genji and Hanzo *(bottom left)*.

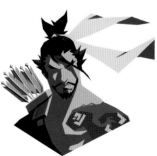

BEN ZHANG, JOHN POLIDORA, BLACK ZEBRA STUDIO, ARNOLD TSANG, AND POWERHOUSE

JUNKRAT

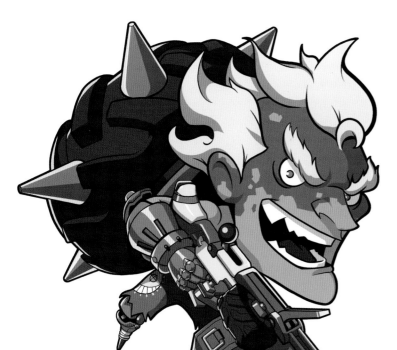

SE BUSCA

"JUNKRAT"

RECOMPENSA:

$25,000,000

JOHN POLIDORA, DAVID KANG, BEN ZHANG, AQUATIC MOON, PAUL WARZECHA, AND JOSHUA MANNING

LÚCIO

Every *Overwatch* hero has a unique color scheme, such as green and yellow for Lúcio. The game team relies on these core palettes to give each character a library of sprays that are cohesive and easily recognizable.

ANDREW ERICKSON, JOHN POLIDORA, DAVID KANG, BEN ZHANG, ARNOLD TSANG, AND AQUATIC MOON

McCREE

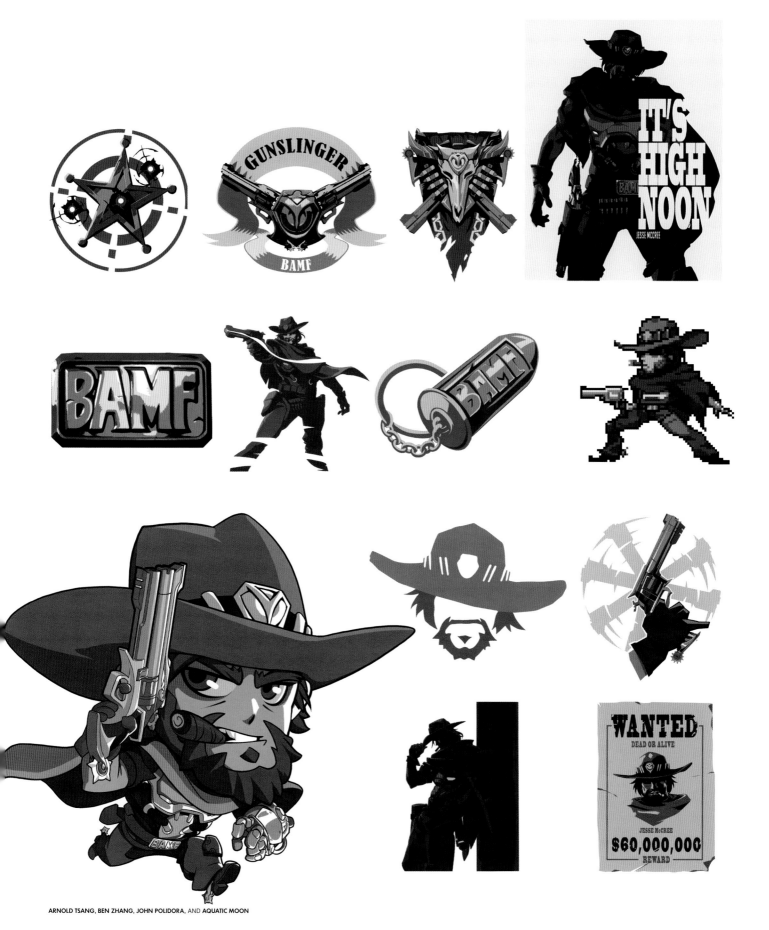

ARNOLD TSANG, BEN ZHANG, JOHN POLIDORA, AND AQUATIC MOON

MEI

Mei's journal spray (bottom right) represents part of her backstory. Similar pages are scattered across the Ecopoint: Antarctica map, the Overwatch base where Mei was once stationed.

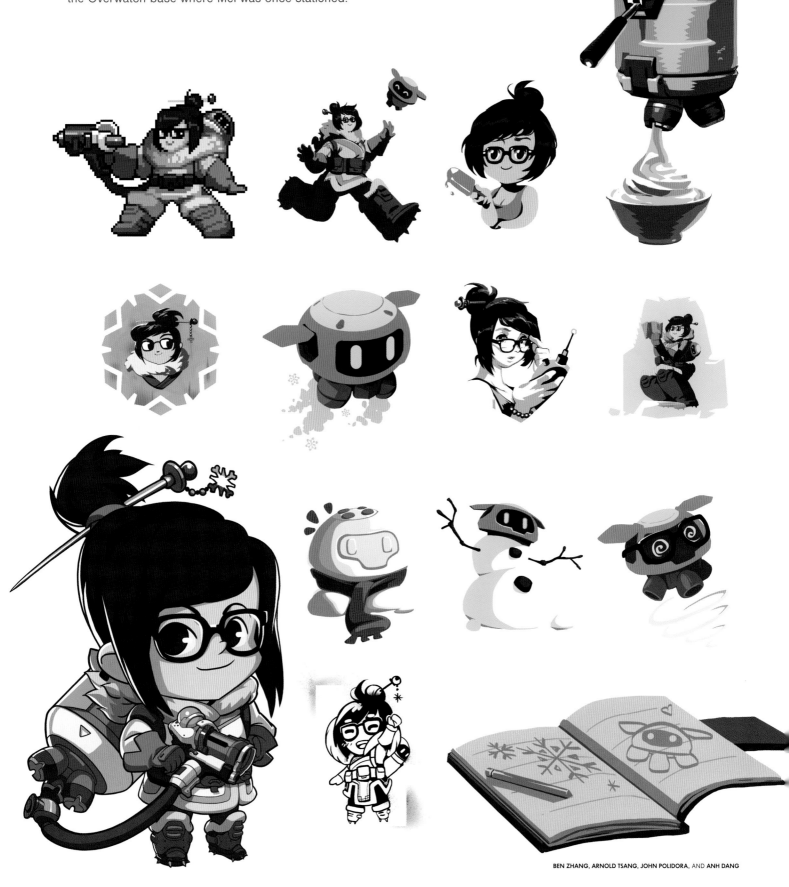

BEN ZHANG, ARNOLD TSANG, JOHN POLIDORA, AND ANH DANG

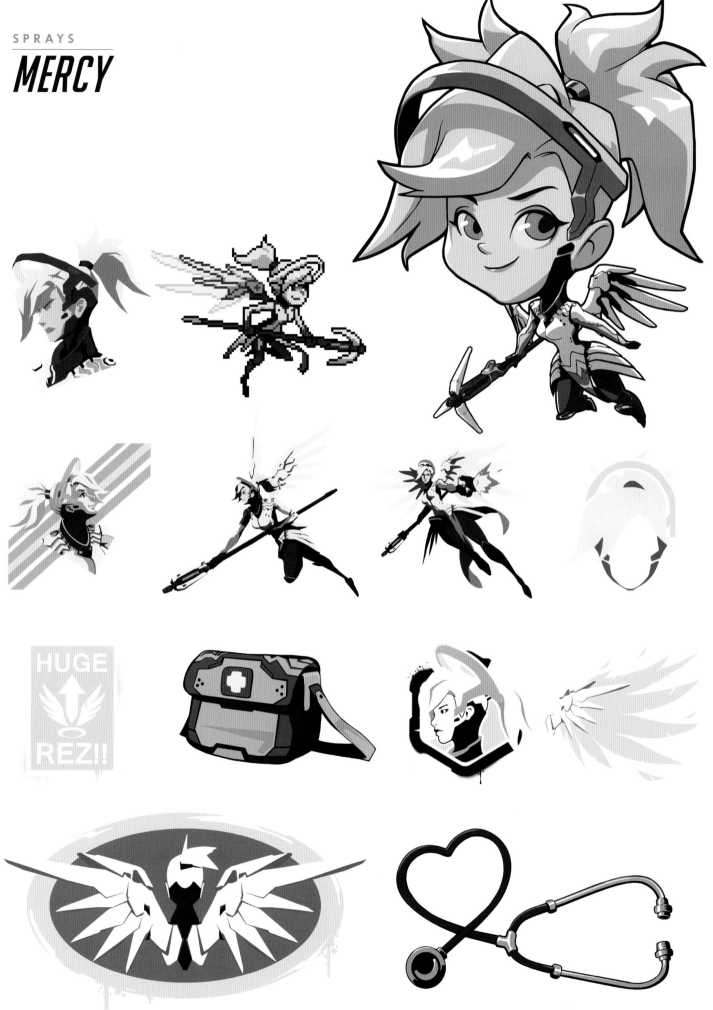

HUGE
REZ!!

BEN ZHANG, AQUATIC MOON, JOHN POLIDORA, ARNOLD TSANG, AND DAVID KANG

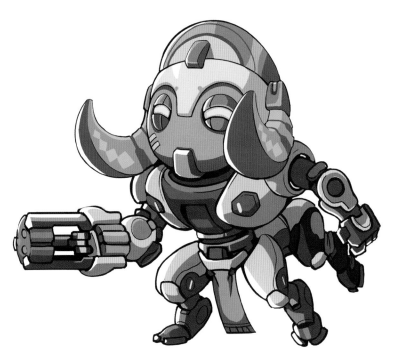

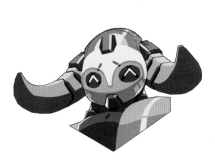
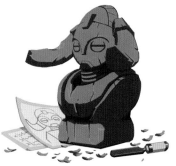

ANH DANG AND MORTEN SKAALVIK

PHARAH

When establishing guidelines for sprays, the *Overwatch* team was drawn to the idea of pixel art (first row, first column). The style felt like a fun homage to past games that had influenced the developers. Pixel art also allowed the team to create simplified designs with limited color palettes, which made the sprays easy to grasp at a glance during gameplay.

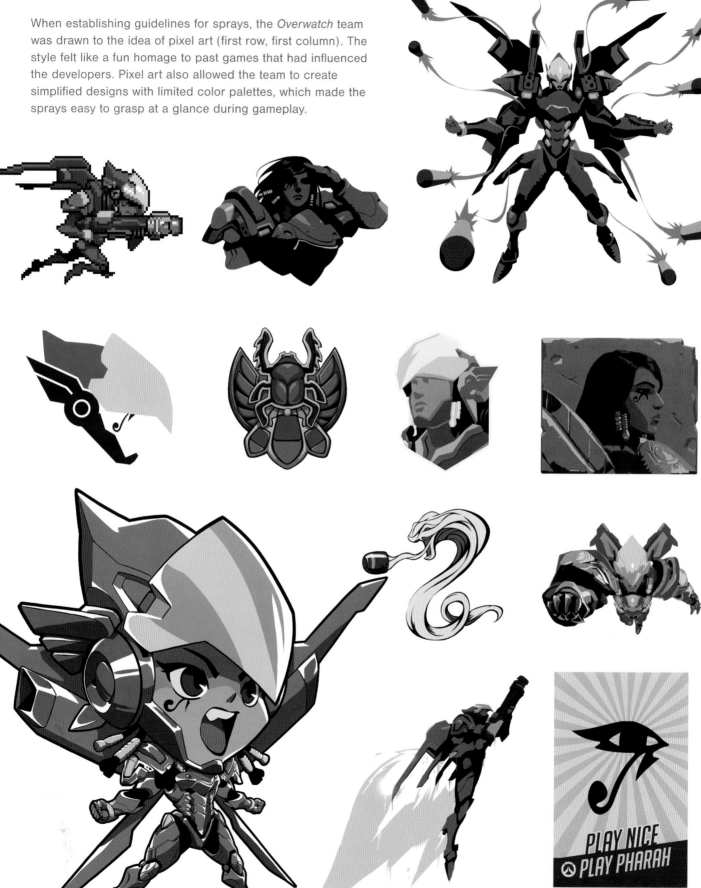

ARNOLD TSANG, JOHN POLIDORA, AQUATIC MOON, AND DAVID KANG

PLAY NICE
PLAY PHARAH

REAPER

Most sprays feature clean edges, but not Reaper's. The *Overwatch* team went for a rougher, graffiti-like style to symbolize the character's chaotic and uncontrollable nature.

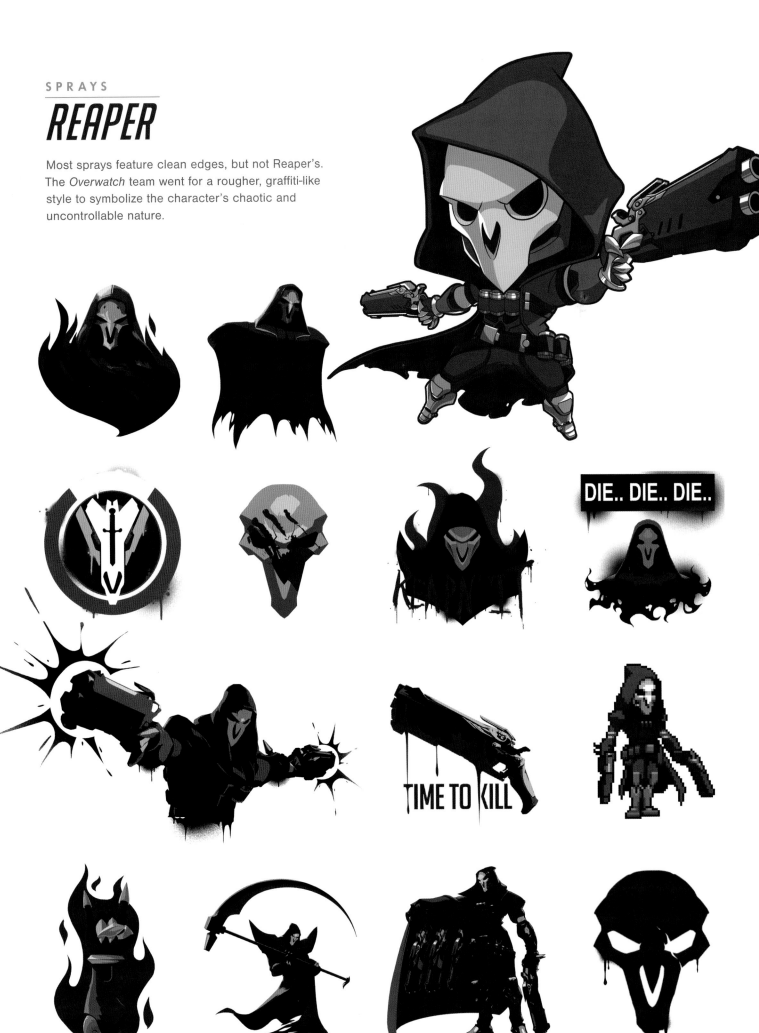

DIE.. DIE.. DIE..

TIME TO KILL

MARTIN OCEJO, DAVID KANG, JOHN POLIDORA, AND BEN ZHANG

REINHARDT

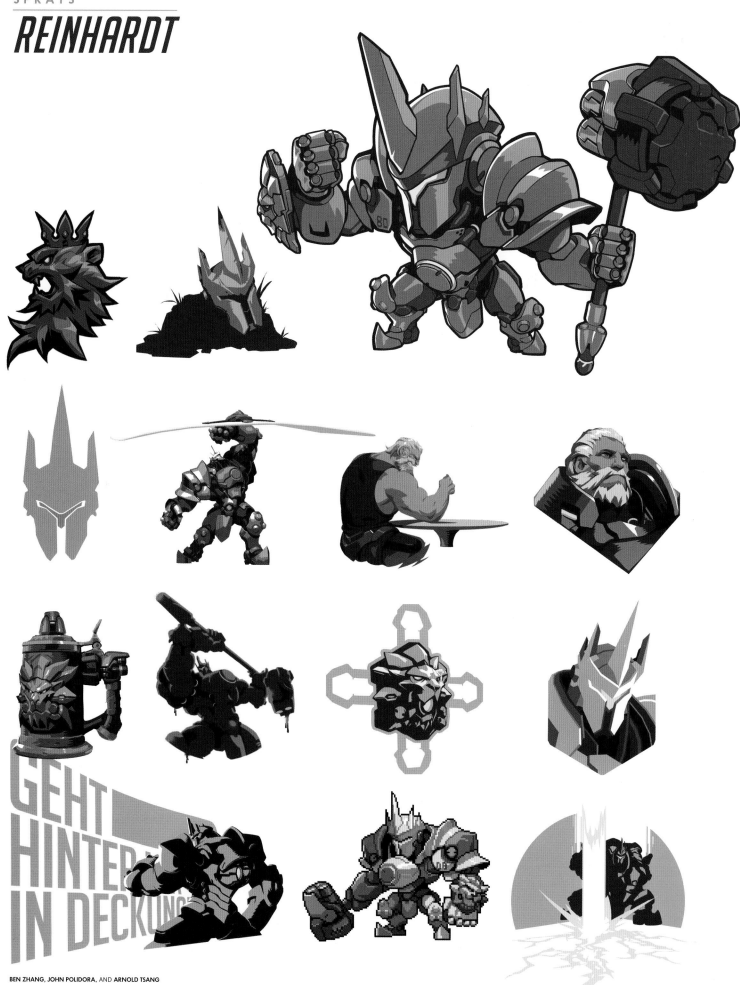

BEN ZHANG, JOHN POLIDORA, AND ARNOLD TSANG

ROADHOG

WILD

HOG POWER

ROAD RAGE

AQUATIC MOON, BEN ZHANG, ARNOLD TSANG, AND JOHN POLIDORA

SOLDIER: 76

The *Overwatch* team included many bits and pieces of the characters' backstories in their sprays. The tombstone *(upper left)* ties into Soldier: 76's origin animation, which reveals his tragic past and former life as Jack Morrison.

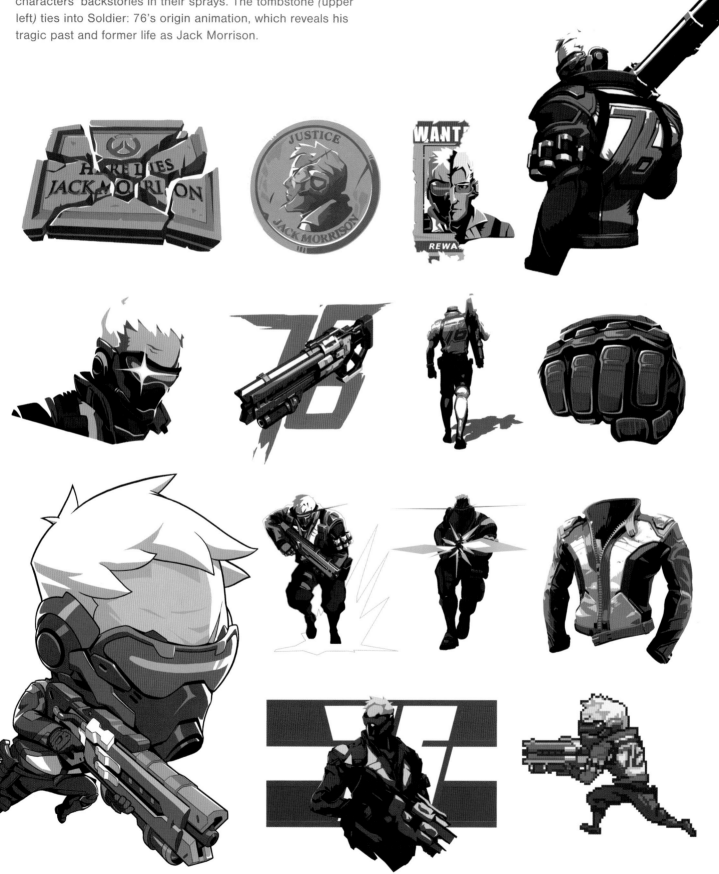

JOSHUA MANNING, JOHN POLIDORA, AQUATIC MOON, ARNOLD TSANG, AND MARTIN OCEJO

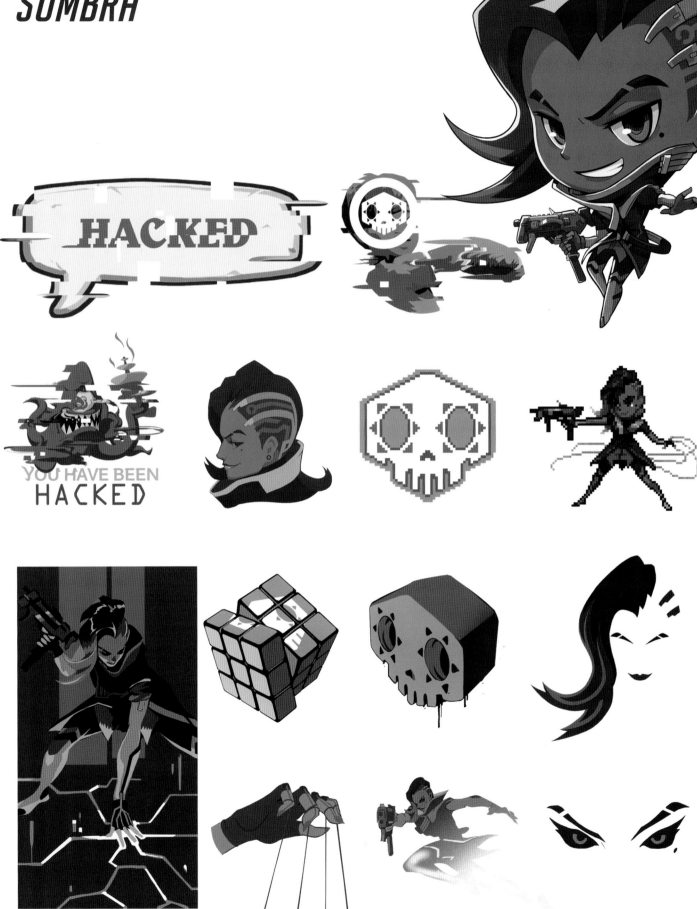

SYMMETRA

In addition to expressing backstory elements, the *Overwatch* team designed sprays to reflect the characters' abilities and outfits. The lotus flower *(bottom right)* is based on Symmetra's teleporter.

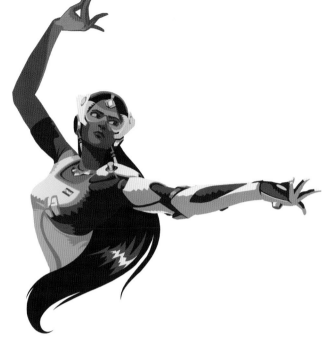

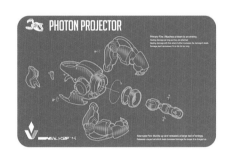

JOHN POLIDORA, BEN ZHANG, AND ARNOLD TSANG

TORBJÖRN

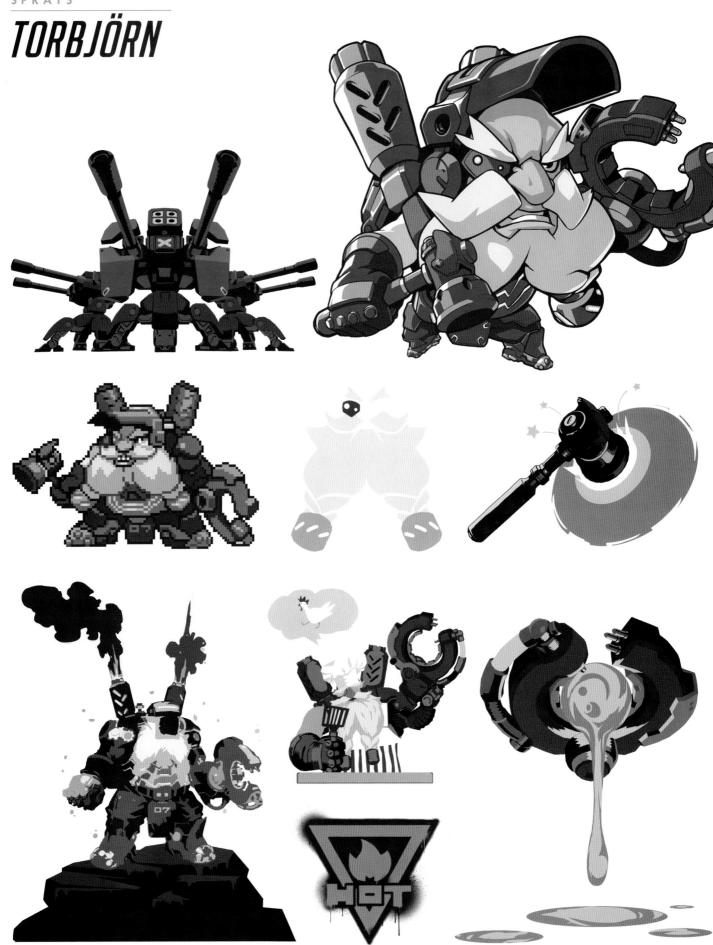

JOHN POLIDORA, DAVID KANG, ARNOLD TSANG, BEN ZHANG, AND BLACK ZEBRA STUDIO

TRACER

When the game team began experimenting with sprays, they used Tracer as the test case. Artists created dozens of illustrations for her, and they came in all varieties. Some showed parts of her outfit or her weapons. Others were decals or logos. As the game team reviewed the sprays, they realized that the most impactful ones featured Tracer herself.

From that point on, the *Overwatch* team decided that the majority of sprays would feature the actual heroes in some way, whether through full body poses (fourth row, second column) or through unique designs (second row, fourth column).

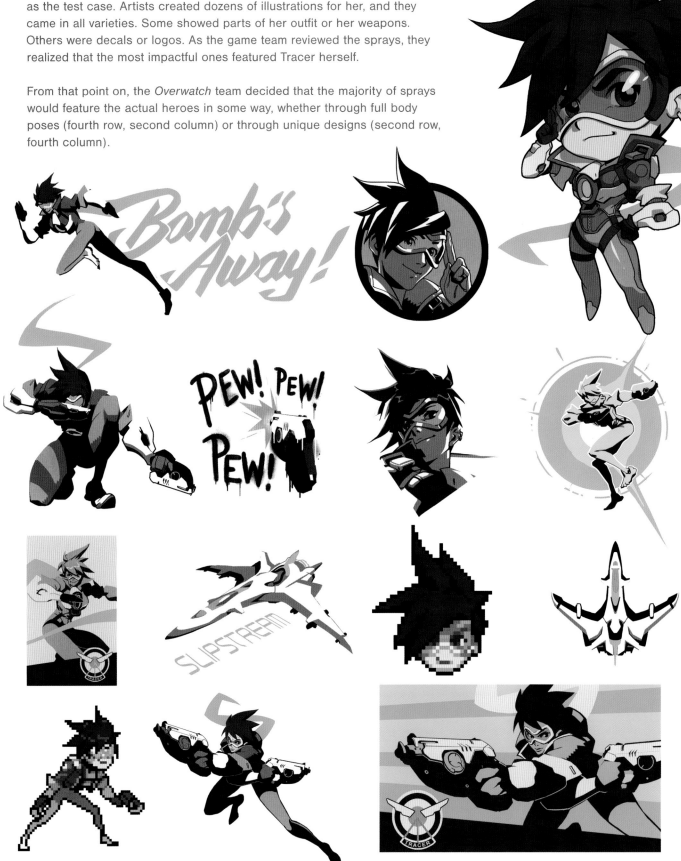

ARNOLD TSANG AND **POWERHOUSE**

WIDOWMAKER

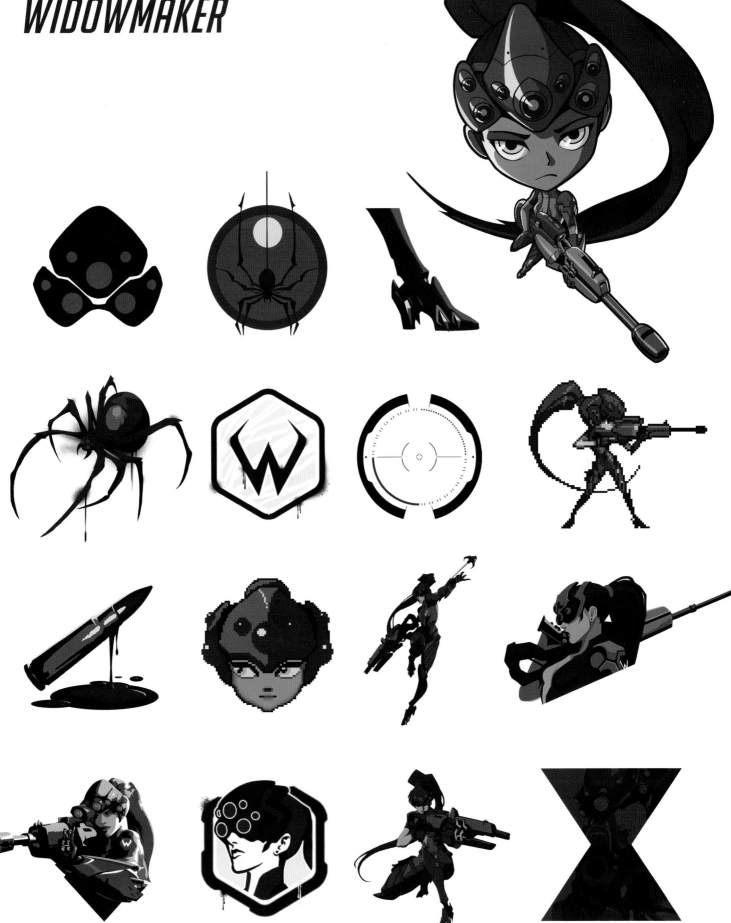

ARNOLD TSANG, JOHN POLIDORA, DAVID KANG, BEN ZHANG, NICK CARVER, AND BLACK ZEBRA STUDIO

WINSTON

A handful of Winston's sprays were based on the "Recall" animated short. Images like the picture (first row, second column), lexigram (second row, second column), view of Earth (third row, second column), and poster (third row, third column) were inspired by props and scenes from the film.

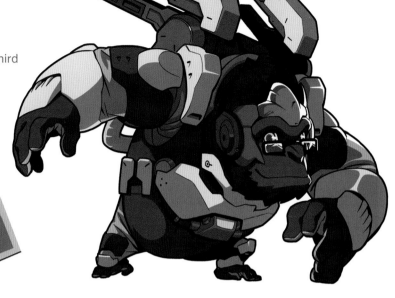

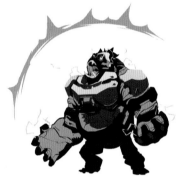

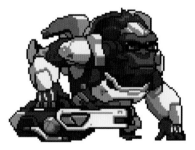

ARNOLD TSANG, BLACK ZEBRA STUDIO, DAVID KANG, AQUATIC MOON, AND BEN ZHANG

ZARYA

Overwatch includes heroes from the far corners of the world. The developers honored this diversity by making sprays that featured words in the characters' native tongues (first row, second column). In these cases, the text was not translated into other languages. It was left as is to highlight the heroes' nationalities and avoid issues associated with localizing artwork.

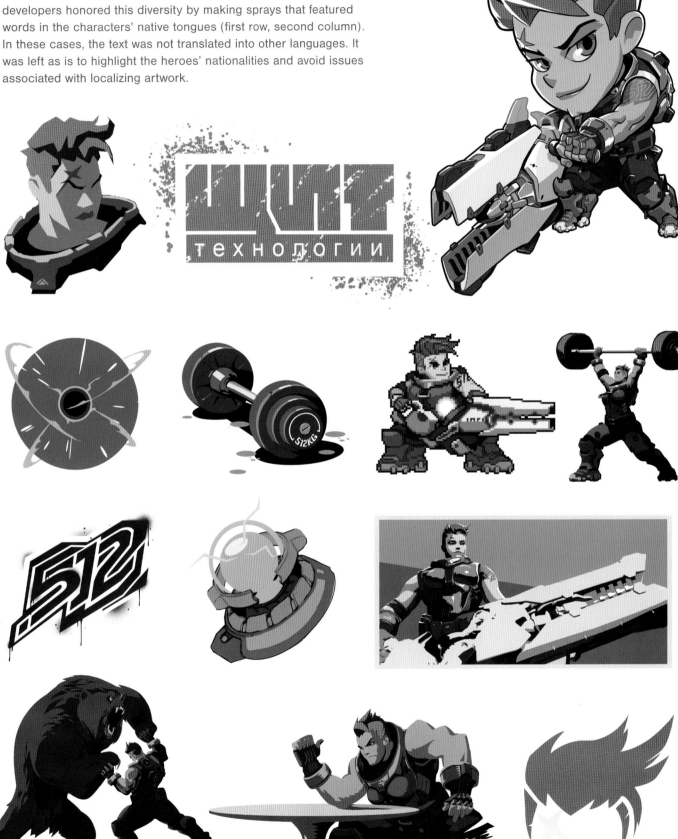

технологии

512KG

512

NICK CARVER, JOHN POLIDORA, ARNOLD TSANG, BEN ZHANG, AND RANDAL DUMORET

ZENYATTA

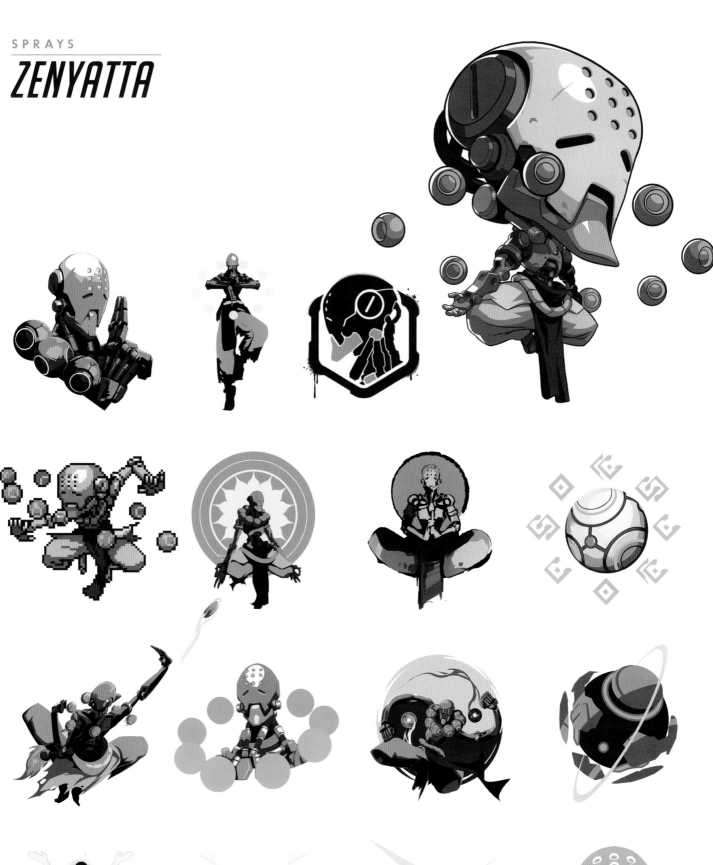

ARNOLD TSANG, JOHN POLIDORA, BEN ZHANG, NICK CARVER, BLACK ZEBRA STUDIO, ANH DANG, AND MARTIN OCEJO

SUMMER GAMES

ANDREW ERICKSON, ANH DANG, SAMANTHA RUSSO, AQUATIC MOON, AND ARNOLD TSANG

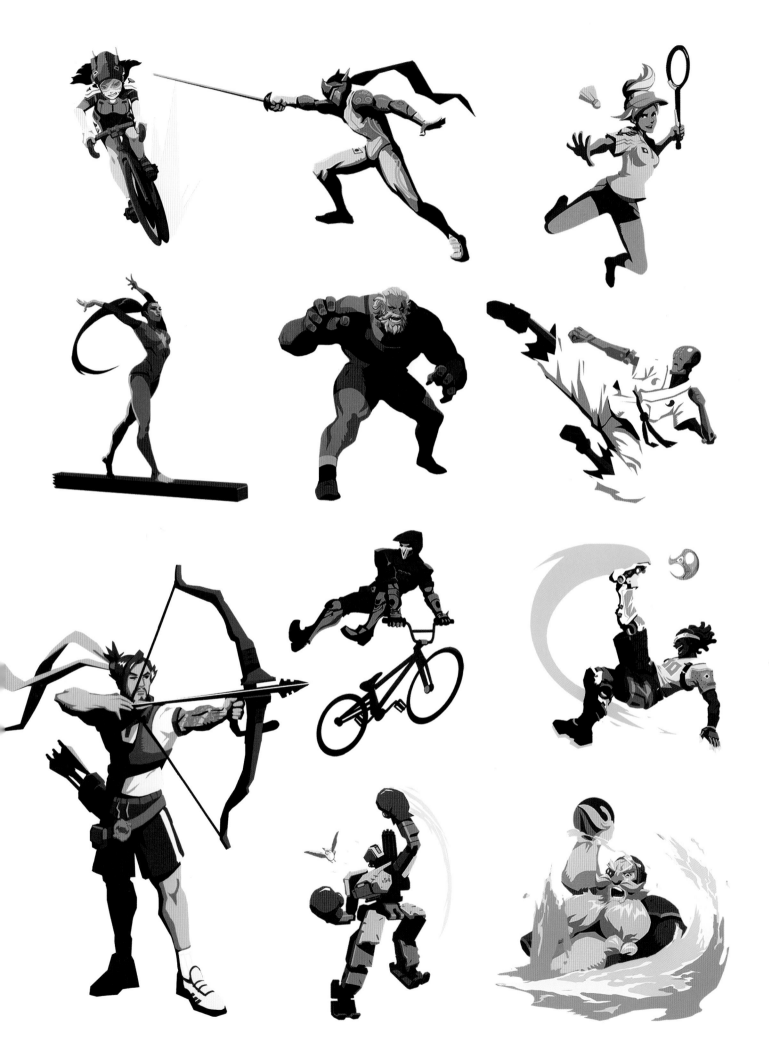

OVERWATCH HALLOWEEN TERROR

Holiday events like *Overwatch* Halloween Terror are an opportunity to step outside the guidelines established for regular sprays. The illustrations below portrayed the heroes as children and explored new color palettes that are not usually associated with a character's visual theme.

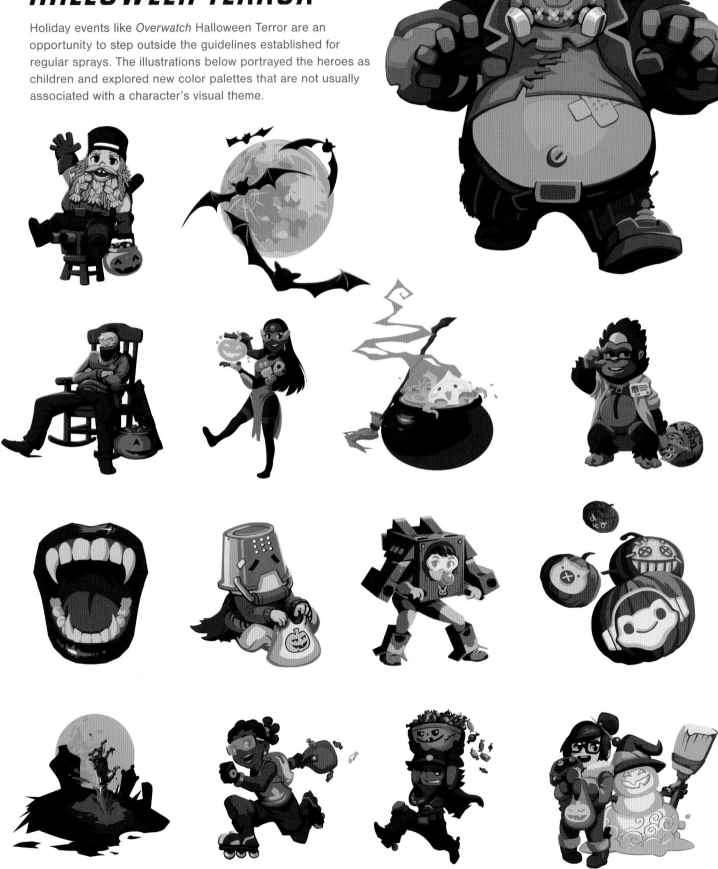

AQUATIC MOON AND **SAMANTHA RUSSO**

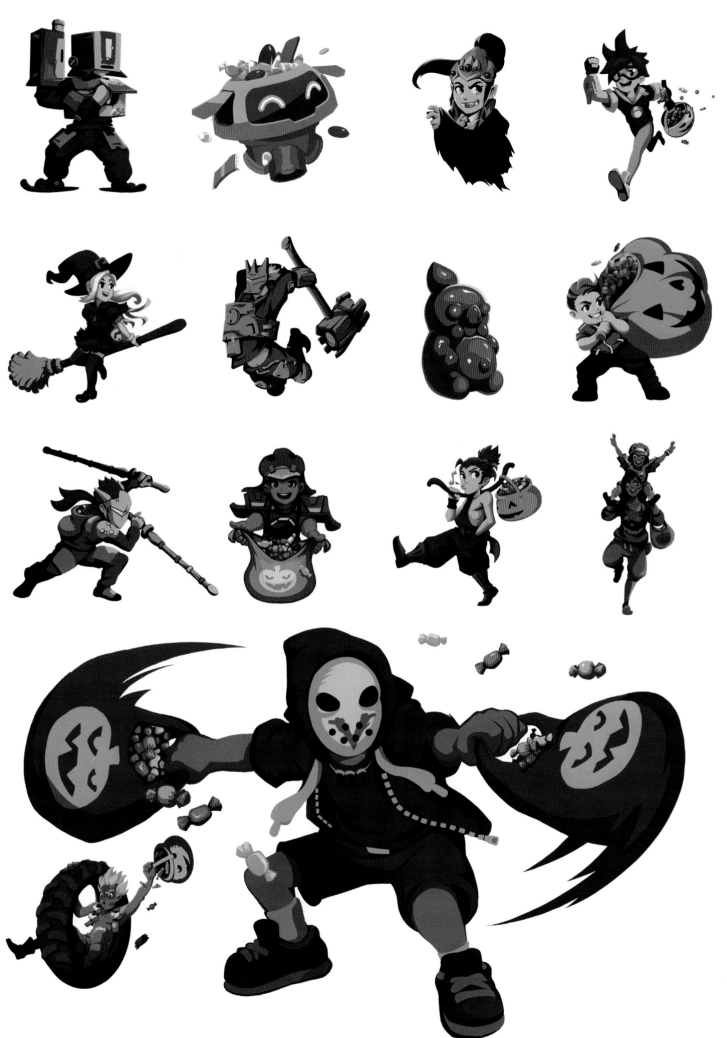

WINTER WONDERLAND

For the first Winter Wonderland event, the *Overwatch* team reimagined the heroes as holiday ornaments *(opposite)*. These were more than just fun new expressions of the characters; they were a way to facilitate interactivity for the players. Artists also created a Christmas tree spray that players could combine with hero ornaments or other decorations.

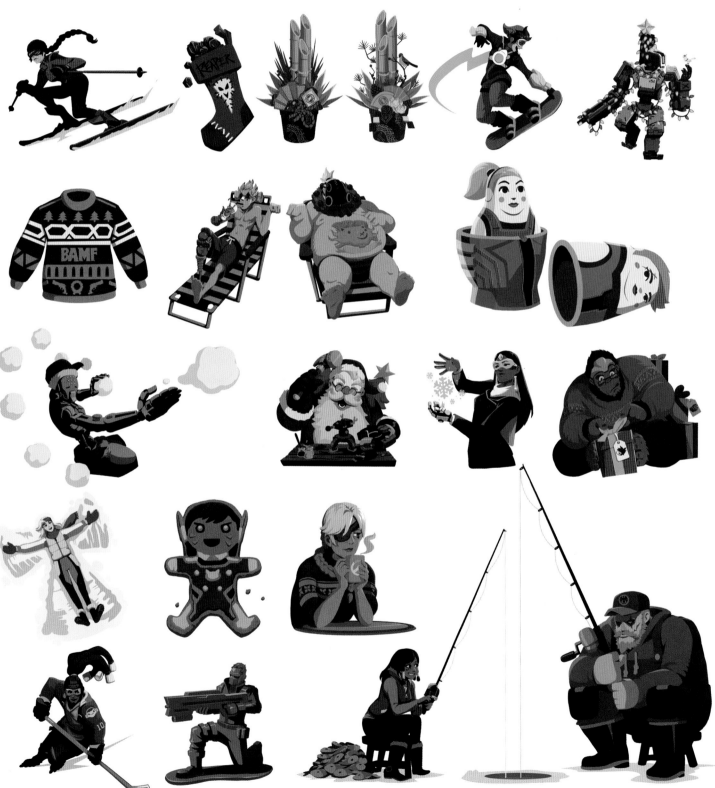

AQUATIC MOON AND ANH DANG

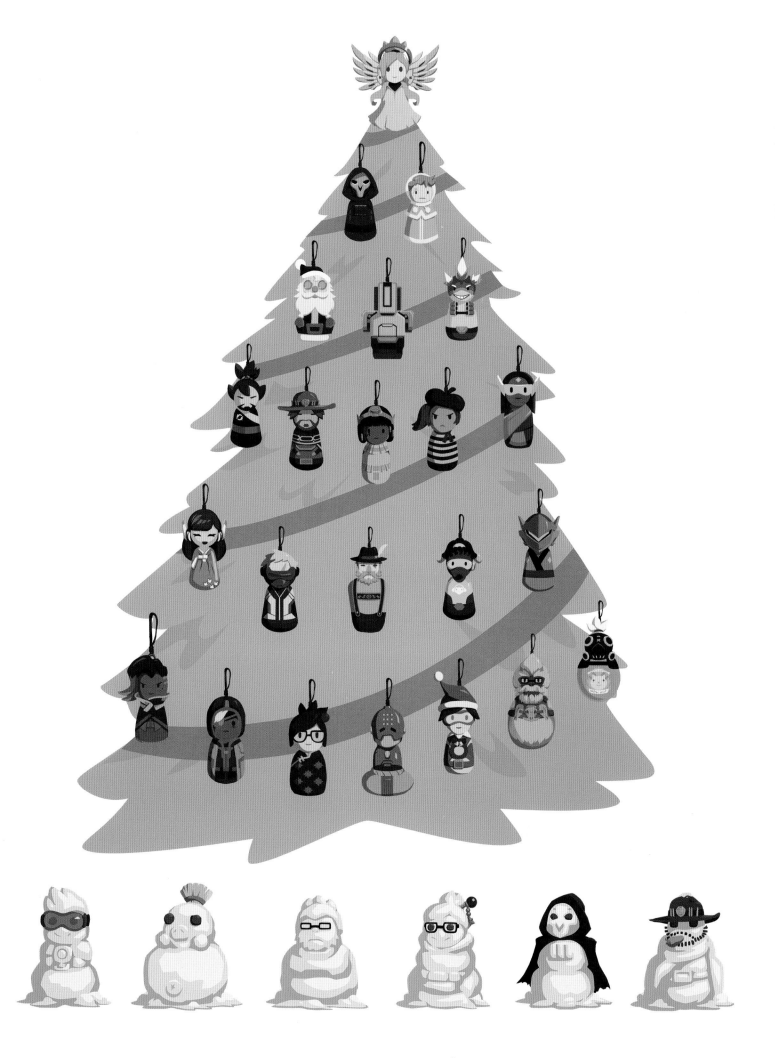

YEAR OF THE ROOSTER

Several of *Overwatch*'s artists were from countries that celebrate Lunar New Year. They eagerly took on the task of creating sprays for the Year of the Rooster event, seeing it as a chance to reflect part of their heritage through the game's heroes.

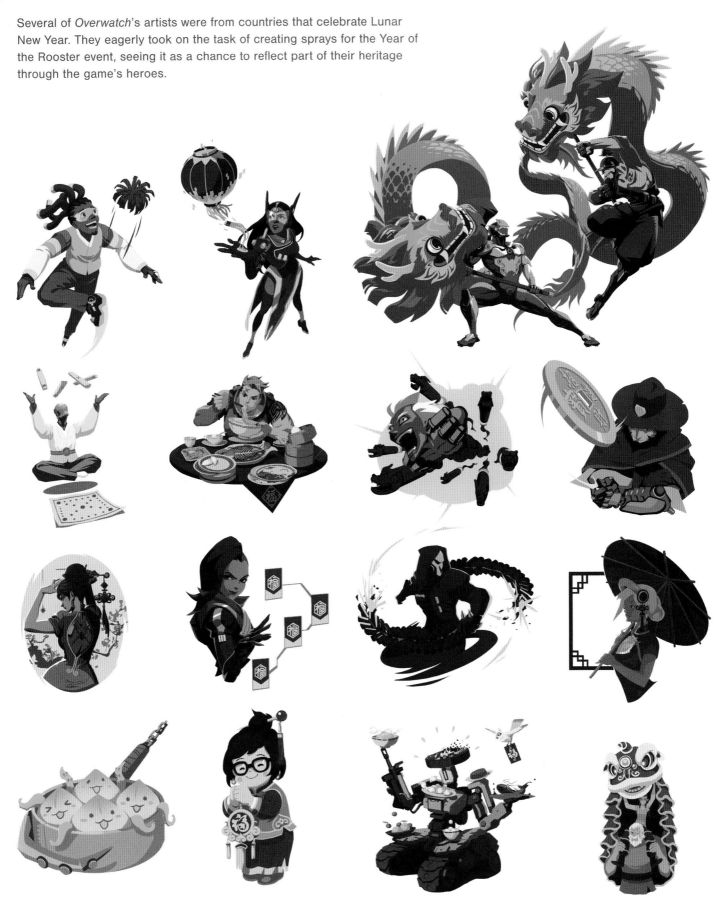

DAVID KANG, QIU FANG, BEN ZHANG, ARNOLD TSANG, AND **ANH DANG**

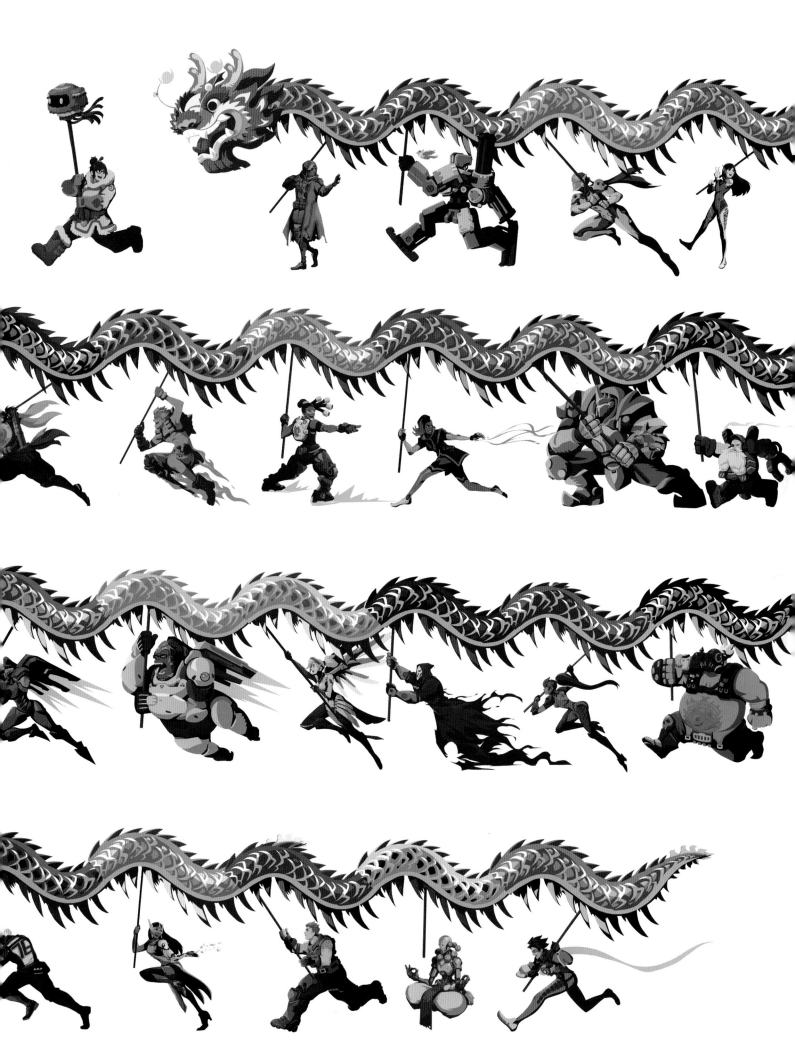

BEN ZHANG AND AQUATIC MOON

UPRISING

Because Uprising revealed several heroes' backstories, it seemed fitting that the event's sprays would do the same. Many of the designs conveyed touching moments from the characters' histories, such as infant Pharah and her parents (first row, first column). Others were fun Easter eggs, like the espresso machine (second row, first column), which was based on an element from the alternate reality game leading up to Sombra's announcement.

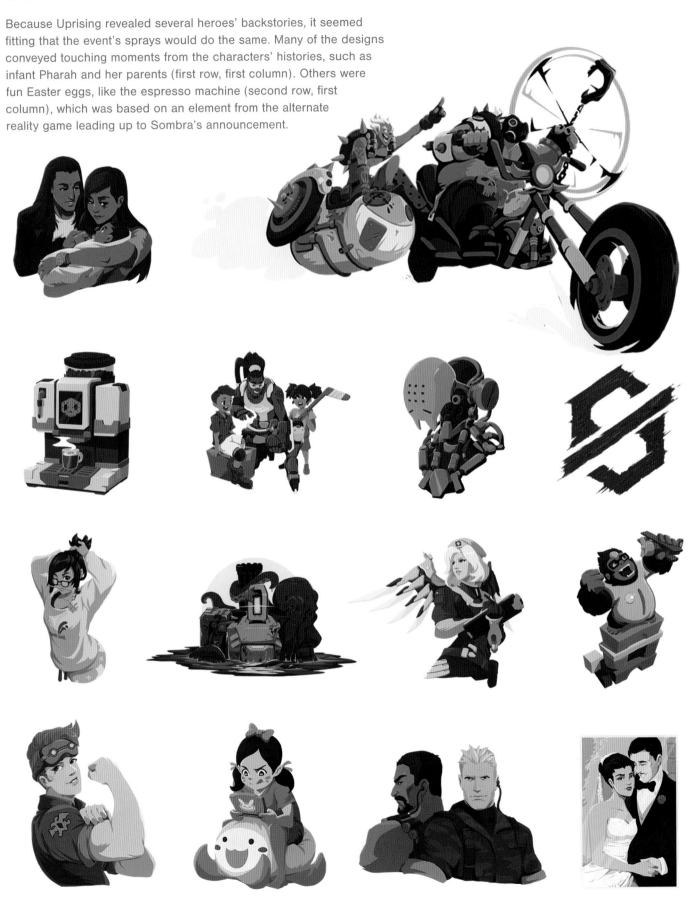

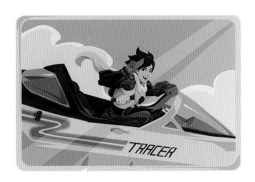

OVERWATCH: ANNIVERSARY

Before *Overwatch*'s launch, a playing card-themed spray was made for McCree. The game team liked the idea, and similar designs were crafted for many of the other heroes. However, the developers held off on releasing these sprays. In preparation for the *Overwatch*: Anniversary event, they revisited the concept of hero-inspired playing cards. Sprays were created for the rest of the characters, and this distinct set of images was unveiled to the world.

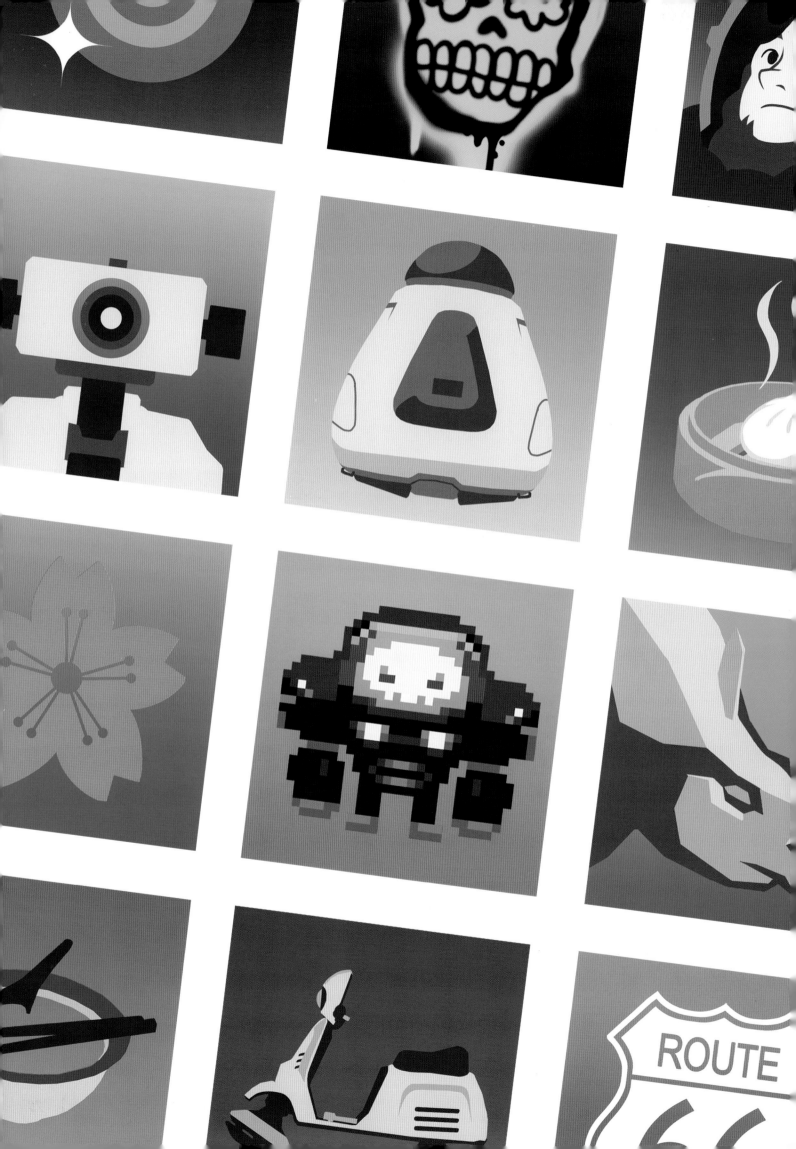

PLAYER ICONS

The *Overwatch* team's approach to creating player icons was similar to how they designed sprays. The keys were simplicity and clarity. Because the icons would be small, it was important that players could understand them at a glance. The designers limited shading and the amount of color in each piece of art as much as possible, relying on strong, readable shapes to convey the imagery.

GENERAL

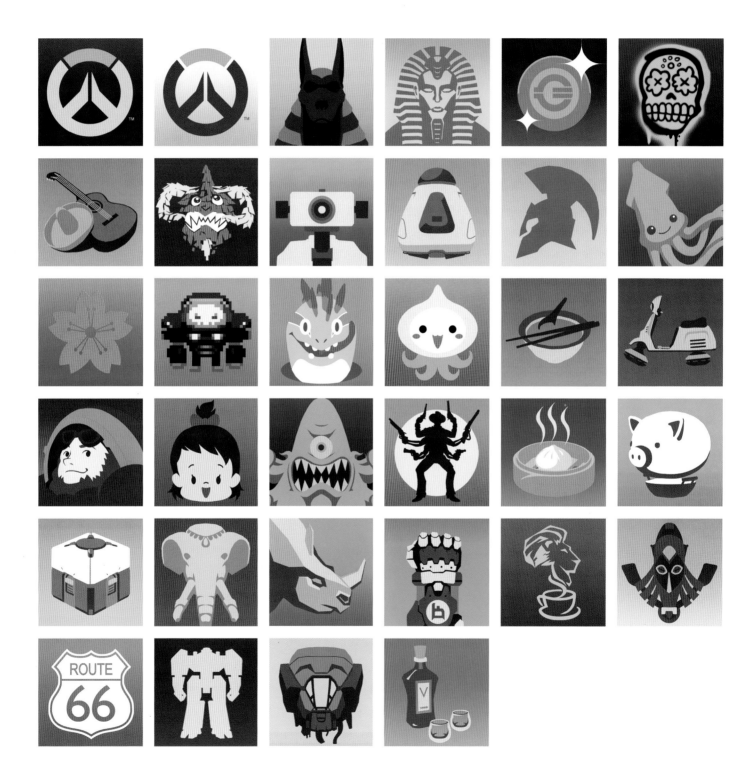

ARNOLD TSANG, BEN ZHANG, DAVID KANG, AND ANH DANG

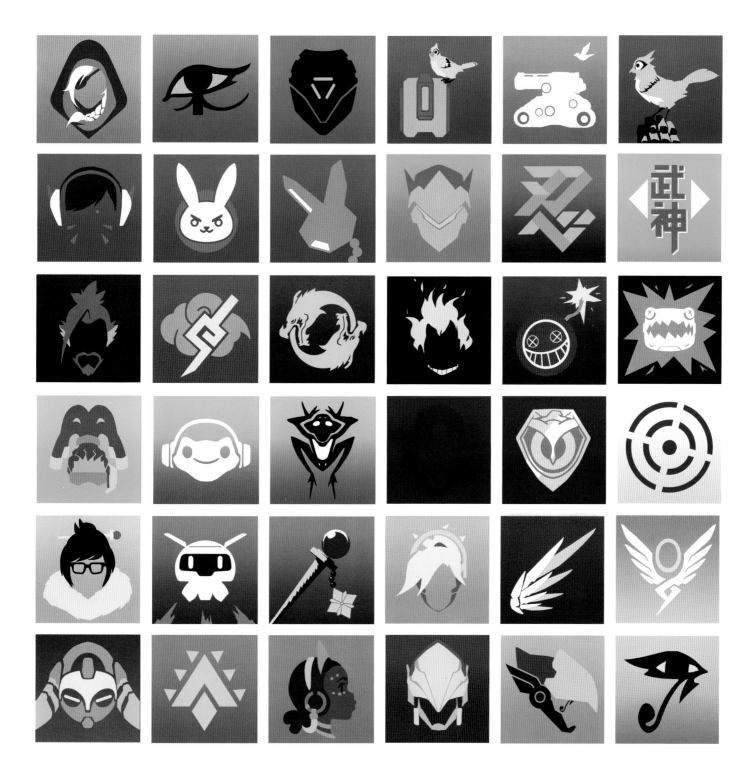

HEROES, CONTINUED

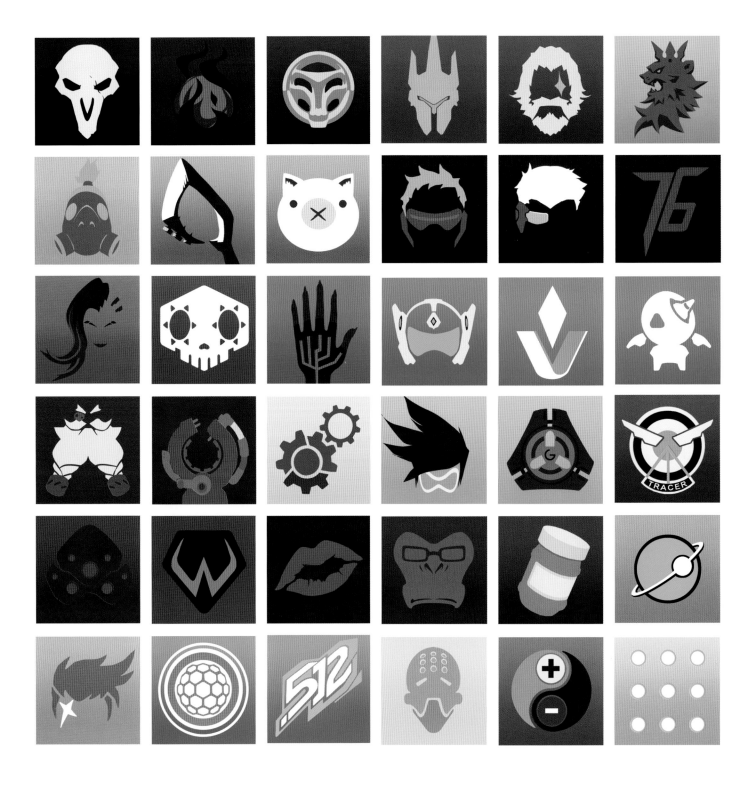

BEN ZHANG, ARNOLD TSANG, DAVID KANG, AND ANH DANG

EVENTS

SUMMER GAMES

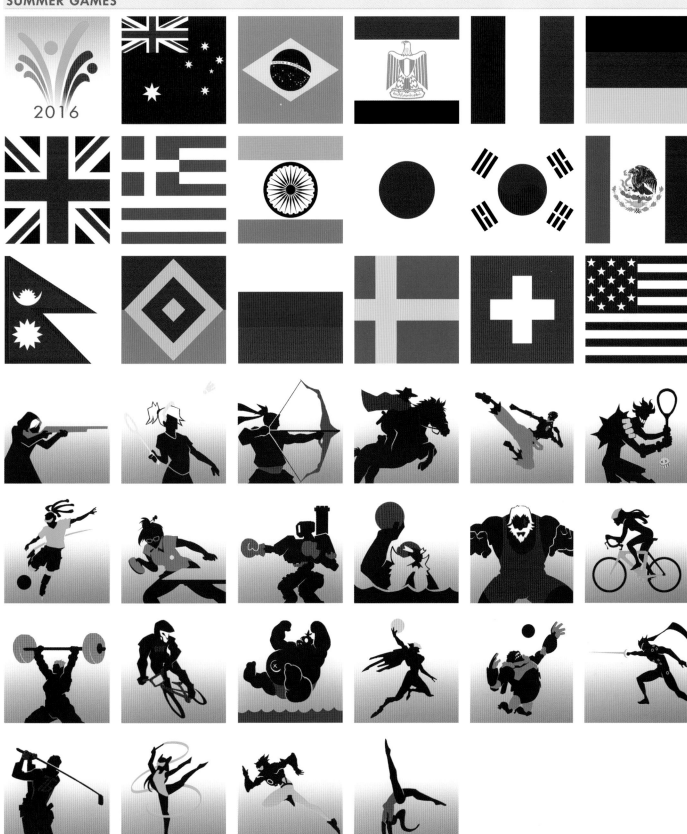

SAMANTHA RUSSO, ARNOLD TSANG, AND ANH DANG

OVERWATCH HALLOWEEN TERROR

WINTER WONDERLAND

YEAR OF THE ROOSTER

ANH DANG AND SAMANTHA RUSSO

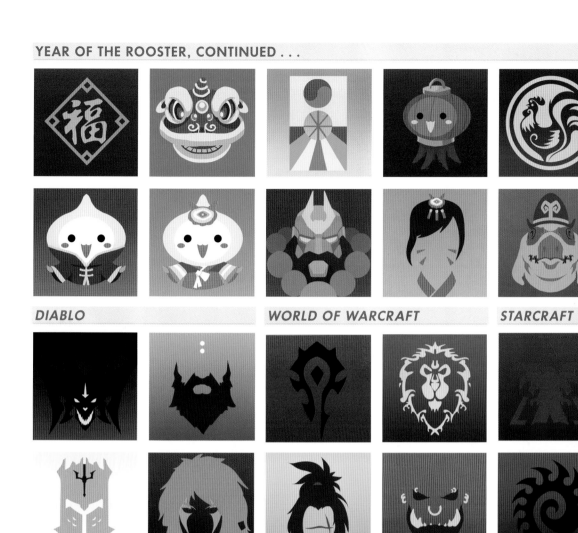

DIABLO

WORLD OF WARCRAFT

STARCRAFT

HEROES OF THE STORM

HEARTHSTONE

ANH DANG, BEN ZHANG, ARNOLD TSANG, AND AQUATIC MOON

ANIMATED SHORTS

Every *Overwatch* character has a story to tell. The challenge for the game team was *how* to tell it.

Before the game's release, the developers talked options with Story and Franchise Development (SFD), the department responsible for creating the company's cinematics. Many ideas sprang from those discussions. Not all of them stuck, but the one that did was something the company had never tried. The game team and SFD would create more than just a cinematic trailer for *Overwatch*—they would create a series of animated episodes. Each one would shine a spotlight on a character (or characters), showing them struggle and grow through a difficult challenge.

Producing these shorts brought its own challenges to the *Overwatch* team and SFD. One of the biggest was finding artistic styles for the shorts that stayed true to the game but also presented the *Overwatch* universe in a level of detail never seen before.

ANNOUNCEMENT

This short was the public's first look at *Overwatch*, and it was important that it captured the game's hopeful, futuristic setting. Success largely rested on the design of the museum. The *Overwatch* team and the film's creators went through many iterations (below) before settling on the right one: a streamlined, modern environment with a glass roof that allowed for ample natural lighting and a glimpse of a boundless blue sky.

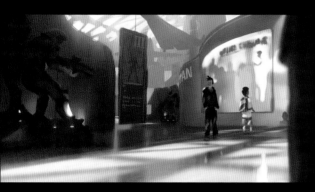
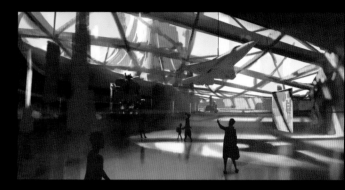

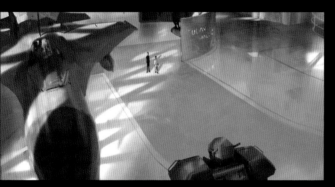
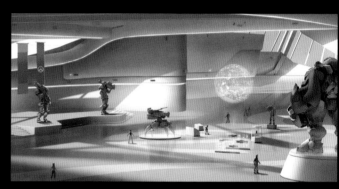

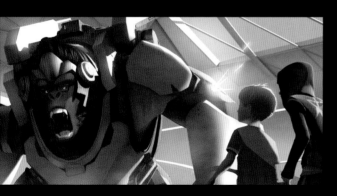
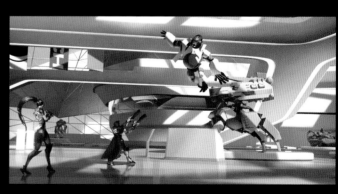

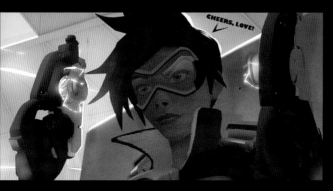

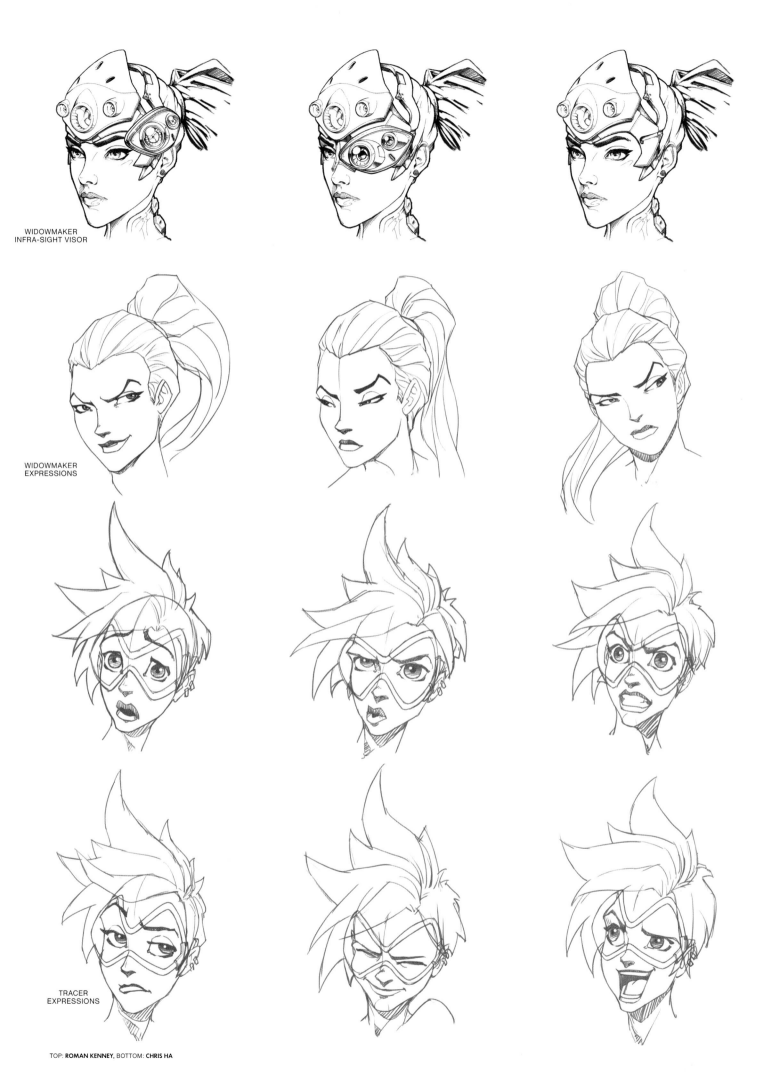

WIDOWMAKER
INFRA-SIGHT VISOR

WIDOWMAKER
EXPRESSIONS

TRACER
EXPRESSIONS

TOP: **ROMAN KENNEY**, BOTTOM: **CHRIS HA**

► **CHARACTER CONCEPTS**—For the clothing worn by the brothers, contrasting colors and designs were used to show their different personalities: optimism and excitement vs. cynicism and indifference.

ARNOLD TSANG AND STEPHANE BELIN

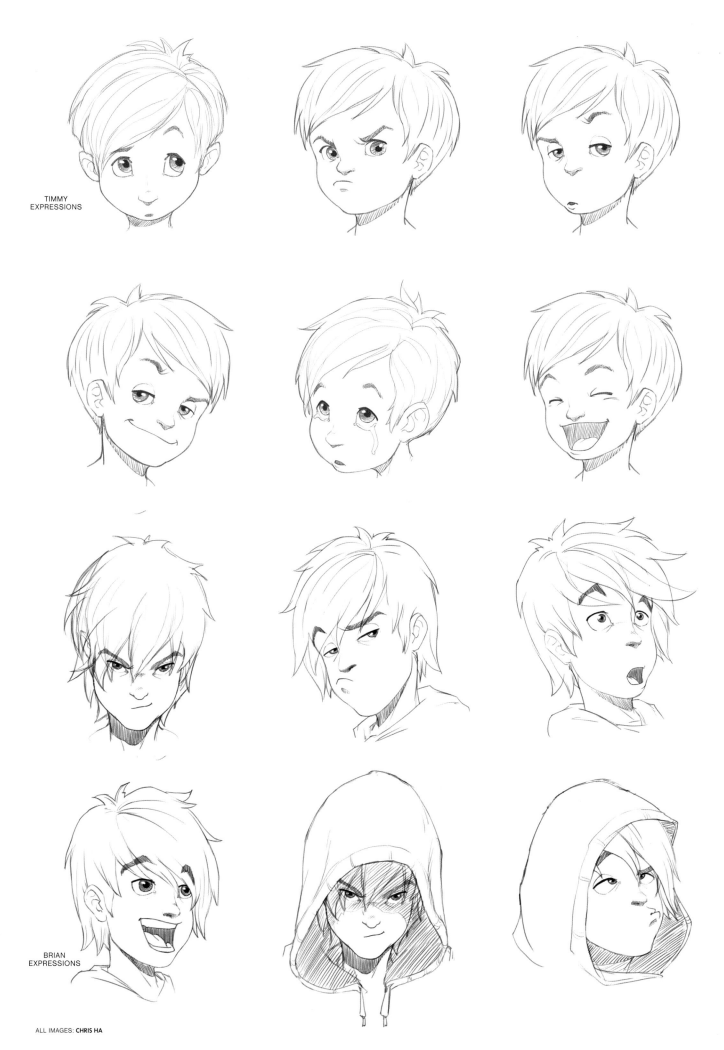

TIMMY
EXPRESSIONS

BRIAN
EXPRESSIONS

ALL IMAGES: **CHRIS HA**

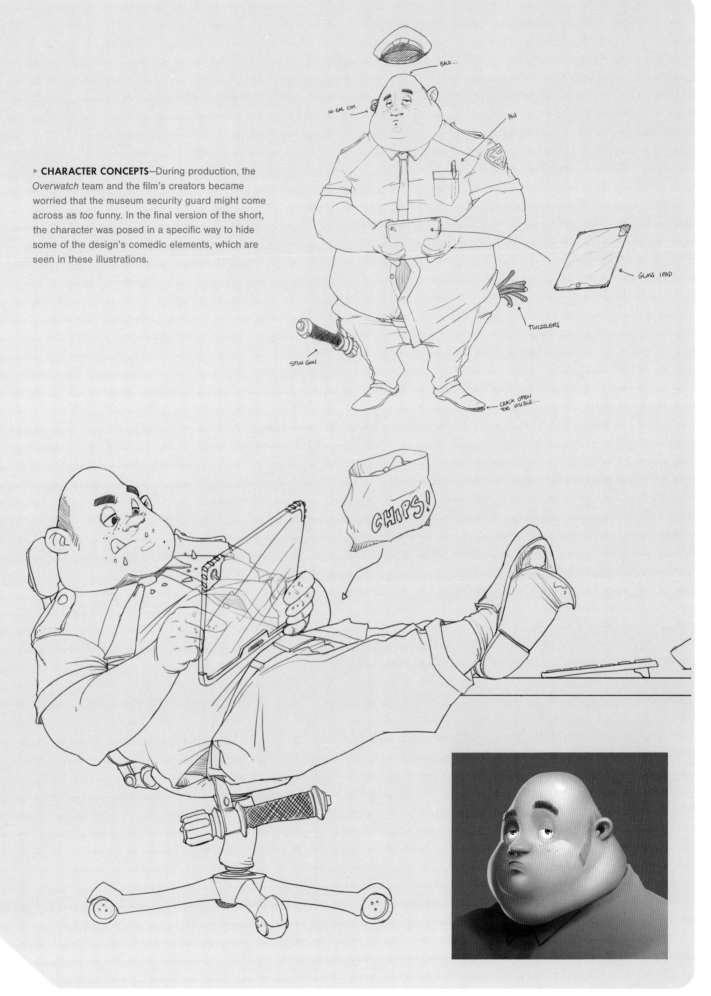

▶ **CHARACTER CONCEPTS**—During production, the *Overwatch* team and the film's creators became worried that the museum security guard might come across as *too* funny. In the final version of the short, the character was posed in a specific way to hide some of the design's comedic elements, which are seen in these illustrations.

BALD...

IN-EAR COM.

PEN

GLASS IPAD

TWIZZLERS

STUN GUN

CRACK OPEN
TOE VISIBLE...

CHIPS!

LEFT: **CHRIS HA**, RIGHT: **CHRIS HA** AND **STEPHANE BELIN**

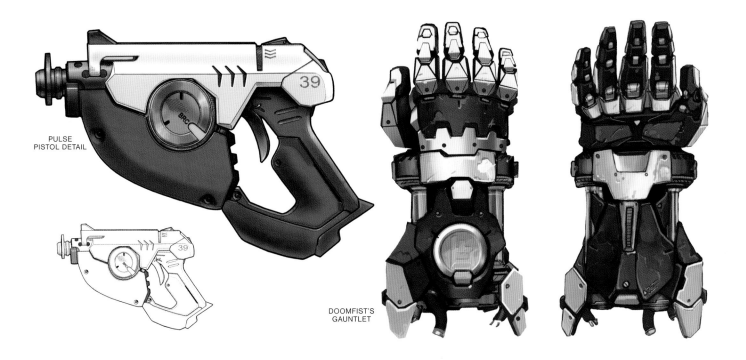

PULSE
PISTOL DETAIL

DOOMFIST'S
GAUNTLET

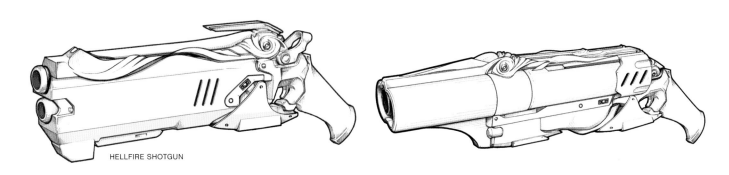

HELLFIRE SHOTGUN

Holographic volume with animated "data flow"

Revolving information "Touch me" icube

Little cubes link the icube to information panels

Blue glass

Smooth matte off white polycarbonate

Brushed steel

Reflective light warm grey polycarbonate

Smooth matte dark warm grey polycarbonate

DISPLAY CASE

ROMAN KENNEY, STEPHANE BELIN, AND **ARNOLD TSANG**

ARE YOU WITH US?

One of the main goals of this short was to tell the history of Overwatch and establish the current state of the world. To overcome time and resource constraints, the game team and the film's creators relied on 2-D paintings (below). The progression of illustrations created a story arc that spans from an era of peace and optimism to one of conflict and uncertainty.

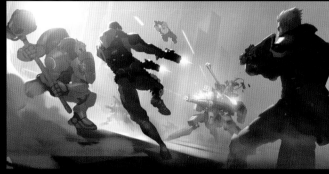
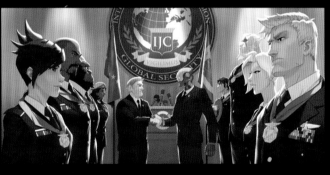

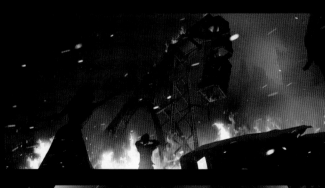
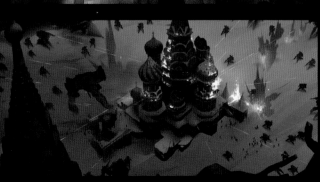
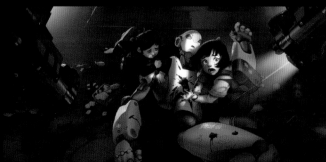

ARNOLD TSANG, BEN ZHANG, AND STEPHANE BELIN

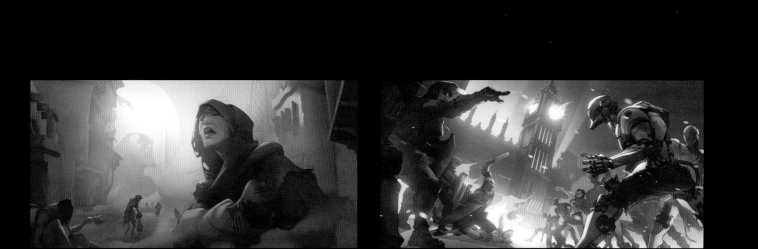

WE ARE OVERWATCH

Clear imagery was the key for "We Are Overwatch." Because the animation was a series of very short scenes, it was important that each one focused on a few crucial elements. Details beyond that were left subtle, such as the N Seoul Tower barely visible in the background of the first image below.

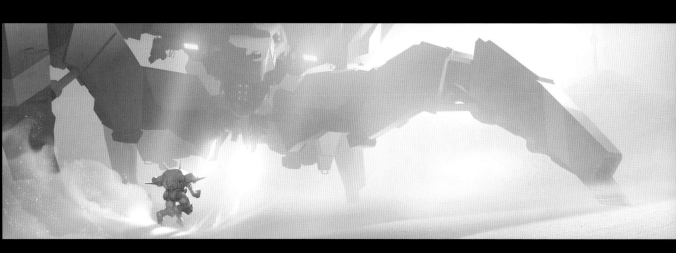

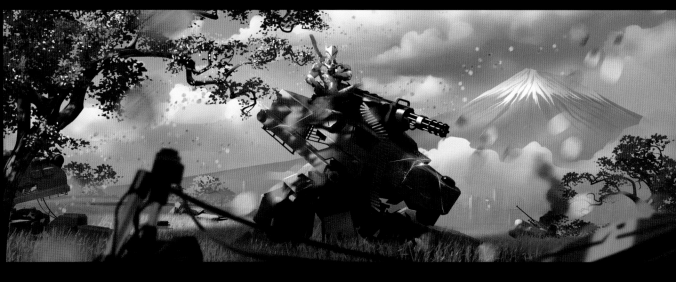

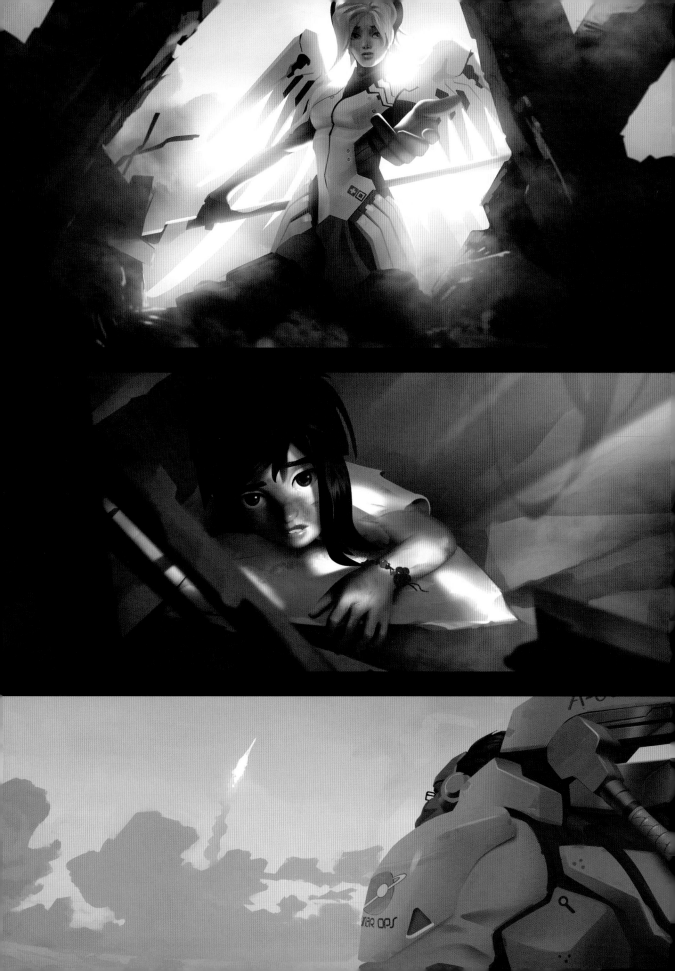

# ANIMATED SHORTS
RECALL

The illustrations below show young Winston's range of facial expressions. Making these was an important step for the film's creators because it established the hero's personality and set general guidelines for how he should be animated.

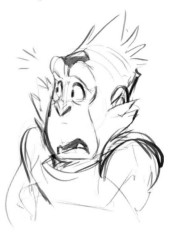
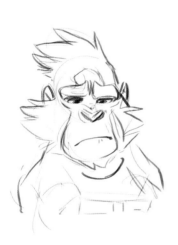
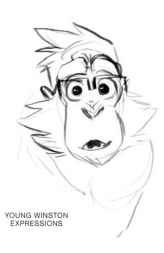

YOUNG WINSTON
EXPRESSIONS

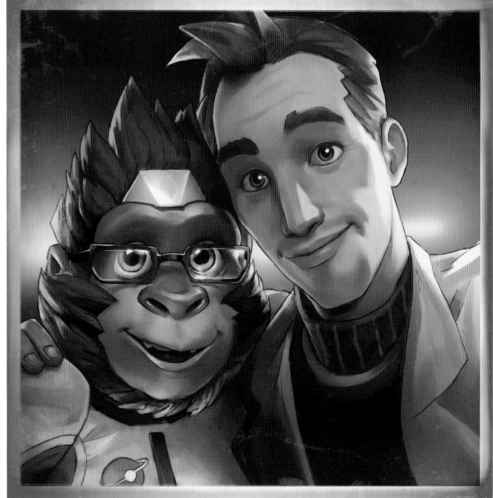

PHOTO OF YOUNG WINSTON AND DR. HAROLD WINSTON

SKETCHES: HAYLEE HERRICK, LOWER RIGHT: JUSTIN THAVIRAT, ROMAN KENNEY, SEAN MCNALLY, AND MATHIAS VERHASSELT

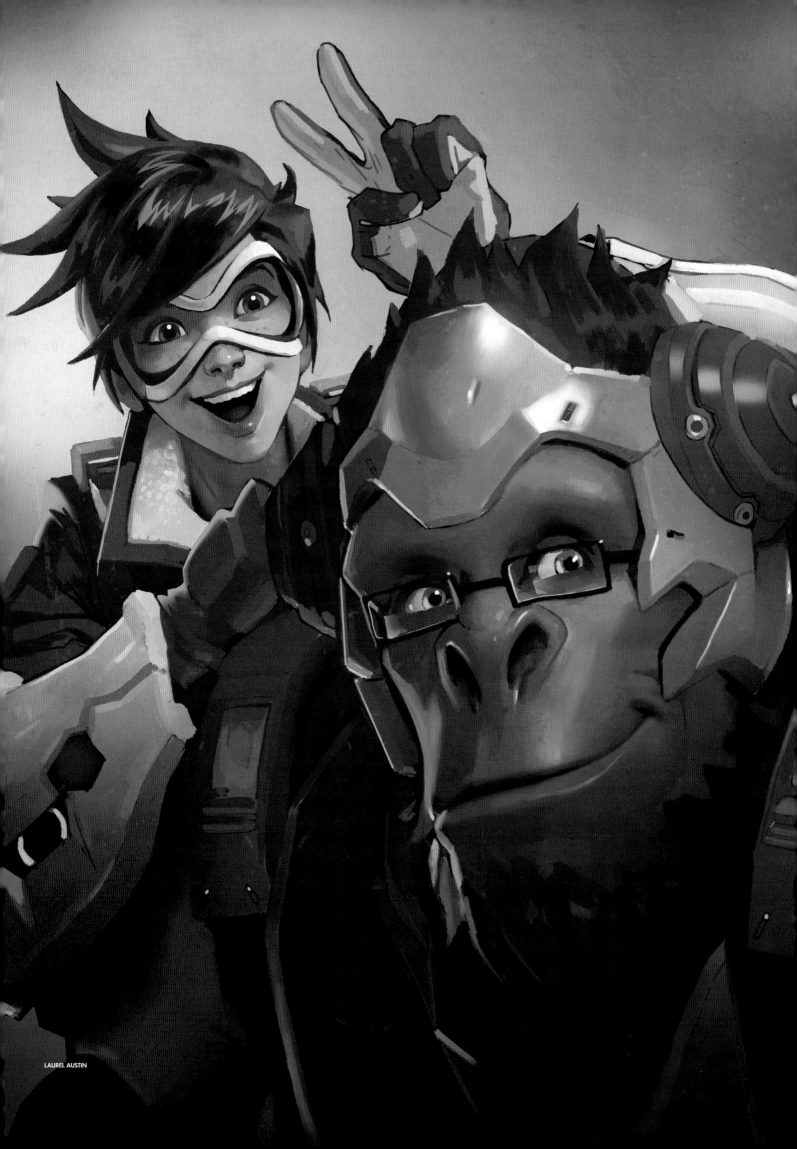

LAUREL AUSTIN

ATHENA LOGO

OLYMPIA SHAW

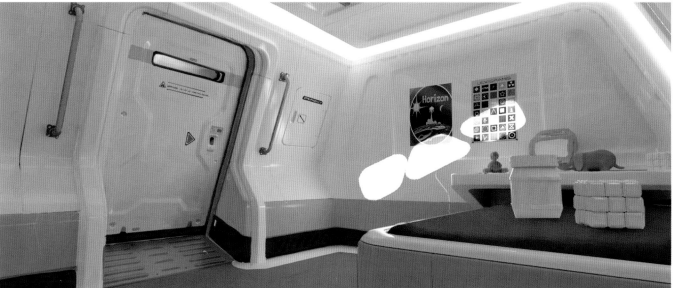

WINSTON'S ROOM

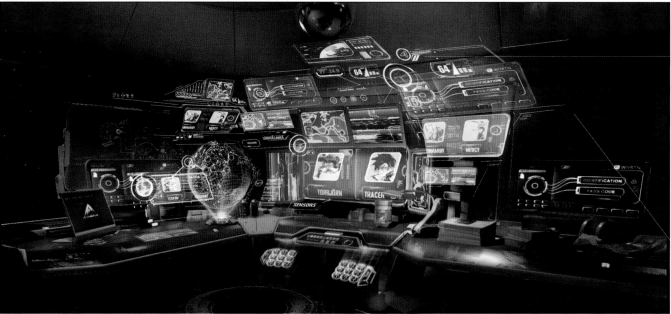

WINSTON'S COMMAND CONSOLE

TOP LEFT AND BOTTOM: **TAE YOUNG CHOI**, TOP RIGHT AND MIDDLE: **MATHIAS VERHASSELT**

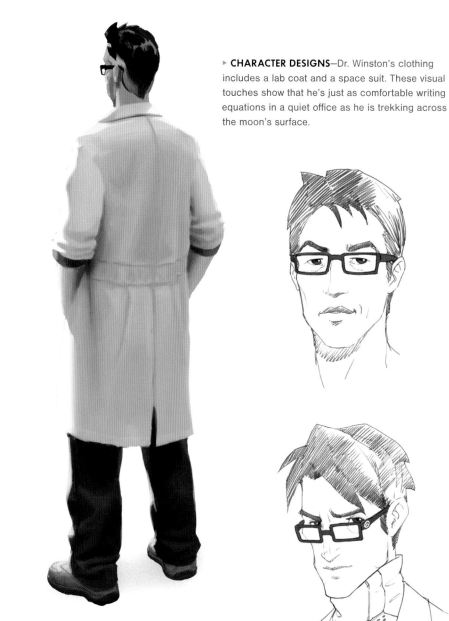

▶ **CHARACTER DESIGNS**—Dr. Winston's clothing includes a lab coat and a space suit. These visual touches show that he's just as comfortable writing equations in a quiet office as he is trekking across the moon's surface.

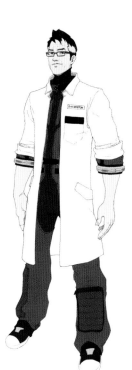
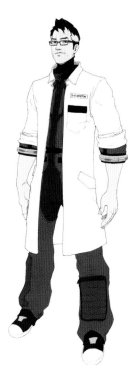

TOP: **MATHIAS VERHASSELT**, BOTTOM AND RIGHT: **CHRIS HA**

TALON
SOLDIER

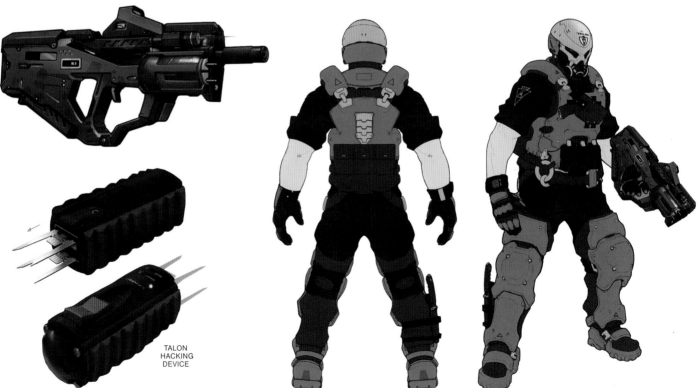

TALON
HACKING
DEVICE

TOP AND BOTTOM LEFT: **MATHIAS VERHASSELT**, MIDDLE LEFT: **ROMAN KENNEY**, BOTTOM RIGHT: **JOHN POLIDORA** AND **ROMAN KENNEY**

▶ **ENVIRONMENT DESIGNS**—One of the big challenges in "Recall" was designing its flashbacks. These scenes are in the past relative to the *Overwatch* world, but they still take place in *our* future.

The film's creators used color schemes and designs that evoked 1960s and early 1970s science fiction (images below) to create sets and clothing that would feel both futuristic and retro.

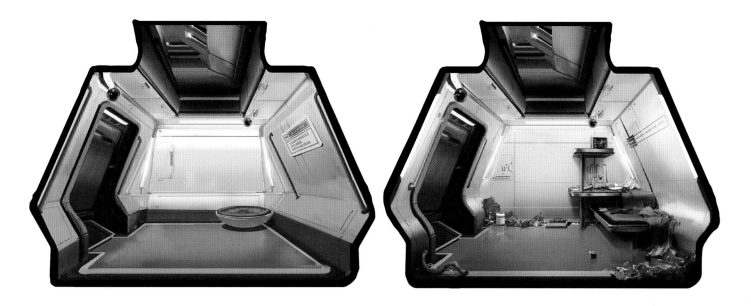

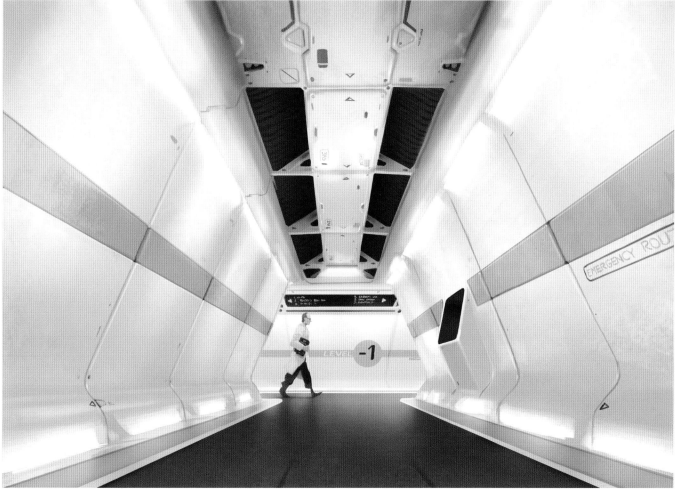

LUNAR COLONY CORRIDOR

ALL IMAGES: **MATHIAS VERHASSELT**

▶ **COLOR KEYS**—"Recall" involves different time periods, sets, and lighting conditions. Color key paintings (opposite page) were vital in establishing the right atmosphere, such as the Gibraltar base in full lighting (first row, second column) and in darkness (fourth row, first column).

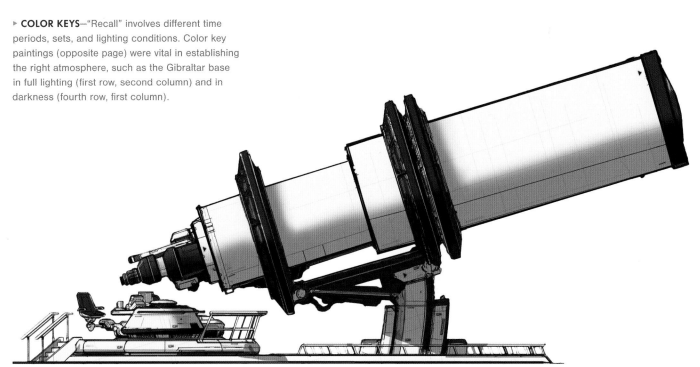

OBSERVATORY TELESCOPE

ALIVE

The bottom image of Widowmaker was an early exploration of how to light the short. The intent was to create a London enveloped by fog and heavy orange and yellow lights, giving the unsettling impression of a fire burning in the city. Ultimately, this felt too different from what is seen in the game, so the artists went in another direction.

KING'S ROW LIGHTING STUDIES

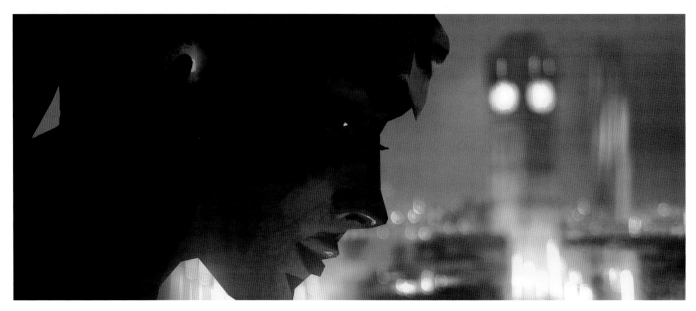

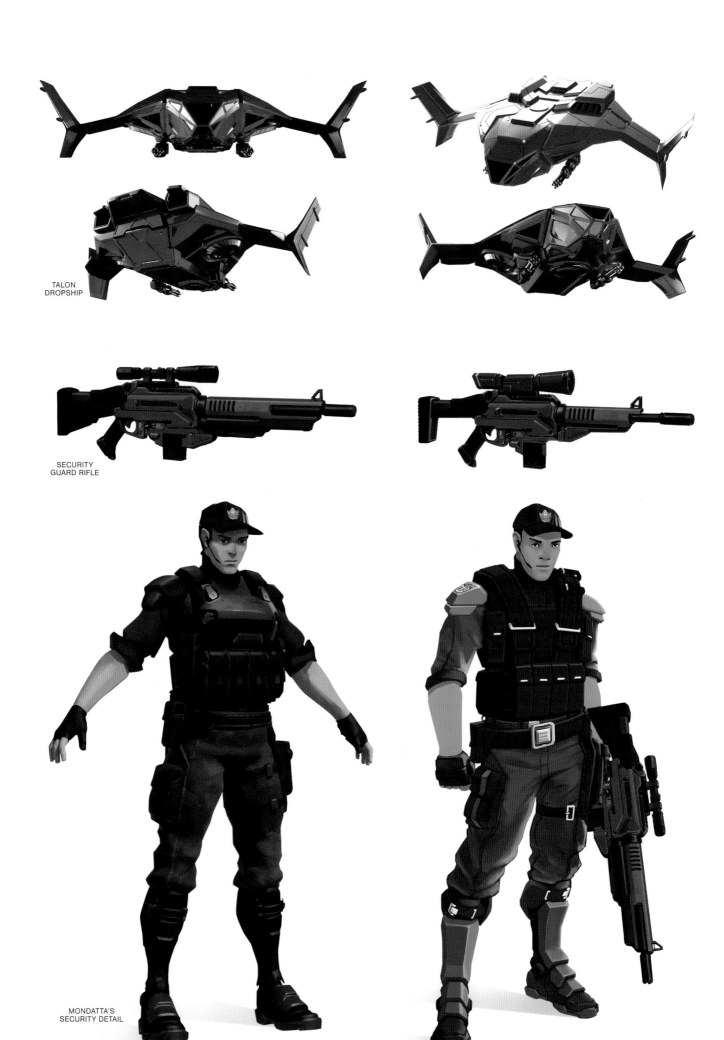

TALON
DROPSHIP

SECURITY
GUARD RIFLE

MONDATTA'S
SECURITY DETAIL

TOP: **DOMINIC QWEK**, BOTTOM: **ROMAN KENNEY**

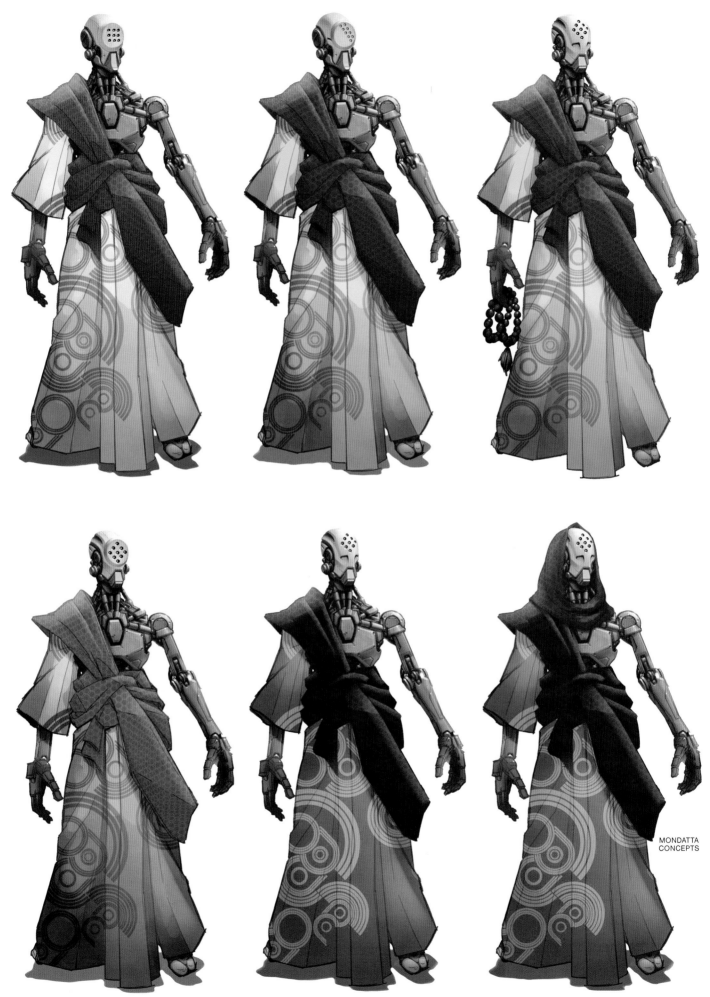

MONDATTA
CONCEPTS

ALL IMAGES: **ROMAN KENNEY**

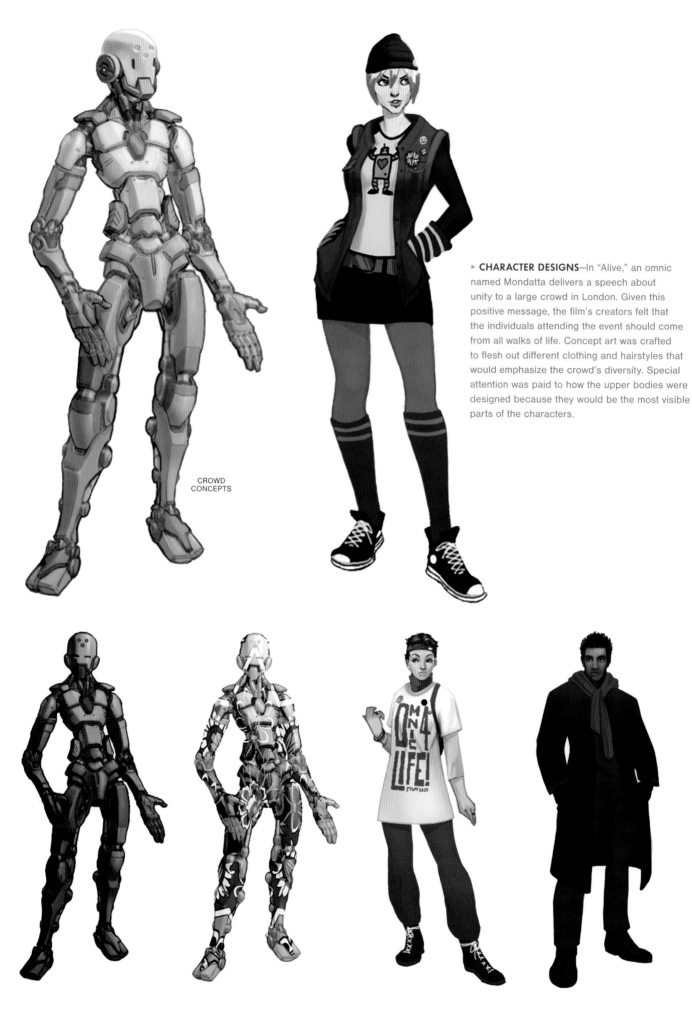

▶ **CHARACTER DESIGNS**—In "Alive," an omnic named Mondatta delivers a speech about unity to a large crowd in London. Given this positive message, the film's creators felt that the individuals attending the event should come from all walks of life. Concept art was crafted to flesh out different clothing and hairstyles that would emphasize the crowd's diversity. Special attention was paid to how the upper bodies were designed because they would be the most visible parts of the characters.

CROWD CONCEPTS

LEFT: **ROMAN KENNEY**, RIGHT: **LAUREL AUSTIN** AND **ROMAN KENNEY**

▶ **LIGHTING DESIGN**—"Alive" follows two *Overwatch* characters who couldn't be more different: the noble and optimistic hero Tracer and the cold and nihilistic villain Widowmaker. Specific colors were used to reflect who these two individuals are. Tracer first appears on London's streets, which are lit in warm gold tones (first column, second row), and Widowmaker stalks the shadowy rooftops, which are bathed in cool shades of blue (first column, third row).

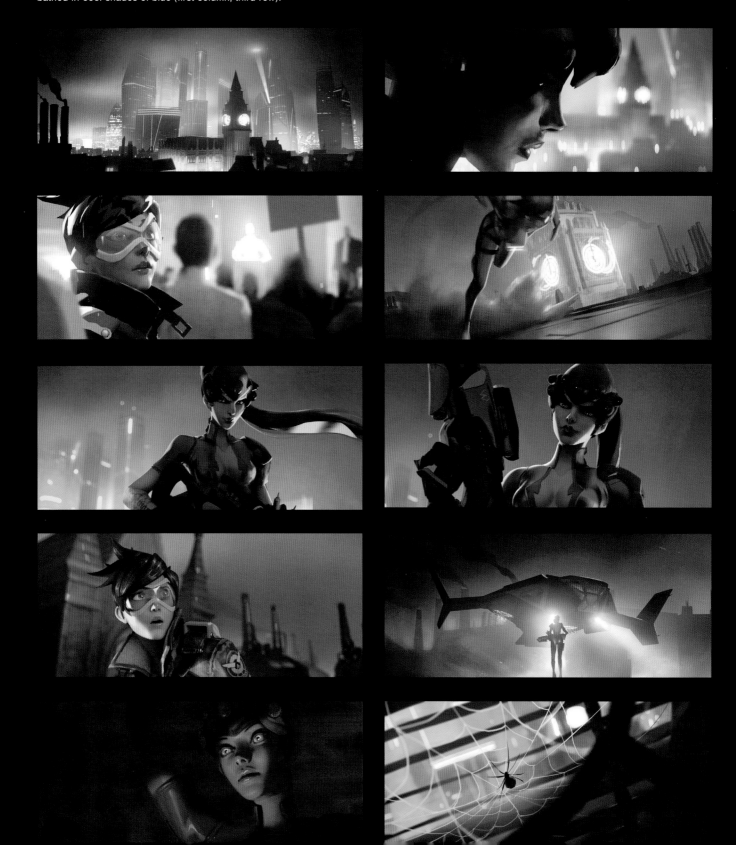

► **ABILITY DESIGNS**—The color key paintings below were made to explore how Tracer's Recall ability would be rendered in the short. The film's creators decided that the world around her should become slightly ethereal and blue when she turns back time, helping make her feel detached from the rest of London.

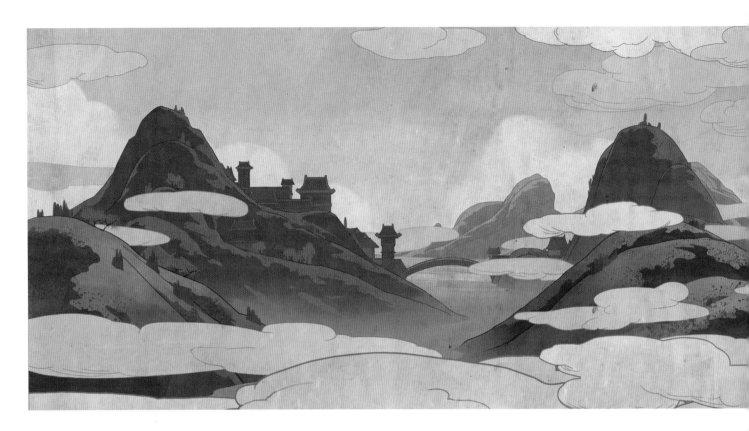

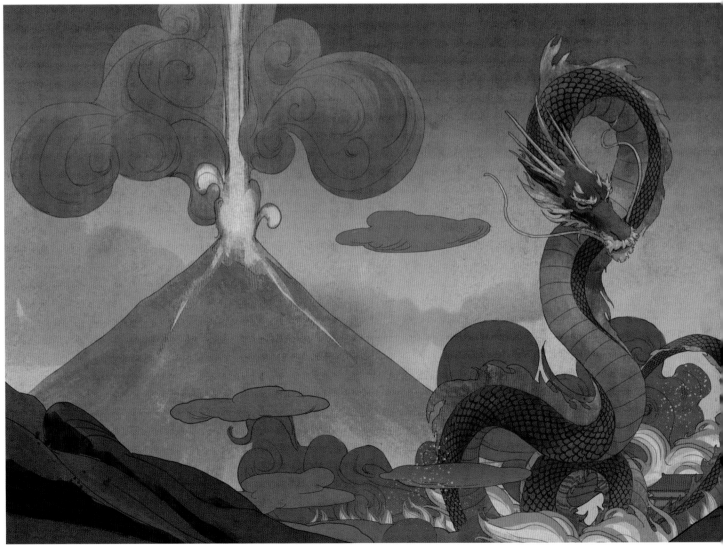

TAE YOUNG CHOI AND EVEN AMUNDSEN

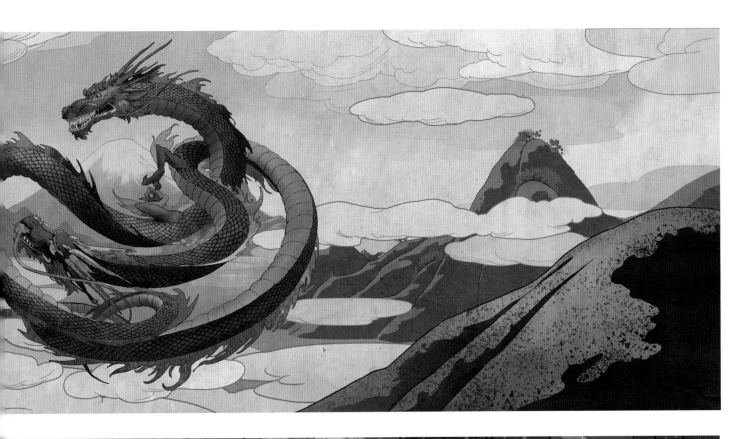

DRAGONS

The "Dragons" short film contains a story within a story, a fairy tale told through illustrations inspired by traditional Japanese art. The process to create these images began with storyboards, which were then redrawn and fully rendered in color. Limited animation, such as moving clouds and fiery embers, was added to further bring the paintings to life.

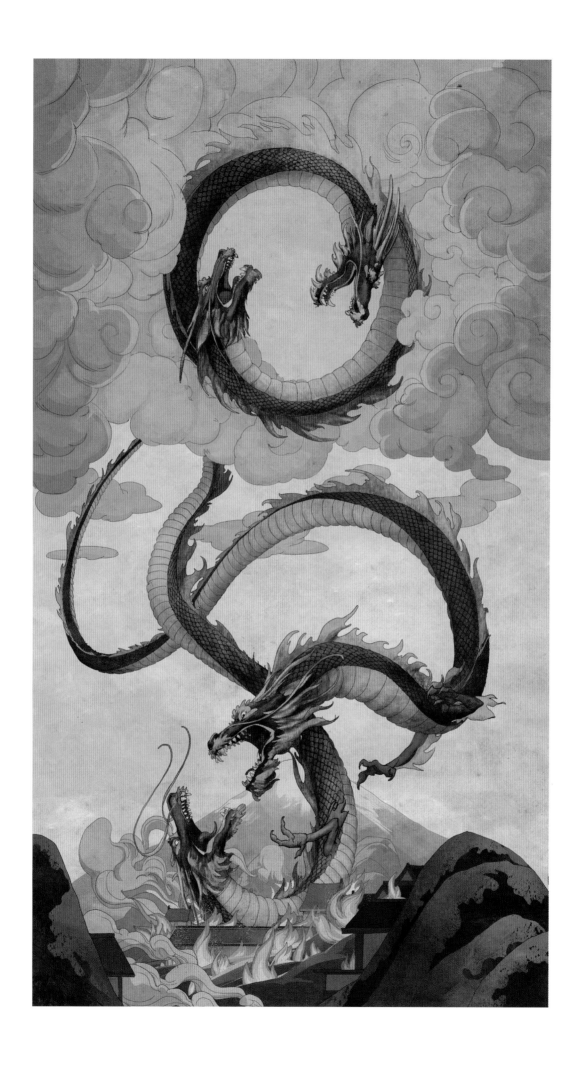

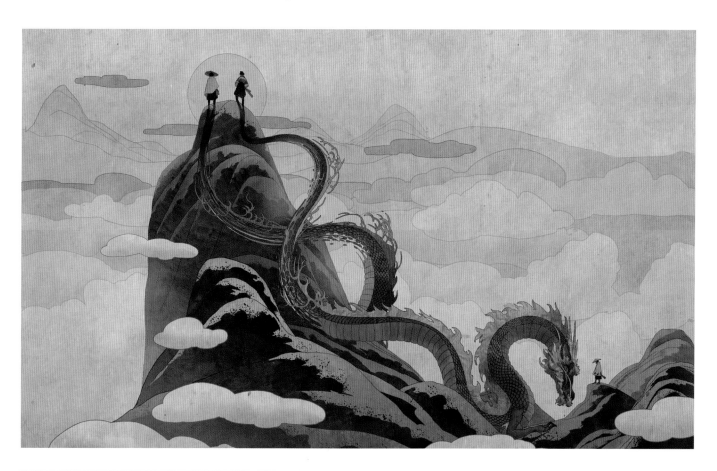

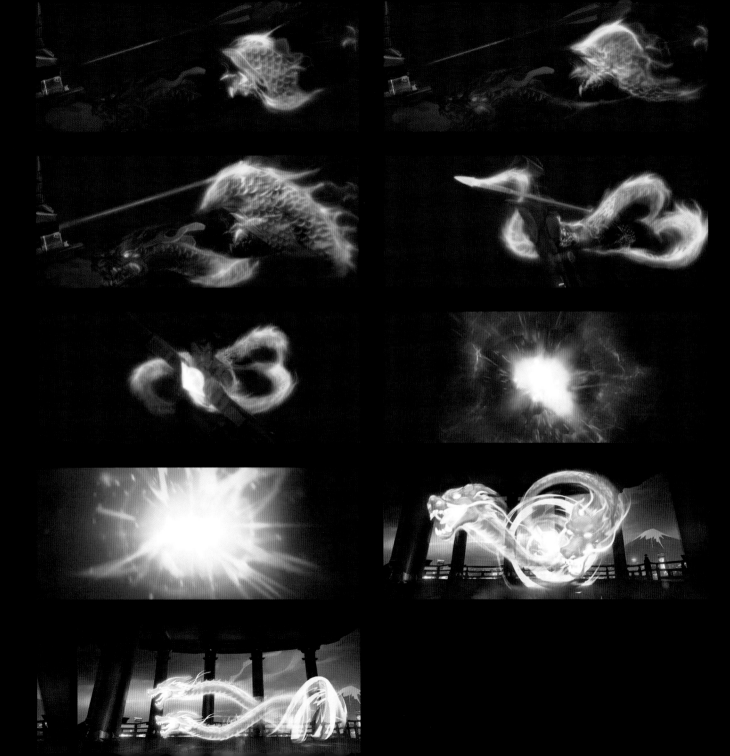

▶ **COLOR KEYS**—Before the release of the "Dragons" short, players had seen Hanamura only in daytime. The film's creators decided to show the location at night. They drew on the pink and blue colors that were prominent in the game map to flesh out the film's version of Hanamura. This was done to keep the setting familiar to players while infusing the story with a sense of magic and surrealism.

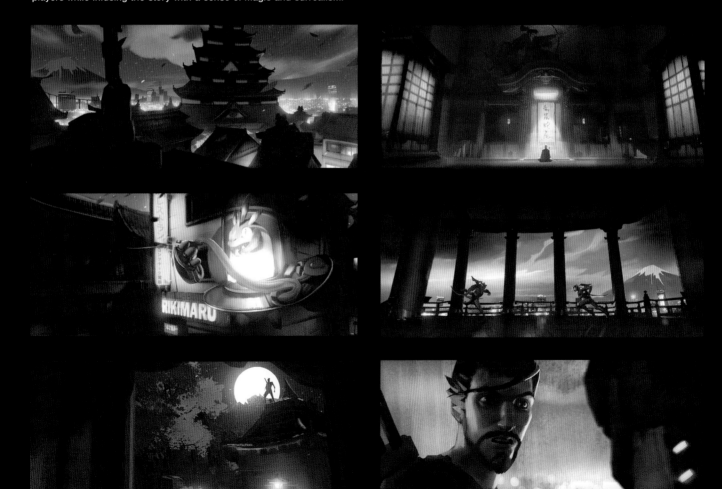

HERO

The creators of "Hero" knew they wanted to stage the film at night. It fit well with the story of a masked vigilante—Soldier: 76 —stalking the streets under cover of dark. It was also an opportunity to show off the vibrant glowing tattoos of the Los Muertos gang (opposite page, top left).

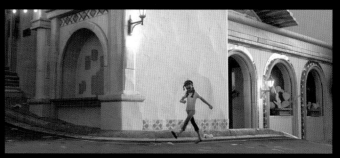

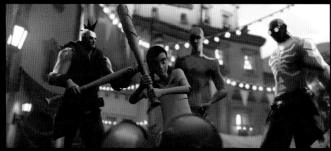

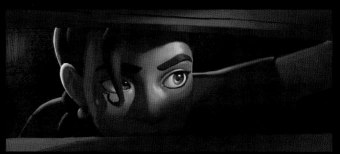

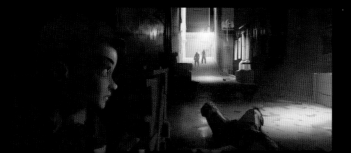

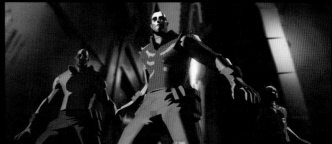

▶ **LIGHTING DESIGN**—While the creators explored the film's visuals in color keys (below), a slight change was made to enhance the atmosphere even more. They decided to begin the story at sunset. This direction escalated tension and provided a sense of increasing danger for the film's young protagonist, Alejandra, as she struggles to get off the mean streets of Dorado before darkness falls.

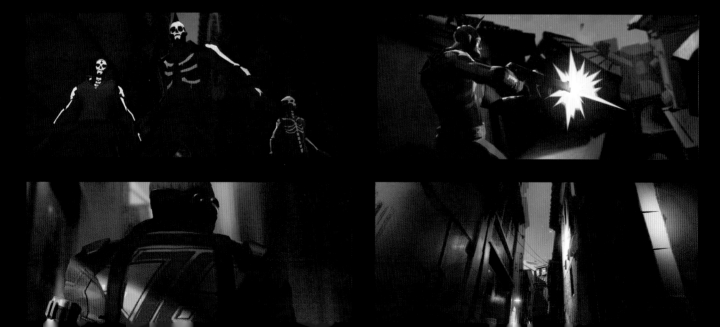

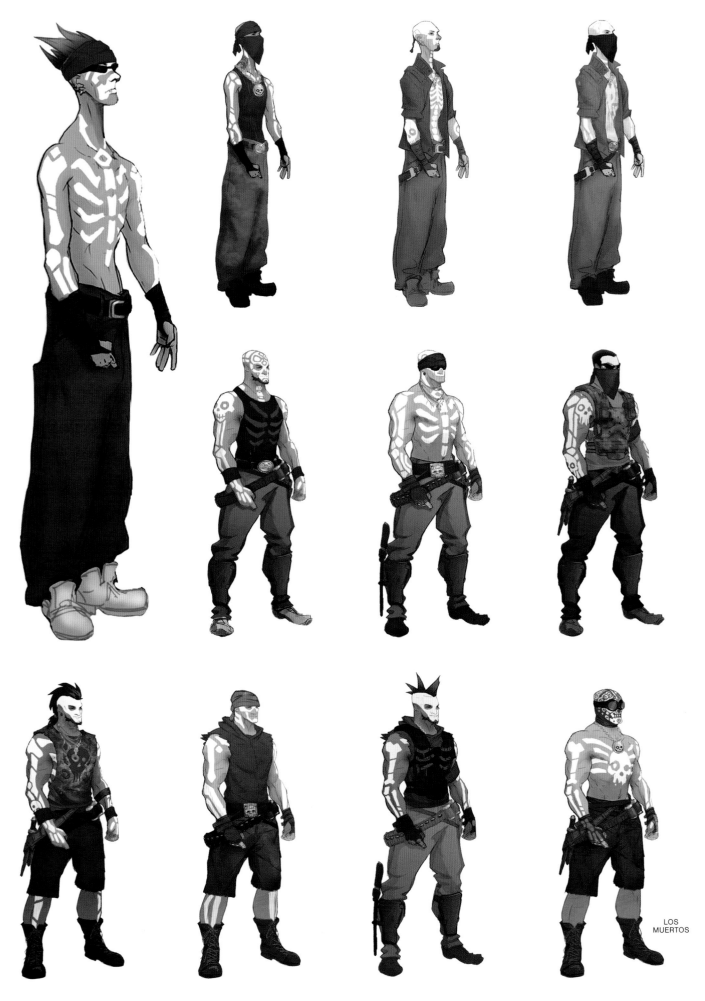

LOS
MUERTOS

JOHN POLIDORA AND ROMAN KENNEY

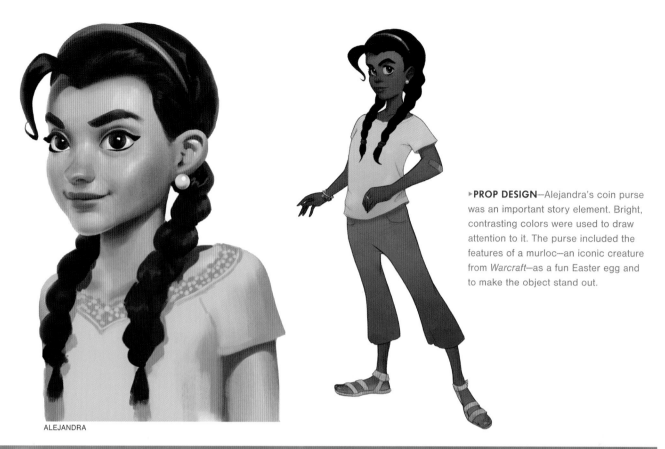

ALEJANDRA

▶**PROP DESIGN**—Alejandra's coin purse was an important story element. Bright, contrasting colors were used to draw attention to it. The purse included the features of a murloc—an iconic creature from *Warcraft*—as a fun Easter egg and to make the object stand out.

ALEJANDRA'S PURSE

TOP LEFT AND BOTTOM: **MATHIAS VERHASSELT,** TOP RIGHT: **ROMAN KENNEY**

THE LAST BASTION

"The Last Bastion" depicts a battle between omnics and the German military. This was an opportunity to show off the Crusaders, heavily armored soldiers like the hero Reinhardt. However, the film's creators didn't want to simply duplicate his design. They removed much of the filigree that makes Reinhardt's armor iconic, and they created outfits with color palettes that felt more appropriate for members of the German military.

CRUSADER

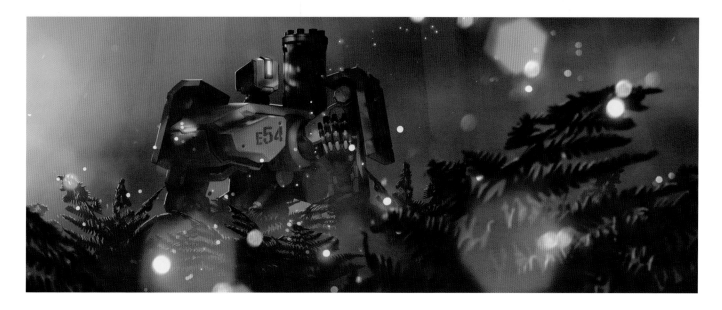

TOP AND BOTTOM: **STEPHANE BELIN,** MIDDLE: **JAKE PANIAN**

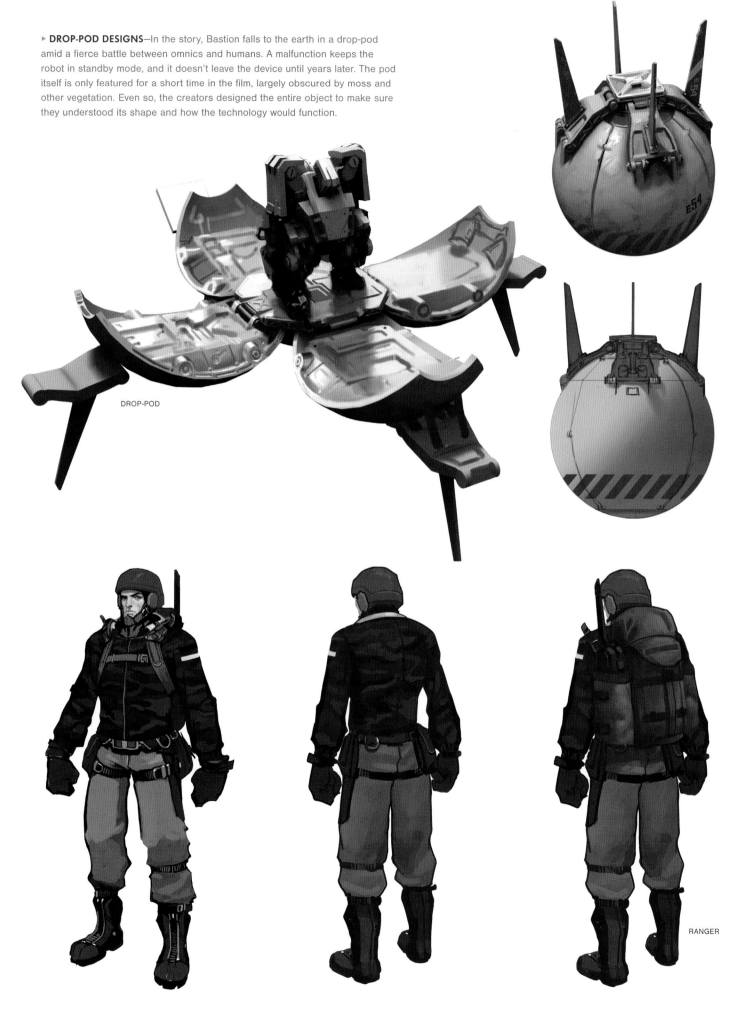

▶ **DROP-POD DESIGNS**—In the story, Bastion falls to the earth in a drop-pod amid a fierce battle between omnics and humans. A malfunction keeps the robot in standby mode, and it doesn't leave the device until years later. The pod itself is only featured for a short time in the film, largely obscured by moss and other vegetation. Even so, the creators designed the entire object to make sure they understood its shape and how the technology would function.

DROP-POD

RANGER

TOP: MATHIAS VERHASSELT, BOTTOM: LAUREL AUSTIN AND JOSH TALLMAN

▶ **ENVIRONMENT DESIGNS**—"The Last Bastion" was the only short film not based on an existing *Overwatch* map. That meant the creators had to build the woodland environment from the ground up. They explored many different types of foliage in their quest to create a forest. One of the guidelines they followed was limiting complexity in plant designs and using only strong and clear shapes. That made the forest feel real, but also unique and visually appealing.

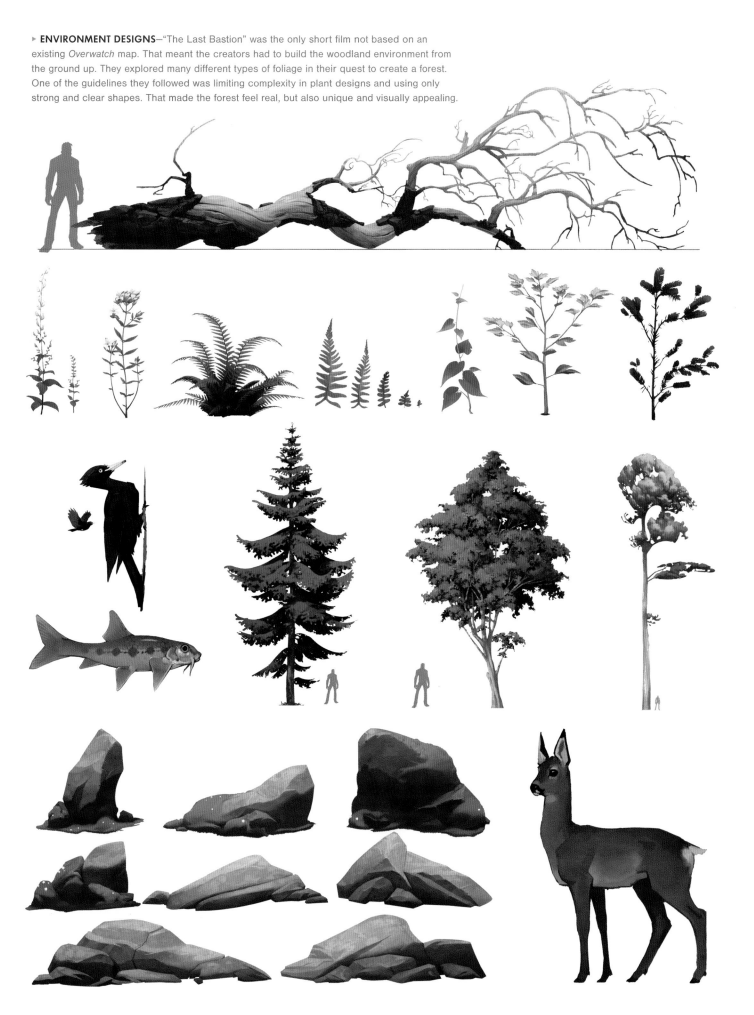

JAKE PANIAN AND LAUREL AUSTIN

▶ **EARLY CONCEPTS** —Early in development, artists were tasked with painting forest scenes, either with Bastion or without. This was an important step to discovering the look and feel of the environment as well as interesting story moments. Some of these explorations inspired scenes for the final film, such as Bastion walking on the fallen tree (second column, second row) and sitting at the river's edge (first column, third row).

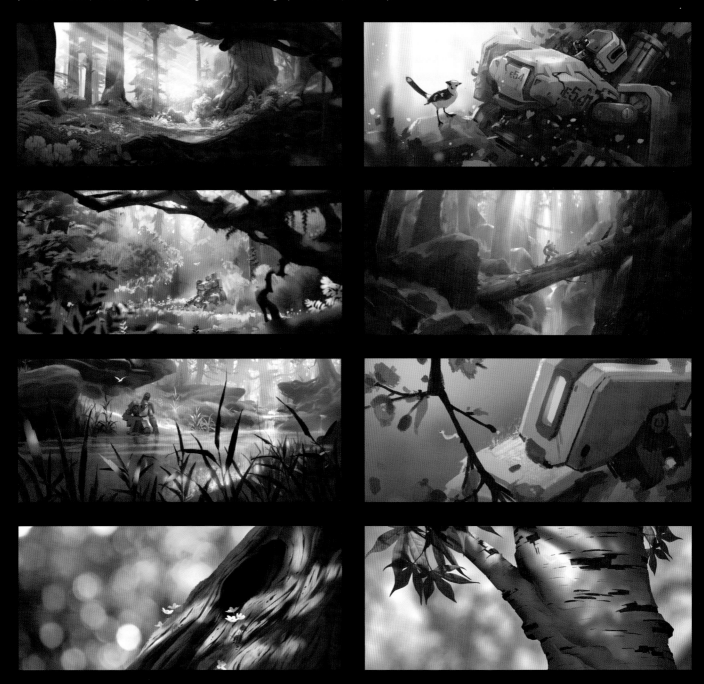

MATHIAS VERHASSELT AND STEPHANE BELIN

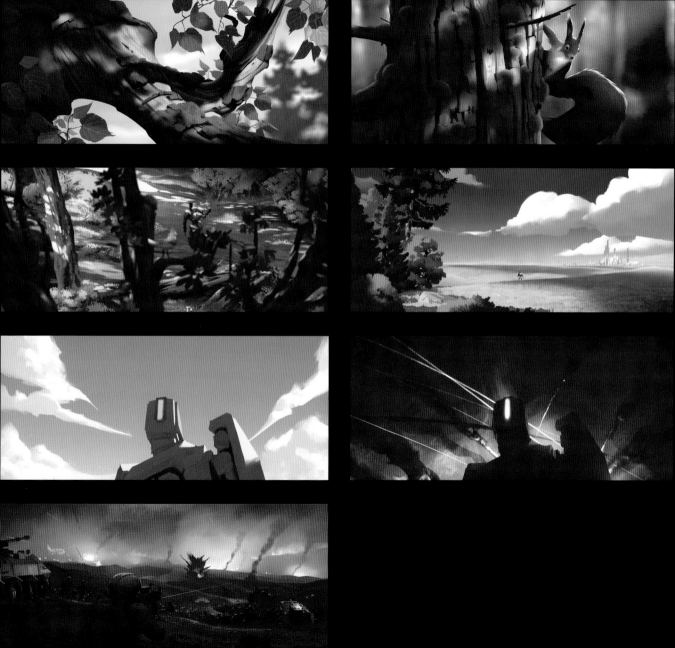

INFILTRATION

Most of "Infiltration" takes place in existing parts of the Volskaya Industries game map, but Katya's office (below) was made specifically for the short film. The creators designed the room with warm yellow colors to contrast with the colder blues and whites in the rest of the factory and outside the facility.

This also made the office feel like a safe haven, which was an important story point. During the film, Katya locks herself inside the room to escape an assassination attempt by Sombra, Reaper, and Widowmaker.

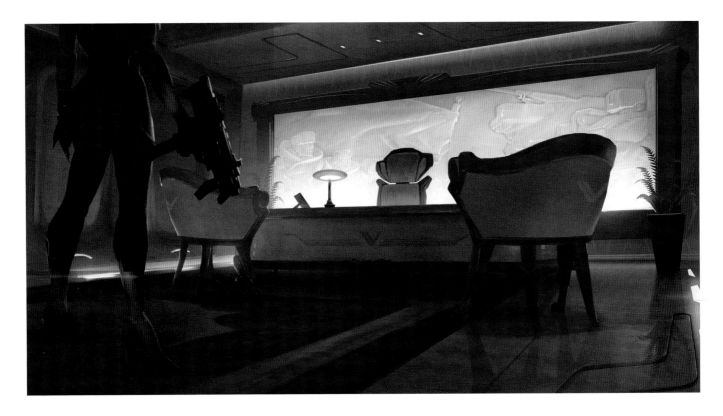

TOP: **JAKE PANIAN**, BOTTOM: **YEWON PARK**

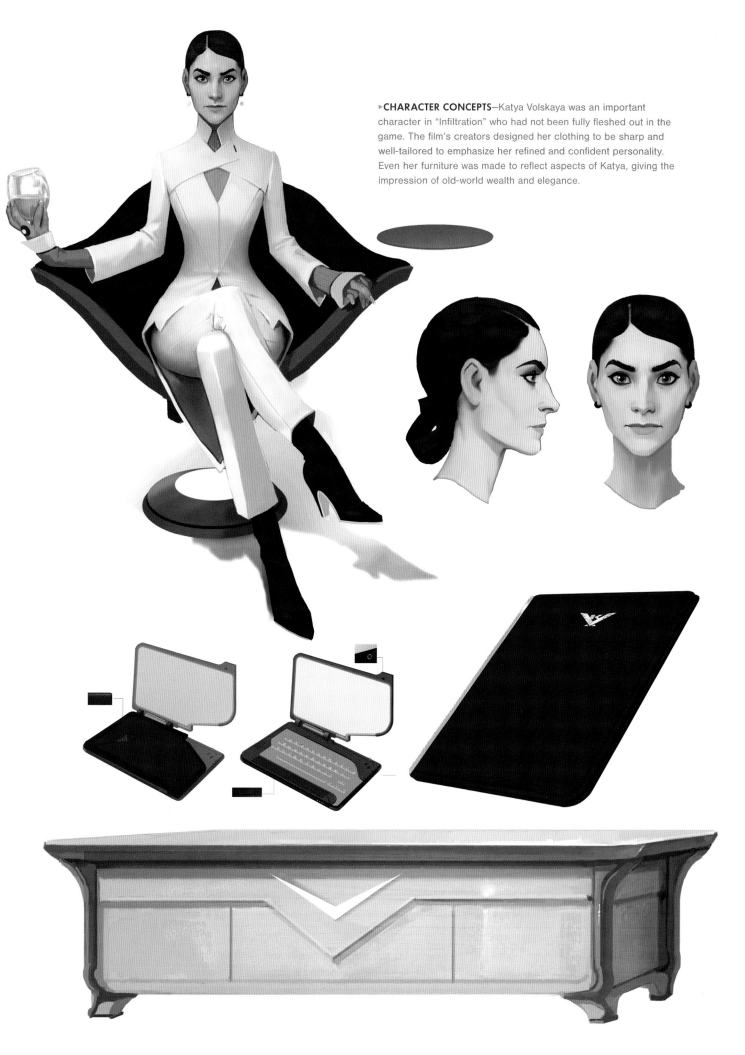

▸**CHARACTER CONCEPTS**—Katya Volskaya was an important character in "Infiltration" who had not been fully fleshed out in the game. The film's creators designed her clothing to be sharp and well-tailored to emphasize her refined and confident personality. Even her furniture was made to reflect aspects of Katya, giving the impression of old-world wealth and elegance.

TOP: **LAUREL AUSTIN,** MIDDLE AND BOTTOM: **YEWON PARK**

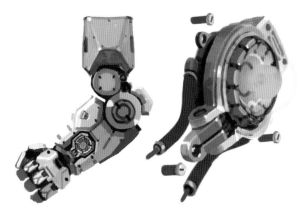

AUTOMATED
DEFENSE TURRET

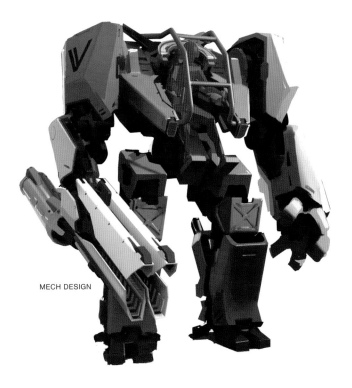

MECH DESIGN

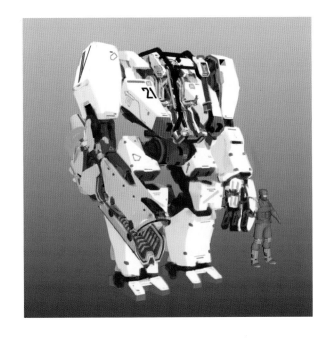

SOLDIER

MECH PILOT

LIEUTENANT

TOP AND MIDDLE: **VASILI ZORIN**, BOTTOM: **JUNGAH LEE**

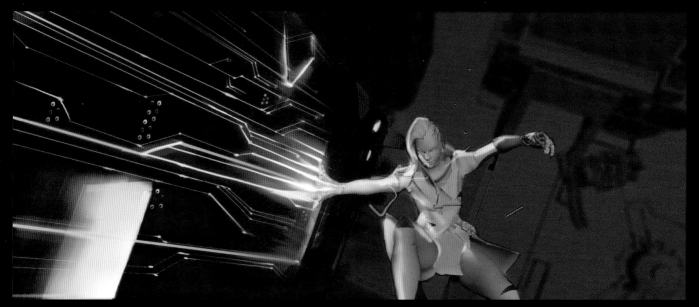

▸ **MECH CONCEPTS**—An important story point in "Infiltration" was that the Russians were enemies of omnics. Rather than using autonomous robots, they created mechs that were piloted by humans.

To emphasize this point, the film's creators designed the mech so that the pilot would be clearly visible (opposite page). They also made his jumpsuit red to draw attention to him and symbolize that he was the beating heart of the machine.

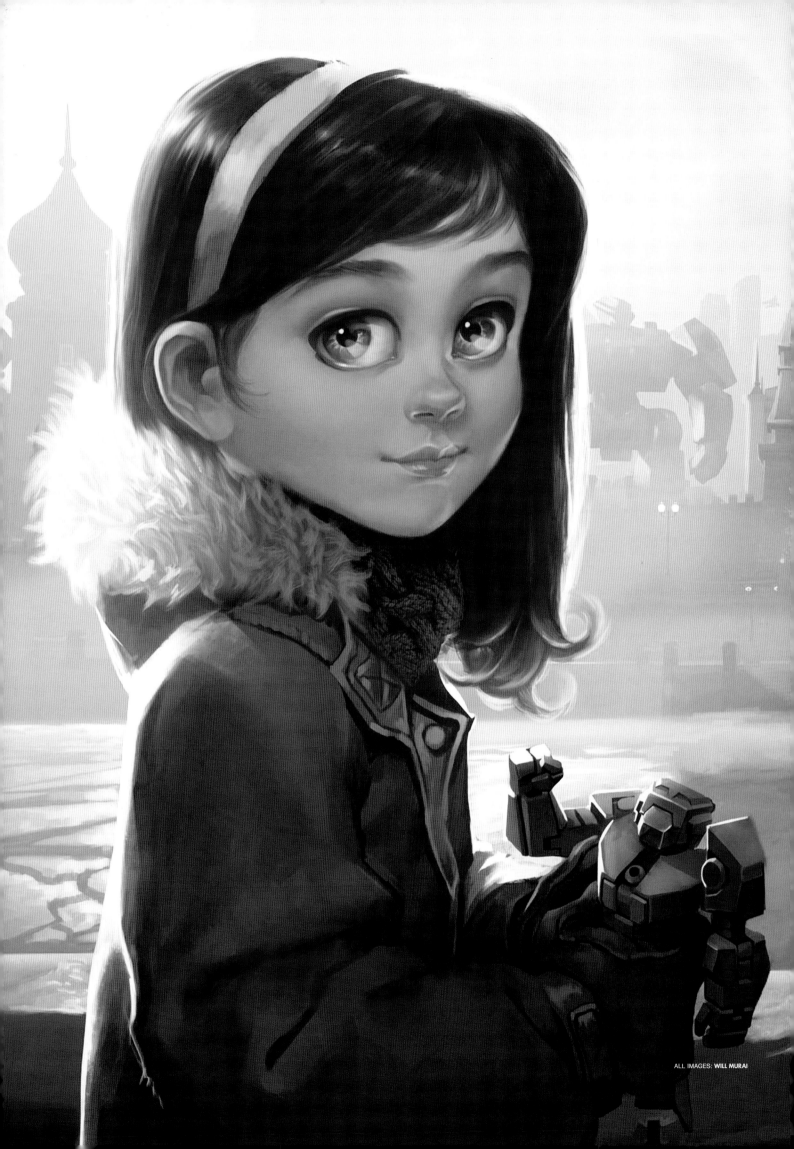

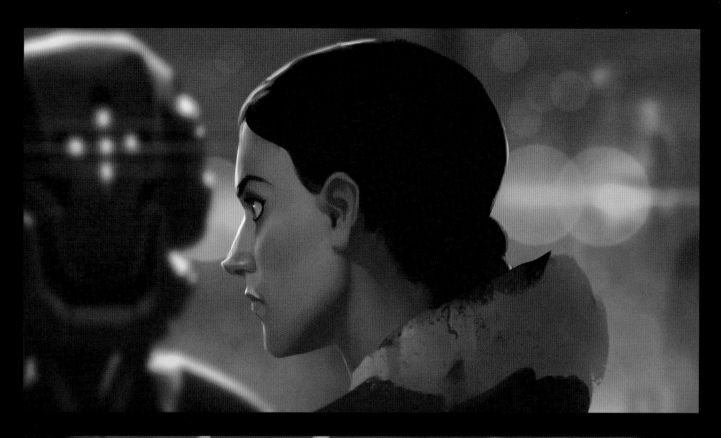

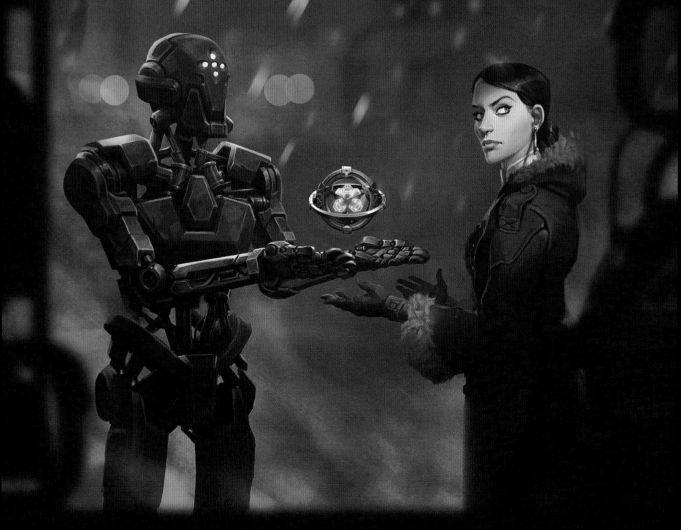

creators of "Infiltration" wanted to try something different. However, they still needed to make an environment that Sombra, Widowmaker, and Reaper could use to conceal their movements as they snuck into the facility.

Early concepts and color keys explored the idea of a heavy snowstorm (first column, first row), which created the perfect conditions for the characters to perform their infiltration.

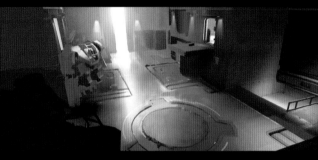
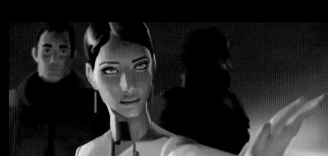

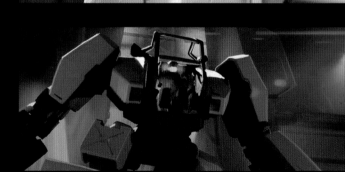

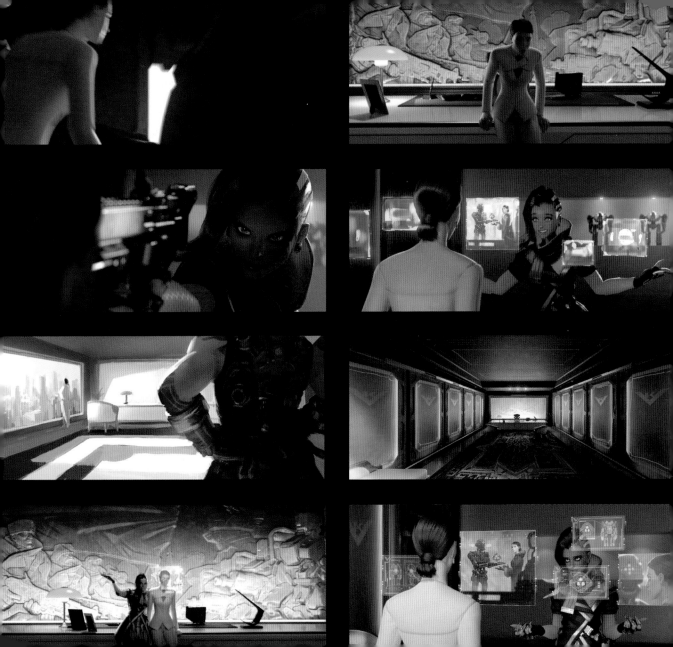

ORIGIN STORIES

In the busy weeks leading up to BlizzCon 2014, as the *Overwatch* team was preparing to unveil its game to the world, a small project took shape. It would turn out to be a very special one. The team wanted to show that each of *Overwatch*'s characters had a rich history. The developers decided to introduce Tracer and her backstory at BlizzCon, but time was short. And so were resources.

To overcome these hurdles, the team created a story that was short and economical—one composed entirely of illustrations. Tracer herself narrated it, revealing her past and the origins of her time-bending powers.

The *Overwatch* team was so happy with how the project turned out that it went on to create more. These origin pieces were an ideal way to set the mood of a character, explore their past, and establish their personality. They also became the perfect means to highlight what the team believed was the core of *Overwatch*'s visual style: line drawings, like those used in the creation of concept art.

TRACER

The first origin piece revolved around the character considered to be the face of *Overwatch*: Tracer. Before BlizzCon 2014, the game team created a few key illustrations to depict her backstory. The plan was for the designers to give a presentation at the convention where they would simply show these images and guide the audience through the story.

But that didn't seem quite right. It didn't feel as if Tracer was getting her day in the sun. It wasn't until the team decided to have Tracer's voice actress narrate the story that the pieces started falling into place. Other aspects of the project soon evolved as well. The game team made more illustrations and combined them with Tracer's dialog to create an animated short.

Tracer's origin story had a tremendous influence on future pieces. It established a clear tone and style for what would become a crucial medium for the game team to unveil their characters.

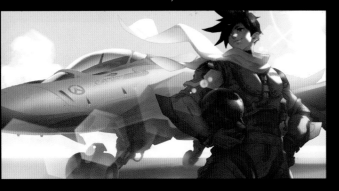

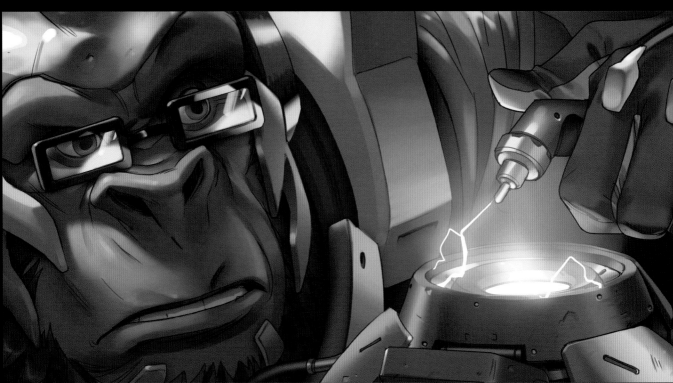

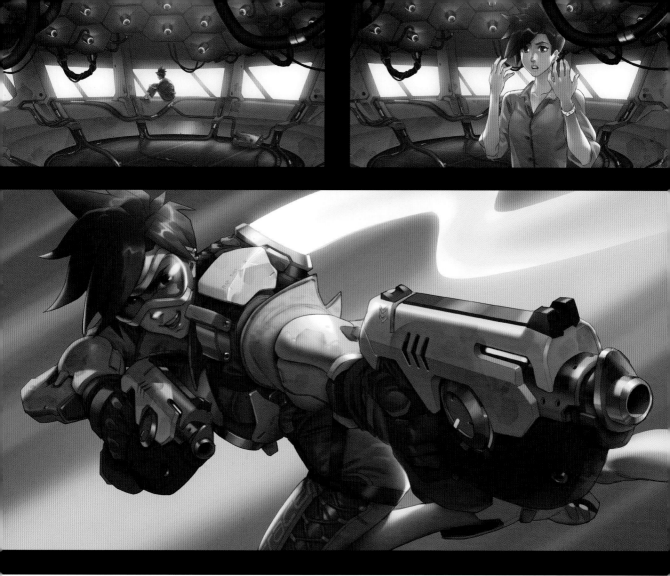
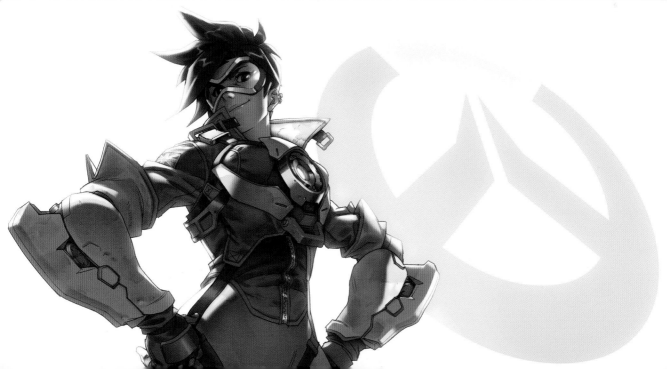

SOLDIER: 76

When the game team set out to make the Soldier: 76 origin piece, they knew it would serve many functions. This character—otherwise known as Jack Morrison—was the core to the Overwatch story. He had served as the group's leader. His rise to fame and his fall from grace paralleled the rise and fall of Overwatch itself. Through Soldier: 76, the team had a chance to unveil key moments of the organization's history.

The Soldier: 76 origin story visually evolved from the previous piece (Tracer). The game team moved from blue monotone to sepia colors, making the short feel even more like a snapshot of history than its predecessor.

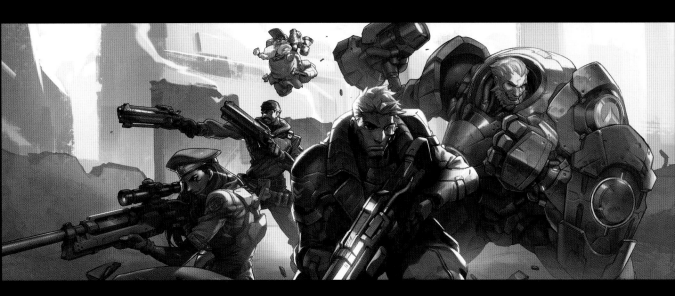

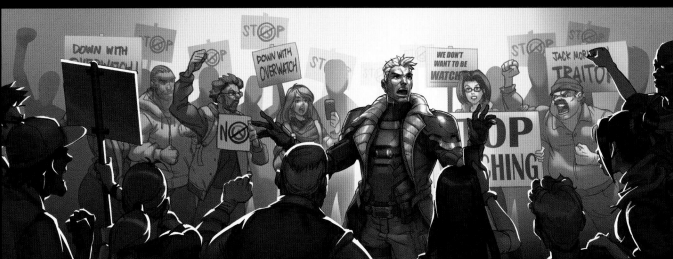

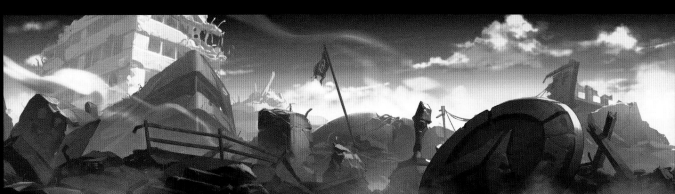

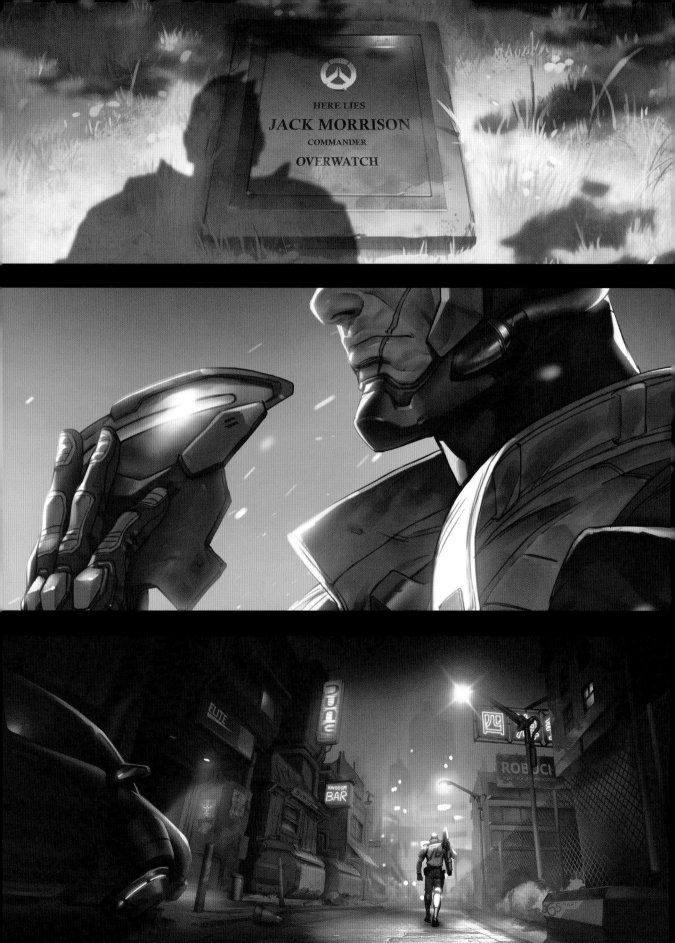

THE JUNKERS

The game team always saw Junkrat and Roadhog occupying a special place in *Overwatch*, bringing a unique flavor to the world. Capturing the correct tone meant creating an origin piece that would stand apart from the others.

To accomplish this, the team went away from the blue monotone or sepia colors in the first origin shorts (Tracer and Soldier: 76) and opted for full-color illustrations. Rather than telling the duo's backstory, they shined a light on Junkrat and Roadhog's absurd hijinks and personalities through the lens of a tongue-in-cheek show called *A Moment in Crime*.

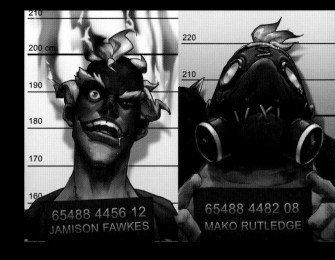

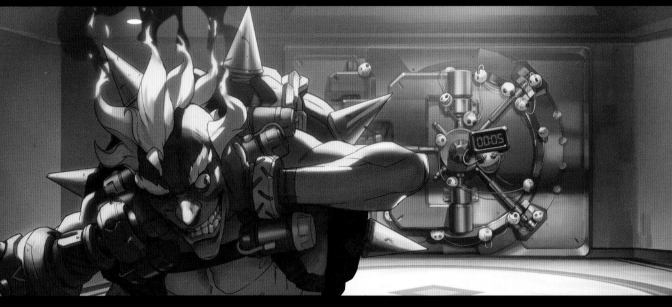

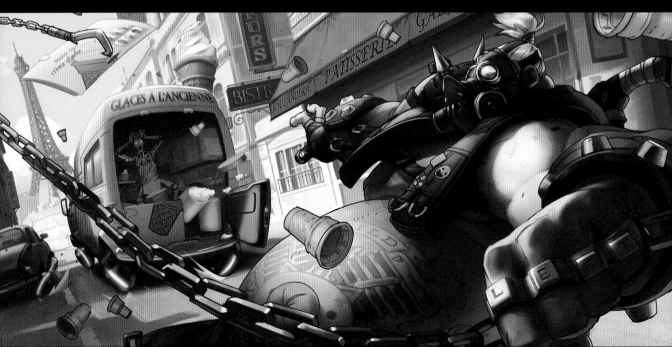

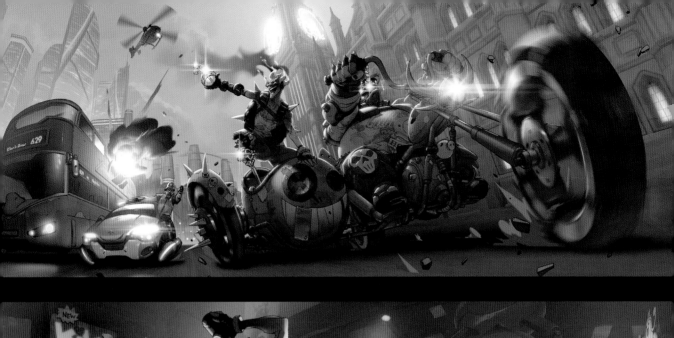

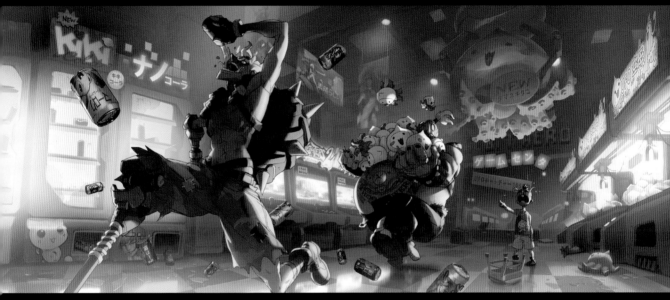

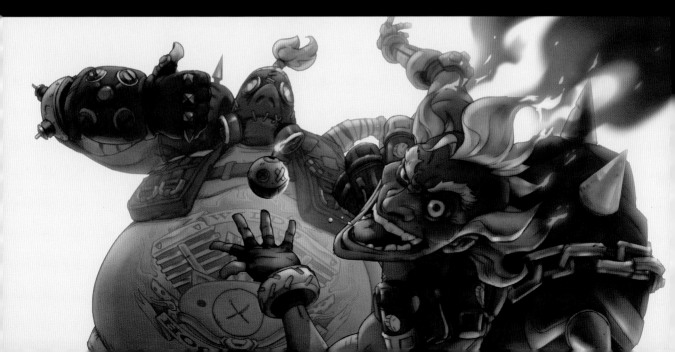

ANA

Ana was a character whose history was tied to the very beginning of the Overwatch organization. However, the game team already told that story in Soldier: 76's origin piece, and they didn't want to cover the same ground again. With Ana, they focused on her relationship with other characters, most of all with her daughter, Pharah.

The origin story's narration comes from a letter Ana wrote to Pharah in Arabic (second row, second column). The game team wanted to animate the writing itself, but making it feel authentic was a challenge. There are many differences between English and Arabic, including the fact that the latter flows from right to left. Only someone

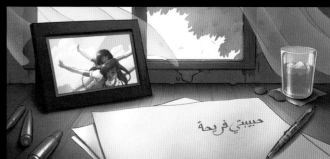

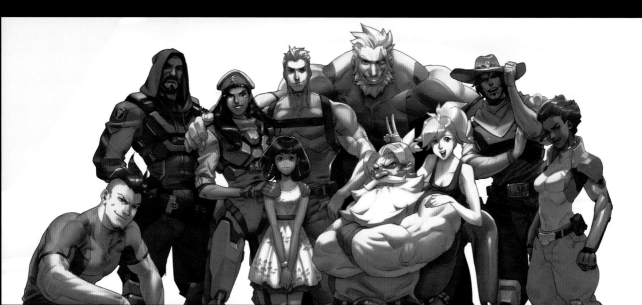

They filmed this person—a fellow *Overwatch* developer—
penning the letter in Arabic. This recording was then used
as a reference for animating the writing.

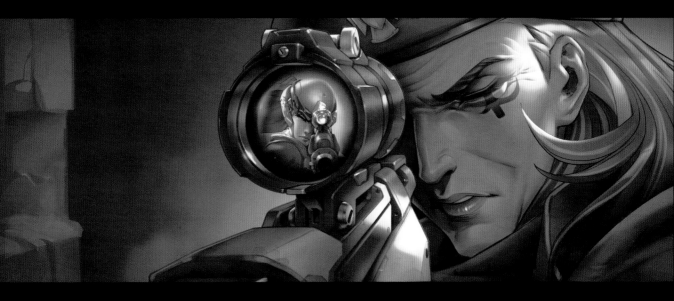

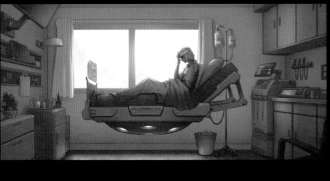

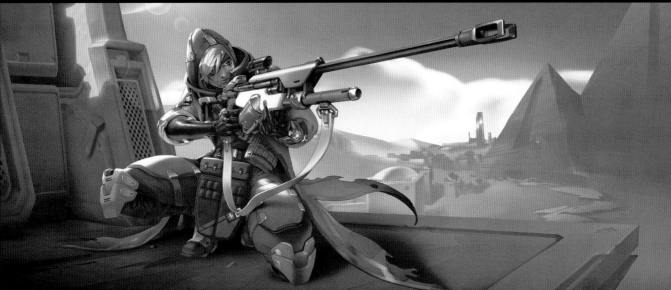

SOMBRA

For Sombra's origin piece, the game team wanted to try something new. They felt that the character's cyberpunk aesthetic would be a good fit for a full-color short featuring more complex 2-D animation than anything seen in the previous pieces.

Making that jump brought a host of technical challenges, but stylistically it was perfect. The line art used in the origin pieces transitioned well into 2-D animation.

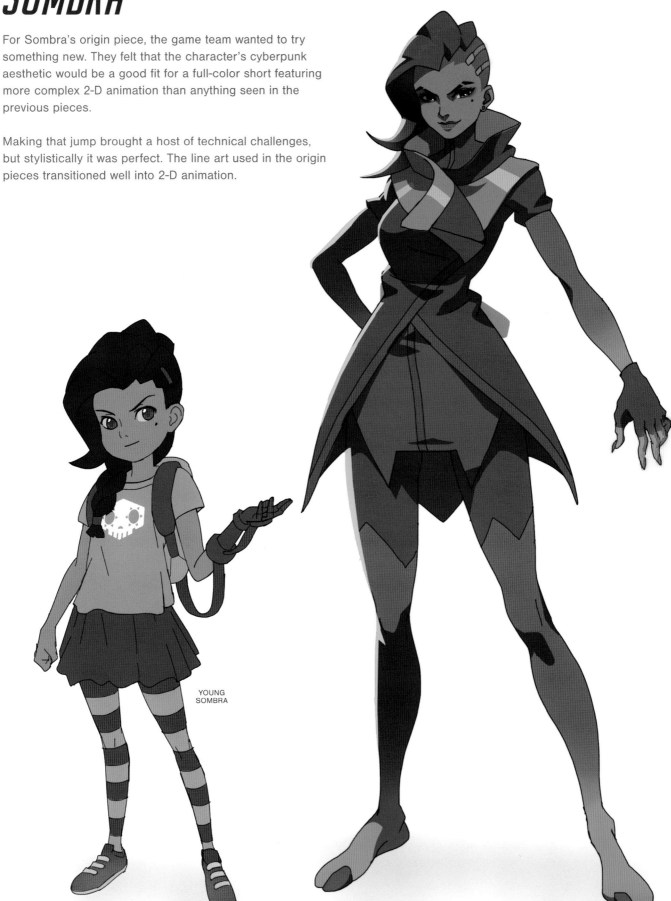

YOUNG
SOMBRA

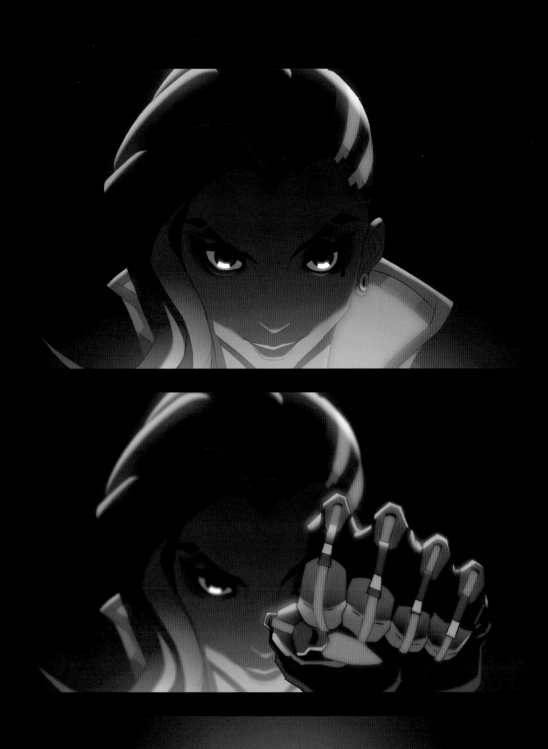
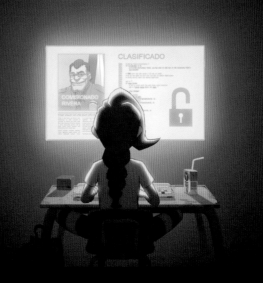

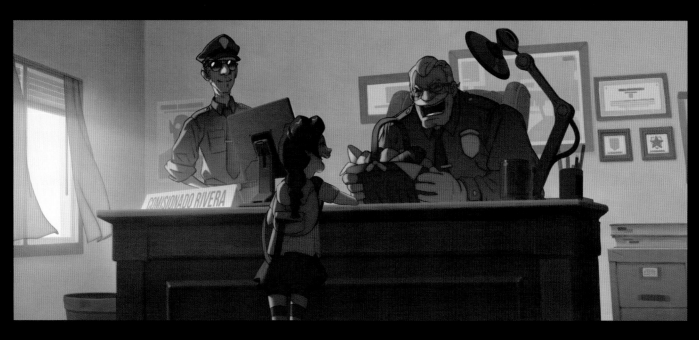

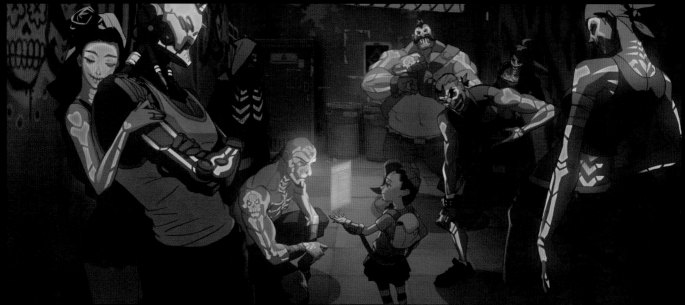

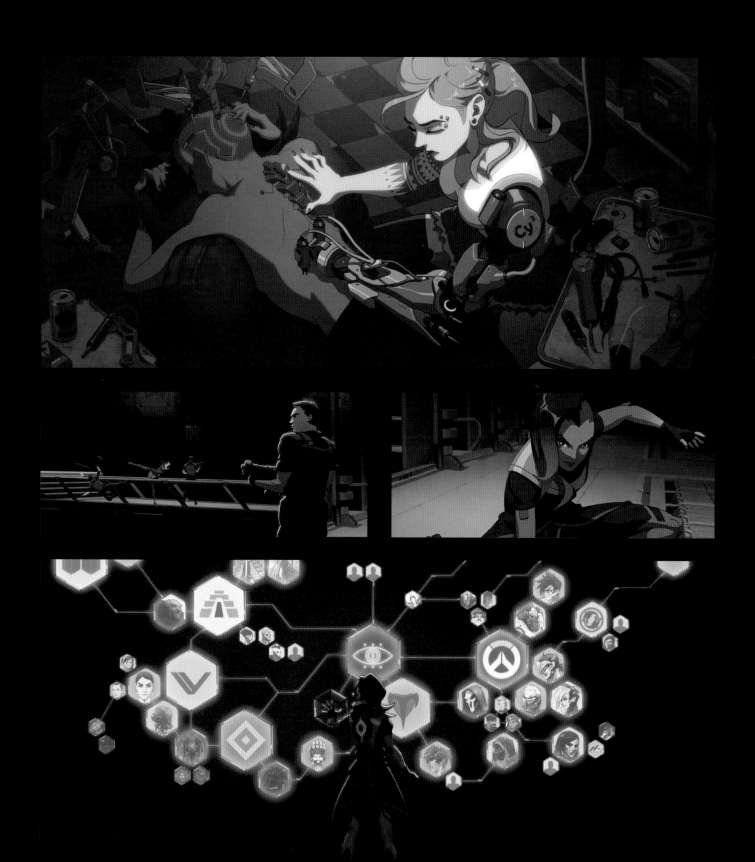

ORISA

When designing Orisa's backstory, the game team decided that the robot was created by a young human genius named Efi Oladele. Introducing this supporting character helped the developers flesh out Orisa's personality, but it also presented a challenge. Efi would not be a playable character in the game, so how could the team explain who she was?

Orisa's origin piece fit the bill. The game designers worked with Story and Franchise Development to craft an animated short that explored the relationship between Orisa and Efi. This had a dual benefit. Not only did the film make Orisa more relatable, but it also cemented Efi's place in the *Overwatch* world.

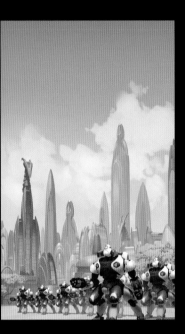

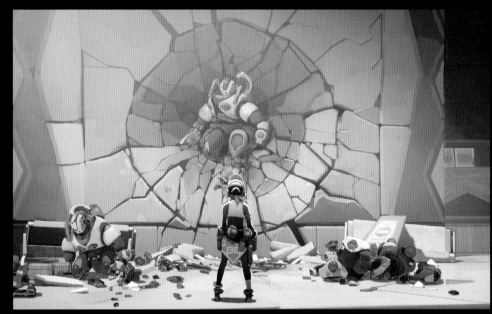

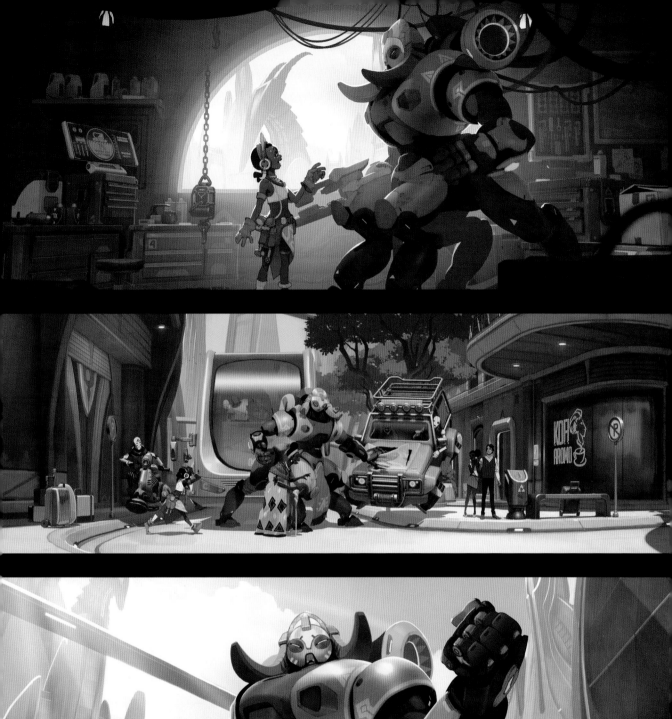
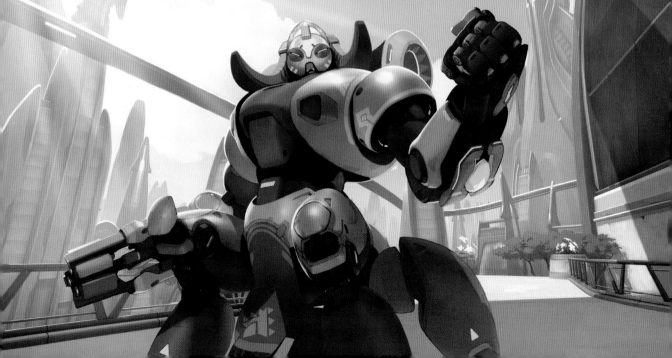

UPRISING

Uprising was a departure from previous origin pieces. Instead of telling a specific hero's story, it revealed historical events to set up game content. Early in the creation process, the developers chose Tracer to narrate the film. Including her added a level of familiarity to the short, and it also tied into Uprising's story. The event was Tracer's first mission as part of the Overwatch organization.

Uprising was the first time the developers worked with an external artist to create an origin piece. Nesskain, who had worked on some of *Overwatch*'s comics and created the Anniversary painting, crafted the film's visuals. Though it was important to make Uprising visually similar to previous origin pieces, the game team was eager to have the artist express his own distinct style in the animation.

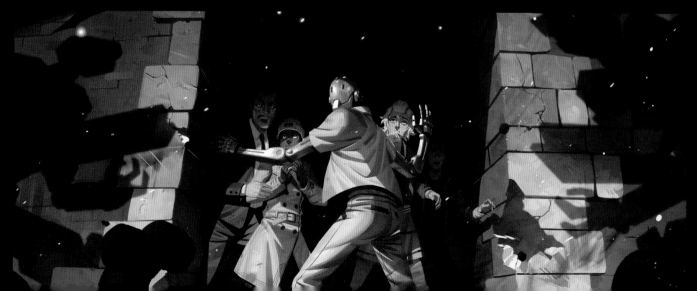

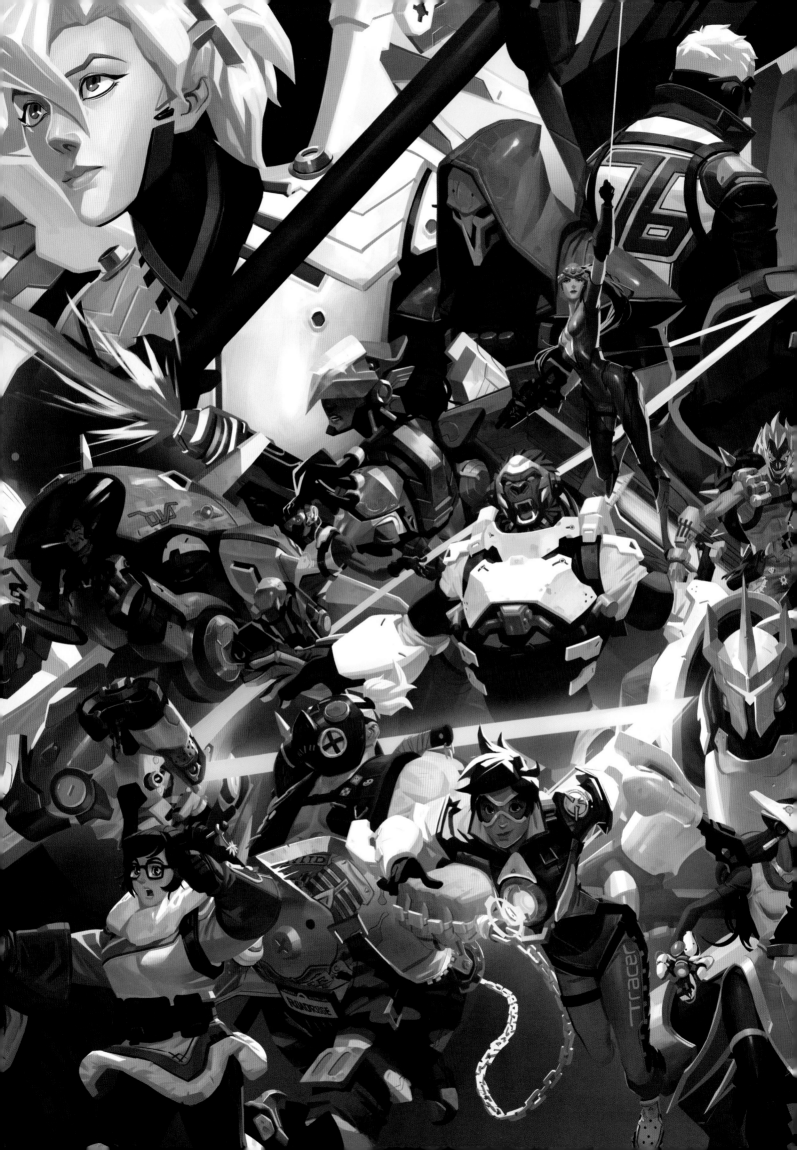

PROMOTIONAL ART

After *Overwatch*'s announcement, a diverse community formed around the game. People from all walks of life embraced Tracer, the other heroes, and the vibrant world where they lived. Artwork made by members of this community soon popped up across the internet. The developers were so inspired by these works that they hung many of them in their offices. *Overwatch* didn't just belong to the game team anymore; it belonged to the community, too.

Promotional art gave the developers a chance to build *Overwatch* with this passionate community and share these artists' unique vision of the game with the rest of the world. The team worked alongside artists from around the globe on illustrations to showcase heroes, maps, and events. These pieces appeared in different places and in different forms. Some were used on websites to announce upcoming content. Others were blasted across social media. What these works of art had in common was how they enriched *Overwatch* with new styles and perspectives.

NESSKAIN

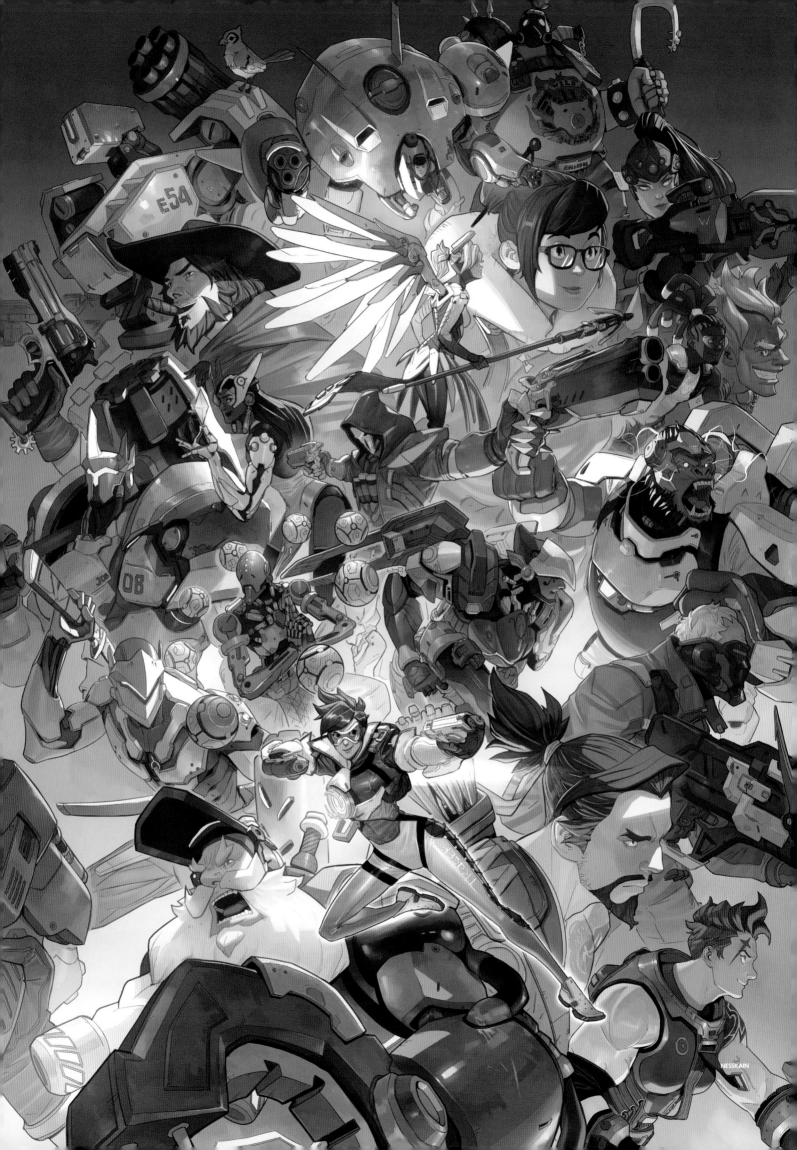



OVERWATCH HALLOWEEN TERROR

The developers joined forces with other Blizzard teams and an external artist to make lighthearted illustrations themed around the *Overwatch* Halloween Terror event. These pieces were distributed on Twitter. If someone retweeted a message from *Overwatch*'s official account, or replied to it with "#HalloweenTerror," they would receive art in the form of a "trick" or a "treat."

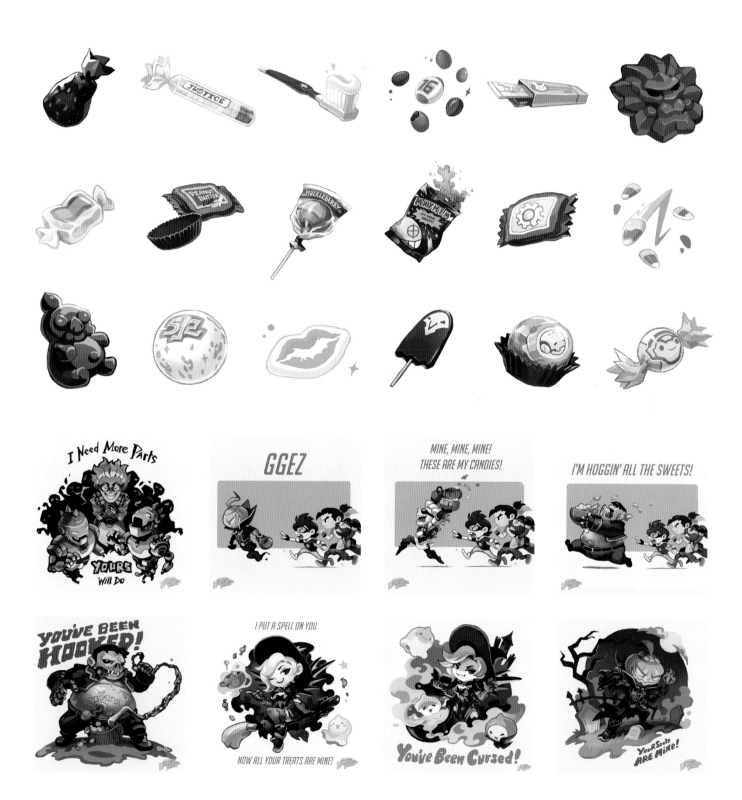

ALL IMAGES: **ONEMEGAWATT**

WINTER WONDERLAND

Following the success of *Overwatch* Halloween Terror's Twitter campaign, more were launched for Valentine's Day and Winter Wonderland. Once again, the game developers worked alongside other Blizzard teams and external artists to craft an array of fun, holiday-themed illustrations.

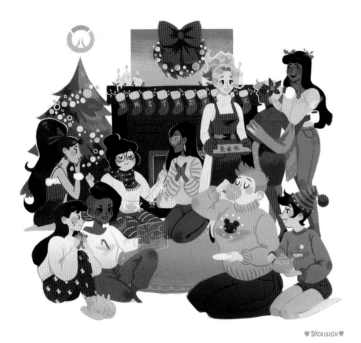

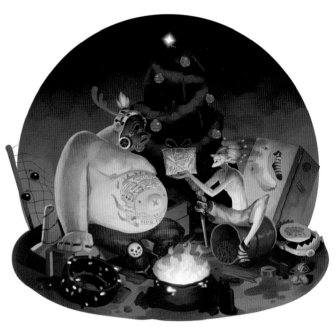

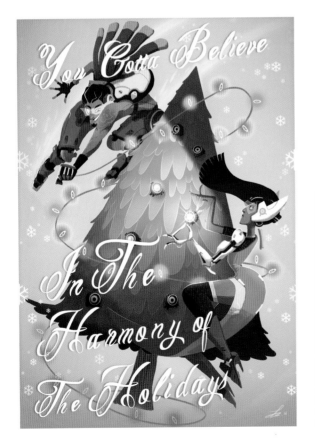

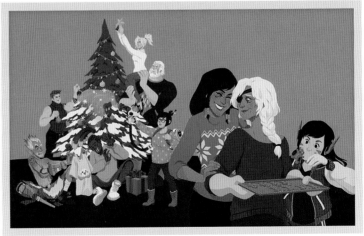

TOP LEFT: **VICKISIGH**, TOP RIGHT: **E.M. ENGEL**, MIDDLE RIGHT: **ONEMEGAWATT**, BOTTOM RIGHT: **LAZERLILLY**, BOTTOM LEFT: **ART CALAVERA**

VALENTINE'S DAY

ALL IMAGES: **TINYSNAILS**

UPRISING POSTERS

Uprising was about an Overwatch mission to thwart a faction of omnics attacking King's Row. The game developers worked with multiple teams at Blizzard to create and launch promotional art leading up to the event. Posters inspired by classic military recruitment ads seemed like the perfect style to pursue, based on Uprising's themes and story.

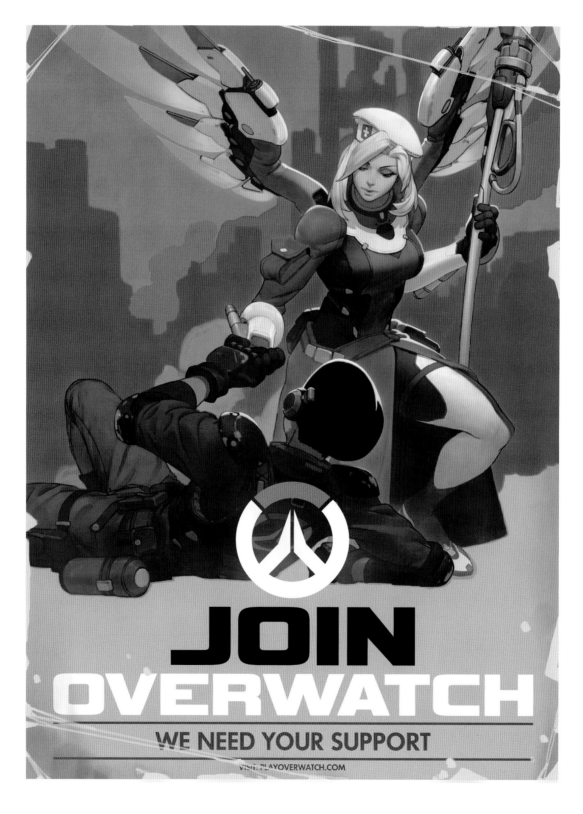

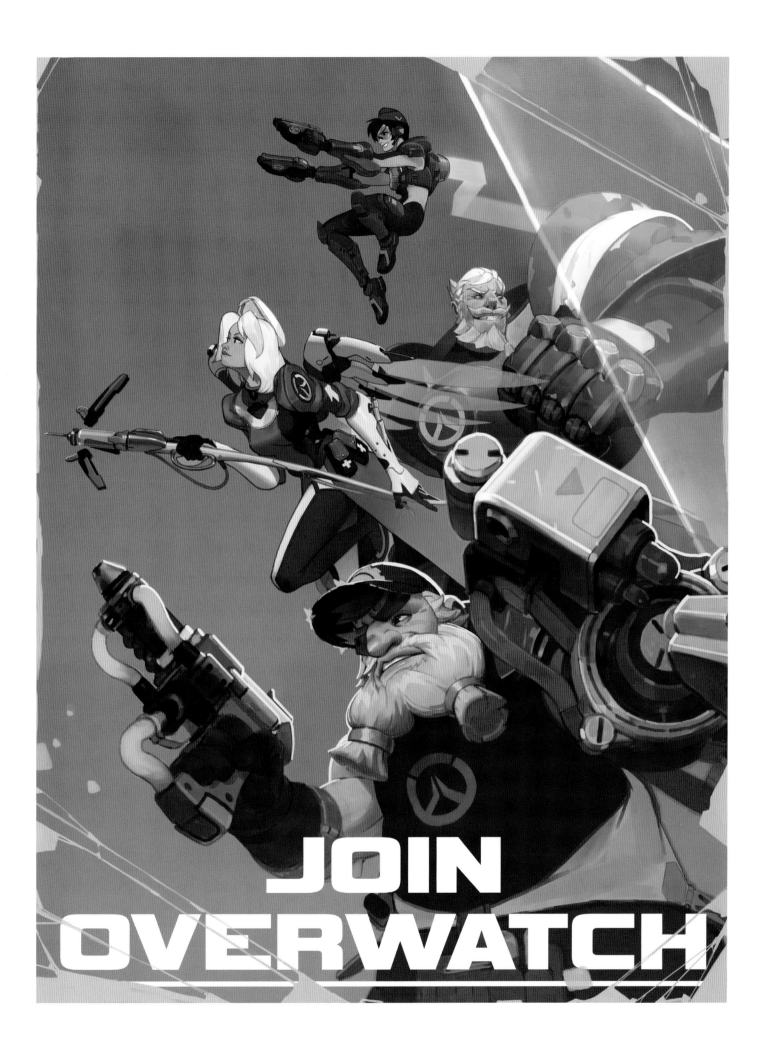

JOIN OVERWATCH

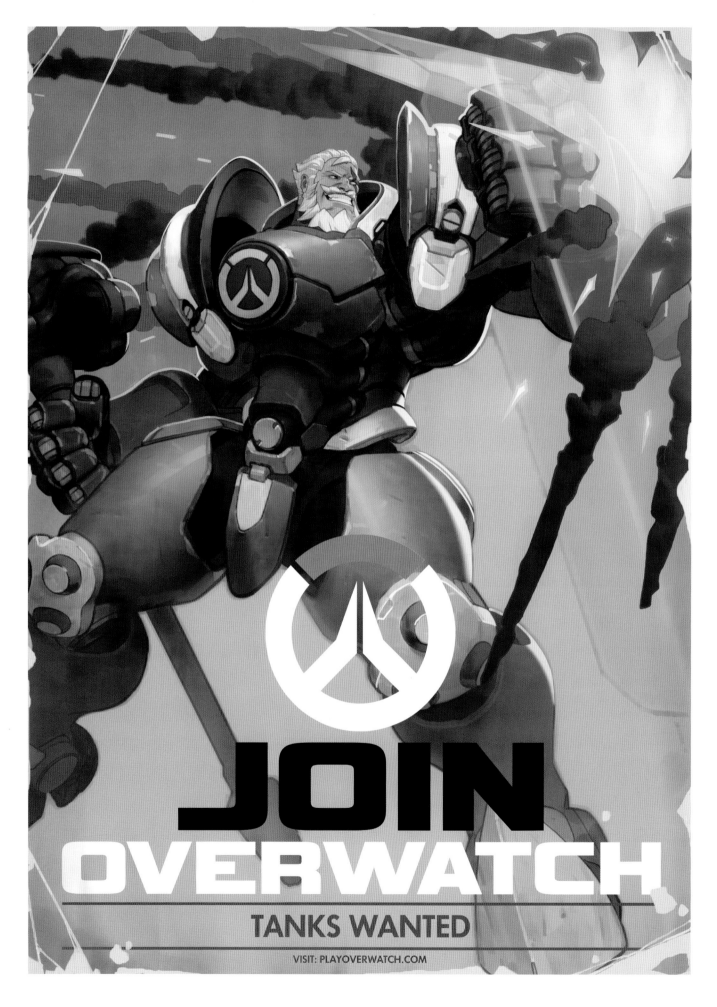

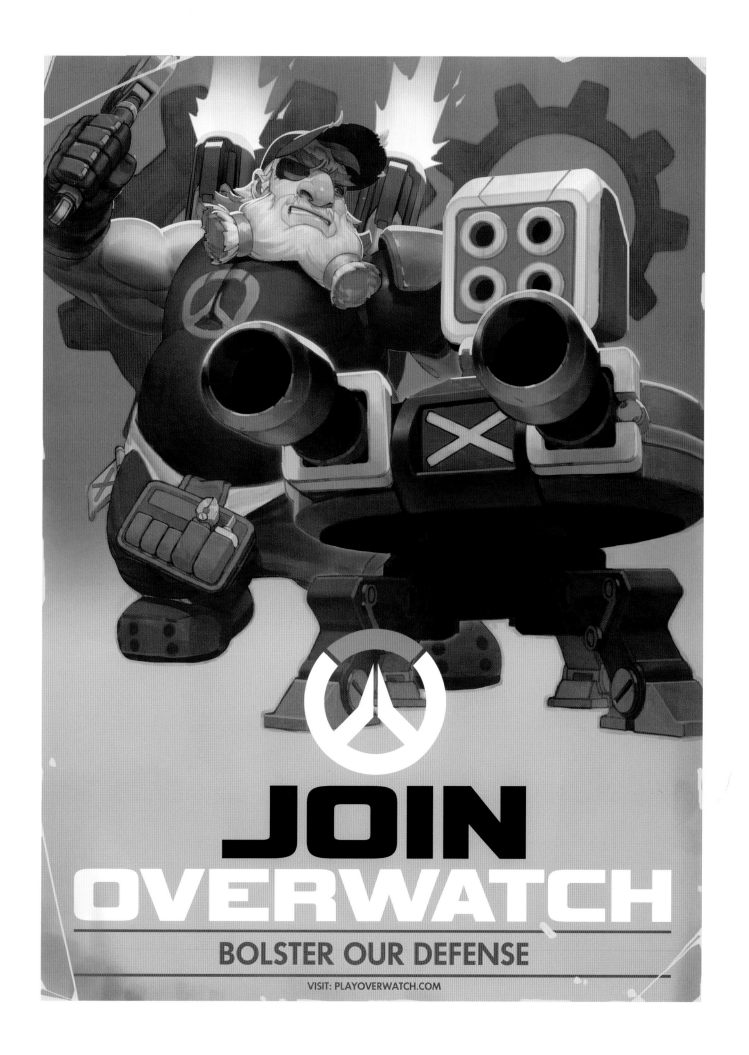

JOIN OVERWATCH

BOLSTER OUR DEFENSE

VISIT: PLAYOVERWATCH.COM

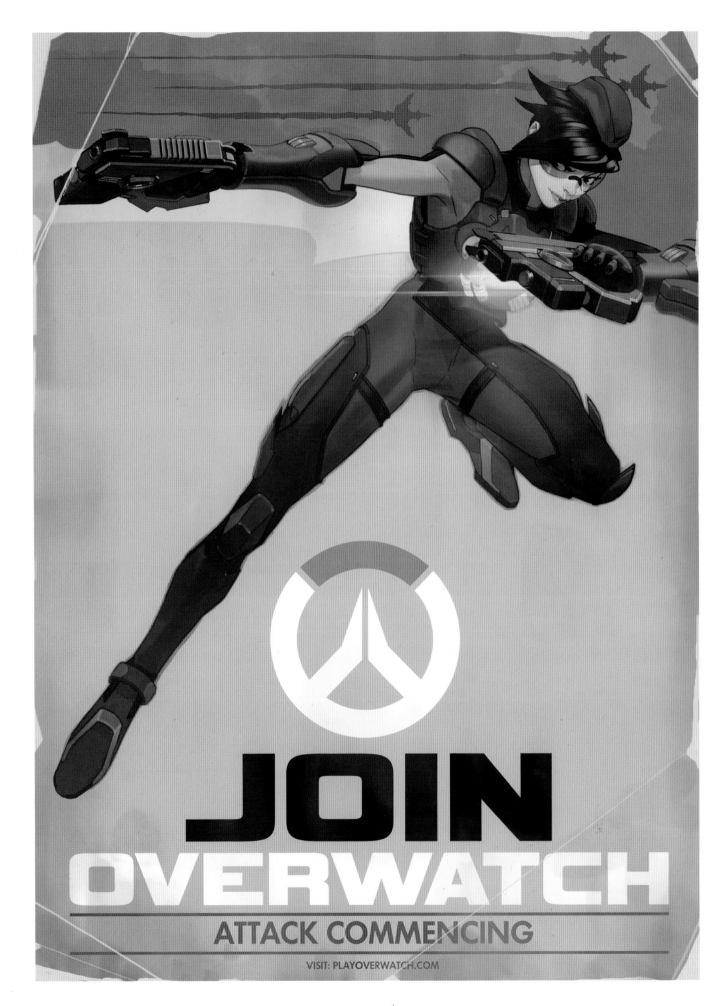

OVERWATCH: ANNIVERSARY

Overwatch's Anniversary event marked one year after the game's release. Much had changed in that time, including the arrival of new heroes. The developers worked with an artist from the community to create an image that would celebrate *Overwatch*'s expanded roster of characters. The resulting painting was different from previous hero lineup illustrations. Rather than show the characters' full bodies or depict them to scale, the Anniversary piece took a highly stylized approach to create a dynamic composition.

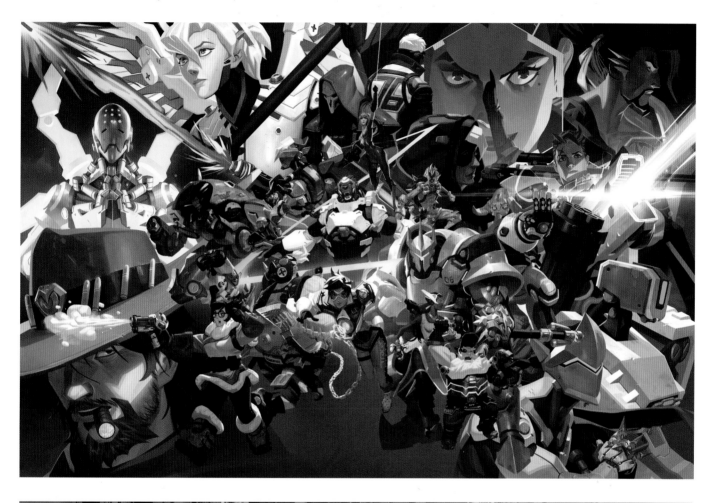

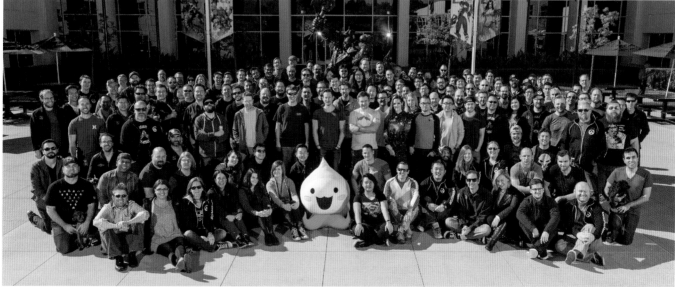

TO COMMEMORATE THE GAME'S ONE-YEAR ANNIVERSARY, A GROUP PHOTOGRAPH WAS PRINTED AND DISTRIBUTED TO THE MEMBERS OF THE *OVERWATCH* DEVELOPMENT TEAM.

TOP: **NESSKAIN**, BOTTOM: *OVERWATCH* DEVELOPMENT TEAM